LEICESTER'S TRAMS AND BUSES

AND BUSES

20TH CENTURY LANDMARKS

LEICESTER'S TRAMS AND BUSES

20TH CENTURY LANDMARKS

Andrew Bartlett

PEN & SWORD
TRANSPORT

AN IMPRINT OF PEN & SWORD BOOKS LTD.
YORKSHIRE - PHILADELPHIA

First published in Great Britain in 2018 by
Pen & Sword Transport
An imprint of
Pen & Sword Books Ltd
Yorkshire - Philadelphia

ISBN 978 1 52673 249 1

A CIP catalogue record for this book is
available from the British Library.

Typeset by Aura Technology and Software Services, India
Printed and bound by Replika Press Pvt. Ltd.

Pen & Sword Books Ltd incorporates the Imprints of Pen & Sword
Archaeology, Atlas, Aviation, Battleground, Discovery, Family History,
History, Maritime, Military, Naval, Politics, Railways, Select, Transport,
True Crime, Fiction, Frontline Books, Leo Cooper, Praetorian Press,
Seaforth Publishing, Wharncliffe and White Owl.

For a complete list of Pen & Sword titles please contact
PEN & SWORD BOOKS LIMITED
47 Church Street, Barnsley, South Yorkshire, S70 2AS, England
E-mail: enquiries@pen-and-sword.co.uk
Website: www.pen-and-sword.co.uk

Or
PEN AND SWORD BOOKS
1950 Lawrence Rd, Havertown, PA 19083, USA
E-mail: Uspen-and-sword@casematepublishers.com
Website: www.penandswordbooks.com

CONTENTS

LIST OF ILLUSTRATIONS AND MAPS

All photos were taken in Leicester unless otherwise stated, and dates (where known) will be found in the text accompanying each picture.

Front Cover

Main picture Midland Red 3463 (MHA 463) was a Southgate Street garage bus throughout its career (1949-64). In this photo, probably from around 1960, it is standing 'wrong side' between platforms 1 and 2 at St Margaret's bus station. The concrete shelters, now approximately 20 years old, are showing signs of weathering, and 3463, which is (or has been) employed on the 617 Syston service, is not displaying a full destination display as it has been filling in on what would normally be a Sandacre Street duty (*LTHT*)

Lower left Leicester Corporation Tramways Car 22, on its way to the town centre, is about to pass Stoneygate-bound car 33 on the London Road hill between the railway station and Victoria Park during the very early days of the system. This colour-tinted postcard was posted to Quarndon, near Derby, on 26 September 1904 (*Author's collection*)

Lower right The competition between Midland Fox and Leicester CityBus was still very much an issue when this photo was taken, with vehicles from both companies seen in Humberstone Gate early in 1985. Bound for Scraptoft on a 51 working, Midland Fox 2901 (KUC 961P) is an ex-London Transport Daimler Fleetline acquired in late 1983. No doubting that Leicester CityBus is the operator of Dennis Dominator 41 (TBC 41X); having come from Braunstone Crossroads, it is now on its way to Rushey Mead on the 21. The late, lamented Lewis's store can be seen in the background, and the Fox Cub minibus era is now only a few months away (*Author's collection*)

Maps

Chapter 1

Chapter 5

Appendix 8

Photo credits

Author or author's collection
9-13, 15-19, 21-34, 36, 37, 39, 40, 43, 46, 48, 52, 54, 57-60, 63, 64, 66, 76, 77, 79-87, 90, 93, 94, 99, 101, 104, 107, 108, 110-113, 116, 117, 119, 121, 122, 124-126, 133-135, 138, 140-145, 147-150, 152-154, 156-161, 163-181

Bedfordshire & Luton Archives Service
38

Leicester Transport Heritage Trust collection
14, 20, 35, 47, 49, 56, 61, 62, 67, 68, 73, 102, 103, 105, 106, 109, 114, 115, 120, 123, 130-132, 136, 139

Mike Greenwood or Mike Greenwood collection
44, 45, 75, 137, 146, 155

M A Sutcliffe OBE
78

Leicester Mercury
69, 70, 74

Peter Newland or Peter Newland collection
41, 42, 50, 51, 53, 88, 89, 91, 92, 95-98, 100, 127-129, 151

Record Office for Leicestershire, Leicester & Rutland
1-8, 71, 72

Roy Marshall
55, 118

Tom Shaw
65

Trevor Follows
162

FOREWORD

I was delighted to accept when Andrew kindly asked me to write the foreword for this fascinating book.

Andrew is a valued member of the Leicester Transport Heritage Trust and I have regularly tasked him with researching facets of Leicester's early road transport history. His thoroughness and attention to detail, together with the necessary cross-referencing, has made it an easy decision for me to delegate this type of work to him. In consequence he has made a huge contribution to the research work undertaken by LTHT.

Andrew is also a regular contributor to the Trust's quarterly journal with 'From Our Correspondent....' column. With this he selects small extracts of items about buses which have been published in local newspapers over a wide time-frame. This gives an excellent social history balance to the more mechanical aspects of transport which also appear in the journal.

When Andrew first disclosed that he planned to write a book on five of Leicester's most important bus-related landmarks using the same 'first person' approach

I must admit I was somewhat sceptical as to whether it would work. However, the unusual nature of using correspondence and reports published at the time has added a unique richness and vitality to the subject matter which is being conveyed.

In fact, when reading the original manuscript, I found it hard to put down, such was the compelling way in which the subject matters were being reported. Leicester's road transport history is not widely covered and this reference will, I am sure, prove invaluable to transport and social historians, as well as the general reader, in the years ahead.

The quality and thoroughness of the research together with the way it has been presented are a real joy and I congratulate Andrew on a great achievement.

Mike Greenwood
Director of Archives & Research
Leicester Transport Heritage Trust
www.ltht.org.uk

INTRODUCTION

Right up to the end of the eighteenth century, the vast majority of Leicestershire's inhabitants had neither the reason, the desire nor the wherewithal to travel far from their home town or village. They were not the potential clientele of the stagecoach, despite the fact that Leicester was among the first places outside the London area to benefit from such a service; a newspaper report in October 1700 – appropriately enough in the *Flying Post* – tells of the London to Leicester stagecoach setting out 'from the Ram (in Smithfield) on Mondays, and from the Rose on Thursday, twice a week all winter'.

In the early years of the eighteenth century, Leicester's population was around 6,000, which was around three times what it had been at the time of the Norman Conquest roughly 650 years before. Indeed, by 1801, the first year in which a census of sorts was taken, it was only 17,000. But now came the time when the effects of the Industrial Revolution started to be felt. By 1851, the figure had risen to 60,600. The next fifty years brought phenomenal growth; by 1901 it stood at 211,600. My own family provides a classic example of migration to Leicester in this period for the greater opportunities for work it provided; the males on the paternal side were, to a man, agricultural labourers in the south of the county in the 1820s, but virtually all had moved to Leicester by the 1880s, and most were employed in the building industry.

Although the coming of the railways from the 1830s onwards was one factor in the movement of labour, anyone who wanted to travel into Leicester did have other options, although only one came at no cost, namely to walk. Those with a few pennies to spare might have been inclined to ride with the local carrier on his weekly trip to Leicester and back. The carriers were in effect the forerunners of bus operators, and every town and most villages had one (and sometimes more). They were tradespeople whose principal job was to carry goods to and from Leicester, operating on Wednesdays and/or Saturdays, which were market days. They might take paying passengers, space permitting. Starting times from their villages were generally not recorded in the early days, presumably because they would be well known to all in the community. Return journeys from Leicester were advertised in the trade directories such as Kelly's, and were timed between 4 and 5pm, usually departing from outside one of the many public houses in the centre of town.

So until the mid-1860s, walking was the option preferred by the majority. But then, as the town boundaries expanded to accommodate the burgeoning population, so affordable public transport from the new suburbs to the centre started to become available. Leicester was among the frontrunners in terms of both the introduction of horse buses (1863) and the first railed horse tramway (1874), but it came late to electrifying the system (1904). As in many other places, the first independent motor bus operators were active by 1910, and larger operators (such as Trent and Midland Red in Leicestershire) began to establish their territories in the period between 1919-21. Leicester Corporation started to operate its own motor bus fleet soon after that, in 1924. The city fathers toyed with the idea of running trolleybuses but finally ruled against the idea in 1938, and the closure of the tramways came in 1949, 15 years after Derby and 13 years after Nottingham, but 10-11 years before Leeds and Sheffield.

So, on the surface at least, Leicester's progress in the field of public transport was, if you will forgive the pun, fairly middle-of-the-road; there was nothing about the development of the infrastructure that marked it as being particularly out of the ordinary. But while researching the story behind the opening of St Margaret's bus station in 1941, I discovered that there was much more to it than simply a straightforward acquisition of land on which platforms and shelters could be built. The idea of a proper bus station was in fact first mooted in 1928, and there had been two very basic attempts at providing off-road termini for buses and their passengers between then and 1941. During that period, I found evidence of strained relations between the Birmingham & Midland Motor Omnibus Co Ltd, or as it was more popularly known, Midland Red, and the members of both the Council's Tramways and Watch Committees, and it is clear that this impacted upon the workings

of both. Whilst one might accept that it was inevitable that there would be areas of disagreement between any Corporation undertaking and its local independent bus operator(s) from time to time, the Leicester situation seemed to be unusually difficult.

I was intrigued by the fact that it had taken so long to provide even the most basic of amenities for intending passengers, and wanted to find out more about how on-street termini had been managed in the earlier years. This led me to look at the arrival of the first Midland Red bus into Leicester in 1921, and the way in which the city fathers set about making space for all the new services as the company built up a network of county services throughout the 1920s. I soon realised that I had to trace some of this history back to the electrification of the tramway system in the 1900s; that led me to the decision-making process behind its closure in 1949. And finally, I knew from personal experience that government policy in the early 1980s, which led to privatisation and deregulation legislation, had a profound effect on the industry and locally strained the working relationship between Leicester's principal operators almost to the metaphorical breaking point. Behind most of this, as will be seen throughout the narrative, was the overwhelming desire of the Corporation to try to protect its own services at whatever cost; a feat that was well-managed in the 1920s and 1930s, but less well so in the 1980s. But there they were; five landmark events that marked the development of public transport in Leicester over a period of 100 years.

The huge amount of information that I found in Council minutes and reports in Leicester's newspapers meant that it was possible to tell the whole story of each of these five landmarks for the first time. I have used the words of the Council's minute-writers and the newspaper editors and reporters wherever possible, as they provide contemporary factual and contextual detail invaluable in the presentation of a fully-rounded picture upon which conclusions may be reasonably drawn. I have also dipped into the letters pages in the press for each of the landmark occasions. The general public have always been quick to put pen to paper to comment on issues that affect them, either as passengers or ratepayers – some humorously, some tetchily – and I believe these add an extra dimension in the telling of the story.

So what follows is not strictly a technical work, although it does touch on some issues of a technical nature. I hope that readers, whether they have an interest in public transport or not, will see it as a historical journey that is more concerned with ordinary people – those in authority whose role was to give shape to these events; those journalists whose contemporary pieces report on these events which, in my view, needed to be told exactly as they had been at the time; and the public, for whose benefit these events were designed, and who could be relied upon to tell anyone who would listen precisely what they thought of them.

What has changed most noticeably over the period is the newspapers' style of presentation. Street names are a particularly important part of the narrative, and readers will notice immediately that instead of, say, London Road or Belgrave Gate, in the early days we have London-road or Belgrave-gate. What is more, changes were not made at the same time; the Leicester Mercury appears to have adopted the current style during 1947, but the Evening Mail continued in the old ways until the start of the 1950s. I have remained faithful to whatever each newspaper was using at the time. On the other hand, headlines have appeared in various print sizes, in capitals, either entirely or with just the first letters capitalised, and most articles would have at least one, but often several, sub-headings throughout their length. For consistency, and to avoid any confusion, I have used capitals for all main headlines, and removed the sub-headings altogether.

I have already mentioned the research element; in relation to illustrating each of the landmarks, besides my own photographs, I am fortunate enough to have amassed a sizeable collection over the last thirty years or so. Where that has proved to be lacking, I have been able to delve into the collections of the Leicester Transport Heritage Trust and some of its members, who are thanked below. Many images do not reveal the identity of the original photographer, but I have tried wherever possible, and with the help of Peter Newland, to discover those responsible and record the proper attribution. Any error on my part is entirely unintentional.

There are many people to thank for their help making this work possible:

- my wife Debbie, for her support, encouragement, and her limitless patience
- Mike Greenwood and Peter Newland from the Leicester Transport Heritage Trust, who have played important roles in bringing this work to fruition; adding to my knowledge in several key areas, generously allowing me the use of their own and the Trust's photographs and checking the manuscript and captions
- other Trust members who have contributed, particularly Michael Webster, for his helpful comments on the draft and John Breen, who was employed by Midland Red and its successor companies for almost 52 years and can therefore tell a tale or two about them
- also Trevor Follows and Tom Shaw from the Trust, and Mike Sutcliffe, Henry Conn and the late Roy Marshall who have generously allowed me to use their excellent photographs
- the staff at the Leicester Record Office, for their help in tracking down some of the information and for allowing me to use material, maps and photographs from their archives
- the *Leicester Mercury*, for allowing me to use material and photographs from past editions of the paper, and for publishing the responses to my plea for first-hand accounts of Belgrave Gate and Abbey Street bus stations 1929-41; also to Ken West of Humberstone, Ted Brown of Markfield, Robert Brewin of Ravenstone and M.J. Mayes of Rothley, whose memories helped to shed more light on early city centre termini
- John Scott-Morgan and all those at Pen & Sword for their faith in me and the book
- and last but not least, to Ray Stenning, editor of the magazine *Classic Bus*. Some years ago, I submitted a much shorter version of Chapter 3 for inclusion in the magazine, but Ray decided not to run with it at the time. Although it is easy to say with hindsight, I believe that was the motivation for me to continue the researches, leading to the uncovering of the stories behind the other landmarks. The old adage about acorns and oaks springs to mind; thank you Ray.

Andrew Bartlett
Kibworth Beauchamp

MAPS – LEICESTER CITY CENTRE

This series of Ordnance Survey maps from the 1930 edition covers Leicester city centre and its environs. The street layout is essentially the same as it had been at the turn of the century; thirty years on and the slum clearance programme is only in its very early stages. The widening of Belgrave Gate and the extension to Charles Street have still to be made. Thus, the locations of events from the first three landmarks, and to a large extent the fourth also, can be seen at a glance. Readers will find that the story of the fifth landmark is a largely political one, which renders a more up-to-date map less of a necessity.

My thanks go to the staff at the Leicestershire, Leicester and Rutland Record Office for allowing me to use the original documents.

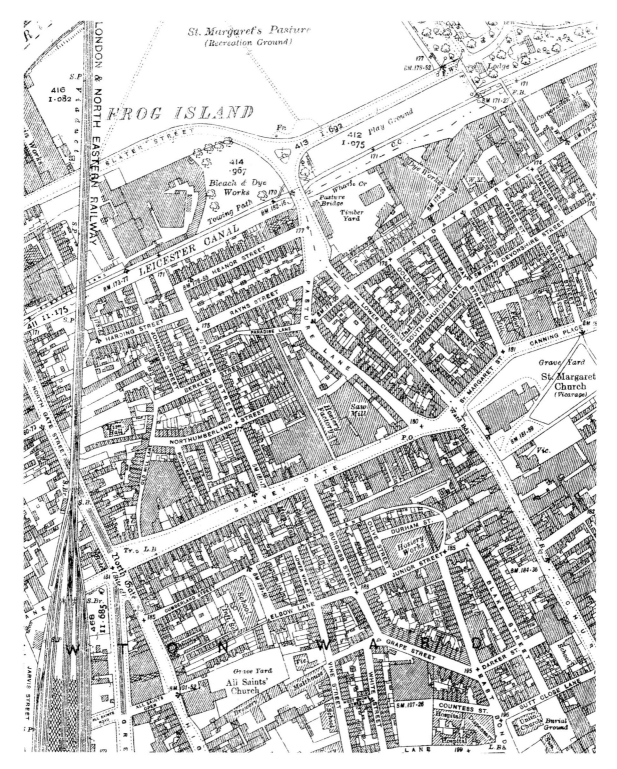

Map 1

This map covers the area to the north west of the city centre. On the left, the Great Central Railway station was built concurrently with the council's debates on the merits of buying the Tramways Company, being opened in 1899. All Saints Open and All Saints Road can be seen in the bottom left hand corner of the map – they served as the terminus for both Midland Red and independent operators' services using the Groby Road until 1935. St Margaret's Church stands proudly on the right-hand side of the map; the surrounding area is much changed today, with the St Margaret's Way dual carriageway replacing Church Gate/Lower Church Gate from a point just to the south of Junior Street. Church Gate and Sanvey Gate were served by horse-drawn trams until 1904; the electrified route used Great Central Street and Northgate Street instead.

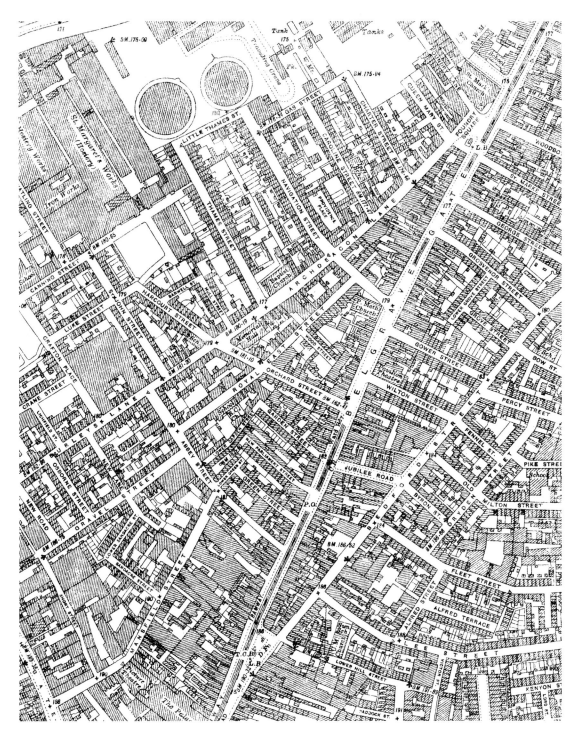

Map 2

This is the north eastern side of the city; the link with map 1 is along the western border. Belgrave Gate, one of two main thoroughfares opened to electric trams in 1904, runs diagonally through the centre of the map. We can see Jubilee Road, one of the original termini, but the demolition of the slum properties to make way for the Belgrave Gate bus station would not have taken place when the area was surveyed; it cleared the buildings on the left-hand side of Bedford Street heading north from its junction with Belgrave Gate. The layout of streets that would come to form the boundaries of the Abbey Street bus station, described in detail in Chapter 3, can also be seen. Burleys Lane, almost halfway up the map on the left, is now the multi-lane Burleys Way, part of the inner ring road; the flyover linking it with St Matthews Way now starts at the northern end of Orchard Street. Archdeacon Lane was considered as a potential site for a bus station in the late 1920s, but the idea was not pursued. St Margaret's bus station was built in the area enclosed by Burleys Lane, Abbey Street, Gravel Street and New Road, while Lower Sandacre Street was lost to the building of the Midland Red garage in 1937.

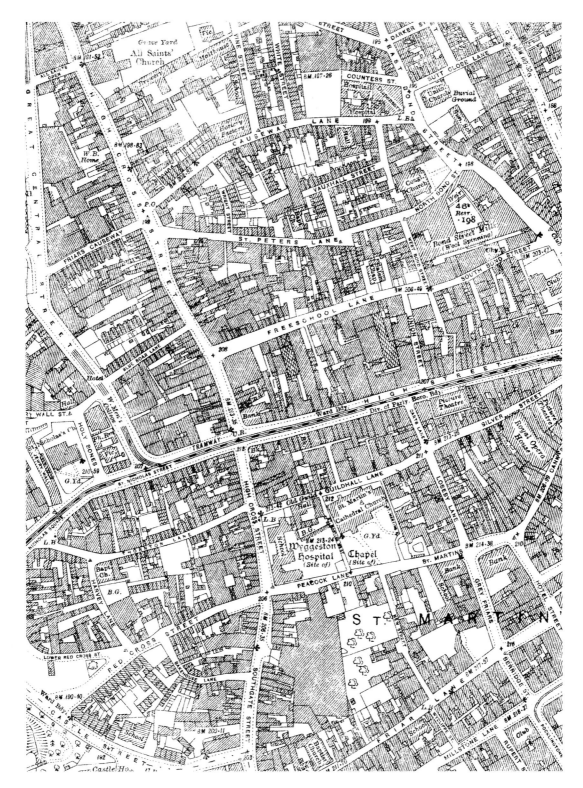

Map 3

The area shown on this map lies directly below that on map 1. It is dissected by High Street, with the lines for Narborough Road and Hinckley Road heading along St Nicholas Street, and for Groby Road and Fosse Road North along Great Central Street.

The landscape has changed dramatically in the last 50 years, with the Highcross shopping centre taking up much of the area north of High Street, and the building of the Southgates underpass affecting the whole of the south western corner. But back in 1927, Midland Red had opened its new garage – the shaded area at the bottom of the map between Southgate Street and Peacock Lane – which was to have an operational life of almost 82 years. Although since demolished, the iconic "Midland" archway above the Peacock Lane entrance has been saved.

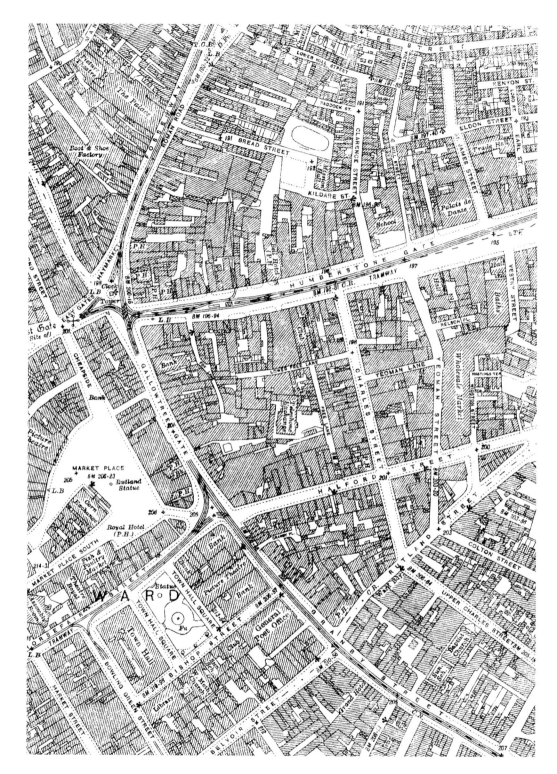

Map 4

The area shown here lies directly below that on map 2. Note the complex arrangement of tramlines at Gallowtree Gate, Bowling Green Street, and particularly at the Clock Tower. The "hole in the wall" entrance to the Humberstone Gate tram depot can be clearly seen; later extended back to Bread Street, it became a Leicester Corporation bus garage from 1950 until 1969, when Leicester City Transport opened its new control centre on Rutland Street, north of Colton Street.

Charles Street and Upper Charles Street have yet to be widened and extended; the new road met Belgrave Gate where the Old Cross terminus was sited. The Charles Street bus station site proposed in 1932, had it been proceeded with, would have lain between the new road, Lower Hill Street and the northern end of Clarence Street – opposite its modern-day counterpart at the Haymarket.

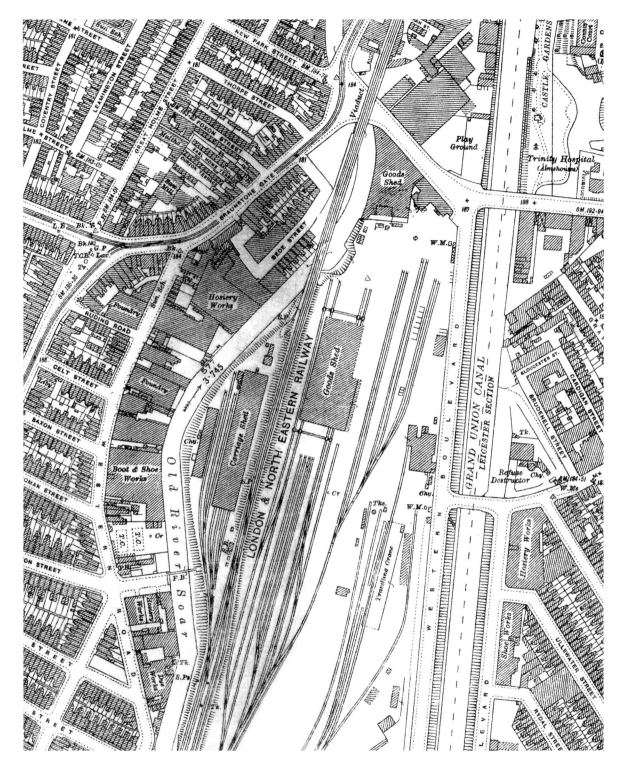

Map 5

This area lies to the south and west of map 3; there is no overlap, but the continuation of Castle Gardens in the top right-hand corner is the link.

Running to the right of the Great Central Railway (LNER as it became in 1923) tracks is Western Boulevard, which for many years was the terminating point for services using Narborough Road and Hinckley Road. One can only marvel at how accepting passengers must have been in years gone by, faced as they were with such a lengthy walk into the city centre. The tramlines run in from Duns Lane to Braunstone Gate, after which they split; the southern branch headed for Narborough Road while the remainder followed Hinckley Road for Western Park and Fosse Road.

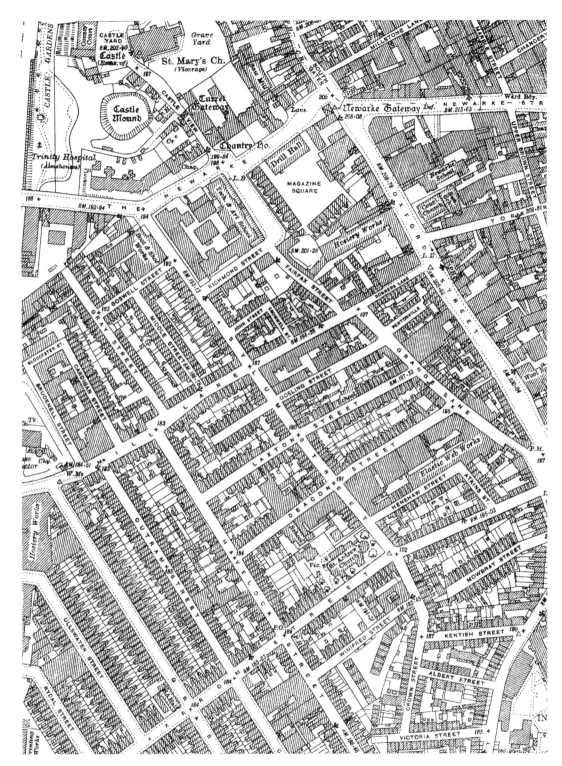

Map 6
This map links with map 5 along its western border and map 3 on its northern edge. There is much here to interest the transport historian, most notably The Newarke in the top left-hand area below Castle Gardens; it was here that the first service 68 arrived from Nuneaton in May 1921. Both The Newarke and later Newarke Street were terminal points for Midland Red and Leicester City Transport services for many years. Newarke Street ceased to be used when it (and Oxford Street) became part of a wider one-way system in the early 1960s; the area around Upper Brown Street was used as a bus station for services to Eyres Monsell, Wigston, Countesthorpe and towards Lutterworth, lasting until 1978. The Newarke continued until 1980, although in a slightly different location nearer to Oxford Street following the building of the Southgates underpass, when what few services remained there were finally transferred to St Margaret's bus station.

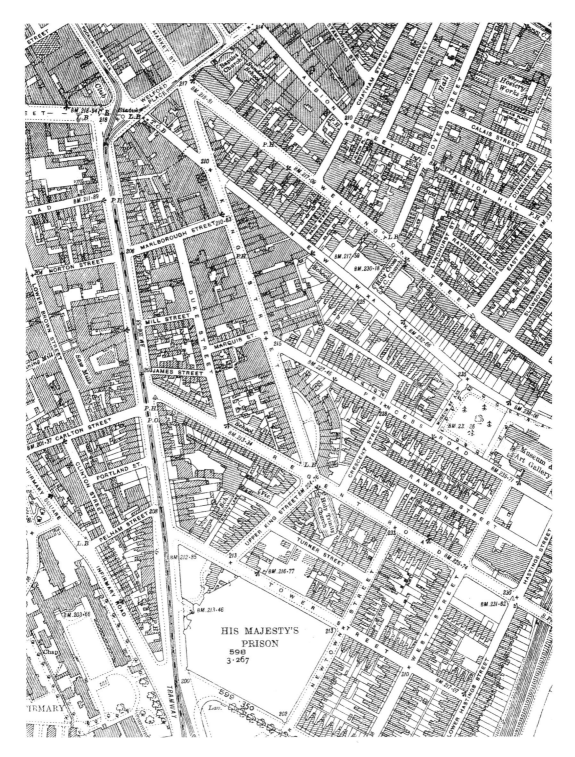

Map 7

This map continues to the east of map 6 and south of map 4.

Tramlines can be seen emerging from Bowling Green Street (top centre). Services continued along Welford Place (returning via Pocklington's Walk and Horsefair Street) and Welford Road, where they split; the right-hand branch, opened in 1922, continued to Welford Road (Clarendon Park), while the left-hand lines went on to Aylestone.

When the two-way system was abandoned in the 1960s, Infirmary Road and Infirmary Square (which led to Oxford Street) became northbound only; Newarke Street eastbound only, and Welford Road as far as the Granby Halls (just outside the southern boundary of the map) southbound only. Leicester City Transport termini previously sited at the top of Welford Road (whose services travelled towards their outer destinations via Newarke Street, Oxford Street and Infirmary Road) were relocated to Bowling Green Street.

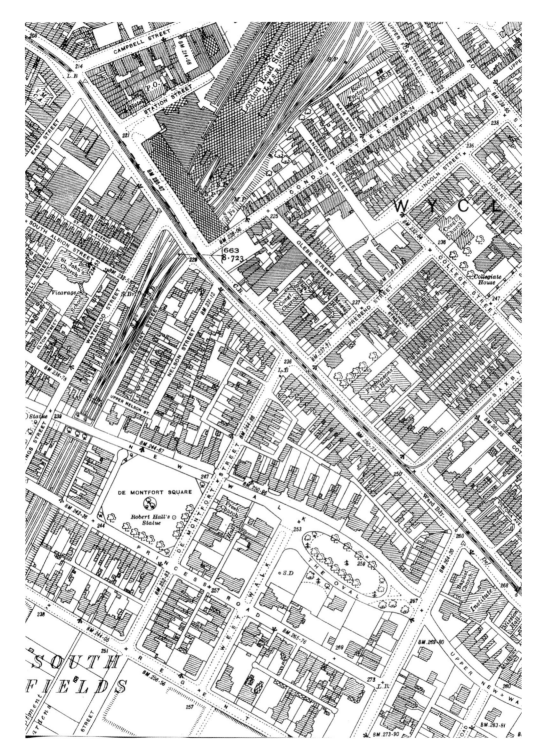

Map 8

The area shown here continues eastwards from map 7.

In the top left-hand corner, Campbell Street was the site of the first Midland Railway station (London Road was not built until 1892). The point where Campbell Street meets the Granby Street/London Road junction was redesigned to accommodate the newly built and widened Charles Street, which opened, along with the Northampton Square bus station (just off the map, parallel with Campbell Street) in 1932.

South of the station, Regent Street was the terminus for services to Wigston, Oadby and beyond on the A6 from the 1910s until 1932., although vehicles had to negotiate Nelson Street and Upper Nelson Street to reach it. The Hind Hotel, described as the terminus on timetables of the era, was actually on London Road. Tramlines head up the hill away from the station bound for Melbourne Road (the first to close, in 1933), Clarendon Park and Stoneygate.

1893-1905: THE COMING OF THE ELECTRIC TRAMWAY

Introduction

By the start of the twentieth century, Leicester had experienced forty years of exceptional growth in population. From a figure of 68,100 in 1861 it had more than trebled, with the greatest decade upon decade increase coming between 1891 (142,100) and 1901 (211,600). New suburban housing developments were springing up at all points of the compass, many two miles or more away from the traditional heart of the town centre – the Clock Tower. It was self-evident that Leicester's inhabitants needed greater mobility than ever before. But there was a significant problem, in that by the mid-1890s, it was obvious that the provision of public transport in Leicester was seriously lagging behind the times. It had not always been so; the horse buses had been introduced in 1863,[1] only three years after the pioneering work of the Birkenhead Tramways Company, and on Christmas Eve, 1874, the first of a network of horse tram routes began, running from Belgrave. A network soon built up, with a number of services radiating out from the Clock Tower, run by the Leicester Tramways Company Limited, as follows:

- Belgrave (Thurcaston Road)
- Stoneygate (Knighton Drive)
- Aylestone (Grace Road)
- Humberstone (St Barnabas Road)
- Woodgate/Fosse Road (the 'Church Gate flyer')

However, as time went on, many municipal authorities began to invest in electric tramways, and this did not pass unnoticed by the Corporation, the press and therefore, to some degree, the public. One of the earliest systems, that of Blackpool, had one line opened in 1885 using conduit collection, with conversion to overhead wires in 1899. In England alone, Blackburn, Bolton, Bristol, Hull, Liverpool, Middlesbrough, Plymouth,

Sheffield and Southampton were among the towns and cities that had electric tramways up and running before 31 December 1899; by the end of 1901, when Leicester's Bill to authorise the building of the tramway was passed, Birmingham, Manchester, Newcastle, Norwich, Nottingham, Portsmouth, Sunderland and Walsall amongst others, as well as three separate schemes in London, were also operational.

The preliminaries

The first indication that Leicester Council was seeking to move with the times came in 1893 with the formation of a Tramways Committee. The brainchild of Councillor (later Alderman) T. Smith, its principal work was to consider the question of the acquisition of the horse trams by the Corporation. Up to this point, it is fair to say that the Corporation had had little control over their operation, despite there having been an agreement in force since 1874 that gave it the right to buy out the Tramway Company after a period of 12 years if it so wished. But the Corporation did not have the powers to operate the tramways even if they purchased them, and there was also no basis for ascertaining the value at which the undertaking could be taken should the matter go to arbitration. So the issue lay dormant for another four years, until in 1897, a Leicester Corporation Bill which sought the necessary powers to run tramways was carried through Parliament. Once again, driven by Alderman Smith and with Councillor Charles Bennion in the chair, the committee was re-formed, and negotiations were started with the Tramways Company. Eventually, a provisional agreement was reached whereby the Council would pay £154,000 for the undertaking as a going concern, and thanks to the *Leicester Daily Post*, in a 'special' published on Friday 13 May 1904 entitled 'Leicester and its trams – General sketch of the work 1893-1904', there is a record of the committee meeting

that took place on 10 October 1898 to consider whether or not to formally adopt the agreement:

'Mr Bennion proposed the adoption. He argued that it was advisable that the Corporation should possess the tramways, for monopolies should always belong to the community and be worked by the community for the good of the community. He went on to say that probably the whole argument would hinge on the question of price. The committee through him said emphatically that the undertaking was worth every pound they were agreeing to pay for it. At this there were cries of 'Question' and 'No, no' and Mr Bennion's forecast as to the difference of opinion was fully borne out in the discussion. Councillor Walters argued against overburdening the scheme at first by spending £154,000 for purchase, and then equipping a system of electric traction at an estimated expense of £265,000. It may be remarked, in passing, that the cost of equipment has gone up much more than the price of purchase has come down. Councillor Walter's argument was that if they waited till 1901, when they could buy compulsorily, they would get the undertaking at a smaller price, and have an opportunity of giving the scheme a fair chance. What they wanted, he added, was no beggarly system of tramways; they wanted electricity and a good long ride for a half-penny.[2] Councillor Bruce, emphatic as ever, said this was an attempt to saddle the ratepayers with a rotten concern.– There was a good deal of language, figurative and emphatic, from other members.–Councillor Hancock said he would not call the recommendations of the committee a dark horse, but it was a horse from a very dark stable.–Councillor Edwards said it was not wise to give £154,000 for the worst rails, the worst trams, the worst horses, and the worst service in the whole country.[3] Finally, Councillor Walters moved the following amendment: 'That the Council considers it advisable to purchase the tramways at such time as it can be done compulsorily, as provided by the Act of Parliament, but does not accept the price set out in the report.'–Councillor Bennion warned the Council that if the amendment was carried, they would regret it, but his warning had no effect, and the clock was put back by a majority of 27 to 17.'

So the whole issue was left once again until the time set for compulsory purchase as provided by the relevant statute arrived. The Tramways Committee was once again re-formed on 3 November 1899, with a brief to open negotiations with the Tramway Company and report back to the Council. Notwithstanding the fact that another year had elapsed, and that the state of the system had deteriorated still further, there might have appeared to the casual observer to have been no particular urgency attached to their work. Indeed, one of the first actions of a newly-formed sub-committee was to organise a fact-finding mission to witness at first hand other tramway systems both in the UK and in Europe, which became known as the 'Grand Tour'. Not only did the party visit Prescot and Liverpool, Blackburn, Blackpool, Bolton, Sheffield, Leeds, Edinburgh and Glasgow, they also found time to call in at Brussels, Hamburg, Berlin, Vienna, Budapest and Paris. This was completed by 29 May 1900, when the Council was asked to authorise a payment of £807 10s 3d to cover the expenses of those taking part. A major argument ensued. Readers might see a parallel with the twenty-first century parliamentary expenses 'scandals' and deduce that there is nothing new under the sun. On 30 May, the *Daily Post* took up the story:

'For upwards of two hours last night, the question of the Tramways Sub-committee's recent visit to the Continent was the subject of heated debate in the Council Chamber, the proceedings at one time threatening to assume a character which could only be described as bordering upon disorderly. Despite the utmost exertions of the Mayor (Ald. Windley) to maintain the dignity of the Chamber, excited and occasionally unparliamentary language was frequently indulged in, threats of resignation were flying about broadcast, and it was only by the withdrawal of the Finance Committee's recommendation to check the expenditure of special committees that the indignant tramways tourists were placated. In fact, the attack on the sub-committee, which commenced so boldly, ended in a complete "scuttle", members who had come to curse remaining to bless, and, figuratively speaking, falling over one another in their anxiety to withdraw anything and

everything which could be construed into a vote of censure upon the deputation, or the officials who accompanied it…the exchange of "compliments" between councillors and aldermen were too serious to be amusing, However, like everything else, the meeting came to an end at last, and things began to "simmer down".'

It took another seven months, until 14 December 1900, for details of the proposed scheme to be made public, in the form of a comprehensive report from the sub-committee, and this was adopted with only a few small amendments by both the Tramways Committee and Council. It recommended that the system should adopt the overhead power system, fed from a central power station at the 'LERO' in Painter Street. Councillor Flint moved the adoption of the report at the Council meeting on 6 February 1901. Even now, however, there were dissenting voices, particularly that of the Mayor, Alderman Lennard, who opposed both these recommendations, favouring instead a surface contact or conduit system and the siting of the power station at the Aylestone Road gasworks. More delay ensued, as the report was sent back to committee with instructions to have an expert cast his eye over the sub-committee's recommendations and report as to the best course of action. Mr E. Manville was appointed, and his report, made in May 1901, was unequivocal. He estimated the cost of construction of tracks for the whole of the proposed system at £299,306 using the overhead system, as against £644,925 for the conduit system, both figures being exclusive of feeders. On the siting of the central station, his estimate (excluding buildings but including plant in each case) was £75,854 for Painter Street and £84,317 for Aylestone Road. Because sub-stations would be necessary if the power station were to be placed in the gasworks site, he thought there would be relatively little difference in the cost of buildings. The Painter Street 'LERO' also won as regards the estimated expenditure in providing the necessary power per annum – £12,399 against £13,571 at Aylestone.[4]

Not surprisingly, Manville's report and recommendations were adopted by the committee. Despite his views having been comprehensively excoriated,

Alderman Lennard was clearly in no mood to back down, reaffirming his support for the Aylestone Road site and declaring that 'the overhead system was doomed'. It is unfortunate that he died before the electric tramway opened, though it is a matter of conjecture as to whether its successful operation might have made him have a change of heart.

Acquiring the system

The task of purchasing the Tramways Company could now begin. At the Council meeting on 31 July 1901 Councillor Flint moved, on behalf of the Tramways Committee, that the purchase should take place for the sum of £134,000. This was £20,000 less than was recommended in 1898, and the general consensus was that the Council would have been better to proceed on that offer, thus avoiding further delay and general inconvenience, as well as the increased rate of interest that would now be paid on amounts borrowed to finance the scheme. At a special meeting to approve the sale, Mr Simpson Gee of the Leicester Tramways Company asserted that the Corporation had lost the profits for three years and had put back the installation of electric traction, which he believed would bring them in £20,000 a year. He added that he did not think it had been 'much catch' for the Corporation to act as they had done. This did not impress a Daily Post journalist, who was moved to comment that 'Mr Gee can see as far into a brick wall as most folks, and everybody nowadays will agree that he was quite right in the opinion he then expressed'.

The Bill promoted by the Corporation in November 1901 sought the power to borrow £537,000 for the purchase of the undertaking, the laying down of trackwork and the provision of plant for generating power, plus another £113,000 for street widening, alteration to bridges, etc; £650,000 in all. It duly passed through Parliament and received royal assent. Contracts in respect of the many and various requirements of the new system had now to be awarded. The first two were settled on 28 October 1902 (note that almost another year has passed in the meantime), for:

- the supply of 4,800 tons of rails and 175 tons of fish plates for £32,325 18s 9d., to be made by the North Eastern Steel Co. Ltd. of Middlesbrough

- lay outs and special track work, for £13,041 10s by Hadfields, of Sheffield

The next contracts were let in January 1903, as follows:

- overhead work, R. W. Blackwell and Co., Limited, London, £23,194 12s 2d
- bolts, nuts, and tie-bars, R. W. Blackwell and Co., £1,921 5s
- stoneware pipes and conduits for cables, T. Wragg and Son, Swadlincote, £3,368 14s 4d
- feeder cables, telephones and test wires, W.T. Glover and Co., Ltd., Manchester, £7,382 14s 2d

- engines, generators, condensing plant, and other electrical equipment, Dick, Kerr and Co., London and Preston, £28,417
- Lancashire boilers, etc., Yates and Thorn, Blackburn, £9,609
- supply and riveting anchor joints of rails, the Cooper Patent Anchor Rail Joint Co., 12s 3d per joint
- erection of chimney shaft at the 'LERO', Leicester Builders Ltd., £2,389 12s 4d.

The award for the tramcars themselves will be discussed shortly, but completing this review of the process, several other tenders were let on 29 July 1903,

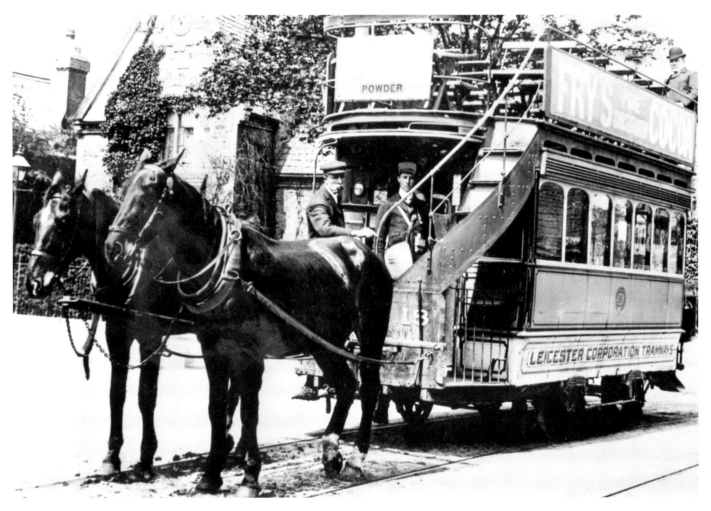

9. Leicester Corporation acquired the Tramways Company in 1901 along with 39 tram cars. This is no. 18, pictured at the Belgrave terminus during the brief period of Leicester Corporation ownership, 1901-04, with the National School in the background. It is a particularly good study of the driver and conductor, neither of whom would necessarily be guaranteed employment when the conversion to electric power took place.

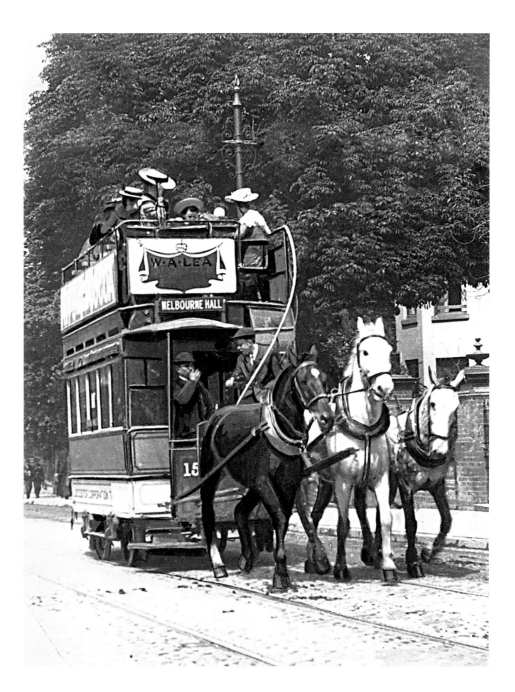

10. There is a steep climb up London Road from the railway station to Victoria Park, which must have been quite a slog for a loaded horse tram. So it is hardly surprising that in this view of car 15, which is only going as far as Saxe-Coburg Street on its way to Melbourne Hall in or around 1902, an extra animal has been added on the nearside to share the load. The conductor is engaging in some banter with the driver, while the passengers on the upper deck are wearing their summer hats and boaters. On completion of its duty, the "spare" animal would be uncoupled and walked back to the station to assist with the next uphill journey.

the most important of which was for the erection of the main car depot, at £16,845 17s 3d., to Messrs. T. Hutchinson and Sons, Leicester.

Building the electric tramway

On 30 March 1903, two teams or 'gangs' of men started at each of the London Road and Belgrave termini, working towards the centre laying the ducts for the feeder cables. Despite poor weather and a particularly wet winter, progress was maintained to the point where the

tracks in London Road, Belgrave Road, Loughborough Road, Saxe-Coburg Street,[5] Highfields Street, St Peters Road (as far as Melbourne Hall) and Clarendon Park (as far as the end of Queen's Road) were ready for opening by early May 1904, although the poles were not yet painted and 'one or two other small details' had still to be dealt with. Fosse Road, Narborough Road, Hinckley Road, and Nedham Street route trackwork was also completed by then, with the electrical work proceeding. The Aylestone Road, Humberstone Road,

East Park Road, and Clarendon Park Road work had been started, and a double line of rails had been laid to a point opposite the Abbey Park main gates for use on show days. The only routes still to receive attention of any sort were Groby Road, Great Central Street, and Melton Road from Melton Turn. Welford Road was not included as the Clarendon Park Road work would shortly bring it to the Welford Road junction. The Church Gate service was also under consideration, but it was decided at the Tramways Committee meeting on 21 September 1904 that it was 'not desirable' to construct a tramway in Church Gate and Sanvey Gate, and that the rails should be at once taken up. The December 1904 service to Groby Road would now run via High Street and Great Central Street.

Of the first four routes to open in May 1904, only London Road (Stoneygate) and Belgrave Road had

had long-standing horse tram services; there had been a temporary horse bus service to Clarendon Park, but only since 2 September 1903. Service frequency on the London Road corridor was set at every two minutes, departing from the Clock Tower. The first car would leave London Road at Saxe-Coburg Street for Melbourne Road; the second car would carry on to the Stoneygate terminus, and the third would divert from London Road at Victoria Park Road for Clarendon Park. The road up to Saxe-Coburg Street thus benefitted from a two minute service, and from there to Victoria Park Road would see two cars every six minutes. Belgrave cars would leave the Clock Tower every three or four minutes. The Tramways Committee did not intend to set these times in stone; however, if it was found that the traffic justified it, more cars would be put on. Other important aspects of the work in setting up the system included

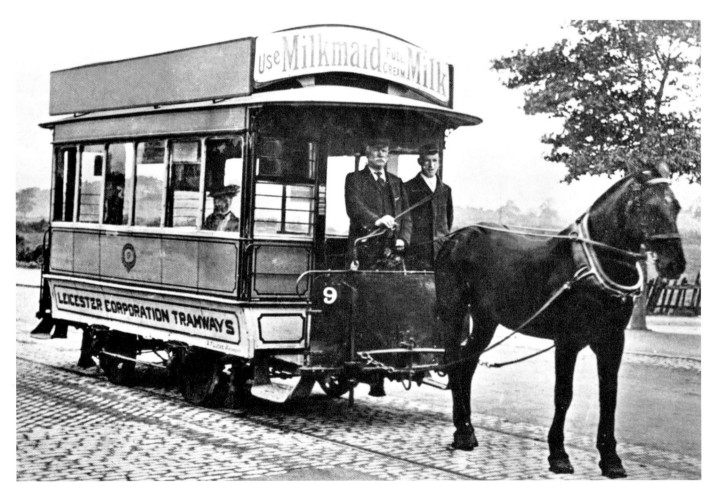

11. Horse tram car 9, photographed at the Groby Road terminus in 1902 and found on an undated postcard issued by Leicester Museums. The scene is one of peaceful tranquillity, and the journey back to the town centre, being relatively flat, will hopefully not inconvenience the solitary horse too greatly.

issues such as the type and location of stopping place notices. On 22 and 24 March 1904 the committee visited each of the first four routes and decided upon 'compulsory' and 'permissible' stops for each. These are listed in Appendix 1, and they make an interesting comparison with the bus stops used on the equivalent services of First and Arriva today. Readers should be aware that both the positioning and the type of some stops were changed over the years, often more than once, and in some cases even before the system opened. It then took until 2 May – only 16 days before the opening – for the committee to recommend that compulsory stopping place notices should have white letters reading 'Cars stop here' on a red background, while permissible stopping place notices should have green lettering reading 'Cars stop by request' on a white background.

Recruitment

The minutes of the Tramways Committee meetings reveal that a push to recruit drivers and conductors for the electric cars began in February 1904. The numbers required are not given, although there is an interesting insight into early twentieth century market forces with the publication of the wage rates. This information, together with further published details from May and June that year covering a variety of other, mainly blue-collar positions, is reproduced below:

17 February 1904

Motormen	Start 6d per hour or 30/- (£1.50) per week
(60 hours per week)	After 6 months 6¼d per hour or 31/3 (£1.56) per week
	After 12 months 6½d per hour or 32/6 (£1.62) per week
Conductors	Start 5½d per hour or 27/6 (£1.37) per week
(60 hours per week)	After 6 months 5¾d per hour or 28/9 (£1.44) per week
	After 12 months 6d per hour or 30/- £1.50) per week

4 May 1904

Car shed foreman	£2/10/- (£2.50) per week with house, coal and lighting
Night car shed foreman	32/6 (£1.62) per week
Drivers	34/- (£1.70) per week
Stokers	28/- (£1.40) per week
Office porter/ messenger	28/- (£1.40) per week
Linesman	7½d per hour
Cleaner and general man	6d per hour
Man to assist in boiler house	6d per hour
Youth to assist in boiler house	4½d per hour

1 June 1904

Motor inspectors	36/- (£1.80) per week
Emergency waggon	28/- (£1.40) per week
Fitters	7d per hour
Linesmen	7d per hour
Brakesmen	6d per hour
Trolleys	6d per hour
Overhauling	6d per hour
Cleaners	4¾d and 6d per hour
Greasers	4¾d per hour
Controller	4¾d per hour

The extent to which employees from the old company were expected, or even encouraged, to transfer to the new company, is unclear, although the evidence from this piece from the *Leicester Advertiser* on 14 May 1904, headed 'The Old Conductors', implies that existing staff were not necessarily given the opportunity to move:

'In my journeys round the town I found that a very considerable number of the old conductors were missing, and in reply to my inquiries I was told that they had been "sacked". Like many others with whom I have conversed on the subject, I regret the disappearance of many familiar faces. Times without number have I watched the conductors not only since the trams have come into the possession of the Corporation, but also under the old company's regime–aye, and in Alderman Barfoot's time–but never once have I detected the slightest irregularity in the matter of receiving and checking of fares. Some of the men, of course, were more civil than others, and I must say that it is not, generally speaking,

the least obliging who have gone to the wall. Perhaps the general public do not know that five years' character is one of the qualifications for the lowly office of conductor. Under the old box system for fares three inspectors were employed. There are now 15. One instance of their value was brought under my notice during my run round. One of the inspectors left the company of two others–they are so thick on the ground that they are obliged to keep each other company sometimes, you know–and got on a tram which was accommodating me with an outside seat. No sooner had he reached the top than one of the passengers thoughtlessly tore up his ticket and threw it into the road. The inspector watched the pieces fall, then smiled, and politely called on the passenger to pay his fare again. This the passenger willingly did, remarking that he knew as well as the inspector could tell him that he had broken the rules. The incident is all the more worth telling as bearing on the harsh system under which some of the conductors think they are working. I am told that any such an incident is liable to be taken by the new broom inspectors to be suspiciously like a case of collusion between the passenger and the conductor for the purpose of robbing the Tramway Committee of the Leicester Corporation of the penny fare. At all events, I heard the conductor of this particular car say to the gentleman to whom he supplied the second ticket (by order of–the inspector), "you'll be sure to make him understand that you paid me for one ticket. Won't you sir, or else I may be reported". The passenger did as requested, and the inspector simply "smiled another smile" of satisfaction. He had only done his duty.'

Others were not so lucky – through their own wanton acts, of course – as this report from the *Leicester Mercury* on 13 May shows.

'A WARNING TO TRAMCAR PASSENGERS
'Ebenezer Clarke (47), Bonsall-street, and George Hull, Northampton-road, Market Harborough, were summoned before the Leicester Borough Magistrates today for not immediately showing their tickets as passengers on the Corporation tramways to duly authorised officers, on April 13th and 30th respectively.
'...Clarke said he could not find the ticket at the time, but he had since discovered it, and now produced it.

'...in the other case...an inspector named Cooper gave evidence to the effect that (Hull) tore up his ticket and threw it away, and refused to take another one.
Defendants were each fined 5s.'

The first 100 electric cars

The first two electric cars had arrived as early as June 1903 and were housed to begin with in the Belgrave Gate horse tram depot. No. 1 was supplied by Dick, Kerr and Co of Preston, No. 2 by Brush, Loughborough. Based on their experience with these trial vehicles, the Corporation asked both companies to quote for 60 vehicles. The Brush tender was cheaper (£497 18s per car as opposed to £510) and followed the Corporation's specifications to the letter but the Dick, Kerr tender included various additional items which the Council preferred. Brush were asked to make various modifications without increasing their quotation in return for half the work. Hardly surprisingly, they were not prepared to do this, and thus Dick, Kerr and Co picked up the entire order for what was now 58 cars, the first of which arrived in March 1904. The entire batch was numbered 2-59, to be put in service on the first four routes when they opened. Leicester retained No. 1 and operated it throughout the lifetime of the system, but the original No. 2 was never used and was taken by Dick, Kerr and Co in exchange for one of their own cars. It was ultimately sold to Metropolitan Electric Tramways in London.

A second order for tramcars 60-99 was placed with Dick, Kerr & Co for the new routes opened between July and November 1904. For the technically minded, all 99 were open-top vehicles built on Brill 21E trucks with a 6ft wheelbase, powered by two DK25A 25hp motors. 22 passengers could be accommodated inside, and 34 outside. The livery was officially described as deep crimson lake (though this tended to look almost like chocolate with the application of several coats of varnish) and cream, and the interiors were finished in mahogany, ash and oak. There was one final vehicle, numbered 100, a 2500 gallon water car, the arrival of which completed the deliveries for 1904.

The key players

On 13 May 1904, the *Daily Post* devoted several column inches to an appraisal of the various people who had been, and would continue to be, involved in the planning, building and running of the system, and it is

appropriate in a history such as this that their efforts are recognised and appreciated.

'In Councillor Flint they (the Tramways Committee) have had an excellent chairman – one of the hard-headed, clear-sighted, business men who are fitted by nature for the position of leaders in municipal trading affairs.

'Alderman Smith has always been earnest in his desire that Leicester should own its own tramways, and the reward for his long and persistent efforts is well in sight. That he should be vice-chairman of the committee which has the work in hand is peculiarly fitting.

'Mr. E. G. Mawbey, the borough surveyor, has been chief engineer of the scheme all through. He has had all the important details to superintend, both in regard to the trackwork and the electrical equipment, for Mr. Manville has only been consulting engineer. In fact, Mr. Mawbey has been practically the head and centre of the work. He has made a close study of the systems of electric traction, and it is safe to say that what he does not know about them now is not worth knowing. Besides, all the plans for the necessary buildings have been prepared under his supervision. In a word, the whole of the scheme has been 'put through' in his office. It will readily be understood that Mr. Mawbey has not confined himself to the eight hour day one hears so much about. He has worked early and late, and has given his best to the scheme, and now that it is within measurable distance of completion, probably his greatest reward will be knowledge of the fact that Leicester will have a system surpassed by none in Britain.

'Mr. T. R. Smith has been appointed electrical engineer, and is admirably qualified for the post.

'Mr. A. F. Lucas, secretary and manager of the old company, has been appointed as traffic manager, and here again we have a man certainly in the right place. During the transition period, and since the new lines have been in working order for horse trams, Mr. Lucas had a difficult task to satisfy the growing needs, but by dint of ingenuity and skill he has done exceedingly well. With the larger facilities given in the new cars, he should arrange a scheme of transit which will satisfy practically every one who has occasion to use it.'

Trialling and testing

The first appearance of an electric car over the new rails took place in the dead of night; to be precise, at midnight on Thursday 21 April 1904. Organised by the contractors, this initial system test was not widely observed, although it would seem that a *Leicester Daily Mercury* reporter was present throughout from the detail his report contains, of which this is an edited version:

'THE NEW ELECTRIC CARS
'SUCCESSFUL TRIAL RUN
'A trial run of the electric cars took place last night, on the Belgrave and Stoneygate route. The comparatively few people out of doors between twelve and one o'clock were "electrified" by the sudden appearance of a brightly illuminated car, travelling at a high speed, along the new permanent way, and those amongst them who had dined unwisely might have been excused if they supposed themselves to be in Birmingham or Leeds. The main significance of the trial was the complete success which attended it.

'There was no vulgar ostentation about the initial trip. When the streets were quiet, and most people had retired for the night, the trial car stole out of the depot in the Abbey Park-road, and, taking the turn to the left in Belgrave-road, ran smoothly on to the Melton Road section. The actual experimental run commenced here, the whole route to the Stoneygate end being covered in the space of a few minutes. Speed was not, of course, the main consideration, but even from this point of view the old tram horses, had they been spectators, must sadly have realised that, like Othello's, their occupation was gone. The weird hum of an electric car can be heard for miles on a quiet night, and it is a sound that one has to get accustomed to before it can be considered as agreeable.

'The trial run was a purely private affair…and as far as could be observed, the passengers did not include any member of the Tramway Committee, whose turn will come this afternoon. The car was driven by the electrical engineer, Mr. T. R. Smith, who handled levers and brakes with an ease suggestive of both skill and experience. At one point of the drive the car and its occupants had an enthusiastic ovation, despite the lateness of the hour. This was at the General Post Office, where the whole night staff practically turned out and cheered as the car moved swiftly by on the

return journey. The maximum speed attained on the run was probably about fifteen miles an hour.

'Naturally it will be asked, in view of the statement that the run was a successful one, whether the London-road route is to be opened at once. The answer is in the negative; further trials will be necessary before the public service can be commenced. We are not yet able to give the exact date of the opening, but the public may take it that it will be a few days before Whitsuntide, and that in the holiday week the cars will be running full swing on the Belgrave-road and London-road section, and probably some of the other routes.

'Meanwhile the work is proceeding apace on the other main routes. The Aylestone-road and West End sections are rapidly approaching completion, and splendid progress is being made along the Humberstone-road, while the construction of the permanent way between Evington-road and Humberstone-road, via East Park-road, has been commenced.'

The second run was undertaken later that day, and the report was also filed in the 21 April edition of the *Daily Mercury*, directly beneath the first one. Note that such were the number of editions published each day that the public were kept up-to-date in a commendably short time. Under the heading 'Trial trip this afternoon', it began with a list of all those invited by Councillor Flint, including most members of the Tramway Committee. The events of the day then began to unfold:

'The party assembled at the power station…About three o'clock No. 2 engine, which is of 800 horse-power, was started, and after it had run for a quarter of an hour Councillor Flint switched the current on to the cables. The party then proceeded to the car sheds in Abbey Park-road, and boarded one of the Belgrave-road cars, the electrical engineer, Mr Smith, undertaking the responsibility of driver. A large crowd had assembled in the vicinity, and as the car moved out of the depot a cheer was raised. Travelling at from eight to ten miles an hour the car was driven to Belgrave without incident, beyond the startling of the horses attached to the trams, the animals showing some objection to the close proximity of their more powerful rival. When, however, it was desired to commence the return journey, no current was available, and it soon transpired that a slight hitch had occurred at the

power station. At first it was believed that the failure of the current was due to the presence of pitch in the rails at the terminus, and the spectators assembled here enjoyed the novel spectacle of a group of "city fathers" descending from the car for the purpose of pushing it a dozen yards along the rails. Encouraged by their chairman, the committee discharged their strange duty with a will, and amid the good-humoured chaff of the bye-standers the car was moved along. This unfortunately proved to be labour lost, for the all-essential current was missing, and a messenger from the power station brought the disappointing information that the engine had stopped owing to the over-heating of one of the bearings. As a consequence of this unrehearsed "regrettable incident" the party came back to town in one of the horse cars, but it was hoped that before six o'clock the engine would be in running condition again, so that the trip might be completed.'

There is no indication that any other trials rook place over the next three weeks, but records do show that an intensive period of system testing began on Wednesday 11 May. At that time, my grandmother, Jessie Nesta Tarry, then 11 years old, lived at 47 Belgrave Road, where her father Robert was a grocer. I well remember her over sixty years later describing the time when she was allowed to stay up late one evening and wait with her parents and siblings on the corner of Abbey Park Road to watch the electric trams making their way back to the depot. To the watching crowds, and in particular to a youngster, the transition from the dimly gas-lit horse trams to these double-deck leviathans with blazing electric light was the epitome of progress. As she recounted the tale, the inference was that this was the night before the grand opening, but it seems more likely that it was the first running on 11 May that she witnessed. The *Daily Post* reporter was there too and included this in his special report on 13 May:

'During Wednesday evening a number of cars were run over the completed routes. The principal object was to give instruction to the men who will act as drivers, in order that when the time comes for a regular public service there shall be little or no risk of accident through the incompetency of any man entrusted with the management of a car. Ten cars were kept running until a late hour, and large crowds assembled

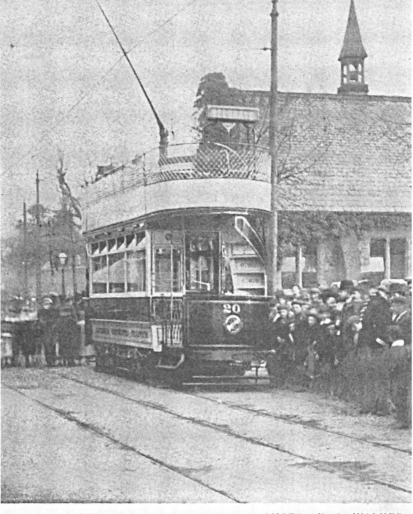

COPYRIGHT. PHOTO: F. C. WALKER.

THE ELECTRIC TRAM.
Run in Leicester April 21st, 1904.

12. Whilst it is not recorded which car took to the road for the midnight trial of 21 April 1904, thanks to F C Walker we do know car 20 was the one chosen to convey the Tramway Committee and other officials for the afternoon run. It is seen in Loughborough Road, outside the National School which still stands today, though in different use, easily recognisable from the bell tower on the roof. By virtue of the fact that the passengers have disembarked and a large crowd is viewing proceedings, we can assume that the photograph was taken after the current was lost. It is doubtful whether 20 actually reached the Belgrave terminus, which was situated on Loughborough Road between Thurcaston Road and the River Soar bridge – if it had, it would have crossed over onto the town-bound line. But what is known is that power was eventually restored, and the car made it safely back to the depot later in the day.

in London-road and Belgrave-road to view the unaccustomed spectacle of electric cars gliding along our thoroughfares. Another object the committee had in view was to accustom horses to the innovation, and perhaps the public also, for there was no little alarm exhibited by some horses and some people when the overhead wires at the Clock Tower were seen to emit sparks. There was no danger, of course, a shower of sparks being a common sight when the conductor jumps the wire. There was no hitch whatever…'

The reporter from the *Leicester Advertiser* went a stage further. Imaginatively styling himself 'The Driver', he

had inspected each of the new routes – including those scheduled to open later in the year. His report, published on 14 May, contains some insights not found elsewhere about what the construction of the electric tramway had done for the wider community, particularly that in the Braunstone Gate and Hinckley Road area:

'This section I found to be complete right out to the Western Park gate, and also along the Fosse-road to a point beyond Newfoundpool but within a yard or two of the Groby-road, thus bringing the Church-gate section to within a few yards of the Fosse-road terminus. The only portion of the line not complete at the time

of my visit (it is now through) was the short stretch running from the West Bridge Post Office and along by the old Wheat Sheaf Works to a point just beyond the West End General Stores, where a much-needed improvement has been effected by the pulling down of property, including a public house, which has been rapidly rebuilt and is now fast approaching completion. The front elevation is set back apparently about nine feet, and the road is widened to allow the double tramlines to be properly carried through. The corner from the end of the public house leading round under the bridge has been neatly boarded up. Up to the time of this work being taken in hand probably more danger was occasioned to the travelling public at this point than at any other throughout the Borough. I happened to have been on one car when a nasty accident occurred. The lines were so set as to gradually come within a foot of each other. Consequently if two trams met at the Boulevard corner nothing could avoid a collision. This occurred on the occasion to which I refer, and quite a consternation was created among the passengers, some being thrown forward on their seats by the force of the impact. The board which ran the whole length of the tram was ripped off and hurled into the road, narrowly escaping the head of a passer-by. Therefore a much needed order was given that trams should "walk past" so that if there was seen to be a likelihood of their "meeting" those going in one direction should stop some yards before coming to the corner to wait for the others to pass.

'Side poles are used on this section until the Hinckley-road is reached, when centre poles are brought into requisition as far as the Fosse-road. Thereafter side poles are again used, but they had not been carried further than the Kirby-road when I took my run round. The centre poles, each of which carries two incandescent lights, have effected a splendid improvement on the Hinckley-road. The shopkeepers there are delighted with their prospects. Two of them told me that their takings have very considerably increased since the road has been so well lighted. Probably no part of the town has benefited more from a lighting point of view than this particular section, for incandescent double lights have been set up from the West Bridge to where the centre poles begin in the Hinckley-road. Similar lighting improvements (only single lights) have within the last fortnight been made

along the Fosse-road. This is appreciated by the whole of the residents, but by none more than Councillor Berry, whose front, which contains plenty of 'greenery', has been converted, into a veritable fairyland.'

As well as the trial running on 11 May referred to above, there was the inspection by the Board of Trade to be gone through, covering at this point only the routes that were electrically equipped. Major Pringle and Mr Trotter, M.A., M.I.E.E., were accompanied, as might be expected, by a phalanx of Corporation officials – Councillor Flint, Alderman Smith and Messrs. Mawbey, Manville, Lucas and Smith. It was reported in the *Leicester Daily Post* the following day.

'Highly complimentary remarks were made by (the inspectors) as to the smooth running of the car, due not only to the splendid way in which the track had been laid, but also to the excellent manner in which the overhead equipment had been constructed and finished….Mr. Mawbey (the borough engineer) was noticeable on the front of the car during the journeys giving a full description of the scheme to the inspectors….We understand that the object of the inspection was not only to certify the satisfactory completion of the overhead work and feeder cables, etc., but also to determine the speeds at which the cars shall be allowed to run on the various routes…a few days may pass before the official verdict can be formally notified to the committee. But it may fairly be assumed that it will be forthcoming in due course, and thereby enable the public to take possession of these handsome new cars with their electrical equipment on Wednesday.'

The opening day

So to the big day itself, Wednesday 18 May 1904. Civic dignitaries and invited guests gathered at 2pm for a reception at the Town Hall. There followed tours of the power station in Painter Street and the Abbey Park Road depot, followed by electric tramcar rides to Belgrave and Stoneygate, before a reception in the Mayoral Rooms. Each of the newspapers devoted considerable column inches to the event, giving their reporters the chance to present a potted history of the planning and development of the system. The dailies (*Leicester Mercury*, *Leicester Daily Post*) carried blow-by-blow accounts of the afternoon's proceedings on the opening day, following

up with reports of the evening traffic in their editions on the 19th. The weekly papers had much the same coverage, the *Leicester Journal* on Friday 20th and the *Leicester Advertiser*, *Leicester Chronicle* and *Leicester Guardian* on Saturday 21st.

In fact, it is to the *Leicester Guardian* we turn for a detailed commentary on the first day. Their unnamed journalist was fortunate to be among those invited to the afternoon event. He began his piece with brief sections on cost, trackwork, and in particular that around the Clock Tower, overhead equipment and the power station. He described the depot and the cars, of which more later. But he got fully into his stride when relating his experience of the tour, of which this is an edited version:

'Those of us who were fortunate enough to be favoured with an invitation from Councillor Flint to attend the opening ceremony of the long-waited for electric system, assembled in front of the Town Hall in our silk hats and frock coats, trying to look important, for were we not about to take part in an epoch-making function?

'Councillor Flint and his wife welcomed us with a smile, and within five minutes of the time fixed on the programmes we were sitting on one of the twelve horse cars that were to take us in solemn state down to the power station on the Belgrave Road. Solemn is the right word, for the procession took somewhat of the nature of a funeral. The allusion is not, this time, to the pace at which horse cars move, but to the fact that we were, on this journey, burying the horse-car system.

'As we passed the waggonettes standing in Belgrave Gate…the drivers looked a little disconsolate as they gazed upon us, spite of the fact that, as the tram car service was suspended for the afternoon, they were reaping a last glorious harvest.

'The townspeople had turned out in force at various points on the route, and most of the windows had eager sight-seers at them. Occasionally, we were faintly cheered, but on the whole our journey was uneventful, and we dismounted at Painter Street, to do the journey on foot to the Power Station.

'Here the great event of the afternoon was to take place. After we had looked round the huge engine house…Councillor Flint was introduced to us by the Mayor (not that we needed any introduction) that he might tell us about the great iron and steel giants that were presently to be started to produce the electricity that was to draw us over the route when we mounted the new cars. He talked learnedly about dynamos and generators, and kilowatts and boosters, and the rest of it, we looking wise and pretending we understood all about it.

'Then our cicerone…by dint of much turning of a wheel, started the first engine, cheers being raised as the monster fly-wheel began to revolve. Alderman Smith did likewise at the second engine, and more cheers were raised as Mrs. Flint and Mrs. Smith switched on the current.'

What he omitted to describe in the detail it seems to have merited was the switchboard. Another journalist present that day represented the *Leicester Journal*; his report mirrors that of the *Leicester Guardian*, except in this one respect:

'One only has to turn on one's heels…to see the switchboard. It is reached by a flight of steps. The twenty-five panels of white marble of which it is composed look quite inspiring. In each panel is a handle by which the engineer may switch the current on or off from, say, the Clock Tower section, the Melton Turn section, the Clarendon Park section, and so on. There is one which will bring "the whole show" to a standstill.'

Back to the *Leicester Guardian*:

'A peep into the boiler house and the battery room were all that we had time for inasmuch as we were summoned to mount electric cars, awaiting us outside. These…conveyed us the short distance that separates the Power Station from the Main Car Depot on the Abbey Park Road. When we reached the Belgrave Road School, we got our loudest cheer yet, for Mr. Read, the head-master, had arranged his play-time so that his boys might see us pass. How they enjoyed this came out in their lusty-lunged cheering. Round the corner, in the Abbey Park Road, we heard more vigorous cheering, and were astonished when we came in sight of the cheerers to find they were girls. Could so much sound come from feminine throats.

13. The residents of Painter Street have turned out in force to watch the dignitaries return from their trip to the LERO on the opening day of the system, with car 51 leading. 12 horse-drawn trams, performing their final duty, had conveyed the party on the outward journey, and now they were on their way to the Abbey Park Road depot, where an inspection of the cars therein was due to take place.

'We dismounted again at the car-sheds, which, we were told by Councillor Flint, cover four and a half acres. We admired the few cars that were stored in them, and many of us got underneath to study them from below, for pits running the length of the building make it possible to do this…We were not permitted to stay long, but were hurried off to mount another set of electric cars on which to make our tour of the routes to be opened. The first three had been prettily decorated by Mr. W.H. Noble, with bunting and evergreen festoons. They also bore an epitomised history of the Leicester Tramways–"1874 to 1904".

'We started off at a fast pace for the Belgrave terminus, admiring the exceedingly smooth running of our vehicle ere it has carried many yards. We realised the contrast between this gliding sensation and the switchback bumping we used to get on some of our old routes. Soon after we got round the curve on to the

Loughborough Road, Councillor Chaplin's hat blew off, and the car had to be stopped. The journalists on the car at once began to chaff each other about bringing out an "extra special" to record the 'First Accident on the Leicester Cars'. Spite of our stoppage we reached the Belgrave terminus in eight and a half minutes from starting…In eleven minutes we were (back) at the Clock Tower–not bad time for a journey of nearly two miles. Here we were delayed for a minute by a couple of carts laden with bricks. The drivers showed no particular desire to get out of our way. Presently, however…we were taking the London Road hill as if it were only a gentle slope. There were plenty of people out to see us, and we were kept busy raising our hats to our acquaintances in the crowd. We startled many horses, for they did not seem to like the look of us. Perhaps in some half-conscious way they realised that these electric cars were their enemies. Any way,

some of them reared and pranced in a very excited way. It took us fifteen minutes to get to the London Road terminus (almost as far as the gates of the new racecourse), and in ten more minutes we were back at the end of Waterloo Street, and disembarking, so that we might journey to the Mayor's Rooms to partake of the hospitality of Councillor Flint.'

As regards that journey along London Road, the *Leicester Mercury*, whilst admitting that 'the cars travelled up London-road at a rattling pace', conceded that 'the drivers (exercised) a wise discretion…seldom exceeding twelve miles an hour'.

Horse trams had already ceased on the new routes at 2pm, and the Tramways Committee had decided (on 11 May) that from 19 May onwards electric tramways running times would be from 5.30am, or 9.30 am on Sundays, until 11pm in the evening. But on that first day, the system was opened to the public from 7pm until 11pm, and it was the *Leicester Chronicle* on 21 May that contained the best description in all the papers of what it was like to be in the crowd that evening:

'LEICESTER'S TRAMWAYS UNDERTAKING
'OPENING OF THE PUBLIC SERVICE

'Promptly at seven o'clock in the evening, Leicester's new electric tramways were opened for public use. The first car came gliding along Belgrave-gate five minutes before the hour, and took up its position in Gallowtree-gate. Every available seat having been occupied in a very short space of time, a card bearing the inscription "Full" was conspicuously displayed, the gong sounded a warning note, and the car immediately set off smoothly and gently for aristocratic Stoneygate. At the same moment another car began its journey to Belgrave under precisely the

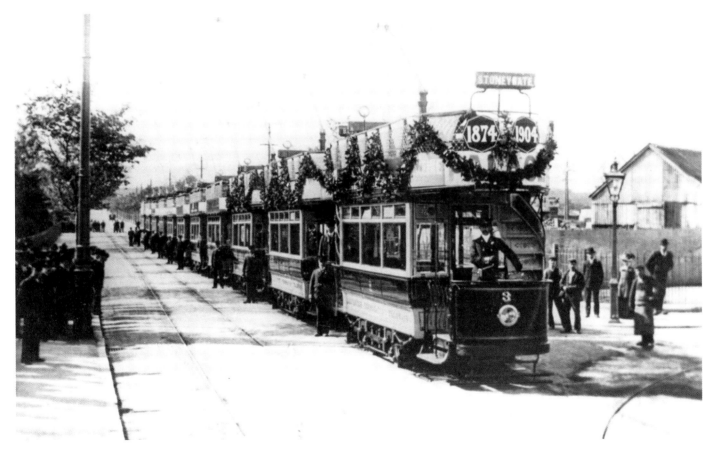

14. Car 3 headed the procession in Abbey Park Road on the opening afternoon, 18 May 1904. The reason that car 1 was not used was because it had been the prototype Dick, Kerr vehicle and was regarded as non-standard in comparison with the batch that followed. It is recorded that the first three trams were decorated with "bunting and evergreen festoons" by Mr W H Noble. In this view the cars await their passengers; other postcards of this event exist showing them fully laden and awaiting departure to Belgrave.

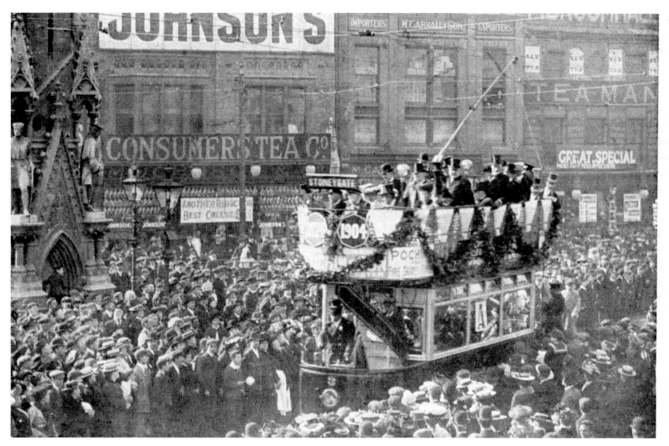

H. PICKERING, PHOTO-CHEMIST, LEICESTER.
Official Opening Electric Trams, Leicester, May 18, 1904

15. The procession has been to the Belgrave terminus and back, and car 3, still at the head of affairs, has reached the Clock Tower and is about to lead the way to Stoneygate. People of all ages and from all walks of life have certainly turned out in force to witness this historic moment in the life of the town (Leicester did not regain city status until 1919).

same conditions. Then the Melbourne Hall and the Clarendon Park cars started away from Gallowtree-gate, and the new service was practically in full swing.

'Let it be said at once that there was not the slightest hitch in connection with the opening. The arrangements were complete in every respect, and those responsible can justly take credit for so admirably meeting the exigencies of the occasion. The number of people desirous of making the first journey would have filled more cars than the writer cares to enumerate. They thronged each side of Gallowtree-gate, they clustered round the Clock Tower, and they were thickly packed in the Haymarket. But though the crowd was so great, there was not the slightest semblance of disorder. Barriers were arranged at the particular spots from whence the cars started on the four different routes, and with two policemen and several inspectors in neat uniforms regulating the traffic, the public were able to take their seats on the cars with as

much ease and comfort as could possibly have been desired. Mr. A.F. Lucas, the tramways manager, was here, there, and everywhere, and under his guidance nothing was left undone which ought to have been done, and, on the contrary, nothing was done which ought to have been left undone. "The scene reminds one of the Coronation", remarked an observer, and in point of numbers the simile was quite appropriate.

'From 6.30 till late in the evening queues were rapidly formed in Gallowtree-gate and the Haymarket, but even then many had to postpone their "ride" until a more favourable opportunity. Twenty-seven cars were running altogether, but if there had been double the number the accommodation would have been insufficient. Those with statistical minds speculated upon the probable number of passengers which would be carried in the cars in the course of the evening, while others wondered what the total amount of fares would work out at. The most

prolific theme of comment, however, was the attractive appearance of the cars, and the neat rig-out of motor-men and conductors.[6] When the shades of evening began to fall, and the cars swiftly passed through the streets, a flash of brilliant light, the wonderful transformation effected within a few short hours in the method of traction, was peculiarly striking. The new cars ran beautifully, and beyond a little difficulty in arranging the trolley poles on the wires, there was nothing to indicate – except, of course, their spick and span appearance – that they had not been in our midst for years.

'The contrast between the horse cars and the latest innovation afforded the humourist an excellent opportunity for indulging in his witticisms, and as might be naturally supposed some genuinely funny remarks were heard. Some of them may have been a little unkind, but for all that they summed up the situation in a terse, pithy sentence. Here is a sample. A squalid looking little horse car came modestly creeping round the corner of Church-gate into the Haymarket, and was brought to a standstill a few yards away from an electric car in the full flush of youth, and paint, and polish...a jocular individual observed, "My word, look at the 'Church-gate express'", and the car seemed to shrink in very shame and confusion. The cynic was to be found in the crowd as well as the humourist. He indulged in cheap sneers at the expense of "the childish delight in a new toy", and could not understand such unwonted excitement on the part of people. That, however, was merely an individual opinion, and even if the public generally did display a marked interest in this latest municipal undertaking it shows that progress is appreciated, and that the electric tramways are likely to be received with public approbation.

'About 20,100 people travelled on the cars during the evening...Everything passed off satisfactorily, there being no hitches or accidents of any kind.'

A proposal to charge 1d for each journey had been recommended by the Tramway Committee at their meeting on 17 February and was announced by Councillor Flint on the opening day. It seems that the decision was not universally popular, as the *Leicester Guardian* thought it necessary to fire a broadside at the complainants in this leader on 21 May:

'HALFPENNY FARES

'Councillor Flint made one announcement on Wednesday which will disappoint some people, but will be welcome to those who think deeply on the matter. His committee have decided not to have halfpenny fares. They are anxious, of course, that they shall make the trams pay as soon as possible. This may account for their present decision, but we are rather inclined to hope that when the profits permit of it they will consider deeply ere they decide upon halfpenny fares.

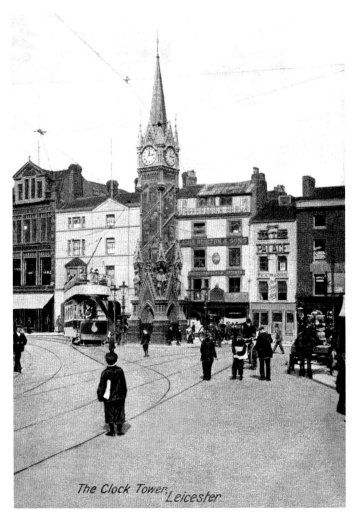

The Clock Tower, Leicester

16. Very few colour photos of the electric tramway system exist, and those that do date from the later years of its existence. So we must be grateful to the enterprising postcard manufacturers who colour-tinted their wares and thus give us a clearer picture of Leicester's chosen livery in those early days. Here are two examples from the mid 1900s, starting with this almost whimsical representation of car 1 as it passes the Clock Tower from Belgrave Gate into Eastgates. Interestingly, the card was posted from Hunstanton to an address in Ramsey, Huntingdonshire, on 13 March 1908.

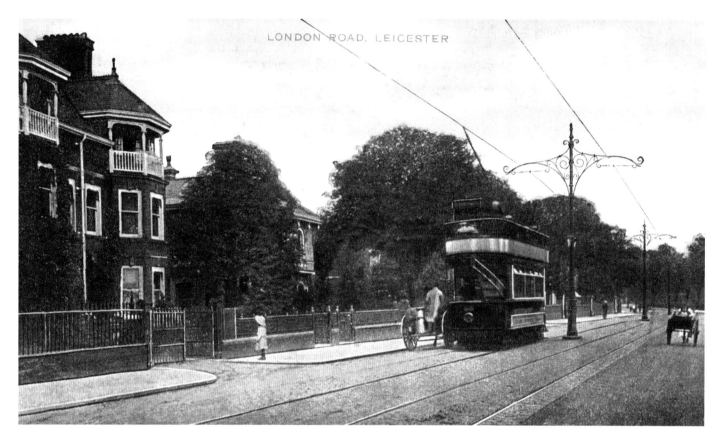

17. London Road is deserted; a far cry from conditions encountered today. This unidentified open-top car is as yet unsullied by advertising, and is bound for the Stoneygate terminus. As with many postcards of the time, we are given a marvellous view of the ornate centre poles.

It seems to us that it would be better for the town if they made concessions to the public in the matter of distance ere they lower prices. Let them rather give the public a longer ride for a penny than a cheaper fare for a short ride. What we want this new tram scheme to do is to induce people to live on the outskirts of the town, rather than to crowd into the centre. To bring this about we must go on the same principle we adopt in our letter carrying, make the short distance people pay for the long distance. That would be unfair if paying a penny were a real hardship to anybody. The people who would ride short distances for a halfpenny may be divided into two classes, those who can afford to pay a penny for their short ride and those who cannot. The first may just as well pay the penny and it will not do the rest much harm to walk. Let us have halfpenny fares by all means when the system will allow of them, but don't let us be too anxious about them. There are other things to be considered.'

If those 20,000 or so passengers on the first evening had each paid 1d for their journey, takings for the first four hours of operation would have amounted to something in the region of £80-85, and one imagines that the Corporation would have been very pleased with such a result. And it should be noted that the public never did enjoy halfpenny fares; in 1916, one penny became the cost of a one mile ride and anything beyond that cost 1½d.

Voyeuristic interest in the new system did not end on day one, as the first of these two items from the *Leicester Mercury* shows. It also gave details of the temporary horse routes introduced on the yet to be completed electric lines. The second report, commenting on passenger numbers, seems to indicate that the previous day had been a Bank Holiday.

'TODAY'S PROGRESS (19 May)
'The new trams are running smoothly again today, the ordinary service being at work, viz., a two-minute service from the Clock Tower up London-road, and a

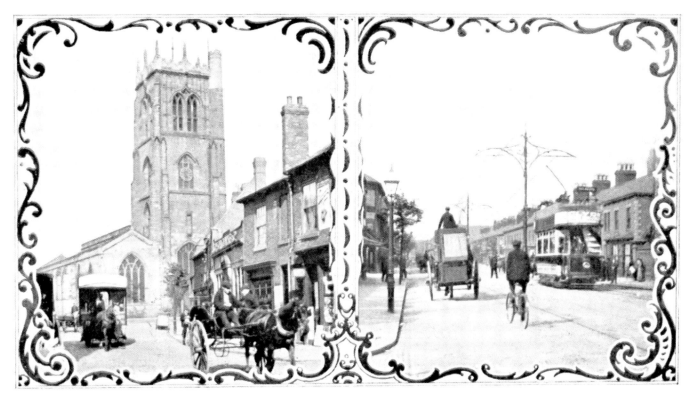

Souvenir of Leicester's Tramways.
December 24th, 1874.

From Ancient to Modern.
May 18th, 1904.

CHURCH GATE EXPRESS. Opened Aug. 29th, 1878. BELGRAVE ROAD. COPYRIGHT.

18. A number of tram-related postcards were issued in 1904; some mourned the passing of the horse trams, but this one, issued by F C Walker from the "Haddon Series", celebrates the transition from ancient to modern. We have the opening date of the Church Gate Express (or "Flyer"), with a horse tram in full view (note that in the 19th century, Church Gate ran from the Clock Tower as far as Sanvey Gate). Also pictured is a building that would give its name to a much greater enterprise 70 years hence – St Margaret's Church. The other snapshot features open-top car 20 as it makes its way along the section of Belgrave Road between Abbey Park Road and Melton Turn, and features a particularly good view of the decorative centre poles.

four-minute service to Belgrave. The novelty has not by any means worn off yet, and a considerable crowd gathered at the town terminus to watch the cars arrive and depart. The operation that seemed to arouse most interest was the changing of the conductor from one wire to another.

'Today sees the establishment of a new horse service, that to the Western Park. Cars will run every ten minutes from the Clock Tower, and this means a treble service to the corner of Narborough-road, and a double service to the corner of Fosse-road…Another new route is to and from the Spinney Hill Park gates in East Park-road–this being a half-hour bus service.

'The cars are being well patronised, those running on the Stoneygate section being well loaded with passengers. The weather being delightfully fine and bright, business people with a half-day's holiday took the opportunity of enjoying a cheap trip to the outskirts of the town…At dinner-time the cars on the four sections were got off in excellent time, and the new arrangement appeared to work very satisfactorily, and to be greatly appreciated.'

'YESTERDAY'S RETURNS (22 May)
'The patronage bestowed on the tramways services of the town yesterday must be very gratifying to the Tramways Committee. As on previous days the bulk of passengers patronised the electric service, but the horse services to Aylestone, the Fosse, and the Western Park, also did well. The total number of

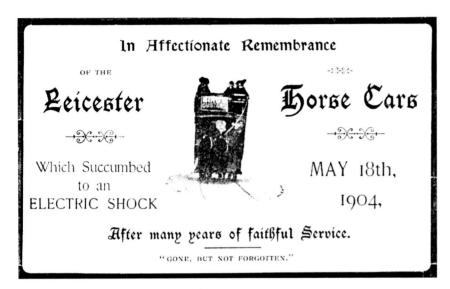

In Affectionate Remembrance

OF THE

Leicester **Horse Cars**

Which Succumbed
to an
ELECTRIC SHOCK

MAY 18th,
1904,

After many years of faithful Service.

"GONE, BUT NOT FORGOTTEN."

19. Those postcards that seemed genuinely sorry to see the horse trams' demise provided a different take on the modernisation of the system. Perhaps some people did harbour an "affectionate remembrance" of them, although that does not entirely square with the press reports of the time. The date in 1904 is of course the first day of electric running; horse trams continued in service for another 5½ months.

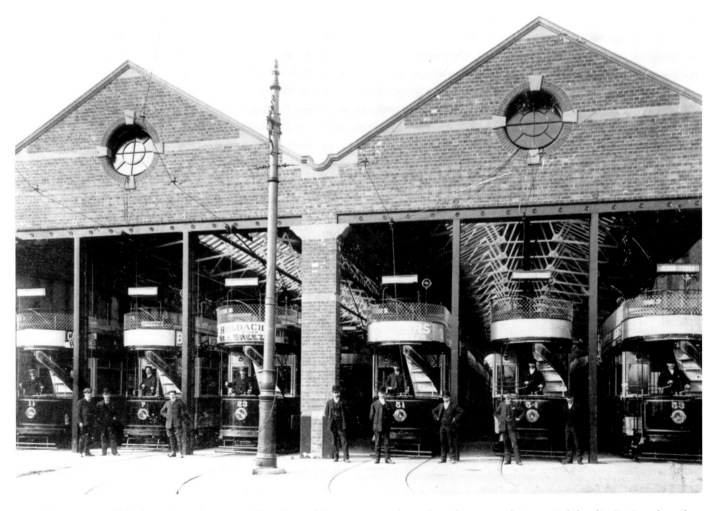

20. This scene certainly dates from the very earliest days of the system, and may have been one that greeted the dignitaries when they arrived at the depot on Abbey Park Road on 18 May 1904. We see an impressive line-up of open-top cars, which from left to right are numbers 11, 7, 23, 51, 54 and 53. Each has its own driver, and there are also a number of sober-suited gentlemen, who, one assumes, had more senior roles within the Tramways Department. The depot itself stood on a 4¼ acre site and the three bays of the car sheds were each 35' 1½" wide and 21' 6" high, accommodating 55 vehicles.

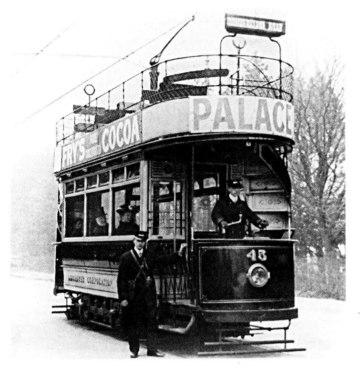

21. An early photograph of car 43 taken at the junction of Ash Street with Humberstone Road. I am grateful to Peter Newland who has carried out some research on the subject and has found that from 28 May until 10 June 1904, during which time it may be assumed the photo was taken, roughly one in three Stoneygate services continued on an informal basis to Ash Street following their return to the centre (and from 11 June to 11 July, there was a further extension to Uppingham Road). So this is an unusual setting for that period of tramway history and, despite the fact that it is a posed picture, it also provides an excellent opportunity to study the uniforms of the drivers and conductors.

passengers carried was 123,000…the day's working was carried through without a hitch…'

West End and Aylestone routes opened

The next in the series of openings planned for 1904 were the West End routes – Narborough Road, Western Park and Fosse Road (or Newfoundpool, as it was sometimes called) – on 12 July. On 22 June, the Tramways Committee decided upon both the new stopping places, as well as a rearrangement of services that would come into effect at that time. Stoneygate and Narborough Road, Melbourne Road and Fosse Road, and Clarendon Park and Western Park would each become through services, establishing a pattern of cross-town working which still survives in a limited form today. This only left Belgrave to be worked

in isolation, until such time as the Humberstone Road route came into being.

The papers were understandably less inclined to devote the same amount of column inches to these new routes as the novelty factor was much reduced – except for those who would benefit from them. By and large, the coverage included at some point a sentence or two saying how successful the original lines were, but was otherwise restricted to a straightforward reporting of the facts. The *Leicester Advertiser* carried only a short piece on Saturday 9 July 1904 referring to the forthcoming opening of the West End lines; that day's *Leicester Chronicle* was a little more forthcoming.

'Residents in the West End and Newfound Pool districts will welcome the announcement that the electrical equipment of the new tramways by which they will be served is now completed, and that in the course of a few days the public will be enjoying the boon which electric traction will confer upon them. The tramway committee will probably find the three routes, Narborough-road, Western Park and Newfound Pool, paying concerns, though the absence of a line by the Newarke-street route to the West will deprive many hundreds of people of the chance of using the new cars.'[7]

The following week's edition, on 16 July, gives the most complete account of the opening day's proceedings:

'The West End routes…were opened to the public… shortly after 6 o'clock, the start having been delayed by a smart shower, a procession of three cars left the Clock Tower…The first car contained the Police Band, which provided music on the journey, and afterwards gave an enjoyable concert in the presence of a large number of people in the Western Park. The cars ran to the Narborough-road terminus, then back and up the Hinckley-road to the Western Park, and finally to the Fosse-road terminus, back to the Clock Tower and then to the car depot in the Abbey Park-road.'

But the *Leicester Guardian*, in a 9 July editorial comment entitled 'Progress with the trams', looked rather more philosophically at the benefits the electric tramway brought to Leicester:

'This opening of the West End routes will add the last scene to the transformation of High-street.

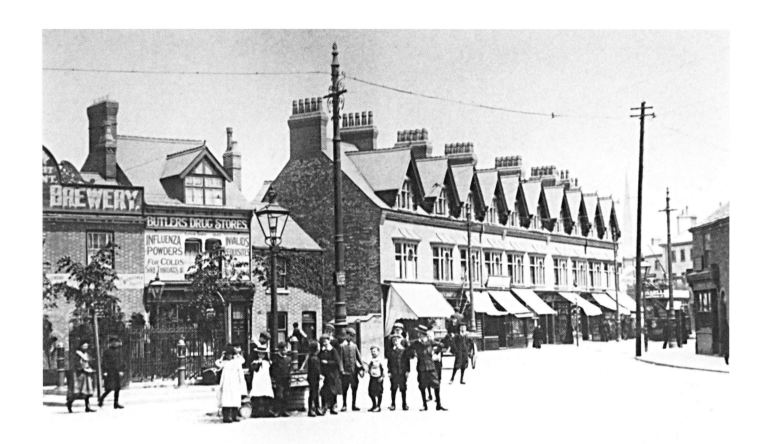

22. An atmospheric photograph from the very early days of the system. This is the junction of Narborough Road and Hinckley Road, and young (and not so young) children in their Edwardian garb have congregated at the tram stop – "cars stop here" proclaims the notice on the pole – which, conveniently situated next to the drinking trough, provides a reminder of old and new methods of transportation. An open-top tram is disappearing into the distance along Braunstone Gate.

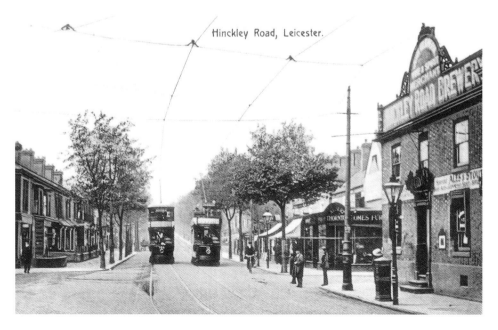

23. In this view, dating from the spring of either 1913 or 1914, the photographer is standing close by the drinking trough and opposite the brewery that we saw in the previous photo, and is pointing his camera at Hinckley Road. The trams in view are on the right, open top car 13, which is bound for Stoneygate, while on the left, car 126, which received its canopy top in 1911, heading for Western Park. The centre poles on the section before Fosse Road have been replaced by side poles, but the decision to fit tops to trams 1 – 99 was not taken until after World War I.

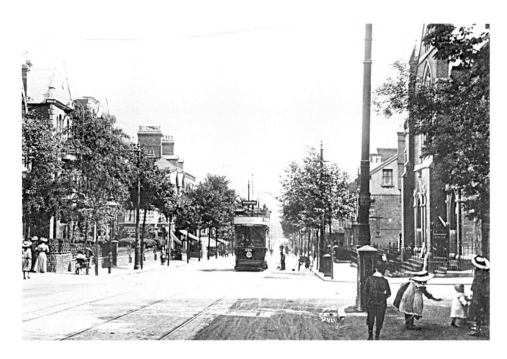

24. Car 138 has made its way up the hill on Hinckley Road with a Western Park service, and is about to cross the Fosse Road junction. It was one of 20 cars supplied by Dick, Kerr & Co in 1905 to the original open-top design, following on from the 21 that came with canopy tops. It appears to be a sunny day in summer, and once again, children dressed in their Sunday best and street sweepers are very much in evidence.

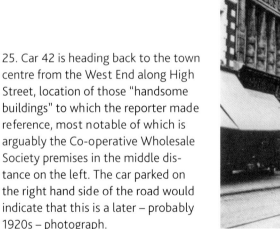

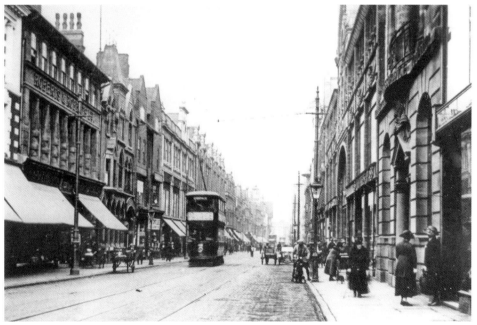

25. Car 42 is heading back to the town centre from the West End along High Street, location of those "handsome buildings" to which the reporter made reference, most notable of which is arguably the Co-operative Wholesale Society premises in the middle distance on the left. The car parked on the right hand side of the road would indicate that this is a later – probably 1920s – photograph.

Think of the narrow, ill-built street of ten years ago, with its stagnant traffic, through which an occasional lumbering bus strove with difficulty to pick its way, and think of the street we shall see next week – wide, with handsome buildings on each side, and with scores of brightly lit cars careering down it at a rapid rate in an almost continual procession. What would we not give, some of us, to bring our grandfathers back for a few minutes, to gaze upon the astonishment that would come over their faces when we took them to the new thoroughfare, with its new buildings and new locomotion, and told them this was High-street.'

The Aylestone route was the next to open, on 5 September, and this time reports were fairly thin on the ground. There were brief notes after the event in the *Chronicle,* the *Guardian* and the *Daily Post*; the greatest

detail came in this short paragraph in the 10 September edition of the *Advertiser*:

'The Aylestone-road section of the electric tramway system was opened for traffic on Monday evening, the Tramway Committee having first made a trip to the village and back in one of the new cars. For the remainder of the evening a brisk business was done on the new section. It has been decided that there shall be a five-minute service to Aylestone, with special cars for football matches, &c.'

The final routes of 1904

However, the Humberstone and East Park Road lines, scheduled to open on 1 November, attracted much greater coverage. One might think that it was because the opening of these routes finally signalled

the ultimate demise of the horse tram, but neither the reporters nor the travelling public appeared to give this much regard at all. More likely is the fact that as these were the final major lines to open in 1904, they marked the end, in calendar year terms, of what had been an exceptional achievement by the Corporation and its contractors.

On 29 October, the weekly *Leicester Advertiser* carried the following news:

'HUMBERSTONE-ROAD TRAMWAY
'A trial trip over the new tramway routes, Humberstone-road, East Park-road and Evington-road, was made on Wednesday, and it is announced that the sections will be opened for traffic next Tuesday. On the East Park-road route the cars will run every 20 minutes in each direction, and on the

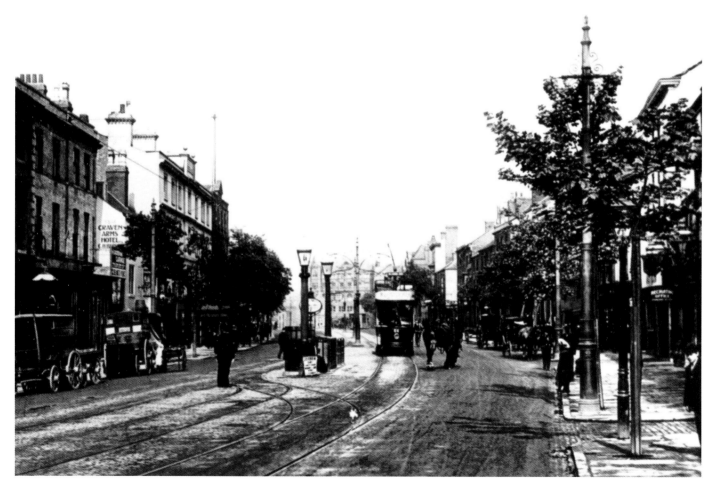

26. Only a handful of years separate the following two photographs of Humberstone Gate, both taken from the vicinity of the junction with Gallowtree Gate. The relative tranquillity of this scene suggests that it was taken early in the day, most likely in 1904, and the oncoming tram car is bound for Western Park.

Melbourne-road circle there will be a ten minutes' service each way.'

The *Leicester Mercury* reported on the opening in its 1 November edition, making the point in the opening sentence that this took place without any formal ceremony. This completed the 'outer circle' (London Road, Evington Road, East Park Road, Humberstone Road), and with the Humberstone Road section, now allowed the completion of the 'inner circle' (London Road, Melbourne Road, Humberstone Road) as well. The Tramways Committee had decided previously that terminal points should be fixed on Melbourne Road and East Park Road for the purpose of determining the extent of availability of the 1d fare. As we will see, the public were quick to complain to the press about the perceived

anomalies of the fare structure on the circle routes. It did not help that the staff were getting it wrong on day one, as the Mercury reported:

'Before 9 o'clock this morning an account of a misunderstanding on the part of one of the conductors as to the fare to be charged, passengers being requested to pay again at the top of Evington-road. However, about 9 o'clock, Councillor Flint, chairman of the Tramways Committee, happened to board this car, and by his advice some of the overcharged money was returned, and matters were soon set right.'

There was one final opening to perform, that of the short stretch of line in Woodgate to finish the Groby Road line. There is some doubt as to the actual

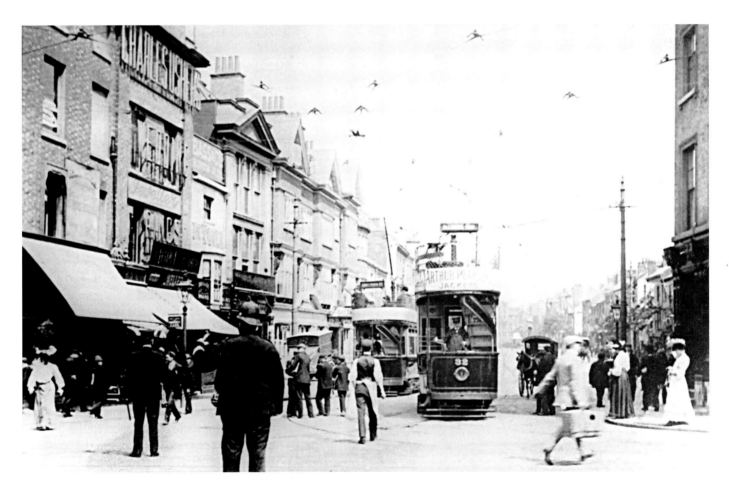

27. Pedestrians seem unconcerned about the fact that car 32 is bearing down on them, while the policeman on point duty is holding back traffic from the direction of the Clock Tower. 32 is about to turn from Humberstone Gate into Gallowtree Gate on a Melbourne Road via London Road working, while the unidentified car opposite is bound for East Park Road via Humberstone Road. Visible to the left of the policeman's helmet is the Humberstone tram stop. The fashions, and the general lack of any other transport suggest that this dates from the early days of the network.

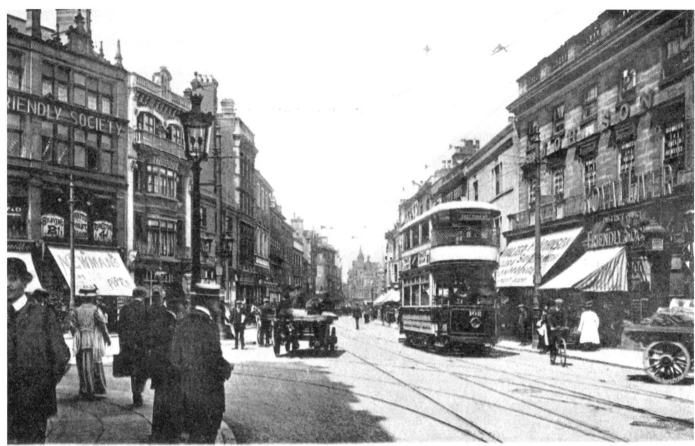

Gallowtree Gate, Leicester

28. A Valentine's Series postcard that was sent to Lincoln on 29 March 1910 shows closed-top car 102 making its way along Gallowtree Gate, heading for East Park Road via London Road. It is just possible to see the Clock Tower in the distance. The road layout is much the same over a century later; some of the buildings on the left hand side of the street have survived, but the same cannot be said for those opposite.

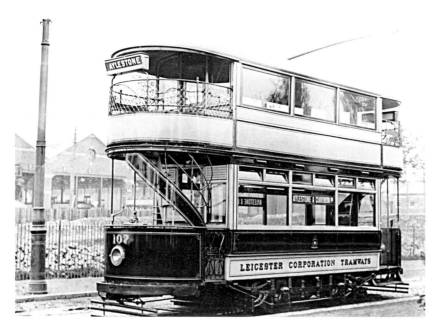

29. The further 21 cars supplied by Dick, Kerr & Co in 1905 were numbered 101-121, and were the first to be fitted with canopy tops. In a posed photograph, and in pristine condition, car 107 was standing in Abbey Park Road with the depot clearly visible in the background. When first introduced, destinations were identified by blinds at each end of the car – that on 107 is showing "Aylestone" – but following complaints about poor visibility, side panels were introduced later in 1904 but route numbers had to wait for almost another 30 years.

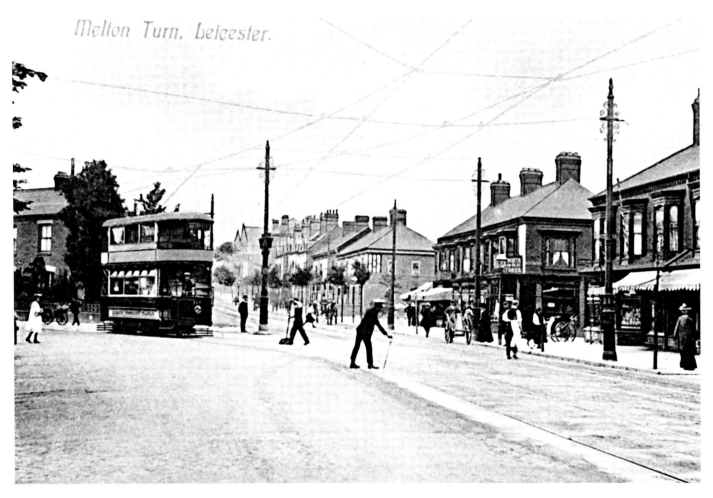

30. A postcard view that dates from around 1905 showing canopy top car 117 at Melton Turn, leaving Belgrave Road for Loughborough Road with a Belgrave service. It is not very often that we get to see the ancillary tramways staff in action, but here is one of the points "boys", setting the road for the next tram, which will proceed along Melton Road, while the man to his left is sweeping the track. Edwardian fashions are very much in evidence too, but the complete absence of any other traffic contrasts hugely with the scene at this busy junction today.

date; M.S.W. Pearson suggests it was 22 November in *Leicester Trams in Retrospect*, but a minute of a Tramways Committee meeting on 21 December 1904 stated that 'the Chairman reports that the Woodgate section has now been completed (overhead equipment) and it is intended to commence the running of electric cars on this section tomorrow' – in other words, on 22 December.

Looking to the future, the Corporation had an option on additional cars to be supplied by Dick, Kerr & Co. A further 41 were delivered in 1905, 101-121 being delivered with canopy tops, while 122-141 were to the original open-top design. That year also saw the opening, on 18 June, of a new route along Melton Road from Melton Turn to Rushey Fields (what is now Lanesborough

Road), and this meant that now only Welford Road of all Leicester's major thoroughfares was without electric traction. Work did start before the war, but it was not opened to the electric cars until 26 September 1922.

Vital statistics

It was widely held that the horse trams were well past their best, and that the advent of the electric tramway brought cheap and easy travel to thousands more people in a very short space of time. But this came at a cost, in terms of the borrowing requirement necessary to fund the building of the system, and several of the papers began to publish weekly data on the numbers of travellers using the trams during these first months of operation. It is from the *Leicester Guardian* that these

details are drawn, starting with this piece on the front page of its 30 July edition:

'TRAM STATISTICS
The electric tram traffic steadily increases, and the passengers conveyed on the West End cars are three times the number carried on the horse cars. The figures are as follows:

Sunday	66,439
Monday	57,360
Tuesday	47,597
Wednesday	48,708
Thursday	46,714
Friday	40,536
Saturday	76,909

	384,083

The number of passengers carried on the Aylestone and Humberstone Road horse tram service was 92,286, bringing the grand total for the week to 476,369.'

Statistics next appeared on 3 September, and weekly thereafter. Those reported on 10 September make particularly interesting reading, as the writer was looking to see what value for money conclusions might be drawn from the ridership and receipts information provided. For that reason, the figures shown below have been merged into a single table for comparative purposes. Note the rather excellent increase of 9.35 per cent in passenger numbers in the second week, which is not attributable to the August Bank Holiday – in England, this was taken on the *first* Monday in August between 1871 and 1964:

	W/E 27 AUGUST 1904		W/E 3 SEPTEMBER 1904	
	ELECTRIC	HORSE	ELECTRIC	HORSE
Sunday	40,245	9,821	61,105	13,548
Monday	41,464	10,939	52,350	12,851
Tuesday	40,595	9,911	43,261	10,381
Wednesday	46,621	11,798	46,917	12,195
Thursday	42,229	9,678	42,436	9,860
Friday	39,709	9,427	39,754	9,801
Saturday	82,879	19,551	78,981	20,238
	333,742	81,125	364,804	88,874
	414,867		453,678	

'Totalled up, the figures for August were:

	ELECTRIC TRAMWAY	HORSE CARS
No. of car miles	161,785	42,026
Number of passengers	1,640,872	394,181
Receipts	£6,771 0s 1d	£1,620 6s 9d

'The figures for August 1903, when there were all horse cars:

No. of car miles	15,841
Number of passengers	879,765
Receipts	£3,761 18s 1d

'The receipts per car mile are: Electric cars 10.14d; horse cars 9.37d. It would be interesting to have the cost of running the electric cars per mile as compared with the cost of horse-drawn vehicles. The public would then be able to see what the real profits of the system were:-

Total receipts for the month	£8,451 17s 4d	2,035,053 passengers
Increase on August 1903	£4,689 19s 3d	1,555,288 passengers
Aggregate increase to date	£15,398 10s 6d	3,733,212 passengers

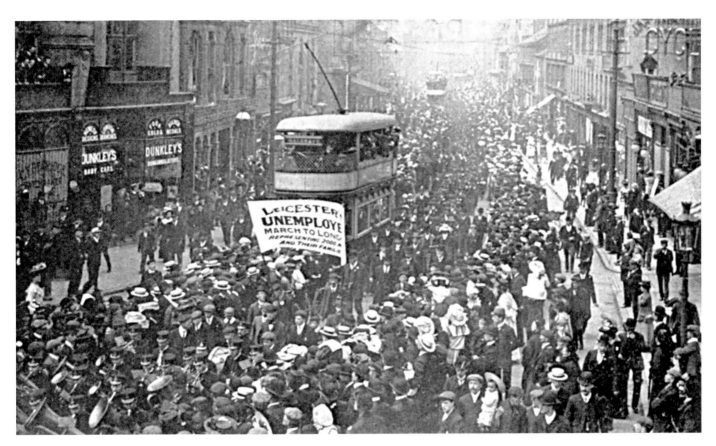

31. A postcard from the "Living Picture Series" demonstrating how trams could move crowds, although this time the tram, a closed-top car from the batch 101-121 new that year, is very much caught up in one. This is Gallowtree Gate on 4 June 1905, when around 500 of Leicester's unemployed began their march to London, to petition either the King, the Home Secretary or the Archbishop of Canterbury about appalling living conditions in Leicester; with unemployment in the town running at 15%, life in the slums was desperate. 30,000 people gathered to send them off, but it was not an altogether successful venture; the King refused a meeting but prayers were said for the protestors in Westminster Abbey, and they were greeted like heroes on their return to Leicester on 18 June. There is a plaque in front of the Corn Exchange steps in the Market Place commemorating their endeavour.

Average monthly increase to date	£1,924 16s 3¾d	466,651 passengers
Total receipts to date	£46,438 6s 5d	10,959,630 passengers

One further piece of data shows beyond doubt that the Leicester public had taken the electric trams to its collective heart. The reported passenger numbers for Christmas Eve – a Saturday – amounted to 112,419. The *Leicester Guardian* columnist in his 31 December 1904 piece simply comments that 'Christmas Eve was an [sic] busy day'.

Public points of view

Search for the *Leicester Mercury* letters page in 2018 and it will always be found in the same place within the paper, but the town's newspapers in 1904 were not so organised. Some did not carry readers' letters at all; others did, in small numbers, on an irregular basis, and on different pages, usually (but not always) under the heading 'Correspondence'. Evidence that the volume of mail generated by the start of electric tramway services in 1904 was considerably in excess of the norm comes from a piece penned – possibly by the editor himself – for the *Leicester Daily Mercury* on 15 July, two months after the official opening. It is unusual to see a journalist openly taking on his readership:

'TO CORRESPONDENTS
'THE ELECTRIC CARS
'We have received a number of letters conveying various complaints and suggestions with reference

to the new electric cars. Whatever the electric traction has done for Leicester, it has certainly initiated a new and painful era of newspaper correspondence. Passengers by the new cars apparently regard themselves as entrusted with the mission of Sherlock Holmes, and by minute processes of induction and deduction they detect errors and faults, a mere catalogue of which would drive Mr. Lucas into retirement at Humberstone. On this, and other grounds, we refrain from publishing more than a selection of the almost innumerable letters which have reached us. It may not be out of place to suggest that a little more patience might be shown on the part of the public. If it be true, as some assert, that the new cars promise to become a slower method of transit than the old ones, owing to the too numerous stopping places, that the indicators are difficult to see and often misleading, that inside riding during the hot weather endangers suffocation owing to the drivers refusing to open the front door, and that the conductors are being worked to death–these are surely matters which the committee and officials will recognise as readily as the general public, and provide remedies for in good time.'

It was as much the case then as it is now that there are two types of letter: those with either some great suggestion, or more usually some specific grievance, for which the writers are seeking both publicity and support, and those commenting upon them, and it will be noted that both types are well represented in this selection. And although the occasional missive is printed these days with the author's name withheld, it seems that hiding behind a pseudonym was not de rigeur in 1904. Starting in the days even before the first trial took place, FOREWARNED was staking a claim to be a forefather of the Health & Safety movement in the *Leicester Daily Mercury* of 19 April:

'WARNING TO TRAMWAY PASSENGERS
'Sir,–May I, through the columns of your paper, call the attention of the public to a danger in connection with the new trams? On London-road, for instance, the poles are erected down the centre, between the two lines, and anyone seated on top of the cars will be in very close proximity to these poles. I have seen narrow escapes of people from getting their brains dashed out. I have not yet seen the Leicester cars, but in other towns I have not observed any screens to prevent accidents in the manner I speak of. For a few weeks, when the service is started, everyone will be filled with curiosity, necks will be craned out over the car sides, and it is just possible that some will forget the existence of the necessary but dangerous poles. I have seen people pulled away just in the nick of time, who would otherwise have been badly injured, if not killed. I am not trying to strike terror into the minds of future passengers, but certainly think that if screens are not attached to the cars, printed warnings should be placed in a prominent position thereon, and not wait for accidents to occur before seeking the remedy.'

Some correspondents saw things in the subsequent trials that were not to their liking and committed themselves immediately to print. We start with COMMONSENSE, whose letter was published in the *Daily Post* on 14 May. It may be that he was a frustrated horse tram conductor who foresaw things getting much worse when he transferred to the larger capacity electric trams:

'Sir,–Just allow me a small space in your valuable paper to express my opinion in regard to the changing of money on the tramcars. I think passengers ought to provide themselves with smaller change to pay the fares. It gives the conductors a lot of unnecessary work, considering they have only a limited time to complete their journey, and the difficulty they have sometimes in changing the coins. They are only allowed a certain sum to meet the large demand for change. Could not something be done to stop this unnecessary inconvenience? Trusting this will meet with favour in the eyes of the general public.'

Another bone of contention was the appearance of the cars themselves. The *Leicester Daily Post* published missives from PROGRESSIVE on 14 May and both DISGUSTED and INTERESTED on 17 May – the day before the launch – all of whom were appalled by what they saw during the trials. But it was Mr F.J. Gould, one of the few correspondents prepared to be named, from the Secular Hall, Humberstone Gate, writing in the *Leicester Guardian* on 21 May, who best summed up the situation. The advertisements carried by the cars were the problem, and we could fast forward and

imagine how Mr Gould would have viewed the type of overall advertising on buses which began to come into vogue in the early 1970s, when, admittedly, liveries were generally less attractive than that employed on Leicester's trams:

'Sir,–The beautiful cars inaugurated in Leicester last Wednesday are disfigured by advertisements. I greatly regret this sordid mistake, and take the earliest opportunity to protest.

'An immense amount of money has been spent on the tram lines and carriages. Electrical engineers have devoted their highest skill to rendering the service efficient. Hundreds of industrious hands have toiled to prepare the roads. Leicester has welcomed the new system with proper municipal pride. We seemed truly modern. We rejoiced to feel that machinery was being put to its noblest use–the comfort of the people, and in the best method, viz., under the control of the people.

'And yet the enterprise has been marked by a sign of degradation from the outset. We are using our public cars for the advertisement of private wares. We cannot look up at our new and handsome vehicles without meeting a vulgar appeal to buy this or that tradesman's paltry products. I say "paltry" with deliberation. The goods in question may be excellent articles, but they assume a paltry character when thrust upon the public notice in this unbecoming and inartistic manner.

'I will not take up your space by discussing the large problem of advertisements in general. I will simply remark that the whole question needs study,

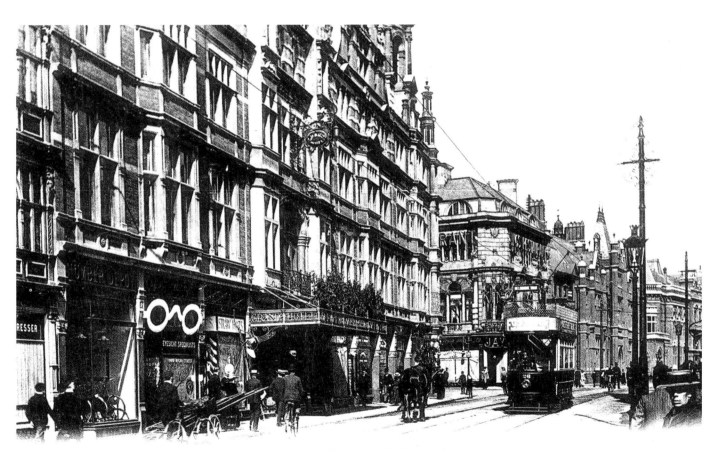

Granby Street. Leicester.

32. A view of Granby Street around 1905, with car 26 heading out of town on a Melbourne Road service. It carries advertising between decks, probably on all four sides, but to modern eyes it does not appear to be intrusive or to detract from the immaculate livery. The imposing building on the left is the Grand Hotel, and the huge spectacles belong to Charley & Son, opticians, or as they would have it, "eyesight specialists". In 20 years time, Midland Red will have their first enquiry office in Leicester at no. 69, one of the ground floor units under the hotel.

with a view to more sensible organisation, avoidance of wasted effort, and the order and niceness of the public highways. Municipal bodies ought to lead towards reform in this direction. When I sat on the late School Board, I spoke against the wretched practice of placing trade announcements on the walls of our educational institutes. Some of these eyesores were removed, and some most objectionable prints still disgrace the class-rooms. And now it seems the Town Council is following the bad example of the School Board, and is eager to pick up a few shillings by acting as tout for shopkeepers. I affirm that the Council does more harm by encouraging a mean competitive spirit than it does benefit by adding a trifle to the municipal income.'

We know from contemporary photographs that horse trams were carrying advertising in the 1890s, and perhaps Mr Gould's disapproval is based in part on the Council acting like a commercial company. No-one, including OBSERVER, who had similar thoughts regarding the tram tickets published in the *Daily Post* on 21 May, stopped to consider that a 'few shillings' multiplied across the entire fleet of cars – 99 by the end of 1904, 140 by mid-1905 – would amount to a substantial income which, in part, would help to hold fares down:

> 'Sir,–Have your readers read their tramcar tickets? If so, they will have noticed that the tickets were printed in Leeds, presumably because our local printers are so extremely busy. There is also a drinkseller's advertisement on the back of at least some of the issues. Perhaps some satisfactory explanation of this will be forthcoming.'

As far as can be seen, none was. A more serious problem was highlighted by a correspondent known simply as G, which impacted on all road users and which still has some resonance today, published in the *Daily Post* on 14 May:

> 'Sir,–Before the starting of the electric car service, something should be done to improve the order of traffic in our streets. Every driver, cyclist, or motorist is a law unto himself. The police serve very little better purpose in the regulation of their movements

than do the new posts in the roadway. Would it not be money well spent to send up a squad of police to London so that they might have an opportunity of studying how things are done by the City police? Here vehicles of all kinds, especially the heavier ones, carts and drays, seem to think the tram lines, or as near the centre of the road as possible, is the correct line of travel. No one dreams of turning a corner to his right without "cutting" it, even in the centre of the town. The motor cars are an increasing terror. The speed at which they are driven on the roads right into the town does not leave a possible chance of escape for any luckless cyclist rounding a corner, or getting in their way. A motorist who knocked down a man the other day is said to have admitted to a bystander that he was going at twenty-four miles an hour. Why was he not summoned for furious driving? The byelaws respecting traffic should be freely posted on all roads leading into the town for the education of the country carters coming in.'

The speed of travel also was behind the next correspondent's complaint; his problem was that it was too slow! The various changes to the stopping places that had taken place since they were first introduced included the reclassification of some 'permissive' stops to 'compulsory', thus slowing end-to-end journey times, as ALACRITY pointed out in no uncertain terms in the *Leicester Mercury* on 8 July:

> 'Sir,–I wonder who is responsible for the additions to the already totally unnecessary number of "compulsory" stopping places for our new electric cars along the London-road? It is perfectly disgusting to see the cars stop and waste time at points on the route where no passengers get on or alight. Already the timing of the trams is much slower. If the authorities will only add a few more stopping places our much vaunted speedy electric cars will be no quicker than the old horse trams. Other towns find "permissible" or "by request" stopping points more conducive to quick traction, and so shall we.'

Let it not be thought that everyone was of the same mind on any of these topics. A particularly good statement of an alternate view came from TH in the same paper five days later. Responding directly to the point

made by ALACRITY, his view was that 'I should think the manager has something else to do, besides noticing such rubbish'.

Church attendance in the early twentieth century was significantly higher than it is today. Every tram route would have run past at least one place of worship, but it seems that Melbourne Road was particularly well endowed in that respect. Strangely, this letter from QUIETUS in the *Leicester Guardian* on 16 July did not appear until the line had been up and running for two months, and I have been unable to find any other letters bemoaning the same issue, but his plea is nonetheless heartfelt:

'Sir,–'Can anything be done to mitigate a nuisance created by the electric car traffic on Sundays? Along the Melbourne-road route there are seven or eight places of worship, and I know I am voicing the complaint of a large number of people who worship in these respective churches when I say that great annoyance is being experienced by clanging of bells, noise of cars, &c., during hours of service. To suspend Sunday traffic might be deemed an unreasonable suggestion, and would doubtless be a great inconvenience to a multitude of people; but surely it might be considerably curtailed, and such annoyance thereby minimised. Is there any need for such a number of cars to run on Sundays, and so frequently? I submit there is not. Of course, the Corporation, or any who are financially interested in the system, will at once argue that there is such need. Why not the Sunday traders be allowed the same plea, in response to our Mayor's request? Where lies the "consistent" difference?

'Trusting those who have the power to alter this will give the matter due and candid consideration…'

One major source of complaint in these early days was the effect of tramcars on different routes converging. Points boys were in charge of controlling the junction where Narborough Road, Hinckley Road and Braunstone Gate met. The way they did it left NO GRUMBLER of Stuart Street in conciliatory mood in the same day's paper:

'Sir,–Allow me, through your paper, to make a suggestion which I venture to think would add to the convenience of our already well-arranged electric car service. I ride down to business or to the railway station on the Narborough-road car, and it has almost invariably had to stop at the Braunstone-gate junction to allow the Fosse-road and Western Park cars to pass into Braunstone-gate first. Sometimes the latter cars have been nearly at the top of Hinckley-road hill, and both have had to stop at the stopping place near Great Holme-street before passing the junction. This of course has delayed the Narborough-road car several minutes, which is just a bit chafing when one is depending upon the quickness of the car service to catch a train or get down to business early. I suppose there must be an arrangement to keep the cars in a certain order, but, with a slight adjustment, this little inconvenience could perhaps be avoided.'

When the East Park Road Outer Circle opened, issues arose almost immediately with its operation, and the question of how far one might travel for a penny, which had been festering since Councillor Flint's announcement on the opening day. M.A.P. wrote in the *Leicester Mercury* on 9 November and gave the appearance of one who had done his homework most thoroughly.

'Sir,–The Tramways Committee are to be congratulated on the improvement of the service to North Evington which came into operation on Saturday, but there are still several curious anomalies which require their attention. For instance:

'Whilst a passenger can travel from any point on East Park-road to town for a penny, or the complete circle for twopence, residents on Humberstone-road east of the Midland Railway Bridge have to pay threepence for the same trip.

'From St Barnabas' Church to Midland Station, London-road, the fare is a penny. From Humberstone-road Station to London-road Station twopence, though only one-third the distance.

'From St Barnabas' Church to Aylestone, nearly five miles, via Evington-road and change at Horsefair-street, fare 2d. From Wharf-street, Humberstone-gate, to Welford-place, via Clock Tower (under half a mile) fare threepence;

Via Melbourne Hall, Wharf-street to Midland Station, one penny; via Clock Tower, twopence.

'Other instances could be named, being the result of the system of making all passengers pay again, or walk, on passing the Clock Tower. It certainly should

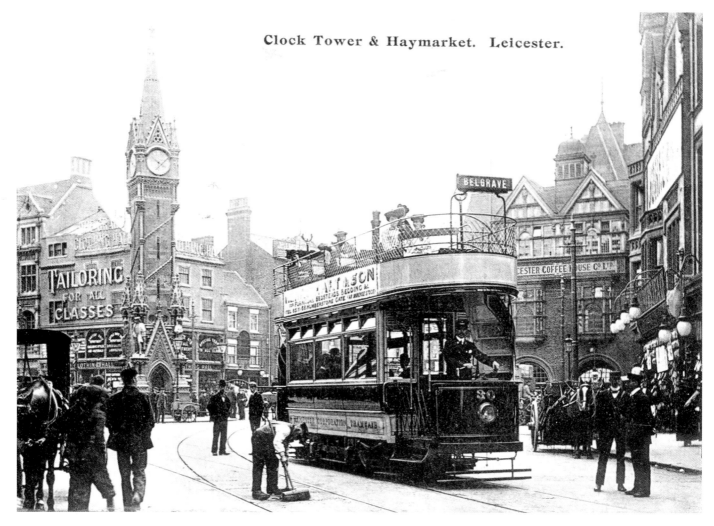

Clock Tower & Haymarket. Leicester.

33. A final visit to the Clock Tower in the Edwardian era as car 30 departs for Belgrave. It is almost 3.50pm, and there is a considerable amount of activity in the area. Apart from the ladies who have claimed the best seats at the front of the tram, all the other people that can be readily seen are male, and all are suitably hatted. Four of them appear to be watching the road sweeper go about his business, which may well be connected with the horses that were still plying Leicester's streets.

be more profitable to the Corporation to take passengers the shortest route instead of compelling them to ride half round the town to reach a point a few hundreds of yards away.–Trusting that means will be found shortly to remedy these matters…'

The introduction of the Outer Circle seemed to have a detrimental effect on the timing of the Inner Circle, increasing as it did the number of cars seeking access to Humberstone Road and, ultimately, the Clock Tower. This is ANTI-TORTOISE in the *Daily Post* on 4 November:

'Sir,–I expect there will be a lot of grumbling in connection with the opening of the new sections of the electric trams. But I, for one, think it very bad management, even for a beginning, when you can walk almost as fast as you can ride. I waited at Horsefair-street nine minutes for a Melbourne-road car on Tuesday evening. Then took my seat and off we went faster than a tortoise! We continued to crawl until we reached Charnwood-street. There we waited for 3½ minutes, and when I asked the conductor why, he said "You don't understand the business!, so shut up!" But we started crawling again, and continued to Wharf-street. Then we went at a fairish pace, and arrived quite safe at the Tower.–Hoping this "reckless" driver will have a stop put to it, or when I am in a hurry I shall have to walk.'

34. Turning 180° from one's position in the previous photograph would have yielded this Belgrave Gate scene. Despite the fact that it is displaying the destination 'Melton Road', car 29, which is exiting the passing loop, is actually heading towards the Clock Tower. The passers-by are male, for the most part, with bicycles, a hand cart and a very early motor car completing the scene. One of Leicester's more noteworthy buildings of the time, the Palace Theatre, can be recognised by its round tower on the left, while the outline of the old tram tracks swinging across to the right leads us to the entrance of the former Leicester Tramways Company depot, whose premises were now occupied by the Leicester Garage Repair Works.

RATEPAYER managed to combine the tardiness of the Melbourne Road trams, the half-penny fare issue and the general inequalities of the fare system in his letter published in the *Daily Post* on 8 November:

'Sir,–May I encroach upon your valuable space to express my disgust at the mismanagement of our tramways. A week ago today I found it possible to reach the Clock Tower via Nedham-street and Humberstone-road on the Melbourne-road cars, and it was explained to me by the conductor that this was to be a circular route, fare 1d. The same evening, I tried to reach the Clock Tower from Melbourne-road Board School, via London-road, and found that they took nearly half-an-hour to do the journey.

Consequently I have walked it five times each day since, until today. Today I took the Melbourne-road car from Rutland-street to the Melbourne-road Board School and found I had to pay twice to reach Buxton-street. In some of our more progressive towns a ½d fare would have done the journey. If this is the way the cars are to be made popular, I fail to see where the benefit comes to the town or the ratepayer. Strangers coming to the town would, I fancy, prefer to walk to being imposed upon in this fashion. The same thing occurs if anyone takes a car to the Wellington Hotel from Great Central-street, 2d fare for a ½d journey.'

But back to issues of timing on the East Park Road outer circle. It seems SHANKS' PONY put pen to paper the

moment he got home on the first morning of operation, and as if to emphasise his point, he sent his letter to the *Mercury* and the *Daily Post*, both of which printed it on 2 November:

> 'Sir,–'Will you kindly permit me to give my experience of the running of the above cars which commenced this morning? I sought a car at the end of Evington-road, opposite Victoria Park entrance, to take me to North Evington. None was forthcoming; and I walked along East Park-road as far as the corner of the Spinney Hill Park before a car overtook me. It was then not worth my while to ride the remaining distance. I saw dozens of people waiting in the rain; some of them got tired of waiting and gave it up. What is the use of a service like that? Surely the powers that be are miscalculating the needs of this important residential and business neighbourhood.'

From the outset, the Tramways Committee had stated that they would be prepared to increase frequencies as and when necessary, and improvements that would benefit the people of North Evington appear to have been planned almost from the outset. Arthur W. Faire, who wrote from a Warwickshire address, was nonetheless well informed about the machinations of the Tramways Committee according to his letter to the *Daily Post*, published on 3 November:

> 'Sir,–There already has been a certain amount of grumbling on the part of those living at North Evington at the poor service to and from the Clock Tower, but I understand that the service since Tuesday has been of an experimental character. Of course, the success of the other sections is mainly owing to the fact that the service is rapid and frequent, so that if a passenger misses a car not much time is lost in waiting for another. I am informed on good authority that from Saturday night the cars will run in both directions every ten minutes (London-road and Humberstone-road), making a five minutes' service for North Evington. I am satisfied that the chairman and management are anxious to meet the reasonable requirements of this important residential and business centre, and I trust, therefore, that the use of the cars will justify the management in the course they are carrying out.'

There were a few further rumblings during that first week of operation, but once the doubling of the East Park Road service had taken place, that was the end of the matter. However, as can so often be the case, complaints about one sphere of operation can sometimes lead to issues surfacing in others. This is RESIDENT, another who deemed it necessary to be represented in both the *Mercury* and the *Daily Post*, on 3 November, who was not to know that the Tramways Committee had instructed the manager to order side destination boards on 19 October:

> 'Sir,–I am at a loss to understand why more of the trams have not been furnished with route boards on the sides. At present, I have only noticed a few with Stoneygate and Narborough-road on. Councillor Flint seems very desirous that the service should be made payable, "and so say all of us", but in order to do so, the wishes of the public must be attended to. It has been previously pointed out that the present indicators are of very little use, and one cannot be expected to wade out into the middle of the road, especially this muddy weather, to ascertain where a car is bound for. Another thing, the indicators ought to be of different colours, varying with the circles they work, so that it can be seen at a glance to which district the cars are running.'

One aspect of tramway operation that got very little mention was the employment of points boys. These youths had the task of ensuring that cars were not admitted to a particular stretch of line until there was room for them – akin in many respects to a signalman's role on the railways – and to prevent the possibility of a collision on the crossovers. First seen at the Clock Tower, whose trackwork was held to be the most complex of any system in Britain, they were for a few years to be found at various other points of the network. With duties that lasted for as many hours per day as the trams operated, they were expected to work in all weathers, which prompted WET AND COLD to make this plea on the West End boys' behalf in the *Daily Post* on 7 September.

> 'Sir,–I should like to ask the Electric Tramway Company why the point boys on the western routes have not been supplied with cabins to shelter them from the rain such as we had last Saturday, in the same

manner as those on the London-road routes? I am told that the cabins are already made, but they are waiting for someone to ask for them. If that be so, it gives me great pleasure to ask, on behalf of the boys, that they be at once supplied. And, as gentlemen riding on the trams who wish to smoke are requested to sit behind the trolley pole, I would deem it a favour if the ladies will use the front seats where possible. Hoping you will find space in your columns for my letter…'

But perhaps the final word should go to FIELDS BEYOND, who wrote to the *Mercury* and the *Daily Post*

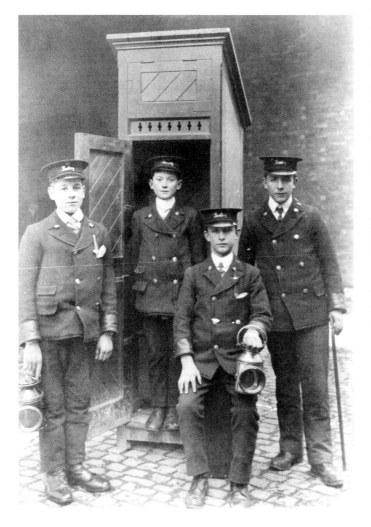

35. The points system at the Clock Tower was highly complex and required the employment of a number of points boys. A sign of their importance to smooth running in that area in the early days of operation was that they were granted the use of a box-like shelter, a luxury not all of their counterparts elsewhere enjoyed. Clearly though they could not all use it at once!

on 25 May. The second part of his letter deals with the points boys; his opening lines speak for themselves:

'Sir,–Will you allow me a small space in which to congratulate the Tramways Committee upon the splendid turnout and the smart and obliging way in which the drivers and conductors are doing their work, also for the splendid service they have given to Clarendon Park, which surpasses all my expectations.'

The way forward?

In a separate development 40 miles away, at the time when virtually all Leicester's 1904 tram routes were operational, a new company was born that in the future would have an enormous presence and influence in Leicester. The Birmingham & Midland Motor Omnibus Company, Ltd was registered on 26 November 1904 – a company popularly known as Midland Red, which name for convenience I will use from now on, except where direct quotations demand otherwise. Although it would be several years before its operations were found outside the Birmingham area, that was attributable to the fact that its early ventures with motor omnibuses were problematic – between October 1907 and May 1912 it reverted to the use of horse buses – and the intervention of the First World War. Interestingly, in the light of Leicester's recent and costly investment in the tram, the *Leicester Chronicle* published an article on 9 July 1904 drawn from the 'magazine of Commerce', in which the writer proclaimed that the future was *not* to be an electrically powered one.

'IS THE MOTOR OMNIBUS SUPERIOR TO THE ELECTRIC TRAM?
'How to grapple with the conveyance of the teeming thousands of our cities and towns is one of the most difficult problems city and urban councils have yet to solve, to ensure a commercially sound undertaking, and at the same time secure a system which shall at once be equal to all ordinary demands, and yet elastic to the maximum extent. Mr. H. Barker-Lake, A.M.I.M.E., suggests the problem is better solved by the motor omnibus than by the electric tram. The electric tramcar, the latest system, requires three times the number of passengers to fill it as compared with the first omnibuses, whilst each car or carrying unit, whether filled or not, occupies the best part of the

public road, and is not capable of deviating from that metal track to relieve congestion or make way for a full car in its wake; therefore, through fast cars are a practical impossibility on railway in a public thoroughfare, and one breakdown or obstruction means the blockage of the whole line. Such are a few of the disadvantages of the overhead electric system, considered only from a carrying aspect. And yet one would this system is the very acme of efficiency from the feverish haste with which it is adopted by our municipal authorities. Everyone knows the strides autocars have been making, and as manufacturers recover from "racing fever" they are turning their energies and resources to producing "motor-cars for commercial purposes", and today a thoroughly sound and reliable motor omnibus is available and, although not perfect, it is quite practicable. This being an established fact, what are the carrying advantages of a system of motor omnibuses? First: Quicker service, resulting from capability to thread in and out of the busy traffic; to pass another of its own class of conveyance, or any other forming an obstacle. Second: Smaller carrying capacity facilitates quicker service, and conduces to higher speed, with safety. Third: No monopoly of the road, and the carrying unit is capable of picking up or setting down at any point, and near the causeway. Fourth: The route may be changed at short notice, without cost, or further outlay, so as to fully benefit new districts, summer traffic trips, or to avoid road-repairing operations. Fifth: Through fast cars may be run at times of going and returning from business. Sixth: In case of a 'bus breakdown, the whole traffic is not stopped. These are a few of the sterling advantages of a motor omnibus system, which any tramway or road railway system will ever be impotent to offer.'

Motor bus services had already started in some parts of the country,[8] but the technology was in its infancy and the fact that Midland Red did not regard motor buses as sufficiently fit for purpose until 1912 is telling. Nonetheless, and whether or not the writer of the piece was biased in favour of the motor bus, it must be admitted that most of the six points of the plan make reasonable sense and are arguably made before their time. So was that to have any influence on Leicester's transport policy? Obviously not, in the sense that the size of the tram car fleet increased by almost 80 per cent between the end of 1904 and 1920. But the Tramways Committee were all the while looking to see to what extent the network could be expanded, and although only the Welford Road, Blackbird Road and Coleman Road schemes came to fruition, one other, potentially ground-breaking, idea very much took root. This comes from the minutes of the Leicester Council meeting on 28 April 1914.

'Your Committee have…to report that they have considered the question of providing and using motor omnibuses in connection with the tramways. They propose to obtain at once three motor omnibuses with chasses of the Daimler type, at an estimated cost of £2,900, and have provisionally accepted quotations of the Daimler Co. Ltd., for the chasses at £550 each, and of Messrs. Christopher Dobson Ltd., of London for the bodies at £212 15s 0d each, the additional cost of tyres, accessories, spare parts, etc., being estimated at about £200 for each vehicle.

'The Committee hope at an early date to be able to establish an omnibus service to Thurmaston as authorised by the Local Act of 1913.

'Your Committee request the Council to approve their proposal and to authorise them to make regulations with respect to the service of the omnibuses, and to fix the fares; also to authorise the common seal to be affixed to contracts for the provision of the vehicles.'

The buses were acquired, but war intervened and they were requisitioned without ever being put into service. By 1918, the idea was dropped. But that was also the year in which Midland Red took over the services previously operated by the North Warwickshire Motor Omnibus & Traction Company from its premises in Tamworth and, most crucially for the residents of Leicester and county, Nuneaton, and it is to them that we owe the next landmark in Leicester's transport history.

1919-1932: THE ESTABLISHMENT OF MIDLAND RED

Introduction

By the early 1910s, the time-honoured tradition of carriers providing transport from the villages in the county into Leicester began to be supplanted by the motor bus; the horse and cart, like its close relative the horse-drawn tram, was rapidly becoming a thing of the past. In some cases, this 'new' transport might still take the form of a converted lorry, used for transporting other goods when not required for passenger service, but crucially, these were locally provided services and customer loyalty was an important consideration. Perhaps not every single village had its own service into Leicester, but with well over one hundred different settlements in the county, there was scope for a considerable amount of new traffic.

Until 1920, the Council was able to charge an annual fee for use of the roads, and thus the Watch Committee would sit in judgement over applications to run bus services into Leicester (which regained its city status the previous year) from the wider county. There was a steady increase in the number of cases being heard each year. Would-be proprietors were told where their city terminus would be, such as in this example heard on 7 October 1919:

> 'Application for licence – Edgar Woodford, 114 Logan Street, Market Harborough, and Arch. Beesley & Co., 30 Nithsdale Avenue, Market Harborough, to run between Market Harborough and Leicester.
>
> 'Woodford to stand in East Street (where he has an arrangement in a gateway there).
>
> Beesley to stand in Regent Street.'[1]

But these were one-man businesses, and larger concerns were on the look-out for growth areas. The Midland Motor Bus Co Ltd was attempting to move beyond its home base of Northampton, and in 1916 began operations from Leicester to both Hinckley and Loughborough, the latter apparently replacing a short-lived service to Barrow-upon-Soar. By 1919, Syston – later extended to Cossington and Sileby – and Broughton Astley were added.[2] Leicester & District (known as the 'Leicester Green') was also starting to build up a portfolio of routes in and around Leicester. But it was the appearance during 1919 of even larger players from the Midlands area, and indeed further afield, that began to threaten the local order. The Trent Motor Traction Co Ltd (henceforth referred to as Trent), busy building up a network of services in Derbyshire and Nottinghamshire, was licensed to run a Loughborough-Leicester service in May 1919. The National Steam Car Company Ltd (National), which had wide-ranging interests in the London area, East Anglia and the south west of England, acquired London General Omnibus Company's premises and services in Bedford in August 1919. By October, a Bedford-Northampton service was introduced, albeit on a temporary licence from the Northampton Watch Committee. National had achieved good results in the 1919 financial year, and the accent was now firmly on operating motor omnibuses as opposed to steam cars. With what it would have considered to be good prospects of setting up a base in Northampton, National's directors were doubtless well aware that there were considerable opportunities to be had in Leicester and its environs, being only 35 miles away and having double the population. But then there was also Midland Red…

National gets in first

At the Watch Committee meeting on 21 October 1919, the chairman read a letter in which National sought to run a motor omnibus service for Leicester and district and proposed to apply for licences to 'generally' ply for hire in Leicester. The response of the Watch Committee was to set up discussions between its chairman and vice chairman and the holders of those posts in the two other committees involved – Highways and Tramways. By 16 December 1919, the application from National to license 19 motor omnibuses had been received, and the

Watch Committee, no doubt as a result of the most earnest consideration of the issues, resolved in the first instance to set up a new body – the Watch Sub-Committee (Motor Omnibuses), hereafter referred to as the Committee – to oversee the whole question of licensing. At its first meeting, on 13 January 1920, members decided that their primary function was to 'consider applications for licences for motor omnibuses to ply for hire in the city in connection with the surrounding districts'. Mindful of the implications of this, as other councils had already been when the prospect of competition for their Corporation tramway systems arose, they resolved that they were in favour of permitting a system of motor omnibuses in the city under suitable conditions to be arranged by the Watch Committee, but they also recommended that 3d per car mile or an equivalent lump sum for each bus licensed be charged, and that this be subject to revision at the end of twelve months.

Four weeks later, at the meeting on 10 February, this line of thinking was taken several stages further. It was carried that:

'…in any arrangement with private companies with regard to the licensing of motor omnibuses, it be recommended that the Corporation reserve the right to run buses themselves at any future time without any compensatory advantages to the companies then running, financial or otherwise.

'Resolved, that buses plying for hire be not allowed to enter or pass through such central area as shall be defined by the Watch Committee from time to time.

'Resolved, that the fares to be charged for taking up and setting down within the city shall be from time to time approved by the Watch Committee in conjunction with the Tramways Committee but shall in no case be less than 3d with power to the Watch Committee to call for an increase at any time in their sole discretion.

'Resolved, that consideration be given to all applicants for licences who shall conform to the conditions laid down by the Watch Committee.

'Resolved, that it shall be recommended that a lump sum of £60 per annum payable in advance for wear and tear of roads be charged for each bus licensed to ply for hire in the city, with power to alter such arrangement after consultation with the Highways Committee.'

This was a bold statement of intent and the first evidence of protectionism towards the cherished city centre termini occupied by the trams. But whereas smaller operators might lack the necessary firepower to challenge such restrictions, the bigger players already had experience in dealing with such committees, and so far as National and Midland Red were concerned, councillors were about to find themselves dealing with some of the most highly regarded professionals in the fledgling bus industry. Perhaps here, at the very outset of their history, the first seeds of antipathy that would come to characterize many of the Council's future dealings with Midland Red were sown.

Midland Red and National representations

No other mention of the application by National was made in these early Committee meetings, which it might be assumed were concerned with setting up the necessary infrastructure to carry out its work. But by 24 March 1920, correspondence had been received from Midland Red which was read out to Committee members, and a special meeting was convened for 29 March to which representatives of Midland Red and National were invited. Whether the former entered the fray having got wind of National's interest, or whether it was the acquisition of the North Warwickshire Motor Omnibus & Traction Co Ltd in 1918 which provided it with a garage in nearby Nuneaton and thus gave added impetus to an expansionist drive towards Leicester will probably never be known. With hindsight, the latter seems the more likely, although it could easily have been a combination of the two.

The importance of the 29 March gathering should not be underestimated. The Chief Constable attended to report on responses from four towns he had approached where motor buses belonging to both companies ran (where, and what testimony was received, sadly history does not record). The floor was then given to the company representatives, Orlando Cecil Power, Traffic Manager of Midland Red, and Walter J Iden, joint Managing Director of National.

It would be proper to say a little about O.C. Power at this stage. He was born in 1879 and was only 20 years old when he took up the post of secretary of the Birmingham General Omnibus Company, becoming their traffic manager in 1902. Two years later, he was appointed manager of the horse department of the

36. When Midland Red returned to motor bus operation in 1912 the first 12 received were Tilling Stevens TTA1s open top vehicles bodied by Tilling that would carry just 34 passengers. They received registration numbers O 8801-8812, and whilst the true identity of A-2-T is not recorded, it is known that in this photo at the Tilling factory it was awaiting collection by Midland Red. All 12 passed to Birmingham Corporation in 1914.

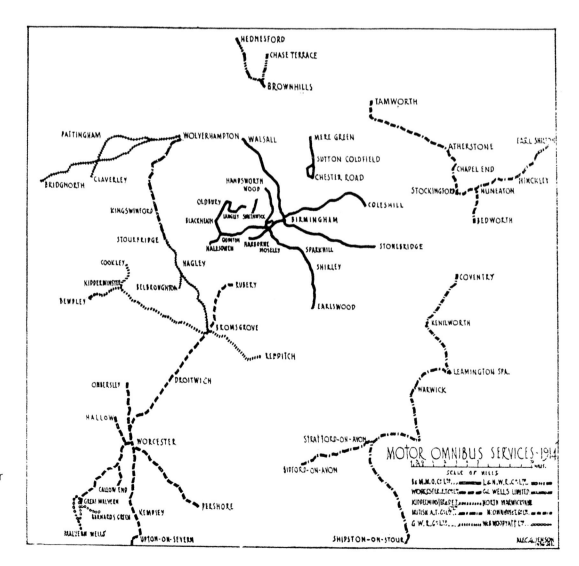

37. Midland Red territory as it stood in 1914. Its routes are shown as heavy black lines in the centre of the map. The remaining routes are those of other operators which were later either absorbed or taken over by Midland Red.

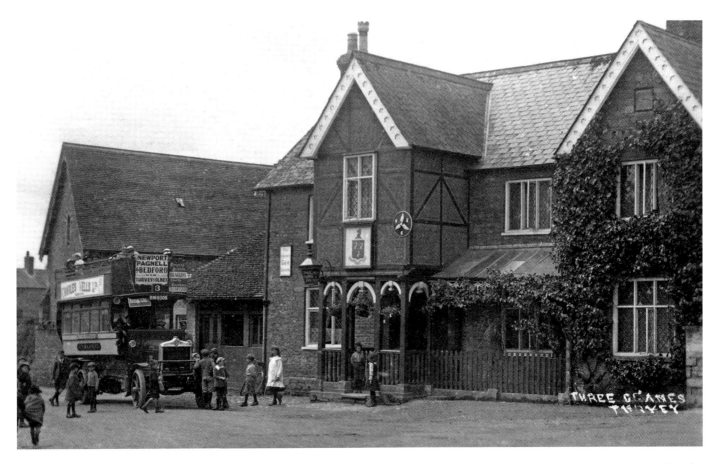

38. A vehicle such as this might have been seen in Leicester had National succeeded in their bid for licences "to ply for hire" in the city. It is their 2042 (BM 8305), an AEC YC with an NOTC OC22/20RO (later upseated to OT28/26RO) body, photographed in 1919 on route 3 outside the Three Cranes public house in Turvey, a village six miles west of Bedford on the A428 to Northampton. "NOTC" indicates that 2042 is carrying a redundant steam car body that was adapted in National's workshops to suit the AEC chassis.

City of Birmingham Tramway Department, recently acquired by the BET,[3] and when Midland Red was formed in 1904, he became the traffic manager for all three. For almost forty years, until his untimely death in 1943, he had complete control of the traffic department, working alongside Mr L.G. Wyndham Shire, the chief engineer. It was thanks to the considerable abilities of these two men in their respective fields that Midland Red went from strength to strength during the 1920s and 1930s. Power in particular was to be a frequent visitor to Leicester during that time, and it is due to his vast knowledge of operating conditions, his attention to detail and his considerable persistence that Midland Red was able to withstand the Corporation's attempts to protect its own services.

Back to the meeting on 29 March. Power went first, saying that his company would 'be prepared to pay 25 per cent of the net profits of the mileage run inside the city, in addition to whatever is fixed by the Road Transport Board, towards the costs of roads, this payment to date from the commencement of each service'. In addition, Midland Red would 'charge double the Corporation tram fare as a minimum when running within the city, allowing the Corporation 50 per cent of such fares', and would give notice to the Corporation of timetable changes. For his part, Iden said that his company was 'willing to pay for road maintenance at the rate fixed by the Road Board, but beyond that (was) not prepared to pay anything more'. Unsurprisingly, given the level of conformance with its pre-conditions, the Committee recommended that the terms of Midland Red should be accepted on a 12 month trial, 'and afterwards at six months' notice to terminate at the end of any year, and the Town Clerk authorized to draw up an agreement with the company'.

For the record, National's application was brought before the Committee at their meeting on 21 May 1920 – along with eight others from Leicester and Leicestershire independents. The Committee recommended that operating licences should not be granted to any of them unless Midland Red, 'with whom the Committee are in negotiation, ultimately decide not to run buses to the places to which the licences are asked for'. By then, applications by National to run other services in Northamptonshire made at the end of 1919 had been refused (in March 1920), although the Bedford route was finally fully approved.

Later that year, National turned down the offer to participate with the Wellingborough Motor Omnibus Co Ltd (which in 1921 became United Counties Omnibus Co Ltd) on the Wellingborough-Kettering road. There is no record of any further interest shown by National towards Leicester.

Thrashing out the detail

By the time the Committee reconvened on 20 July 1920, it seemed an agreement might be close at hand. Power was due to attend, but having arrived late, it was left that 'the Town Clerk be recommended to be authorized to explain the points now agreed to by the sub-committee to Mr Powers [sic] and that it be left in his hands to settle the agreement with the company on or near these lines'. Whatever form this explanation took, about which the notes are silent, it clearly left issues about which Power was not happy. These surfaced in a letter dated 3 August 1920 from Mr R.J. Howley, managing director of 'The Birmingham & Midland Joint Committee (Electricity, Tramways and Motor Omnibus Undertakings)' based at the Electrical Federation Offices, 1 Kingsway, London WC2, to the Town Clerk, R.A. Pritchard:

'OMNIBUS SERVICES
'When I had the pleasure of seeing you for a few minutes on the 22nd ult., I promised to write you my considered views in regard to the proposed agreement between your Corporation and the B. & M.M.O.

'The chief point of difference now appears to be in respect of payments calculated on mileage basis for the repairs of certain roads, a condition which your Corporation require under the terms of section 20 of the Local Government Board Emergency Provisions Act 1916. The offer of the Company was to make retrospective to the date of the commencement of each service any sum for road repairs which an appeal to the Minister of Transport should be determined by him and the period during which such payment should be made. Your Corporation I understand require the Company to undertake to make any such payment for a fixed period of years or until adequate provision is made for the upkeep of the roads by the apportionment to the Corporation of monies resulting from the joint taxation of motor vehicles.

'I am afraid it is impossible for my Company to agree to a payment for a fixed period extending over the end of this year. The Finance Bill has now been passed by the House of Commons and from the 1st January next the Company will be required to pay a considerable amount in taxation for the upkeep of the roads. It is surely not reasonable to ask that the Company should pay again for the same purpose because you have some distrust of the Ministry of Transport and the methods that will be adopted for the allocating of the proceeds of the tax.[4]

'In regard to the amount to be taken by the Company for depreciation I regret to say there is no chance of the amount of 3½d per mile being reduced. The prices of chassis and bodies are rising every day and an omnibus now costs nearly £2,000 before it is ready to go on the road. It is going to be a difficult problem in the future to obtain sufficient net revenue to cover depreciation and a reasonable amount of interest on the capital employed.

'With regard to the right of the Corporation to operate omnibuses, I only wish to say that should the Corporation obtain the necessary powers and operate omnibuses in competition to services worked by the Company, I am of the opinion that the participation of the Corporation in the net profit should cease.

'The erection of a garage at Leicester without some certainty in regard to the future of the business is a big risk. Mr Power has I think discussed this point with you and you are no doubt fully seized with its importance.

'The question of the minimum fares to be charged to protect the revenue of the Corporation tramways is one which I can leave to Mr Power to discuss with you. It has been found possible to give the necessary protection elsewhere and he can explain to you how this has been done.

'Should there be any other points which you desire to discuss I shall be happy to run down to Leicester after the holidays and go fully into them with you.'

The Committee resolved to press on with the formulation of the draft agreement, subject to Midland Red making a payment of 3d per mile traversed within the city boundaries. They did not accept that they 'should not run buses in competition' with Midland Red, which concurrently pressed ahead with expansion inside Leicestershire's borders, August 1920 seeing the introduction of a Nuneaton-Hinckley service. No further record of progress towards a resolution appeared until 22 February 1921, when the Town Clerk reported that he had met with Messrs Howley and Powers (sic) 'with reference to the draft agreement for running omnibuses through the city, and in particular with reference to their application of 15 January 1921 for certain omnibuses to be licensed'. Here at last came the first publicised version of the draft agreement. After an initial introduction, five clauses were set out:

'(1) The omnibuses to start at the points within the city and traverse such streets as may be approved by the Corporation; to issue timetables and to notify changes or alterations therein and to adhere to the timetables and alterations

(2) The company is not to compete with the Tramways or any omnibuses of the Corporation operated within the city

(3) The company, during the continuance of the agreement, to pay 25% of the net profit earned by their omnibuses within the city, and to pay 3d per mile in respect of each mile traversed by each omnibus operated within the city boundaries

(4) The company to charge a minimum fare in respect of their omnibuses operating in the city of not less than 100% more than any fare for the time being authorized by the Corporation in respect of their service on the same route, on the Corporation Tramways, or upon any omnibuses operated by the Corporation, and to pay over to the Corporation 50% of such fares taken upon the inward journey

(5) The Agreement to subsist for 5 years from the date when the operations of the company are commenced and nothing in the Agreement to operate so as to prevent the Corporation running their own omnibuses at any time they seek to do so.'

The minutes also show that Messrs Howley and Power did not agree to:

'(1) Any payment in respect of road mileage provided for in respect of clause 4 of the Agreement, their contention being that the amount they have to pay under the Finance Act in respect of each omnibus which will be returned to the Local Authorities by the Road Board under the arrangement for paying 50% of the cost of repairing Class A roads, meets any obligation they may be under for road maintenance

(2) By arriving at the profit for the purpose of ascertaining the amount payable by the company under Clause 4 of the Agreement in respect of the 25%, the company insist upon being allowed to charge 3½d per omnibus mile in respect of depreciation and interest, and say that they can substantiate this figure if the Corporation choose to ask their accountant to investigate, and state that other places have agreed to a similar amount.

Subject to these matters the company are prepared to continue the negotiations for the Agreement on these terms on condition that the licences are issued and suggest that in the event of the Corporation not agreeing to enter into such an Agreement, they should operate the omnibuses without an agreement upon the terms before mentioned.'

This was to lead to a further meeting between Power and the Committee chairman. Whatever was discussed was clearly still not to the company's liking, as Power wrote on 8 April 1921 that:

'With regard to the conditions mentioned in your letter, I would point out that these are not quite in accord with the arrangement we discussed at our conference on 21 March.

You will remember I suggested that in view of the fact that your Committee could not see their way to comply with several of the clauses of the draft agreement that has been under consideration for a long time, your Committee should:

'(1) License our vehicles in exactly the same way and under exactly the same conditions as other proprietors, firms and companies at present licensed in your city, or

(2) Grant licences to us under exactly the same conditions that we are licensed in the city of Birmingham.'[5]

Having using his experience in dealing with similar bodies elsewhere in the Midlands to full effect, it seems that by now Power had what he wanted, and however inflexible the Committee may have been before, it now resolved to recommend the granting of licences to Midland Red:

'…under ordinary conditions subject to a minimum charge in the city inwards and outwards of at least twice the maximum tram fare on the tram route over which the company travel, and to such terminus in the city as may be decided on from time to time by the Watch Committee.'

With an additional clause requiring the submission of a timetable for endorsement, the recommendation was approved by the Watch Committee at its meeting on 19 April 1921. It is probably no surprise to realise that the final agreement is similar in most respects to the original statements of intent from both the Committee and O.C. Power over a year earlier. But no matter – Midland Red had finally secured the prize and 22 days later on 11 May 1921, the first service 68 from Nuneaton arrived in Leicester at The Newarke.

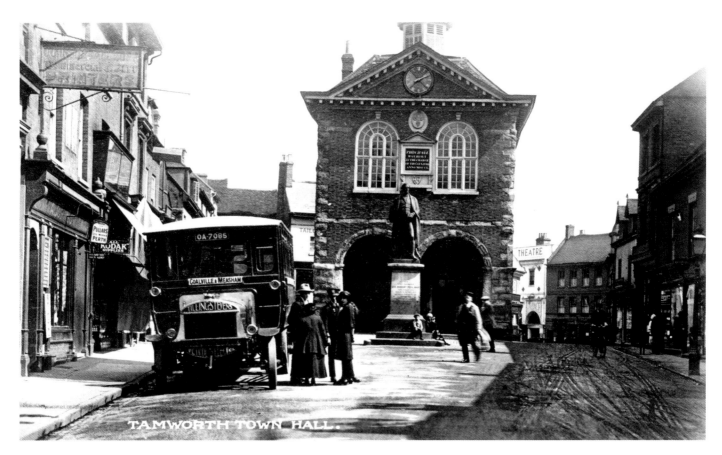

39. It was most probably a Tilling Stevens TS3 that operated that first 68 service from Nuneaton to Leicester in May 1921, and TS3s comprised 100% of the initial Frog Island garage allocation. This is a Tamworth example, photographed outside the Town Hall, A56 (OA 7085), and the board at the front indicates that for its next service it will run light to Measham for a 104A working to Coalville. This route was introduced on 17 November 1922 and remained a Tamworth (Two Gates) operation until premises in Coalville were opened in 1925. Some of the smaller details in this magnificent view – the ladies' fashions, the state of the roadway, the lengthening shadows (at 2.15 in the afternoon, according to the Town Hall clock) – suggest the photograph, on a postcard by A Johnson of Tamworth, might date from that first winter of operation. OA 7085 had Tilling bodywork seating 29 passengers; it was new in 1915, and probably came to Two Gates as early as 1918 following Midland Red's acquisition of the North Warwickshire Motor Omnibus and Traction Co Ltd. It was withdrawn in 1927.

Service No. **104a.**—MEASHAM and COALVILLE (via Swepstone and Hugglescote).

FRIDAYS ONLY.

| | | | | | p.m. | p.m.* | | | | | | | | p.m.* | p.m* |
|---|---|---|---|---|---|---|---|---|---|---|---|---|---|---|
| Measham (Market Place)... | ... | ... | dep. | — | 3-0 | 6-30 | Coalville | ... | ... | ... | ... | dep. | — | 3-45 | 7-45 |
| Swepstone ... | ... | ... | ,, | — | 3-10 | 6-40 | Hugglescote... | ... | ... | ... | ,, | — | 3-50 | 7-50 |
| Heather ... | ... | ... | ,, | — | 3-20 | 6-50 | Heather ... | ... | ... | ... | ,, | — | 4-5 | 8-5 |
| Hugglescote... | ... | ... | ,, | — | 3-35 | 7-5 | Swepstone ... | ... | ... | ... | ,, | — | 4-15 | 8-15 |
| Coalville ... | ... | ... | arr. | — | 3-40 | 7-10 | Measham ... | ... | ... | ... | arr. | — | 4-25 | 8-25 |

*—These 'Buses Run through to and from Swadlincote via Overseal.

40. The 104A timetable from the Midland Red "Official Time Table" for Leicester & District, Winter 1922/23.

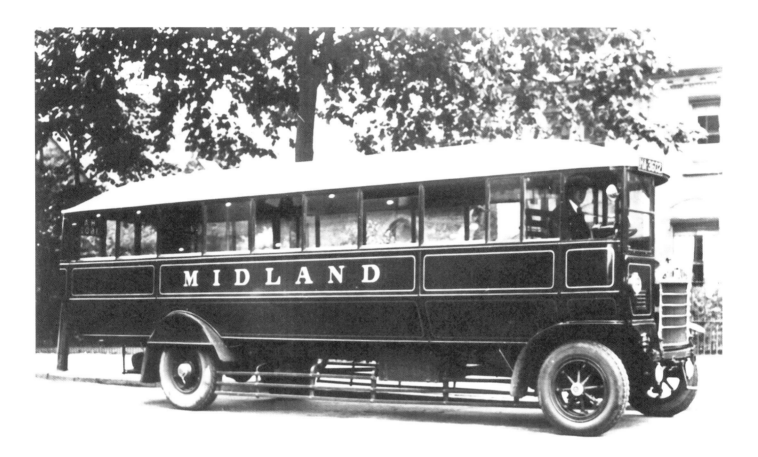

41. The Newarke was the first terminal point offered to Midland Red in 1921, and by 1928, it played host to a large number of services, principally those to the south of Leicester. Waiting to depart from the stands facing the Magazine Gateway on 18 July 1927 is SOS Q/ Brush A686 (HA 3602), new earlier that year. It seated 37 passengers, a considerable number for a saloon at that time, yet at 4 tons 4 hundredweight and 2 quarters it was one of the lightest full-size buses on the road. The Grade 1 listed Magazine Gateway was built in the early 1400s as an entry point into the Newark (as it was then spelt) and Leicester Castle; during the Civil War it became a munitions storehouse.

The situation that Power faced in Leicester in 1921 was, one suspects, very little different from those encountered in other locations where Midland Red had established a presence. By the end of 1914, the company had services from Birmingham to Coventry, Evesham, Great Malvern, Kidderminster, Redditch, Stourbridge, Stratford-upon-Avon and Worcester. While the negotiations with Leicester were

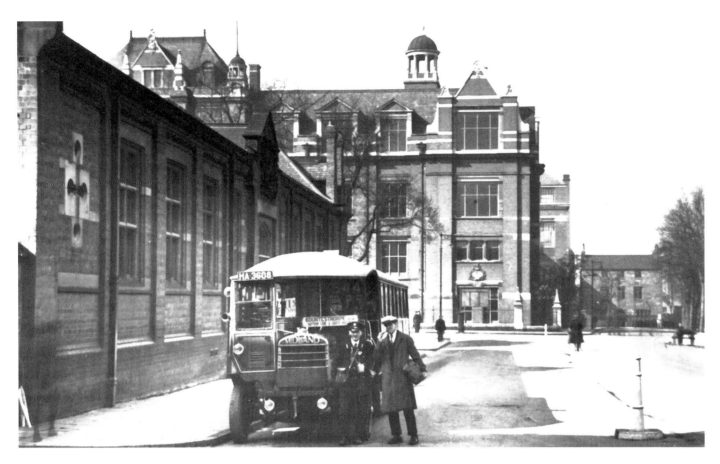

42. From the same batch as HA 3602 in the previous picture, this is A664 (HA 3608) standing on the opposite side of The Newarke, still facing the Magazine Gateway, employed on a 644 working to Countesthorpe via South Wigston. The photo is undated, but as it was the first vehicle in the fleet to be fitted with a route stencil box, it may be assumed that it dates from around 1932. The building on the left was the Territorial Army Drill Hall, backing onto Magazine Square, while the Technical and Art School (now part of De Montfort University) dominates the background. Ultimately, a line of shelters would be built on the road side of the bus lay-by.

taking place, new acquisitions and agreements consolidated its position in Walsall, Wolverhampton, Hereford and Banbury. Providing Midland Red did not encroach upon the interests of the municipal operators within their boundaries, it was free to operate services from such points outside them and bring them into the town or city area. It would of course still face competition – from local carriers and fledgling bus operators in the outlying towns and villages. But the conflicting desires of the Leicester councillors, anxious to retain the prime terminal points in the city centre for the trams and, in due course, buses, and Leicester traders, who wanted customers brought as close to the city centre as possible, created a major headache for the Council as the numbers of buses that required access to the centre increased throughout the 1920s, as will be seen in Chapter 3.

Midland Red expansion

The challenges that Power and his team in Leicester had to address were fourfold:

- to establish new routes from the county into Leicester
- to seek new opportunities within the city boundaries that were not covered by the tram network, as well as in the new housing developments that lay just outside
- to identify suitable premises in which vehicles could be housed and serviced
- to overcome opposition from smaller operators, and from the Corporation

This final point was extremely important. The Corporation found its hands were tied when it came

to trying to compete on level terms, be it with Midland Red or the smaller independents, as without County Council involvement (which was not forthcoming at the time) it remained trapped within its own boundaries. This was a situation which it increasingly came to see as detrimental to its best interests.

From the outset, no time was wasted in establishing more Midland Red services into Leicester. It took only 24 days – until 4 June to be exact – before the next one, the 69 from Coventry (Workhouse) to The Newarke via Walsgrave, Anstey, Shilton, Wolvey, Sharnford and Narborough and worked by Coventry garage, began. On 15 July, Tamworth garage's 103 (Burton-on-Trent to Ashby-de-la-Zouch) was extended via Coalville and

43. This Leicester & District timetable only came to light in the summer of 2017; prior to that it had been assumed that Midland Red only produced combined timetables for their entire network. Details of 17 services are contained within, and there are several advertisements, most notably that on the rear cover, where George F Pears, proprietor of the King Richard III, informed intending passengers that "when in Leicester and waiting to travel by the Midland 'Red' services, information and accommodation can be obtained with civility" at his hostelry!

44. A Midland Red Motor Services "Leicester District" guide, which cost 6d (2½p), which it appears was issued only a few months later. The cover picture is of a Tilling Stevens TS3 sailing around the Clock Tower, and whilst the front destination reads "Leicester", the stylised route board on the side, showing Loughborough, points to the extension of the 133 Mountsorrel service introduced on 28 February 1923. The artist has chosen to illustrate A153 (OE 6182), which was one of a batch of ten TS3s new in 1920 with Strachan & Brown bodywork seating 32 passengers.

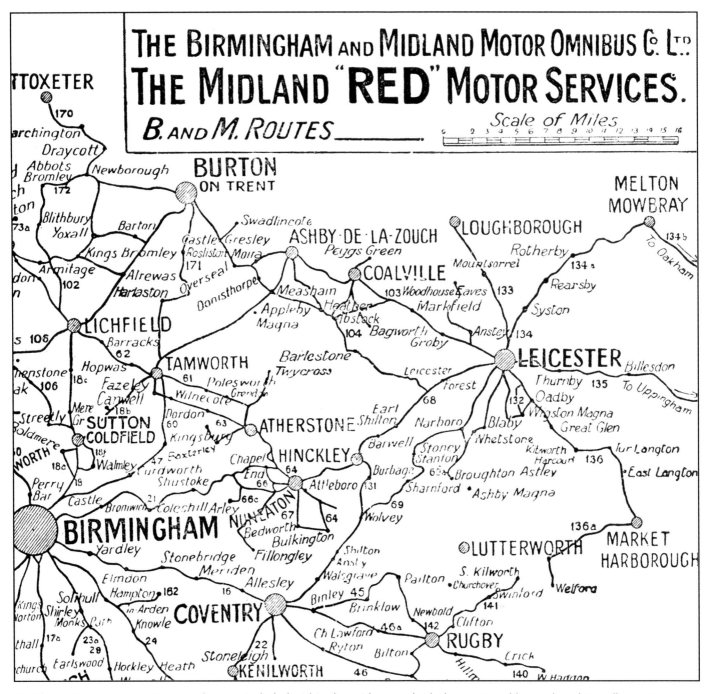

45. The eastern area operations on the map included within the guide cover both the new Loughborough and Woodhouse Eaves services (see Appendix 2), so is not unreasonable to suppose the guide dates from the spring of 1923.

Markfield to The Newarke. The 69A came next, on 3 September; it ran from The Newarke to Broughton Astley via Narborough and Cosby and appears to have been an early example of a route taken over from another operator (the Midland Motor Bus Co). The starting date for the 69B is unknown, although it was probably about the same time as the 69A; initially, it ran to Blaby via Aylestone but had

been extended to Cosby and Broughton Astley by April 1922. And in May 1922, another Tamworth route, the 104 (Ashby-de-la-Zouch to The Newarke via Heather, Ibstock, Desford and Leicester Forest East), was introduced.

In the early days, services ran on certain days of the week only; for instance, the 69 was initially a Monday, Wednesday, Friday and Saturday operation,

with Sunday being added before the year end, while the 104 was a Wednesday and Saturday only service with most journeys terminating at Heather. The 69A and 69B were the first routes to be timetabled as starting *from* Leicester, although the opening of the first Midland Red garage in Leicester was still 11 months away. This was to be a leased property at Frog Island; operational from 26 August 1922, it had been adapted to house a total of 30 vehicles, although on the opening day only eight were allocated. These were all Tilling-Stevens TS3's, seven buses and a charabanc. But having a permanent base in the city now set off a huge expansion programme, and progress was extremely rapid; by August 1923 Frog Island had 22 vehicles, and by May 1925, this had increased to 35, a situation which highlighted an urgent need for additional premises.

A short-term lease was taken that month on a garage in Welford Road for the overflow. Very soon after, land was acquired at the junction of Southgate Street and Peacock Lane, and a new garage with room for 90 buses was opened on 21 July 1927, at which point both Frog Island and Welford Road garages were closed.[6] Appendix 2 gives chronological details of all the routes embarked upon, and subsequent changes made to them, up to the end of 1929. It shows how Midland Red's expansion covered all the main routes out of Leicester into the county and beyond, and that besides a number of short workings on mainly local services, how heavily most of those roads were worked.

As Midland Red expanded, so competition with independent operators became more intense. Issue 42 of the Midland Red Staff Bulletin in March 1950 contains

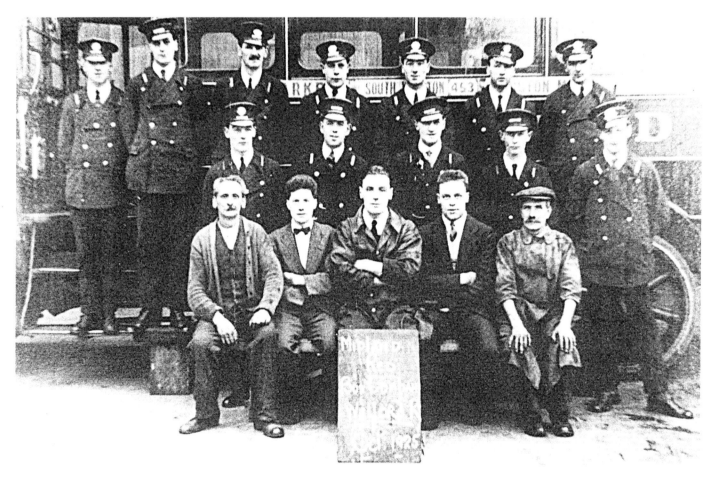

46. The drivers and conductors from Welford Road garage pose for the camera in October 1925. It opened in May that year to alleviate the pressure on Frog Island, which had been housing 35 vehicles, five more than the premises were designed for. The bus behind them appears to be another Tilling-Stevens TS3, whose route boards indicate that it has been working the 453 circular service from The Newarke to London Road (Hind Hotel) via South Wigston and Wigston Magna. The garage had an operational life of only just over two years, being closed in July 1927 (along with Frog Island) when the premises at Southgates were opened.

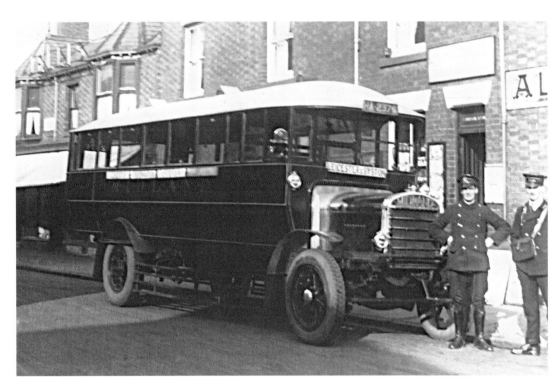

47. Dating from 1924, Midland Red A427 (HA 2376) was one of a batch known as the SOS "S", or "Standard SOS". Similar to the TS3, in this case the frames were supplied by Tilling Stevens but were assembled by Midland Red. In this superb view which is thought to date from around 1925, both driver and conductor pose with their vehicle in Melton Road, Syston, the terminus of the 461 from Leicester.

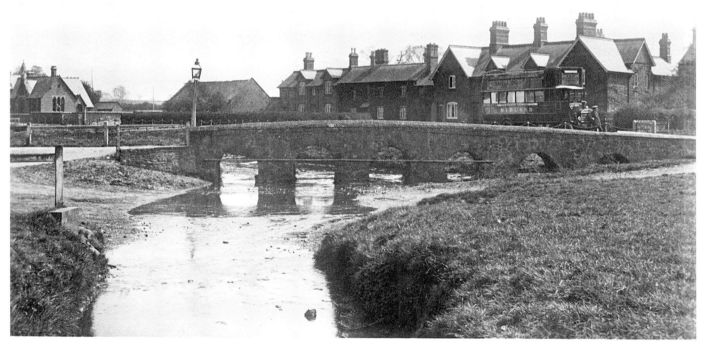

SEVEN ARCH BRIDGE, REARSBY J.T. & Co. M.M

48. Midland Red introduced the Tilling-Stevens FS class between 1922 and 1924. With bodywork by Carlyle and knifeboard seating upstairs, 76 of the type were produced. This superb postcard view of the Seven Arch Bridge in Rearsby shows A341 (HA 2254) waiting time in Brookside before the journey back to Leicester, its driver leaning nonchalantly against the radiator. Originally served by the 134A to Melton Mowbray (renumbered 462 in April 1925), Rearsby got its own route in December 1925 when the 461 was extended from Queniborough. It became the 617 in February 1928 – the year that this postcard was sent to Sheffield and HA 2254 was withdrawn from service. This scene is little changed today, although Arriva Midlands service 5A to Melton Mowbray does not call at this part of the village any more.

an illuminating piece by the then General Manager, W.G. Bond, on 'Operation Leicester':

'...developments in Leicester were not altogether plain sailing, for there were already a large number of operators in the district; and the Police (who acted as the Licensing Authority) would only permit more 'buses on a route if they thought they were needed in the public interest. Time tables for the Midland "Red" were approved to many towns and villages, such as Mountsorrel, Loughborough, Syston, Uppingham, Oadby and Blaby, but the road to Wigston Magna, known as the Welford Road, was looked on as the "plum" in those days, and this in the eyes of the Licensing Authority was already full up with 'buses.'

'The various 'Bus concerns were having a struggle for existence, and each one was trying to beat the other where they operated on the same route. A certain small operator, having come to the end of his tether and deciding that he really had nothing to sell, came to the Midland "Red" one morning and said he was prepared to give his services away to the Company rather than let his opponent on that route reap the benefit. A certain official from Bearwood arriving by train from Birmingham was met in Granby Street by the Company's Resident Inspector with the great news,[7] and together they immediately repaired to the Chief Constable's Office in the hope of obtaining the licences of the defunct operator. The Chief Constable was out, and could not be seen until late in the day; however, about 7 o'clock in the evening a meeting with the Chief Constable was obtained, when the remaining operator on the route was also present, and after a somewhat tough argument the Midland "Red" were granted the majority of the running times that had become vacant, the other operator not having sufficient vehicles to be able to undertake the additional services. The last train for Birmingham had left an hour earlier so the official from Bearwood had to find a bed for the night; and being roused by the Hall Porter in the early hours of the next morning, he caught the first train back to Birmingham, arriving home in time for breakfast, unshaven and looking like an escaped convict. Still, the dearest wish of the Midland "Red" in Leicester had been accomplished, for they had obtained a footing on the Welford Road.'

At this point we should also look briefly at Raymond Tuft, whose career between 1913 and 1924 had been with Walsall Corporation Tramways and South Staffordshire Tramways, but who moved to Midland Red and in 1928 was posted to Leicester. Within two years, he was made Divisional Traffic Superintendent, remaining in Leicester until his retirement in 1963. His memoirs were published over 11 issues of the *Midland Red Staff Bulletin* in 1956/57, and they paint a vivid picture of life in the unregulated environment of the 1920s. This is his description of two occasions when relations with the 'opposition' were particularly fraught, taken from issue 123 (December 1956).

'...a driver of another operator from Newarke Street had laid a charge of assault against Inspector Bentley, who was alleged to have endangered his life. The Inspector told me it was quite accidental. He had sent one of our buses off and backed away to the wall, to await our next turn. He leaned against the wall and did not know that anything was wrong until he heard some gurgling noise at his rear. After some time he heard it again, and, heaving himself off the wall, he found he had been leaning on an opposition driver and his arm had actually been across the man's windpipe. As the Inspector weighed 22 stone the driver was powerless and had to be revived. The Inspector said he was "amazed" when he found the driver there–so were the Police when I put it over to them. It was "Talk yourself out of that one"!

'The same Inspector, one day in Jubilee Road, got hold of a small opposition bus full of people and literally shook the body from side to side–because the driver had annoyed him!'

Council opposition

Raymond Tuft was quoted as saying there were '399 opposition vehicles plying for hire on the routes we were operating, and these were owned by 95 proprietors'. There is no doubt that this sustained level of competition did not go unnoticed at Head Office; Midland Red was not making any profit in the Leicester area at the end of the 1928/29 financial year, and proposals to either sell off the area or create a new company were being actively considered. In addition, the Corporation had, in 1924, at last taken the plunge and begun to

operate motor buses; they were running on seven routes by October 1929, and the Council had become much more aware of potential threats to their transport business.

Working in conjunction with the police, the Watch (Traffic) Sub-Committee carried out surveys which eventually led to a much-needed reduction in the number of terminal points in the city centre. In addition, all operators with services inside the city boundary were obliged to sign a 'Form of Undertaking', which told them precisely the conditions that had to be honoured in order to ply for trade in Leicester. These were extremely stringent, and Midland Red managers were unhappy at what was being asked but had no option but to sign if they wanted to continue in business. For example – 'the driver must be in his cab before the bus is due away and the engine must be running'. A 10.00 departure meant exactly that; operators could be fined for running as little as 30 seconds late, and a bus that was not ready to depart at the appointed time had to be taken out of service and go out 'private'.

Issues over the 'Form of Undertaking' surfaced in 1929, when the Town Clerk's reply to a missive from the Chief Constable concerning Midland Red was read to the Watch (Traffic) Sub-Committee on 29 April. Unfortunately, the original letter was not minuted:

'FORM OF UNDERTAKING – INTERNAL PASSENGERS

'In reply to your letter of the 5th instant I am of the opinion that the Company are in fact contravening their undertaking in picking up and setting down passengers within the City. I cannot agree with their contention that the fact that they charge larger fares than those charged by the Corporation entitles them to break such undertaking. It must however be borne in mind that a refusal to renew the licences of the Midland Red must be on grounds that will appeal to the Minister of Transport, the chief of which is congestion of traffic.'

Hang on a minute! The undertaking the Corporation had sought and received back in 1921 stipulated that

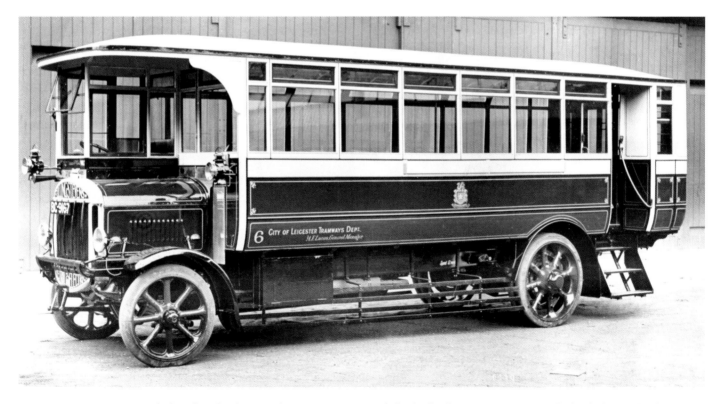

49. Leicester Corporation's first batch of motor buses were six Brush-bodied Tilling Stevens TS6s, of which this is the final one, 6 (BC 9167), showing off the immaculate finish of these vehicles when new. They saw service from day one on the initial bus route to Evington Lane and St Philip's Church, and went on to give 3-4 years service in this form before all were converted to double deck vehicles in 1927/28. In which guise they soldiered on until 1934.

picking up and setting down in the city was admissible 'subject to a minimum charge in the city inwards and outwards of at least twice the maximum tram fare on the tram route over which the company travel'. Surely a breath-taking example of the Committee wanting its cake and eating it? But the matter was raised again on 18 May, when the Town Clerk advised that the only way to deal with the matter was to refuse to licence the omnibuses, leaving the company to appeal to the Ministry of Transport. In the end, this was not an option that the Committee decided to pursue, though it was not just the size and the perceived behaviour of Midland Red that the municipality was finding off-putting at this time, but also the type of partners they were in the process of acquiring. The Railway (Road Transport) Act, passed in August 1928, addressed the issues of competition between the railway and bus industries and, so far as Midland Red was concerned, it led to an agreement between the company and the London Midland & Scottish (LMS) and Great Western Railway (GWR) companies that defined Midland Red's operating area,[8] and allowed the railway companies to take shares in Midland Red, although not to the extent that they would participate in the running of the company. On 1 January 1930, the 400,000 ordinary shares that were held by the Birmingham & District Investment Trust passed to the railways; 240,000 to the LMS; the remainder to the GWR.

As Midland Red became more powerful, management believed that Leicester Corporation was not operating a level playing field, thus making life unnecessarily difficult for it. It is clear that smaller independents thought the same about both Midland Red and the Corporation. So working relations in every direction became ever more strained. Leicester Council was not alone – many other municipalities shared its views. The prospect of railway company involvement inevitably made them still more protective of their areas, so although it had been arranged some time before, it was a happy coincidence for them that a transport conference was to be held in Yarmouth in September 1929, where all their grievances could be aired. Alderman George Banton was Leicester's man at the meeting and his views on the proceedings left no-one in any doubt that the large independents were having the fight taken to them. This is part of the *Leicester Mercury* article that appeared on 16 September:

'WIDER 'BUS POWERS
LEICESTER WANTS TO RUN INTO SUBURBS
'...Salford, Alderman Banton pointed out, have powers to run within a radius of seven miles, but Leicester would want to take powers over a wider field than that owing to its geographical position.

'Alderman Benton was one of the delegates to the Transport Conference at Yarmouth, which threatened to seek powers for municipalities as a whole to run 'buses outside their areas.

'If such powers were conferred, said the alderman, Nottingham and Leicester services might have an arrangement for inter-running, and the same kind of plan could be worked with other large cities around.

'They certainly appeared to have the impression at the conference that the present Government would be prepared favourably to consider their demand, because Mr. Herbert Morrison...urged them to take some action.'

Labour under Ramsay Macdonald had won the 1929 General Election, though it did not have enough seats to form a majority and the Liberals, led by David Lloyd George, held the balance of power. Minister of Transport Herbert Morrison had been a member of the London County Council since 1922 and would, in four years' time, found the London Passenger Transport Board. One can imagine that Alderman Banton, chairman of the Tramways and Omnibus Committee (and also having seats on the Electricity, Highways & Sewerage and Watch Committees) and himself a socialist, would be highly motivated by what he saw and heard, and therefore it is no surprise that he actively sought as much publicity as possible for his ideas, with the reports suggesting that he was continually developing them. This is the *Leicester Mercury* on 7 October 1929:

'INTER-COUNTY CORPORATION 'BUS SERVICE PLAN
MEETING THE COMBINES
LEICESTER COUNCIL TO APPLY FOR GREATER RUNNING POWERS
MONOPOLY FEARS
'...application (is to be made) to Parliament to run Corporation 'buses outside the City boundaries and possibly into adjoining counties.

The reason for this is that the Corporation wishes to be in a position to meet attacks from any big private 'bus monopoly.

'…services will not only be arranged between Leicester and the more important industrial centres in the county, but into adjoining counties, and perhaps to the seaside.

'The possibility of Leicester being linked up with Nottingham, Derby, Birmingham, Coventry and Northampton by Corporation 'buses is being discussed, and the hope expressed that other Corporations in the Midlands will also apply to Parliament for additional powers, which amongst other things, will allow them to run 'buses into Leicester.

'Alderman Banton explained that those in close touch with the activities of passenger transport undertakings in different parts of the country have recognised that developments of a far-reaching character had been taking place for some time.

In the opinion of those best qualified to judge the arrival of the day when there will be comparatively few companies having control of the 'bus services is not so far off as many appear to imagine.

'Leicester, in the past, has been served by a large number of 'bus owners, who, having regard to the system by which licences are granted, have established what, in effect, are small monopolies.

'Alderman Banton thinks, however, that it will not be long before larger companies succeeded in gaining control of the 'bus routes by buying out the owners who have two or three vehicles only.

'Recent legislation, which gave railway companies powers to set up 'bus services also suggests, he maintains, that in a few years, there may be a big 'bus monopoly, privately controlled, operating throughout the country.

'To be in a position to meet possible attacks from a big monopoly is one of the reasons why the Leicester Committee is recommending the Council to get Parliamentary sanction to run 'buses into adjoining counties.

'Alderman Banton also stated that the idea of running Corporation 'buses outside the city was not new. A short time before the outbreak of war an agreement was reached between the City Council and the County Council for services between Leicester and Thurmaston and also Oadby.

'The 'buses were on the point of being delivered for the new routes when the war broke out, and the government commandeered the vehicles, and the proposals fell through. At the time it was agreed to pay the County Council so much per 'bus mile for running over county roads.

'"There will be no arrangement of that sort in future", he added. "'Buses have come to stay and if we run over county roads we shall be subject only to the regulations of the licensing authorities."

'Alderman Banton said the first route to be developed, providing Parliamentary sanction is obtained, will be to the Corporation estates outside the city boundaries, particularly Braunstone.'

By turns patronising, when he refers to those he considers qualified to judge, and disingenuous, where he makes a virtue of not paying for running on county roads, quite ignoring the fact that the 1920 legislation on upkeep of roads freed all bus operators from those charges, Alderman Banton was not going to win many popularity contests outside the Council chambers. But secure in his convictions, on 17 October the *Leicester Mercury* reported that the Tramways and Omnibus Committee had decided to recommend that the City Council should apply for Parliamentary powers to run buses outside the city boundary, and the 30 October edition confirmed the Council's decision to do just that. Alderman Banton told the paper that 'as regards powers to run outside the city, thousands of people from the outskirts came into Leicester daily by bus. Amalgamations between railways and 'bus services were taking place, and the Leicester Tramway Committee wanted to be in a position to co-ordinate with outside services'.

Judging by the responses in the letters pages of the *Leicester Mercury*, Alderman Banton was not capturing the hearts and minds of the people in his quest. After the first report on 7 October, SERVICE FIRST stepped straight into the fray the following day:

'Sir,–Would it not be more useful if Alderman Banton evolved an efficient 'bus service within the city boundaries instead of attempting to compete with those already giving one (at a cheaper rate) outside?

'To quote one instance alone, it is far better to reside the other side of Red Hill than within sight of the Clock Tower or the Abbey-lane. There they have a

'bus service every few minutes, whereas the "dog in the manger" attitude of the Tramways Committee deprives the Abbey-lane of a solitary privately owned bus.'

The writer was, it seems, an Abbey Lane resident, and this obviously was a significant issue as subsequent correspondents continued to refer to it. But putting the view of the 'county' – a word over-employed in the course of this diatribe – ANTI-MUNICONTROL weighed in on 9 October.

'Sir,–It must be most interesting to your county readers to learn of the City Council's scheme to apply for powers to extend the 'bus services into the county. We county people have been well served by the private companies in spite of the actions from time to time by the City Council to impede the progress of these private concerns. The Council has on more than one occasion held a red rag before the county people, with restrictions on the county's bus services. Applications by the private 'bus companies to make extensions to their services have been turned down by the city authorities. The 'buses have been removed to places in the city that have caused much inconvenience to the passengers.

'After all this high-handed policy has been meted out to the 'bus owners, resulting in unnecessary inconvenience to the county people, the City Council desires to "cater" for the county people. Impudence, I call it, and I sincerely trust that all self-respecting county people, along with their representatives on the County Council, and in Parliament, will resist this scheme to the fullest extent.

'The private 'bus owners have played the straight game with us, we must reciprocate. We county people have cheaper fares, more efficient services, civility, and a minimum of red tape under these so-called private monopolies. What would be the result under a municipal monopoly, with its old-fashioned principles of securing soft jobs for next of kins?

'We must now wait for the day when Alderman Banton and his colleagues make their attack on our liberties.'

It is interesting that both the city and county residents whose opinions were aired in the *Leicester Mercury* were equally of the view that the trams and buses operated by the Corporation were less efficient than those that came in from outside. Equally, in all the talk about the 'private bus companies', Midland Red is not mentioned by name, leading to the conclusion that maybe it was the small operators from the villages who had the lower overheads and thus the edge where customer loyalty was concerned. But the debate continued, and on 16 October, two letters were published that reached markedly different conclusions. First of all, S.G.W., another avid supporter of the current set-up in the county:

'Sir,–I am very glad to see the opposition taken up against the City Council's proposed scheme for powers to extend the 'bus service into the county. I hope that every means possible will be taken by the county to oppose it.

'The private 'bus companies are looking after our requirements, better than any City Council can ever hope to attempt, despite all the opposition and inconveniences the Council have subjected us to in the past.

'Let them put the City services in order first, and they will have enough to do there. They did their best to ruin some of the private owners, who were pioneers of the county 'bus services. I may add the county's thanks are due to the "Mercury" for the prominence they have always given to this question.'

But W GREEN of Haddenham Road was the first to venture the thought that change was inevitable, and that the Council was right to want to move into the suburbs. His piece, immaculately argued, appeared immediately below S.G.W.'s letter:

'Sir,–In the discussion on the municipal control of licensed passenger transport, we as citizens ought to attempt to see the matter in its true perspective.

'Control has become essential to allow citizens to move about with a reasonable degree of safety. The traffic on the roads make them almost impassable at times, and a further multiplicity of small 'buses in competition with each other would mean chaos.

'To my mind, the municipal authorities have done the right thing; they have sought to provide facilities for essential transport, and eliminated as far as possible unnecessary competition. No doubt, as the traffic problem becomes more intense, the limitation of competition will have to be extended to the suburbs.

'Whether the Municipality should extend its facilities for transport beyond the city boundaries is

another question. There is no doubt that finally the city-owned vehicles would provide a better service, and better labour conditions than any private company. Our sympathy for the little one-man 'bus owner should not allow us to blind ourselves to the fact that he is doomed, anyway. The big privately owned companies are effectively crushing him, and during the process the fares charged are not comparative.

'When the little man is eliminated, which will not be long, the residents of Greater Leicester will be entirely at the mercy of huge private companies and combines over whose affairs they will have no control; unless they are wise enough now to encourage the extension of the municipally-owned vehicles into these districts which will ultimately become the city, to serve the interests of suburban residents who actually now earn their living in the city, and who are, to all interests, except that of residence, even now Leicester's citizens.'

When on 17 October, the *Leicester Mercury* reported that Alderman Banton's committee were definitely going to recommend that the Council apply for the running powers in question, the tone of correspondents' letters changed; suddenly it was a political issue, and the 'S'-word began to be bandied about. These three letters were all published the next day; in the interests of balance, searches for more correspondents in sympathy with Alderman Banton's position were made, but proved fruitless:

'MUNICIPAL TRANSPORT MONOPOLY
'Sir,–Why does Alderman Banton pretend to discover the bogey of 'bus monopolies when he advocates extending the 'bus service into the county districts?

'As a Socialist he is committed to a policy of public control of everything and everybody, and has been waiting 30 or 40 years for favourable opportunities, so why this pretence?

'The excuse at one time was the curse of competition. Apparently the benefits of that "curse" have become so obvious to an enlightened public that another excuse has to be found. Now it is the "lack of competition" that we must fear.

'As a 'bus and car rider, I would like to see the private bus companies running on city routes. They would show Alderman Banton how to relieve crowds standing in the rain and how to save their halfpence

too. Let us as ratepayers as well as 'bus users, support…. PRIVATE ENTERPRISE.'

'Sir,–It is most astounding to find so many of your readers objecting to Socialism as applied to tramway methods. Socialism wipes out the private trader and fair competition, and in its place gives us monopoly and tyranny with our many officials as clients. The cost of the officials, inspectors, etc., increase the overhead charges so that they cannot compete with the private trader, hence the by-laws prohibiting competition. If we continue to vote for Socialists we shall never have freedom and lack of competition means high prices. DIVIDENDS'

'Sir,–It seems to me that Mr. Banton and his colleagues, whilst professing to be Socialist and labouring for the common benefit, have lost sight of their ideals, and have embraced some of the worst features of monopoly.

'Why again, should all non-Municipal 'buses be compelled to charge 4d from London-road terminus to the city? And why are passengers by 'bus from Coalville, and further out, put down at Sanvey-gate if not with the very obvious idea of forcing them to take an additional 1½d ticket to their proper connection?

'Hundreds of other stupidities could be quoted, and the writer, with hundreds of others, want to know why?

'If this means municipalisation and nationalisation, I view with dismay any extension of it in the county. H.R.C.'

And when the full Council adopted the Tramways and Omnibus Committee's recommendation, the protests were ratcheted up several notches by this intervention, printed in the *Leicester Mercury* on 31 October (it actually appeared as an article, but appears to have been only lightly edited from the original letter).

''BUS OWNERS FEAR OF MONOPOLY
VIGOROUS PROTEST AGAINST CORPORATION'S PROPOSALS
THE COUNTY SERVICES
'Mr C.B. Jenkins, managing director of the Leicestershire 'Bus Federation Ltd, in a letter to the Editor of the "Leicester Mercury", written in

reply to Alderman Banton's proposals to apply for Parliamentary powers to run outside Leicester.

'The inference one draws from Alderman Banton's remarks at Tuesday's City Council meeting, is that the competitive element is to be wiped out of existence, and 'naturally so', at the expense of a shared monopoly between the Corporation (who have not made 'buses pay) and railway-owned 'buses.'

'If Alderman Banton means to suggest that "there is quite a business in Leicester of starting 'buses with the object of selling out", his suggestion is either:

1) The result of bad information; or

2) An attempt to whitewash officially enforced sales and the ultimate smashing of the competitive private owner; or

3) He is guessing badly.

'He is aware of the difficulty that exists for a private owner to obtain a Leicester licence owing to the number that are required by the comparative new comes [sic].

'The county public have reason to be well satisfied with the excellent 'buses provided by the private owners, and with the splendid service and low rates prevailing owing to competition. I am confident they will retain all this.

'Furthermore, the county people should have greater facilities afforded them for coming into and going out of Leicester on private omnibuses. They come in to work and to spend their money, and their private 'bus owners should not be hindered and refused licences, as they are.

'The Leicester public must watch its best interests more closely than ever. Only in the small private trader is there hope of competitive prices.

'Mr Jenkins informed the "Mercury" to-day that a petition is being prepared protesting against 'the present restrictive measures that are operating to reduce the privately-owned omnibus traffic in Leicester.'

'Already, he said, he had received encouraging support from Earl Castle Stewart, M.P., Mr Lindsay Everard, M.P., and Captain Waterhouse, M.P.'

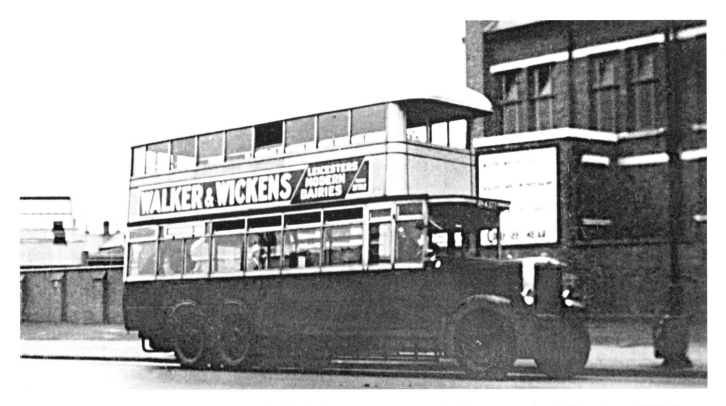

50. Leicester Corporation received 23 Guy CX double-deckers over a two year period from September 1927 to August 1929. First to arrive was 19 (RY 4377), photographed in or around 1933 on the Norwood Road service; the location is believed to be Charles Street. 19 was renumbered 219 in 1937, and withdrawn in 1939, passing to Buckmaster, Leighton Buzzard in 1941.

Meanwhile, demand was continuing to rise month on month and year on year as more new estates were completed, and more outlying villages were becoming served by more and more buses (all of which, as has been said, was providing the Council with a headache in providing suitable terminal points). During October 1929 alone, there were several reports of prosecutions for bus overcrowding, including one case at Ellistown which, on the face of things, should never have been brought, where 16 passengers were being carried instead of the permitted 14. It seems that neither Leicester City nor Midland Red vehicles were involved, so presumably the guilty parties were the small independents,[9] and whilst it would not be right to condone illegal activity, however minor it may appear, it is understandable that in the prevailing circumstances, they would endeavour to retain their market share by whatever means they could.

Road Traffic Act 1930

It is clear from the Yarmouth conference that the government (in the shape of transport minister Herbert Morrison) was determined to do something to rationalise the bus industry. As it turned out, however, Morrison's solution came in a somewhat different form to that which the municipalities were expecting, and with a much wider remit than public transport alone. Ministers were well aware that there had been no major legislation to govern road traffic since the Motor Car Act of 1903. The situation was becoming intolerably dangerous; figures for 1926, the first year in which they had been kept, revealed that there had been 124,000 accidents on the roads, giving rise to 4,886 fatalities,[10] and in 1929, following the report of a Royal Commission on transport, discussions began to frame a new Road Traffic Bill. The draft made its way through the various readings and committee stages during the latter months of 1929 and into 1930, and finally passed into law on 1 August 1930.

This was a far-sighted and far-reaching piece of legislation which needs to be examined in some depth in order to demonstrate its impact on the issues that existed between the Corporation and, principally, Midland Red. Some of it will seem commonplace to us over 80 years later, although at the time, certain parts – such as the section on speed limits – were highly controversial.

It is worth remembering that it was this Act which introduced:

- age restrictions in relation to obtaining a licence (16 for motor cycles, 17 for cars)
- the abolition of all speed limits for cars
- the offences of dangerous, reckless and careless driving, and driving whilst being unfit and under the influence of drink or drugs
- compulsory third-party insurance
- UK driving tests (initially for disabled drivers only)
- the classification of motor vehicles and provisions regarding construction, weight and equipment
- the first Highway Code

Sections 61-110 of the Act related specifically to the regulation of public service vehicles. They began with a series of definitions that drew for the first time distinctions between the two different types of service that had developed:

'Stage carriages; that is to say motor vehicles carrying passengers for hire or reward at separate fares (any or all of which are less than one shilling for a single journey or such greater sum as may be prescribed), stage by stage, and stopping to pick up or set down passengers along the line of route, and any other motor vehicles carrying passengers for hire or reward at separate fares and not being express carriages as hereinafter defined:

'Express carriages; that is to say motor vehicles carrying passengers for hire or reward at separate fares (none of which is less than one shilling for a single journey or such greater sum as may be prescribed) and for a journey or journeys from one or more points specified in advance to one or more common destinations so specified, and not stopping to take up or set down passengers other than those paying the appropriate fares for the journey or journeys in question.'

Bodies of Area Traffic Commissioners were to be set up, eleven in England and Wales and two in Scotland. Leicester was incorporated into the East Midlands area. It would be their principal task to issue licences, because

instead of the free-for-all that had existed until now, Section 67 made it quite clear as to what should happen henceforth:

'No person shall cause or permit a motor vehicle to be used on any road as a stage carriage an express carriage or a contract carriage unless he is the holder of a … public service vehicle licence to use it as a vehicle of that class…

'A public service vehicle licence may be refused or, if it has already been granted, may at any time be suspended or revoked by the commissioners by whom it was granted if, having regard to the conduct of the applicant or holder of the licence or to the manner in which the vehicle is being used, it appears to them that he is not a fit person to hold such a licence.

'If any person causes or permits a vehicle to be used in contravention of this section, he shall be guilty of an offence.'

The powers that were being conferred upon the Commissioners left little room for doubt that it was they, and not the municipalities, the independents, large or small, or the railway companies, who would in future be calling the shots. Section 72, which was divided into no less than 11 sub-paragraphs, set out in great detail the rules that were to apply as regards the granting of road service licences, as they were to be known. The main points were:

- any person granted a licence by the Commissioners will provide the service specified by the licence, and a vehicle shall not be used as a stage carriage or an express carriage except under such a licence, and must be used by the holder of the licence
- every person applying for a licence is to submit to the Commissioners details of the type(s) of vehicle to be used; for regular services, the time-tables and fare-tables of the proposed services, and in all other cases, such details of the frequency and times to be taken on the journeys included in those services as the Commissioners may require
- the Commissioners shall not grant a road service licence in respect of any route if it appears to them that the provisions relating to the speed of motor vehicles are likely to be contravened,

and in exercising their discretion to grant or to refuse a road service licence in respect of any routes and their discretion to attach conditions to any such licence, they will have regard to

 (a) the suitability of the routes on which a service may be provided

 (b) the extent, if any, to which the routes are already adequately served[11]

 (c) the extent to which the route is necessary or desirable in the public interest, and

 (d) the needs of the area as a whole in relation to traffic (including the provision of adequate, suitable and efficient services, the elimination of unnecessary services and the provision of unremunerative services), and the co-ordination of all forms of passenger transport, including transport by rail

The Commissioners will take into account any representations which may be made by persons who are already providing transport facilities along or near to the routes or any part of the routes, or by the local authority in whose area any of the routes or any part of any of the routes is situated.

- the Commissioners may attach conditions as they may think fit, and in particular to ensure that:

 (a) fares are not unreasonable

 (b) where desirable in the public interest the fares shall be so fixed as to prevent wasteful competition with alternative forms of transport

 (c) copies of the time-table and fare-table shall be carried and available for inspection in the vehicles used on the service;

 (d) passengers shall not be taken up or set down except at or between specified points, for the safety and convenience of the public

- if representations are made by parties affected by the granting of a licence that it is in the public interest that minimum or maximum fares should be fixed the Commissioners may fix such fares and make it a condition of the licence that

fares shall not be charged under or in excess of the minimum or maximum

- when granting a licence, the Commissioners will notify every chief officer of police and every local authority in whose district or area any such service is to be provided.

Several other key areas were placed under the Commissioners' jurisdiction, of which as regards this history the most important are:

- certificates of fitness in respect of the vehicles to be used (Section 68)
- licences granted by the Commissioners of one traffic area will not be valid in any other traffic area through which the route runs. But such a licence may be backed by the Commissioners of another traffic area, and if so backed, shall have effect as if it were a road service licence granted by them (Section 73)[12]
- road service licences may be suspended or revoked for non-compliance (Section 74)
- the licensing of drivers (aged 21 or over) and conductors (aged 18 or over). Drivers could be limited to a specific type or types of vehicles, and licences could be revoked by reason of conduct or physical disability (Section 77)
- various provisions relating to the conduct of passengers, as well as drivers and conductors (Sections 84 & 85)
- provisions allowing local authorities to make orders as to highways which may or may not be used by public service vehicles, fixing stands for said vehicles, and determining places where they may stop for a longer time than is necessary for the taking up and setting down of passengers, and the manner of using such stands and places (Section 90)

Finally, Sections 101-10 dealt with the running of public service vehicles by local authorities. In spite of losing the responsibility for the issue of licences, one might imagine that Alderman Banton and his colleagues derived some comfort from the broad thrust of this part of the legislation. To summarise the main provisions:

- any local authority already running buses, trams, trolleybuses, or a light railway may run

public service vehicles on any road within their district (though not on railway premises without prior consent) (Section 101)

- a local authority applying to the Traffic Commissioners must publish a notice specifying the route the service will take, and the manner and time in which any objections are to be made to the Commissioners by any other local authority, council of any county or any persons who are already providing transport facilities on, or in the neighourhood of, any part of the route to which the application relates. The Commissioners will hold a public enquiry and may grant, refuse, or grant with modifications, the application (Section 102)
- local authorities may purchase and maintain their vehicles, including the leasing of land for maintenance and repair (Section 103)
- local authorities may make agreements with neighbouring counterparts, and with anyone else, for the management, working and maintenance of any service (Section 105)
- local authorities may meet expenses out of the general rate fund of their district, and may, with the consent of the Minister, borrow any such sums as may be required (Section 107)

Therefore, so far as Leicester was concerned, the Tramways and Omnibus Committees could operate their trams and buses in exactly the same manner as before, and Section 105 allowed them to enter into joint working agreements with other local authorities, just as they had hoped and planned. But any new route they wished to develop could be challenged, and if the Commissioners decided that the route was already sufficiently well covered, refusal of the application would follow.

The city boundaries were the biggest problem the Committee faced, because many new estates were springing up outside them (as they existed in 1931[13]), and Midland Red were taking advantage of this. Joint operation – Section 105 again – would be one solution, but it is fairly clear that this was not something that the Tramways Committee, and thus the Corporation, seems willing to have contemplated at this time. On the face of things, Midland Red had the best of the new legislation, as it could apply for licences on all the routes developed

in the 1920s to all corners of the county and beyond, and if successful, would no longer face the same levels of competition on its routes; consolidation would now very much be the order of the day. Of the 95 competitors that Raymond Tuft spoke of in 1928, virtually all had either been taken over, had voluntarily ceased or had entered into joint working arrangements by the end of the 1930s; Appendix 3 shows that while Midland Red is known to have acquired nine competitors' businesses during the 1920s, the figure for the whole of the 1930s was no less than 51.

It is worth mentioning at this point that bus services were not the only source of income that Midland Red and many of the independent operators – though not Leicester Corporation – were intent upon pursuing. It will be recalled that one of the first eight vehicles allocated to Midland Red's first garage at Frog Island was a charabanc. The term – derived from the French for 'wagons with benches' – was widely used for touring vehicles from around the end of World War 1 to the end of the 1920s; for example, Midland Red's first purpose-built coach, the XL, appeared in 1929. Available for works outings, day trips and longer coach tours, particularly to the seaside, they were immediately successful; the cheaper cost of the coach as opposed to the train, and the demand created during the industrial holiday fortnight at the beginning of July were significant contributory factors and laid the foundations in most cases

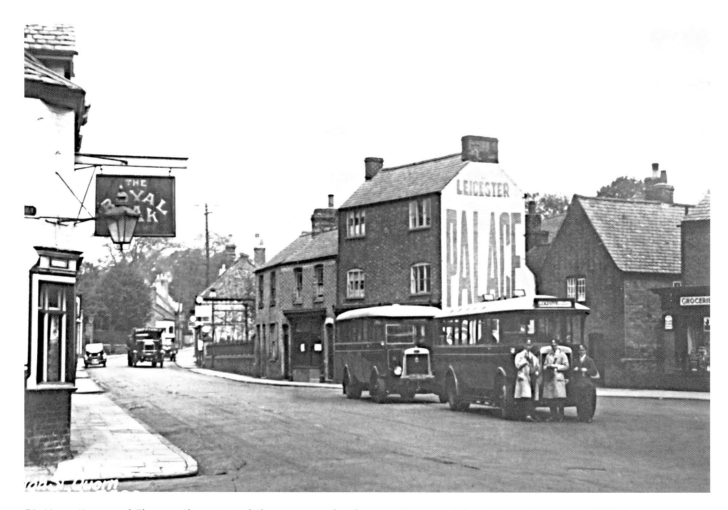

51. Harry Kemp and Thomas Shaw started the company that became Kemp and Shaw Motor Services in 1922 from premises in Loughborough Road, Leicester and by 1927 were operating services to Loughborough, Derby and Nottingham. In 1928, Kemp having left the business, Shaw and Charles Allen became the directors of Kemp & Shaw Ltd; Allen was already proprietor of a bus company based on the Loughborough road at Mountsorrel, and one can imagine that this new arrangement suited him well. In fact Kemp & Shaw 14 (UT 37) had been acquired by Allen in 1927; a Leyland PLS1 with Leyland bodywork, it moved to Kemp & Shaw in 1930 and stayed for nine years. In this splendid period photo, 14 and 11 (UT 1946), another ex Allen saloon, stand at Quorn Cross.

52. Sometimes passenger numbers called for more than one vehicle, and here the Midland Red Sports Club, for whom the fun already seems to have started, needed at least two for its outing. The lead vehicle is A742 (HA 3691), a 1927 SOS Q with Brush 37 seat bodywork. Close behind is A819 (HA 4835), a 1928 SOS QLC charabanc with a 29 seat body by Short. The photo is believed to have been taken in the Nuneaton area in the early 1930s. A742 was withdrawn in 1936; A819 had been sold to Northern the previous year.

for an important adjunct to many local businesses up to the 1970s.

But back to the 1930 Act, and even before the legislation was on the statute books, Midland Red was pushing for more work, and Braunstone was to become the first battleground. The Corporation began a service to Coalpit Lane – later renamed Braunstone Lane East – in January 1928 which clearly incurred the wrath of Midland Red as it constituted an incursion into their territory. The Tramway Committee minutes of 15 January 1930 record that the Town Clerk:

'received a communication from Messrs Sidney Moss & Co, solicitors, acting for the BMMO Co Ltd, stating that they are prepared to take the necessary steps to obtain an injunction without further notice unless the Corporation are prepared to give an undertaking that

the service of omnibuses outside the city boundary along Coalpit Lane to the Braunstone Estate will be immediately withdrawn and not recommenced.'

After discussion, it was carried that 'the running of omnibuses outside the city boundary to the Braunstone Estate be discontinued'. But on 11 March 1930, they were considering a further application from Midland Red for permission to operate an hourly service between Leicester and Braunstone via Narborough Road and via Hinckley Road (circular route) which had been submitted to the Watch (Traffic) Sub-Committee. The General Manager bluntly said there was no need for it. 'Narborough Road and Western Park cars and Coalpit Lane buses adequately deal with passengers to the city boundary. If granted, limit it to Western Park to Coalpit Lane'. He would in those circumstances be prepared to

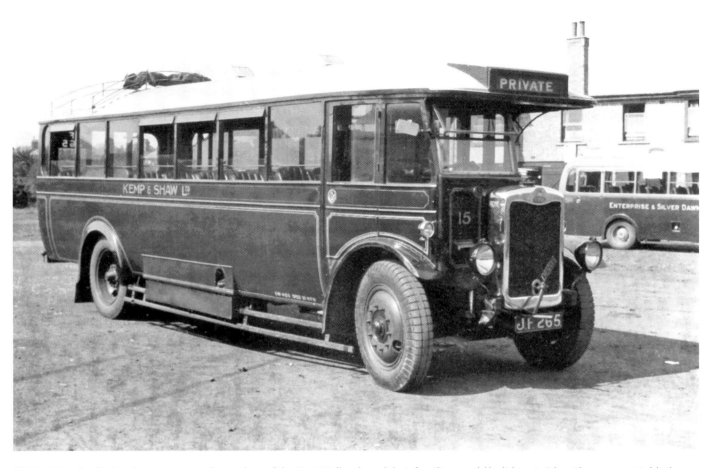

53. Tradition had it that for many years the workers of the East Midlands and their families would holiday at either Skegness or Mablethorpe during the first two weeks of July, and here Kemp & Shaw 15 (JF 265), a Dennis EV with a dual-purpose 32 seat Willowbrook body new in June 1930 which would have been heavily involved in providing transport to the holidaymakers, is seen in the coach park at Skegness.

co-ordinate with Midland Red with regard to transfer tickets.

The communication of these views to O.C. Power brought a response in the form of a letter from him to the Chief Constable dated 29 March 1930, which was not brought before the Committee until 13 May.

'BRAUNSTONE SERVICE
'Further to my letter of the 26th instant with reference to the above, I am quite prepared to enter into some arrangement of co-ordination with the City Tramways department in the way of issue of transfer tickets, as suggested in your letter to me of the 25th instant.

'I feel, however, that this arrangement would not be entirely satisfactory as passengers always dislike having to change vehicles, and the run between the Western Park Tram terminus and the Coalpit Lane omnibus terminus is really too short to be operated economically.

'I would suggest, therefore, alternatively that your Council should enter into a similar arrangement with us regarding this Braunstone Estate route that we have with the Worcester City Council in connection with all their City Services. Under this arrangement we should operate the service from some suitable central point in Leicester and pay your Council the net profits earned on the service (after deducting working expenses and a sum for interest and depreciation) in the ratio which the route mileage in the city bears to the total route mileage.

'I would, in fact, recommend my Directors to enter into such an arrangement with your Council on the other routes as well, for the purpose of serving any

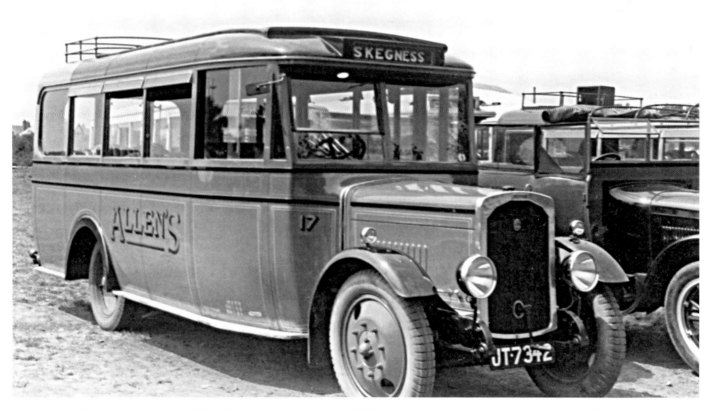

54. Allen's of Mountsorrel also participated in the holiday trade and this is their 17 (UT 7342), seen at Lawn Park, Skegness in the 1930s. It was a Dennis Dart – a name to be more stylishly revived in the 1980s – with a Willowbrook 20-seat body that carried more of the look of an old-fashioned charabanc than its Kemp & Shaw counterpart.

other Leicester City Housing Estates a short way outside the City boundary, and I think that they would be quite willing to agree.

'If your Watch (Traffic) Sub-Committee would like me to attend their next meeting and discuss the matter with them, I should be very pleased to do so.'

The General Manager, Mr H. Pool, was tasked with obtaining details of the Worcester agreement[14] and on 22 July, the Committee decided it was 'not prepared to enter into the suggested agreement – it is left in the hands of the Chairman, Vice-Chairman and General Manager with authority to inform the Birmingham & Midland Motor Omnibus Co. Ltd, when they deem fit.' The reason for this is not given, but it is clear that the Corporation harboured its own ambitions to run buses in the area, and to have acceded to Midland Red requests would have only had the a longer-term effect of hemming in their own vehicles still further.

Apart from an application from Midland Red to pick up and set down on the Saffron Lane bus route – refused on the grounds that there was already an adequate Corporation bus service – there are no reports of any other issues surfacing between the two organisations for several months. But this was in fact the calm before the storm, which broke with the following report, given by the General Manager at the Tramways Committee meeting on 20 May 1931:

'… a letter has been received by the Town Clerk by the Traffic Commissioners for the East Midlands Area asking if the conditions imposed on all services, as follows, would be agreeable to the City of Leicester:

a) THAT Passengers shall not be taken up nor set down on Highways or at any other

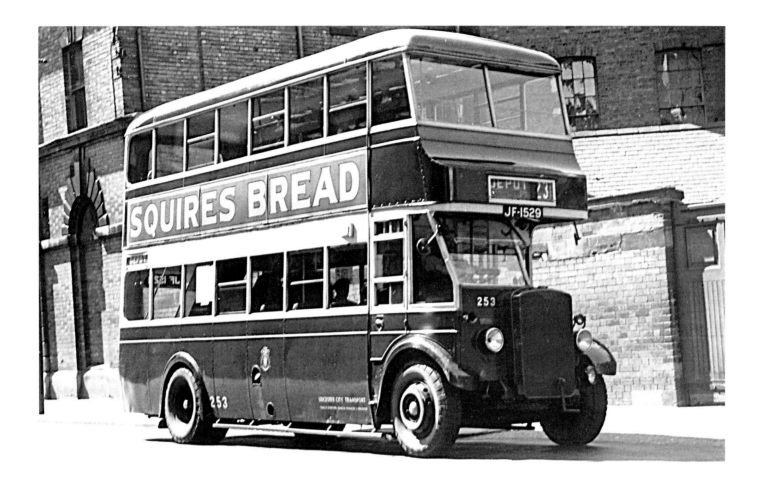

55. Leicester Corporations bus fleet continued to expand, with 37 new vehicles arriving between 1931 and 1934. The AEC Regent would be one of the mainstays of the feet for many years, but initially, only one vehicle was acquired, 53, later 253 (JF 1529), which appeared in June 1931. Experimentally for Leicester, it was fitted with a straight staircase (a feature that was not to be perpetuated) and seated only 48 passengers, despite which it had a hard working life of 17 years. In this photograph, taken on Monday 17 May 1948, a month before withdrawal, it was seen in Horsefair Street on its way back to the garage after completing a duty on the 23 Aylestone service.

public places within the City of Leicester, except at such points as may, from time to time, be specified in any Order made by the Corporation, duly confirmed by the Minister of Transport under Section 90, Road Traffic Act, 1930

b) THAT Operator shall not be allowed to pick up and set down the same passenger or passengers within the City boundary nor on any roads served by the Leicester Corporation Omnibus service nor anywhere within 440 yards of any point on any road traversed or used by a service of the Corporation

c) THAT a separate ticket shall be issued in respect of every fare paid.'

Contrary to popular belief, it would appear that this initiative sprang from the Commissioners, who had already granted similar powers to the Corporation operator in Nottingham. Unsurprisingly, the minutes record that 'the Chairman, Vice-Chairman and Management have gone carefully into the suggestions and they recommend that the suggested special conditions are suitable to the Department'. Naturally enough, Midland Red appealed. The hearing was to be held in London on 24 September 1931, and the Corporation enlisted the help of the Municipal Tramways & Transport Association (Incorporated). But there is no record of an outcome in the Tramways Committee or the full Council minutes, which are silent until 4 December, when Midland Red revealed another weapon in its armoury:

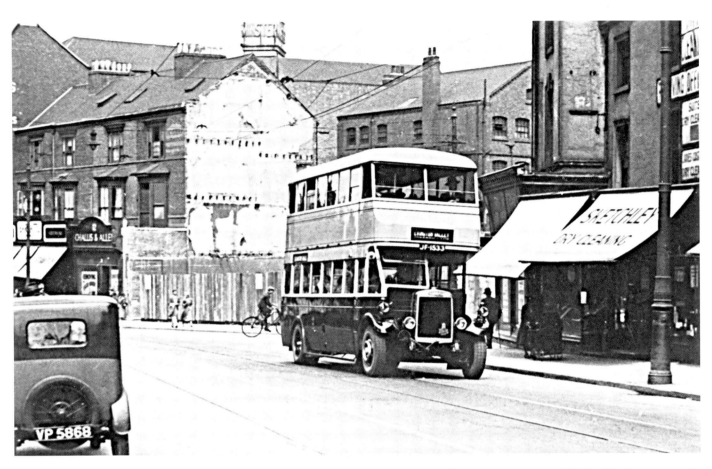

56. Leicester's association with Leyland began as early as 1911, with the purchase of tower wagon BC 1078. The first buses came in June 1931, four TD1s with Brush H26/24R bodywork, numbered 54-57. Leyland's own photographer caught 57 (JF 1533) crossing from Granby Street into London Road on its way to Evington Valley on 18 August 1931. Great change was about to take place with the re-routing of Charles Street to join London Road at this point, the new road layout coming into force in August 1932. 57 and its three sisters, by then numbered 254-57, saw service in London between October 1940 and April 1941; all were withdrawn in 1946, 255-57 joining Barton Transport. Finally in 1951, this example was sold (as so many vehicles were in those days) to the contractor Balfour Beatty for staff transport.

'APPLICATION FOR ROAD SERVICE LICENCES BY THE B & MMO CO. LTD.

'The Chairman reports that applications for 9 new road service licences have been made to the Traffic Commissioners for the East Midlands Area by the B & MMO Co. Ltd. These applications appeared in Notices & Proceedings No. 37 dated the 20th November 1931. Three of the proposed routes are confined solely within the City boundary, the six remaining proposed routes are both within and without the City boundary.

'If these road service licences were granted in their present form, the B & MMO would be able to both pick up and set down the same passenger or passengers within the City of Leicester.

'Formal objections to the granting of these licences have been lodged with the Traffic Commissioners, and also with the B & MMO. In Notices and Proceedings No. 38 dated the 27th November 1931 it is announced that these applications will be heard by the Commissioners for the East Midlands Area at the Guildhall, Nottingham, on Monday the 14th December 1931 or on one of the following days during the sitting.'

The Town Clerk explained the legal position at a subsequent meeting on 7 December and was instructed to take all requisite steps to oppose Midland Red's applications, with authority to secure such legal assistance as he deemed necessary.

A critical look at the services for which Midland Red sought licences reveals that with one notable exception, the company was endeavouring to fill gaps in the Corporation's overall service provision, as follows:

E16133	Leicester Suburban Circle Leicester (Aylestone Boat House) to Aylestone (Canal Bridge)	Service no. L6
E16134	Leicester (Aylestone Canal Bridge) to Kirby Muxloe (Station Road)	Service no. L5
E16135	Leicester (Newarke Street) to North Evington (Crown Hills Avenue)	Service no. L4
E16136	Leicester (Northampton Square) and Doncaster Road	Service no. L3
E16137	Leicester (Newarke Street) and Braunstone Village via Narborough Road	Service no. L2
E16138	Leicester (Newarke Street) and Braunstone Village via Hinckley Road	
E16300	Leicester (Newarke Street) and Aylmer Road	
E16301	Leicester (Northampton Square) and Wanlip	Service no. L9

The ninth (E16302) could perhaps best be described as a 'south east Leicester circular'[15] which bore no relation to any route proposed either before or since. It is interesting, however, to note that Northampton Square is cited as one of its termini, some months *before* it was officially brought into use as a replacement for Regent Street (see Chapter 3).

57. Midland Red continued to consolidate its position in the early 1930s, and though the Area Stop Sign ruling would restrict its growth inside Leicester's boundaries, there was considerable scope for expansion in the county. However, between 1929 and 1931 the company had operated an entirely single deck fleet, but increasing passenger numbers in the Black Country and in Leicestershire indicated a pressing need for new double deckers. A prototype appeared in 1931, followed by 50 production versions in the following two years. Known as the SOS DD, they were reclassified SOS DD (RE) (double decker rear entrance) in 1934, but were more popularly known as REDDs! A1371 (HA 8016) was seen at the terminus of the 619 in Thrussington in or around 1937; it was not withdrawn until 1950.

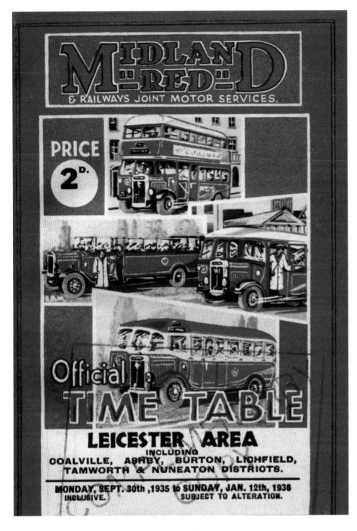

58. Midland Red timetables from this era were altogether more colourful affairs, running to 424 pages and helpfully covering a much wider area than Leicester; links with towns outside the county such as Burton-on-Trent, Lichfield, Nuneaton and Tamworth were also included. This is the edition covering the period from 30 September 1935 to 12 January 1936; it cost 2d.

The appeal meeting did not take place as planned, and that allowed the Tramways Committee to continue making its plans for the introduction of the 440 yards protection. They met on 1 January 1932:[16]

'OMNIBUS SIGNS – 440 YARDS
'The General manager reports that a letter has been received from the Traffic Commissioners for the East Midlands Area asking if the Leicester Corporation would be prepared to fix signs at a distance of 440 yards from the various termini, indicating the last picking up places by other operators in the Leicester area. This has already been agreed by the Nottingham Corporation and Bridgford Urban District Council.

'The question has been carefully considered by the Chairman, Vice-Chairman and Management, and they recommend adoption.

'The signs would be double-sided, and it is suggested that the letters be white on a dark blue background. They would be fixed on tubular poles 2in in diameter, and the position suggested is 14in from the kerb. They would be fixed on the side of the road traversed by the incoming traffic.

'Resolved – the matter be left in the hands of the Chairman, Vice-Chairman and General Manager with authority to order the necessary signs.'

On 20 January, he reported that 12 signs were due for delivery any day, and that arrangements had been made for the 440 yards positions to be agreed between the Tramways Department and other operators. But finally, the hearing before the Commissioners was set to take place, and the Tramway Committee authorised the Town Clerk to appear on their behalf. The minutes have a full report of the proceedings appended to them:

'Applications by the B & MMO Co. Ltd., for the renewal of 48 road service licences were before the Commissioners for hearing on Wednesday the 10th February 1932, when they asked for the withdrawal of the 440 yards protection condition. Objections were lodged by this Department against the renewal of these road service licences, on the grounds that the Leicester Corporation provided an adequate service of tramcars and motor omnibuses for all passenger transport within the City of Leicester, and the Leicester Corporation objected to the withdrawal of the 440 yards protection condition.

'The Commissioners, after consultation with the representative of the B & MMO and Mr. McEvoy, the deputy Town Clerk, gave protection to the Leicester Corporation, as follows:

All buses traversing
the Hinckley Road - 266 yards from the Western
 Park terminus
All buses traversing
Groby Road - 30 yards from Blackbird
 Lane

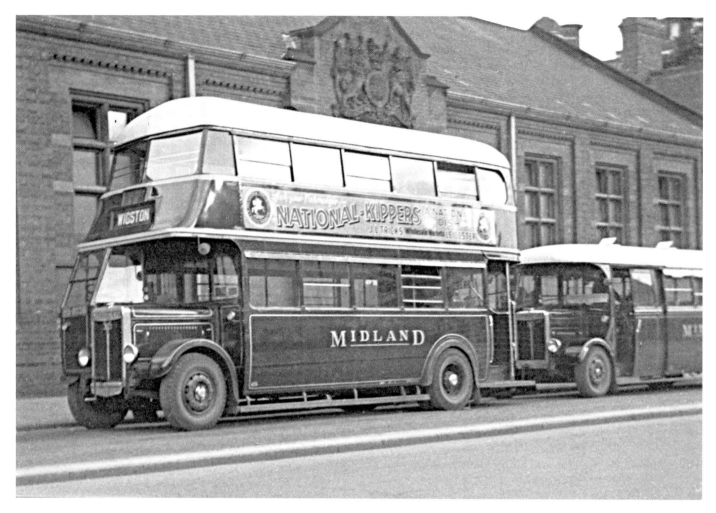

59. By 1940 all the REDDs were stationed in Leicestershire, and it is to The Newarke we go once again to see Brush-bodied A1410 (HA 8036) awaiting its next duty to Wigston on 16 July 1939. When the fleet was renumbered in 1944 the A prefix was dropped, and 1410 was withdrawn in 1949. The unidentified saloon in the rear is a SON ("Saloon Onward"), whose sliding door entrance reveals it to be a CHA-registered example new in 1936.

All buses traversing		All buses traversing	
Anstey Lane	- 30 yards from Blackbird Lane	London Road	- 150 yards from the terminus
All buses traversing		All buses traversing	
Marfitt Street	- 30 yards from the corner of Melton Road and Marfitt Street	Aylestone Road	- 150 yards from the terminus
		All buses traversing	
		Uppingham Road	- 130 yards from the terminus
All buses traversing		All buses traversing	
Saffron Lane	- 100 yards from the Wigston Lane terminus	Melton Road	- 130 yards from the terminus
		All buses traversing	
All buses traversing		Loughborough Road	- 230 yards from the terminus
Aylestone Lane[17]	- 100 yards from the terminus		
All buses traversing			
Narborough Road	- 240 yards from the Coalpit Lane terminus		

'On the Welford Road route, the Commissioners gave the right to the Corporation to extend their present service to within 30 yards of the city boundary. An arrangement has since been arrived at not to extend

this service at the present time, and the point of protection has been fixed at 100 yards on the country side of Chapel Lane.

It should be understood that all these arrangements were at the instigation of the Traffic Commissioners.

'9 applications for new services have been made to the Commissioners by the B & MMO: 4 of these were granted and 5 were refused. The applications granted were:

1) A suburban service (Sunday only) starting from the Aylestone Boat House and running partly outside and partly inside the city
2) From the Aylestone Boat House to Kirby Muxloe (Sunday only). This application is not considered to have any detrimental effect on the services of the Leicester Corporation
3) From Newarke Street to Braunstone Village, traversing Narborough Road, Barclay Street and on to the Village of Braunstone
4) From Newarke Street to Braunstone Village, traversing King Richard's Road and Hinckley Road to Braunstone Village

'An appeal to the Minister of Transport against the decision of the Traffic Commissioners to impose a 440 yards protection condition on the four routes granted was lodged by Messrs. Sydney Morse & Co., Solicitors, on behalf of the B & MMO

An appeal has been lodged by them against the decision of the Commissioners refusing the application to run to Aylmer Road on the Braunstone Estate.'

In summary, the Corporation retained some protection for its routes at the outer limits, but nothing like that which had originally been proposed. Midland Red had gained licences for four new services, of which the two to Braunstone would prove to be very important, and had gained from the fact that it would be for the company to develop new routes in the new estates, as the Corporation was restricted by the city boundaries. But still neither side was prepared to concede an inch to the other, and in a remarkable turn of events, the Traffic Commissioners sent an assistant to Leicester the following day, 11 February, 'to endeavour to get the Leicester Corporation and

Midland Red to come to an amicable agreement respecting the matters in dispute'. History does not record the extent to which heads were proverbially banged together, but it is clear that by the end of the resulting conference, held at the Tramway Offices, agreement had been reached on all the following points:

- the Aylmer Road appeal was withdrawn by Midland Red
- Midland Red would not oppose the application of the Leicester Corporation to extend the Hamelin Road service to Valence Road
- Leicester Corporation agreed they would not extend their Knighton Cross-road service beyond the present Chapel Lane terminus, and that protection be given to them against Midland Red at a point approximately 100 yards on the country side of Chapel Lane
- the 440 yards protection given to the Leicester Corporation along Barclay Street, which was at a point on the Narborough Road side of Sykefield Avenue, be reduced to a point on the country side of Fosse Road South, and that a minimum fare of 2d be fixed without any reduction for return
- Midland Red, who at this time were issuing Workmen's Return tickets up to 9.00am, would limit the time to 7.30am, and the fare would be fixed at 2½d
- as regards the Suburban Circle, protection points for Leicester Corporation were fixed at Kirby Road (Danes Hill Road corner); Abbey Lane, a point 440 yards from Blackbird Road; Clarke Street (Checketts Road); and the first gates of the City Mental Hospital, Gipsy Lane.

An essential part of the agreement was that all the arrangements referred to should be binding on both parties for a period of one year only, although in practice there then existed a kind of truce, and it may be fairly said that the Corporation and Midland Red worked in reasonable harmony for the next fifty years. But sadly, Alderman Banton was not there to lead the Committee into this new, regulated era; he died after a short illness on 19 April 1932, only five weeks after the Commissioners' hearings. He was 75.

60. Throughout all of this the trams carried on as though nothing had changed, and as we will see in Chapter 4, it was during this time that the tram network was at its height. Typifying operations in the early 1930s is Corporation Tramways car 37 making its way down Granby Street towards the station and, ultimately, Clarendon Park. The photograph also captures an interesting array of other transport; cars, vans and bicycles. It was taken in 1932; of that we can be certain as the Prince's Cinema is showing The Big Stampede, a John Wayne film released in that year.

1928-1947: THE BUILDING OF ST MARGARET'S BUS STATION

Introduction

A milestone in the life of St Margaret's bus station in Leicester was reached in July 2016 when it celebrated its 75th anniversary. Established as a departure point for services to locations outside the city boundary, mainly to the north, east and west, it has undergone various cosmetic changes and one major rebuilding in 1984/85 during its existence. With the closure of The Newarke and Northampton Square bus stations in the 1970s and 1980s, it now serves all parts of Leicestershire, and, since the advent of National Express services, most parts of the country too. Whilst the earliest bus stations (or at worst, off-road facilities) in England dated back to the early 1920s, why did it take until July 1941 for Leicestershire people to enjoy similar benefits? Once again, the minutes of the Council Watch Committee provide a fascinating insight into how St Margaret's came into being and the obstacles that had to be overcome to bring the project to fruition over what was, in the end, a 13 year period.

From the introduction of the first organised horse-tram services, and through into the electric tram era, city dwellers had become used to the greater mobility that cheap and frequent public transport provided. The growth of motor bus services from outlying towns and villages, starting from around 1910, received a massive boost by the arrival of Trent in 1919 and Midland Red in 1921. The many smaller carriers[1] increased the frequency of their services as demand and competition grew, not only during the day but on different days of the week. The result was a recipe for congestion on a colossal scale. By 1928, some of the numbers were significant even by twenty-first century standards. The Tramways Department was running 178 tramcars and the Corporation bus fleet had grown in the four years since its inception to 40 vehicles. Midland Red, now housed in its new Southgates garage, had 50-60 buses, augmented on the streets by visitors from other towns, principally Coalville and Nuneaton. Even that figure takes no account of the independents. A survey carried out in 1928 by the Watch (Traffic) Sub-Committee reported at the Committee meeting on 11 March 1929 revealed that, excluding the Corporation's activities, there were:

'…669 omnibuses owned by 109 proprietors licensed to ply for hire in the city, with 1,403 approved departures on a midweek day and 2,025 on Saturday to places outside the city boundary…Some of these proprietors had until this year taken the liberty of running by other than their authorised routes…central thoroughfares were becoming seriously congested, omnibuses stopping anywhere and everywhere to set down passengers and in some cases waiting while fares were collected.'

A census on a midweek day in 1928 revealed that 934 omnibuses passed along Newarke Street during one 16-hour period; the figure for a Saturday was 1,106. Instructions were issued to proprietors that the approved routes and stands must be strictly adhered to at all times. But clearly something more drastic had to be done. Comparisons of Ordnance Survey maps from the 1920s with those of today reveal that much of the basic central road infrastructure has not massively changed, though most of the main thoroughfares have undergone widening schemes (some from as early as the 1900s) or in more recent times, pedestrianisation. Much of this came about as a by-product of massive slum clearance programmes, the speeding up of which is traceable back to the 1920s. But even these were carried out over a 40-year period, which inevitably meant that redevelopment both then and more recently has taken place on a piecemeal basis. The opportunity to create a modern, fit-for-purpose road network has never been properly exploited.

Attempts to rationalise central termini

Keen to protect the virtual monopoly that the Corporation enjoyed on routes within the city boundary,

which on a 'first come first served' basis had seen the prime on-road central terminal points given over firstly to the trams, and later to Corporation buses, the Council was under some obligation to find suitable locations for the other operators. The benefit of having these as close to the centre as possible for commercial reasons was appreciated, though many of the sites in operation in 1928 were anything up to 15 minutes' walk from the Clock Tower, the acknowledged 'city centre'. In fairness, the Watch Committee or its various subsidiaries had over the previous ten years attempted to impose some order on the various termini; their March 1929 report found that:

'...Until recently...omnibuses running over the same route had started from as many as six different stands. For better control and the convenience of the public, the Sub-Committee are endeavouring to provide one

terminus for each route. To some extent, this has been accomplished (for example, the whole of the Hinckley Road and Narborough Road services have their termini in Western Boulevard; all Groby Road services leave from All Saints Road). The difficulties met by us are finding suitable places from which omnibuses may start.'

Besides Western Boulevard and All Saints Road, there were at that time four other termini for non-Corporation services. Coaching operations and long-distance stage carriage services to locations such as Hereford, Coventry, Birmingham, Northampton and Grantham either started from (or would soon be starting from) the yard at Midland Red's Southgate Street garage, now officially designated as a coach station. Being off-road, it was of less concern to the Watch Committee. On the western edge of

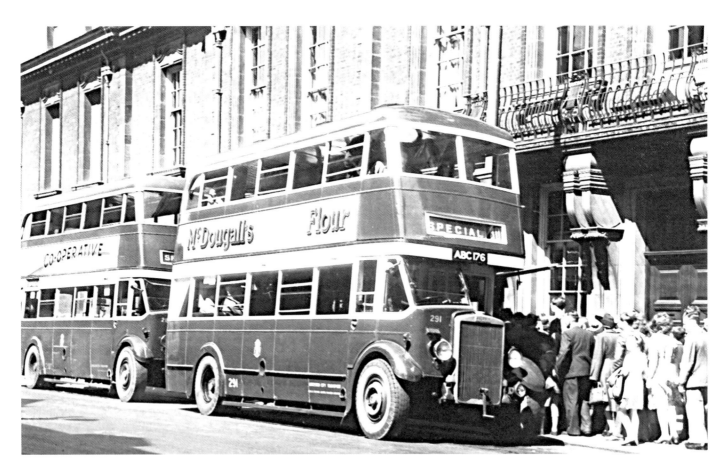

61. Bowling Green Street was originally the terminus for Aylestone trams, so as such had a history stretching back to 1904. That line closed in January 1947, and in this photograph, the tramlines appear to have been removed. Leyland TD4c/MCCW 291 (ABC 176), new in 1936, was busy shifting the crowds on Whit Monday, 17 May 1948; although it displays route number 30, it was actually working a 23 "Special" to a point part way along the Aylestone route – quite possibly the Leicestershire County Cricket ground. 291 was withdrawn in June 1950 as delivery of the new PD2s gathered pace.

62. Western Boulevard was identified at an early stage as a terminus for services from the direction of Narborough and Hinckley, and it continued in use for over 50 years despite the fact that it was a good 15 minutes brisk walk from the Clock Tower in the city centre. Waiting for departure time on a 600 working to Croft in the early 1950s is Midland Red 1504 (HA 9455), an SOS ON with Short B38F bodywork (ON standing for "Onward") which, when fitted with a BMMO 8 litre diesel engine circa 1937/38, was reclassified CON (Converted ONward). It was rebodied by Nudd in 1949 and was one of the last two of the type to be withdrawn, along with sister vehicle 1503, in 1957 – a service life of around 23 years.

the city centre, The Newarke and Newarke Street housed a variety of services, to Lutterworth on the A426 and Uppingham on the A47, as well as longer-distance routes to Market Harborough along the A6 and a circular service to Wigston and Oadby which on its return to Leicester terminated at Regent Street, a small thoroughfare which ran parallel with the LMS railway, opposite the station, described in timetables of the period as Hind Hotel.[2] This was also widely used by some of the smaller independents operating on southbound routes out of Leicester. But it was the fourth terminal in the Belgrave Gate area, principally at the Old Cross and in Jubilee Road, which was causing the greatest difficulty. Heavily patronised routes operated by Midland Red and a variety

of smaller independents left here for Loughborough, via the main A6 (calling at Birstall, Mountsorrel and Quorn) or the "Charnwood" route (Thurcaston, Cropston, Swithland and Woodhouse Eaves) as well as for Syston, Queniborough, Rearsby and villages en route to Melton Mowbray. These had already been the source of confrontation between the operators and the Watch Committee following timetable changes in January 1928. The March 1929 report continued:

'…So far as Belgrave Gate services are concerned, there have been bitter complaints from residents in front of whose houses omnibuses stand all day, but no more suitable street that is conveniently central can

GREEN BUS MOTOR SERVICE.

1930.

R. H. REEVE, The Garage, Leicester Rd., Fleckney

FLECKNEY, WISTOW PARK, GREAT GLEN, OADBY AND LEICESTER.
VIA STONEYGATE TRAM TERMINUS, LONDON ROAD AND NELSON STREET.

Terminus: "HIND HOTEL," REGENT STREET.

MONDAYS, TUESDAYS, THURSDAYS AND FRIDAYS				WEDNESDAYS					
FLECKNEY	-	dept.	7 10	5 40	7 10	10 55	1 55	5 40	8 10
Wistow Park	-	approx.	7 15	5 45	7 15	11 0	2 0	5 45	8 15
Great Glen	-	approx.	7 20	5 50	7 20	11 5	2 5	5 50	8 20
Oadby	-	approx.	7 30	6 0	7 30	11 15	2 15	6 0	8 30
LEICESTER	-	arrive	7 40	6 10	7 40	11 25	2 25	6 10	8 40
LEICESTER	-	dept.	8 10	6 20	8 10	1 0	4 30	6 20	9 0
Oadby	-	approx.	8 20	6 30	8 20	1 10	4 40	6 30	9 10
Great Glen	-	approx.	8 30	6 40	8 30	1 20	4 50	6 40	9 20
Wistow Park	-	approx.	8 35	6 45	8 35	1 25	4 55	6 45	9 25
FLECKNEY	-	arrive	8 40	6 50	8 40	1 30	5 0	6 50	9 30

SATURDAYS

FLECKNEY	dept.	7 10	10 55	12 20	1 40	3 45	5 45	7 45	9 45
Wistow Park	approx.	7 15	11 0	12 25	1 45	3 50	5 50	7 50	9 50
Great Glen -	approx.	7 20	11 5	12 30	1 50	3 55	5 55	7 55	9 55
Oadby -	approx.	7 30	11 15	12 40	2 0	4 5	6 5	8 5	10 5
LEICESTER	arrive	7 40	11 25	12 50	2 10	4 15	6 15	8 15	10 15
LEICESTER	dept.	8 10	11 35	1 0	2 15	4 25	6 45	8 45	10 50
Oadby -	approx.	8 20	11 45	1 10	2 25	4 35	6 55	8 55	11 0
Great Glen -	approx.	8 30	11 55	1 20	2 35	4 45	7 5	9 5	11 10
Wistow Park	approx.	8 35	12 0	1 25	2 40	4 50	7 10	9 10	11 15
FLECKNEY	arrive	8 40	12 5	1 30	2 45	4 55	7 15	9 15	11 20

A. W. HOLMES & SONS, Printers, York Road, Leicester.

63. Although not in the best of condition, this rare glimpse of a 1930 timetable illustrates some of what we already know about services using Nelson Street to get to the Regent Street/Hind Hotel terminus, which had been in existence since at least 1914 and had been used as a Hackney Carriage stand before this time. Reeve had been running his service for some years prior to 1930; note that there was a greater number of departures on Wednesdays, and particularly Saturdays, market days in Leicester. There is no comparable service in 2017 – buses for Fleckney go via Kilby and Wigston – but 20 minutes to travel between Leicester and Great Glen compares favourably with today's X3 service. It may be assumed that Reeve's bus was painted green; there is no known association with the Leicester Green company.

Reeve sold some of his service work to Midland Red on 1 March 1936. It already had a route to Fleckney numbered 639; some journeys were extended to Saddington, and some Saturday workings ran on to Kibworth and were numbered 656. After the war the 656 became the Fleckney – Market Harborough service, worked by Reeve on Tuesdays and Fridays and Midland Red on Saturdays and Sundays. By 1959, Midland Red merged the 656 into its Leicester – Market Harborough group, which also included the 612, 613 and 654, but Reeve retained his Tuesday and Friday commitments for a few more years.

be found. It appears there is no alternative but taking waiting vehicles off the streets on to ground provided for the purpose, and we are giving this our attention.'

In fact, two months earlier, following a proposal to remove the stands from the Old Cross and Jubilee Road which stemmed from the Sub-Committee's

The MIDLAND MOTOR BUS COMPANY, LIMITED

LESTER, SYSTON (via 'Gate Hangs Well')
Cossington & SILEBY

From "THE OLD CROSS," Belgrave Gate

10 MAY 1921

NOTICE

The Company will make every effort to maintain a STANDARD SERVICE but CANNOT GUARANTEE the RUNNING of any particular bus

CURRENT TIME TABLE.

	WEDNESDAY								SUNDAY				
LESTER	8 30	10 30	2 0	3 30	6 0	7 30	8 50	10 30	2 15	3 15	6 30	8 30	
SYSTON	8 55	10 55	2 25	3 55	6 25	8 0	9 15	10 55	2 45	3 40	7 0	9 0	
SILEBY	9 15	11 15	2 45	4 15	6 45	—	9 30	11 15	—	4 0	7 20	9 20	
SILEBY	9 20	11 20	2 50	4 15	6 45	—	9 30	11 30	—	4 0	7 20	9 20	
SYSTON	9 40	11 35	3 5	4 35	7 0	8 0	9 45	11 50	2 45	4 20	7 35	9 40	
LESTER	10 10	12 0	3 30	5 0	7 30	8 30	10 10	12 20	3 15	4 45	8 0	10 10	

SATURDAY

LESTER	8 15	10 0	12 30	2 15	3 45	5 30	6 30	8 0	9 15	
SYSTON	8 40	10 25	12 55	2 40	4 10	6 0	6 55	8 25	9 40	
SILEBY	9 0	10 45	1 15	3 0	4 25	—	7 10	—	9 55	
SILEBY	9 5	10 50	1 15	3 0	4 25	—	7 15	—	9 55	
SYSTON	9 20	11 5	1 30	3 15	4 40	6 0	7 30	8 40	10 10	
LESTER	9 50	11 30	1 55	3 40	5 0	5 30	7 55	9 10	10 40	

All Communications to be addressed to the Secretary.
F. LIQUORISH, THE MIDLAND MOTOR BUS COMPANY, LIMITED, BEDFORD PLACE, NORTHAMPTON.

64. Another old established bus terminal was the Old Cross on Belgrave Gate, and the Midland Motor Bus Company advertises its service to Sileby via Syston and Cossington on this timetable dated 10 May 1921 – one day before Midland Red's arrival into Leicester. At this point operations were confined to Wednesdays, Saturdays and Sundays, but as discussed in Chapter 2, it was Trent that proving to be the greatest threat to the Midland company, which had withdrawn from Leicester by the end of the following September.

65. The Old Cross terminus can be seen in this picture from the mid 1920s. H Boyer & Son's Daimler CM saloon with Brush B32F bodywork NR 7752, new in December 1925, is waiting time before departure, probably to Loughborough. It will travel north along Belgrave Gate, on the left of the photo, where also can be seen a Leicester Corporation tram. On the right is Bedford Street, and it is the area behind the imposing building in the centre, which would shortly fall victim to the demolition ball, that would become the Belgrave Gate bus station. As for the Old Cross, that too disappeared to make way for the extension to Charles Street, opened in 1932.

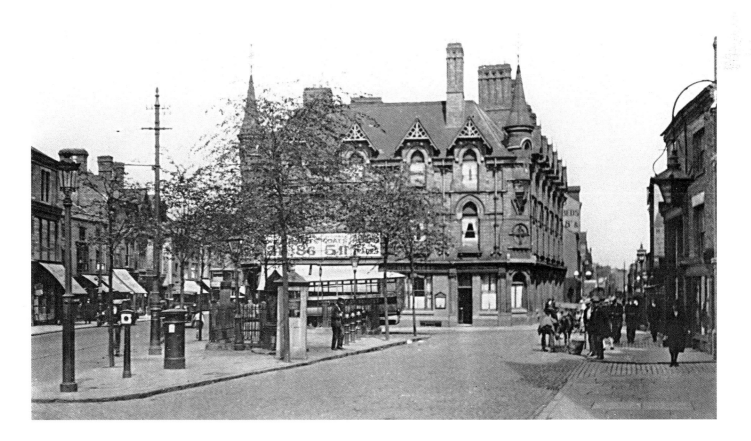

66. Southgate Street garage opened on 21 July 1927 and was built to house 90 vehicles. It had an L-shaped internal arrangement, and being built on the corner of Peacock Lane and Southgate Street, provided an open area which was soon pressed into use as a bus and coach station. Most of this can be seen in the photograph, and only two of the four vehicles on show are Midland Red's own. The double deck bus on the left is 4142 (THA 142), one of 350 lightweight deckers designated D7 introduced between 1953 and 1957 and having Metro Cammell bodywork. It was based at Southgates between 1954 and 1962, and is waiting to undertake the long stage carriage service X68 to Birmingham via Coventry. In the background can be seen the former Alderman Newton's Grammar School, now part of the Richard III exhibition area, and St Martin's Cathedral.

rationalisation efforts, a deputation of bus proprietors had attended the Watch Committee meeting, suggesting three options: that the Council should provide a bus station which would be rented out; that the proprietors should purchase a bus station themselves; or that stands should be provided in Humberstone Gate or Navigation Street. They were promised that the points they raised would be given 'full consideration'.

Three initiatives to improve the traffic flow in the area were already being considered: the widening of Belgrave Gate from the Old Cross to the Great Northern station, a distance of 1100 yards; the extension of Charles Street between Humberstone Gate and Belgrave Gate, and the widening of Charles Street as a whole. This would spell the end of the Old Cross terminal, which had been used for several years for departures along the A6 towards Loughborough. Belgrave Gate was already heavily served by the trams; so was Humberstone Gate (Midland Red started only two of its services from there, to Melton Mowbray and Oakham). Nothing more came of the Navigation Street proposal, although its location, on the northern side of Burleys Lane, was relatively close to the site eventually chosen for the new St Margaret's bus station.

Belgrave Gate Omnibus Station

Instead, on 29 July 1929, the Chairman of the Watch Committee reported the details of an interview he had attended with the Acquisition of Properties Committee, to discuss the possible use of a piece of land 'in the vicinity of Old Cross, Belgrave Gate, to accommodate omnibuses running via Loughborough Road and Melton Road'. The proposed site was ruled out on the grounds of 'instability of foundations', but the meeting resolved that the Chief Constable should negotiate with the City Surveyor for the use of land between Belgrave Gate, Bedford Street and Jubilee Road as an alternative temporary site. Although members also 'urged' the Acquisition of Properties Committee to 'continue negotiations for the purchase of the Hill Street Chapel in view of the pressing need for a permanent omnibus station in this locality',[3] by the time of the next meeting on 9 September, permission had been granted to use the former site, and it was agreed that with effect from 1 October, the following services would operate from what was now to be known as the Belgrave Gate omnibus station:

- routes from the Old Cross via Loughborough Road to Loughborough operated by Midland Red, Parr's Garage, Allen's Garage, Boyer & Son and Kemp & Shaw
- routes from Bread Street via Loughborough Road to Loughborough, operated by Squire Brothers, and to Birstall, operated by G. Branston
- routes from Parr's Garage, Church Gate via Loughborough Road and Woodhouse to Loughborough operated by Parr's Garage and Allen's Garage
- routes from Jubilee Road via Melton Road to Syston and surrounding villages operated by Midland Red, F.R. Wadd, W. & C. Smith, and L. Pole & Son
- routes from Humberstone Gate via Melton Road to the Oakham area, operated by Midland Red, and to Melton Mowbray, operated by C.W. Bishop
- routes from Orchard Street via Melton Road to Humberstone Lane, operated by Midland Red

No facilities were provided for intending passengers, and after clearance, the site was still little more than waste ground, but the Watch Committee was told that it was working 'most satisfactorily' in those final months of 1929. It was also however reported that immediately after leaving the bus station, omnibuses had on many occasions stopped on the opposite side of Belgrave Gate in order to pick up passengers, causing serious traffic congestion. Instructions were issued that there should be no stopping before Foundry Square. O.C. Power wrote on behalf of Midland Red, asking that in view of the distance between the bus station and Foundry Square, an intermediate stop should be introduced, possibly in the vicinity of Orchard Street. On 18 November, the request was summarily refused.

One might have thought that matters would also improve as a result of the widening of Belgrave Gate, but unfortunately that proved not to be the case. The new road layout was finally agreed in February 1930; the tramway track would be moved to the centre of the road, with space for vehicles to pass on either side between the kerb and the tramway. But at the meeting on 1 September 1930, a letter of complaint from the proprietors of General Furnishers Ltd[4] was read to the meeting, to the effect that omnibuses using the Belgrave Gate stand were allowed to park within 12 feet of the present roadway, thereby obscuring the view of their premises. The members of the Sub-Committee resolved to visit the site. On 2 December the company wrote again claiming to be 'suffering a very serious loss owing to the buses being parked in such a position to obscure the views of our premises at 117-121 Belgrave Gate', and this was considered at the Watch (Traffic) Sub-Committee meeting on 12 January 1931. The favoured solution was that the widened Belgrave Gate street line should become the boundary of the temporary bus station, but the Chief Constable poured cold water on the plan, saying that if it was acceded to, it would not be of sufficient size to accommodate the omnibuses at peak times. His proposal was to ask the Acquisition of Properties Committee to allow the use of an additional piece of land between Messrs Evans' factory and the Griffin Inn, although the City Surveyor would need to 'make good the plot and lower the kerbs in Bedford Street and Belgrave Gate', the cost of which was subsequently determined to be £80.

While this may have solved the issues raised by the General Furnishers Ltd, the 'question of provision of accommodation for omnibuses operating services from the city via Loughborough Road and Melton Road' was

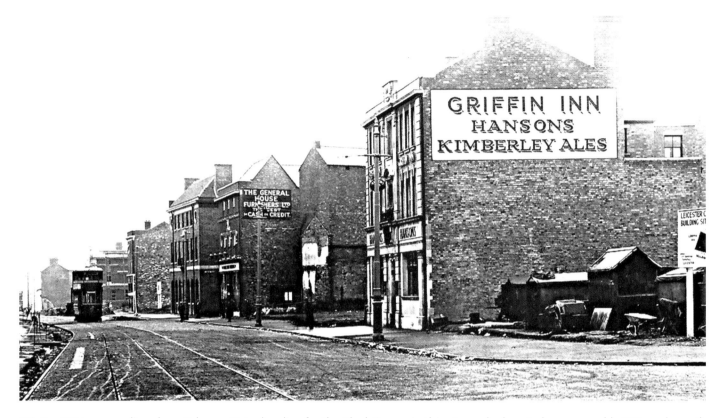

67. Car 118 is proceeding along Belgrave Gate, heading for the Clock Tower, in this strangely deserted scene roughly 100 yards north of the Old Cross. The photographer is standing opposite the entrance to Abbey Street; the Belgrave Gate bus station lies behind the Griffin Inn, and the General House Furnishers Ltd, who were wont to complain about buses obscuring potential customers' views of their premises, can be seen on the corner of Jubilee Road. The carriageway widening still appears to be a work in progress, which suggests that the photograph was taken in early 1931.

still festering. The minutes of the Watch (Traffic) Sub-Committee meeting on 6 October 1930 show that the Chairman and the Chief Constable were empowered to:

> '…consult the City Surveyor regarding the possibility of acquiring a suitable permanent site for an omnibus station in view of the fact that the present position in Belgrave Gate is only temporarily loaned by the Acquisition of Properties Committee, who may require possession of the land at any time.'

A conference between the two committees was convened for 1 December. The Chairman of the Acquisition of Properties Committee reported that all their land on the line of the new (Belgrave Gate) street scheme was 'front land' and could not be made available. The City Surveyor thought that it might be possible to acquire a site for a permanent omnibus station on land which would become available when a proposed

slum clearance scheme had been completed, and suggested a further conference be held between the Watch (Traffic) Sub-Committee and the Health Committee. The Acquisition of Properties Committee was prepared to assist with the provision of a site for an omnibus station, and it was agreed that they would continue to provide a temporary facility as long as they had suitable land available, but, controversially, on condition the Watch Committee pay an agreed rent for the use of the land and that the Acquisition of Properties Committee could re-possess any such site when necessary.

The *Leicester Mercury* reported on the story on 2 December:

'BUS DIFFICULTIES
'Wider Road to Cause Trouble at Jubilee Road Park

'Difficulties of providing an omnibus station, or parking place for 'buses running outside the city boundaries on the Melton-road and

Loughborough-road routes have been raised by the possibility of the widening of Belgrave-gate to be proceeded with at an early date.

When the road is widened near Jubilee-street [sic], the present omnibus station will be reduced to such an extent that, in the opinion of the Traffic sub-Committee, it will be far too small for ordinary requirement.

'The question of taking over another piece of land was discussed at a conference between the Acquisition of Property Committee, responsible for the disposal of 77 sites connected with the Street improvement scheme, and the Traffic Committee, but the difficulty was not solved.'

Contrast this piece with the *Leicester Mail*'s report which appeared on the same day:

'BUS PARKING STATION
'City Watch Committee Acquire Control
'It was agreed at a conference held at Leicester Town Hall last night, the "Leicester Mail" understands, that the Watch Committee should take over from the Acquisition of Properties Committee the control of the bus parking station in Belgrave-gate.

'The site is owned by the Acquisition of Properties Committee, who are dealing with the Street Improvement scheme, but as they are not in any way concerned with traffic, they have agreed that the Watch Committee should take it over.

'It was also suggested at last night's meeting that as the Corporation have to spend money continually on keeping the site in suitable condition for the bus traffic, a small charge should be made to the bus owners for parking.

'This, however, was left to the Watch Committee to deal with and it is understood that they will consider it at their meeting tonight.

'The conference discussed a suggestion that when Belgrave-gate is eventually widened the parking ground will not be adequate, as a large slice will have to be taken off to add to the road.

'It was felt that even then it would be sufficient for present needs, but this, too, will have to be considered again by the Watch Committee.

'The Belgrave-gate park is only temporary, for when the demolitions and widenings are completed, the site will be available for purchasers for the erection of buildings.

'The question of a permanent bus park will have to be considered later on, it is understood a suggestion was made that negotiations be entered into with the Health Committee for a site when they take in hand the slum clearance problem.'

By 15 December, the City Surveyor had indeed identified a site on land adjoining Abbey Street (on the opposite side of Belgrave Gate) which would become available when the proposed slum clearance scheme had been completed. It was 21 April 1931, however, before the Watch Committee approved the plan, the ground to be used being situated between Abbey Street and Garden Street. The long process of acquiring the main parcel of land, along with other supplementary pieces the Committee felt (or were persuaded) would be beneficial, now began. Despite the fact that it was accepted that there was a pressing need for a permanent bus station, it would be 3½ years later, October 1934, before the acquisitions were completed, and preliminary plans of the proposed layout and the costs involved would become available.

Charges for bus station usage

Although on the face of things, this was a controversial development, it was not a new idea. The operators themselves had suggested it in 1929 when their original options for a bus station were put forward, and again in 1930, when the Acquisition of Properties Committee suggested that the Watch Committee should pay an agreed rent for land provided. The Road Traffic Act of 1930 was now in force; Section 90 enabled a charge to be made against proprietors of public service vehicles using a municipal bus station. At their meeting on 21 October 1930, the Acquisition of Properties Committee resolved 'that the Watch Committee be informed that where omnibuses are permitted to stand on land belonging to this Committee, a charge of 2/- per omnibus per day be made for such privilege, and that this Committee shall have the control over the sites to be allotted for the use of the omnibuses and that the net receipts shall be received by this Committee'. The issue was referred to the Watch (Traffic) Sub-Committee, who at a meeting on 24 November, agreed to set up a conference between the two Committees on 1 December.

It has not been possible to trace the minutes of this meeting, and the matter did not resurface until 20 April 1931, when the Town Clerk was instructed to take the necessary procedures under Section 90 to enable a charge to be made against proprietors of public service vehicles using Belgrave Gate Omnibus Station, the charge suggested by this Sub-Committee being 2d per departure.

There followed what appears to have been an acrimonious debate between the Watch Committee and Midland Red, who were in this instance aided and abetted by the Midlands Area Omnibus & Coach Owners Association, acting on behalf of the independent operators. This dragged on for many months and once again served to highlight the nature of the relationship between the Corporation's servants and Midland Red. On 1 September 1931, the Town Clerk reported that steps had been taken to enable a charge to be made against the proprietors of public service vehicles using Belgrave Gate omnibus station. By 20 October, a somewhat understated letter from O.C. Power on behalf of Midland Red was read to the Committee, regarding the approach to the bus station. 'This is in very bad condition, and the surface of the stand itself is badly worn. Perhaps it could be brought to the attention of the appropriate Committee', he asked, not unreasonably. But a decision was deferred, pending the Ministry of Transport confirmation of the Section 90 order. It took until 19 January 1932 for the Chief Constable to report that this had indeed been granted on 29 September 1931, and it was now possible to make charges for use. He said that there were 2,393 departures from existing stations each week and if the Committee felt disposed to charge 2d per departure, £19 18s 5d per week (or £1,035 17s 8d per annum) would be obtained. But because of the bad condition of Belgrave Gate omnibus station, he wanted the stand to be moved to Humberstone Gate. The Committee pointed out that this was impossible, as the large number of buses operating from Belgrave Gate could not be accommodated in Humberstone Gate, and so the City Surveyor was authorised 'at once' to repair the surface of the Belgrave Gate stand, and the motion to charge 2d per departure was carried.

At the next meeting on 16 February, the Committee had heard once again from O.C. Power. This time, his tone was less conciliatory:

'I have to thank you for your letter of the 12th instant and note that your Corporation propose to make a charge of 2d per departure in respect of all omnibuses using the Belgrave Gate Omnibus Station under Section 90, sub-section 3 (b) of the Road Traffic Act 1930.

'I would point out, however, that this Section of the Act states that a Local Authority may make reasonable charges for the use of any accommodation so provided and I must again repeat that I do not consider the proposed charge of 2d is reasonable and I am afraid that I cannot agree to such a payment.'

The Committee was not for turning. It had to stand its ground against the bus companies as otherwise there would be a financial shortfall – the minutes of the Acquisition of Properties Committee meeting two weeks earlier reveal that 'the resurfacing of the Omnibus Station in Belgrave Gate near the Old Cross has been carried out…the Watch Committee be asked to pay the Acquisitions of Properties Committee £500 rent for the first year, to be reviewed thereafter,' and this the Watch Committee had resolved to do. But by the time of their next meeting on 19 April, the pressure had been ramped up still further when the Town Clerk revealed the contents of the letter dated 16 March 1932 he had received from the Midlands Area Omnibus & Coach Owners Association:

'BELGRAVE GATE OMNIBUS STATION
'With reference to the charge which you have suggested making to the Omnibus Proprietors of 2d per departure from Belgrave Gate Omnibus Station. On behalf of our members we lodge a most emphatic protest against the charge.

'I am aware that under Section 90 Road Traffic Act 1930 (sub-section 3 (b)) you may make a reasonable charge for accommodation provided as referred to in sub-section 3 (a). As no accommodation has been made at this particular station such as waiting rooms, lavatories etc, we claim that the charge of 2d per departure is excessive.'

Submissions had also been received from C.H. Allen, H. Boyer & Son, W. & C. Smith, L. Pole & Sons and F.R. Wadd, all of whom repudiated the charge. Nonetheless, the Town Clerk was instructed to 'take such proceedings

as he may consider advisable to recover the amounts now due in respect of the use of the Belgrave Gate Omnibus Station'.

So, an impasse had been reached. Fortunately, the 1930 Act also provided for the Ministry of Transport to act as an intermediary in such cases, and their assistance was sought. On 2 June 1932, the Town Clerk reported that the Ministry of Transport had expressed a willingness to help resolve the stalemate. The Watch Committee, one suspects with some relief, accepted their offer and agreed to abide by the Ministry's decision. What happened over the next six months evidently took place behind the scenes, as the issue is not revisited in the Watch minutes until 6 December, when members were given a copy of a letter from the Ministry. It is reproduced in full, as a classic example of a Civil Service compromise, and with those excessively long sentences of which even 'Sir Humphrey' would have been proud.

'LEICESTER CORPORATION OMNIBUS STATION – BELGRAVE GATE

With reference to the discussion which took place on the 16th instant (November) in my room with Mr O Cecil Power of the Birmingham & Midland Motor Omnibus Co Ltd, upon the subject of the unfortunate difference of opinion which has arisen between the Leicester Corporation and the omnibus proprietors in Leicester as to the powers of the Corporation to require payments from the omnibus proprietors in respect of the use of this station and also, assuming that they are in a position to require payment, the reasonableness of the charges asked for, I have to say that, as verbally explained to Mr Power and yourself, it does not appear that the Ministry has any jurisdiction to deal with the matter.

'It appears to the Department, however, that it would, to say the least, be unfortunate that this difference of opinion should be the subject of litigation in the Courts for obvious reasons, and I understand that both parties accept this view and that they are agreeable and, indeed, desire that the Ministry should indicate to the parties what, in the Department's view, would be a reasonable payment to be made by the omnibus proprietors in respect of the use of the station, and further that if some

indication of this kind could be given (which, of course, has no authority of any sort or kind) they would be prepared to accept it.

'This question has been under discussion for a prolonged period and it does not appear to me that any useful purpose would be served by setting out in this letter the points of view of the two parties – legal and practical – upon this matter as they have been discussed at great length, both from legal and other aspects.

'The Ministry are at all times desirous, where it is practicable, to endeavour to adjust differences of such a nature as this one if, and only if, they are asked to do so.

'I have given most careful consideration to the very able arguments put forward on both sides and I have come to the conclusion that an equitable solution of the difficulty which has arisen would be for the Birmingham & Midland Motor Omnibus Co to pay the Corporation of Leicester a sum of £175, per annum upon the basis of their existing use of the station, such sum of money to be adjustable on a basis to be agreed in case their services increase or decrease, and I am quite definitely of opinion that a commuted payment of this description is preferable to an individual charge per departure in the case of stage carriage services, which is the problem in this case.

'If this solution of the difficulty is acceptable to the Birmingham & Midland Motor Omnibus Co, who, I believe, are the largest operators in Leicester, and to the Corporation, it is understood that Mr Power will use his best endeavours with the other operators to get them to agree to make payments to the Corporation for the use of this station on as near as may be an equivalent basis according to their individual departures.

'I am sir
Your obedient servant
(Signed) J S POOL GODSELL'

Having the potential charge reduced from £1,035 (on the Chief Constable's calculations) to £175 per annum proved just what an asset O.C. Power was to Midland Red, and in this instance, to the other independent operators also. The Watch Committee found that the proposed terms as set out by the Ministry of Transport

should be accepted. The members of the Midlands Area Omnibus & Coach Owners Association came (possibly with Power's help) to a different arrangement, which was agreed by the Watch on 17 January 1933, of a 1d charge per departure with effect from 1 February 1932, the operators in question being:

- Messrs L. Pole & Son, Leicester Road, Syston
- Messrs W. & C. Smith, 51 Central Avenue, Syston
- Mr F.W. Wadd, Ashtrees, Melton Road, Syston
- Mr C.W. Bishop, Asfordby, Melton Mowbray
- Mr G. Branston, 36 Belgrave Avenue, Leicester
- Messrs H. Boyer & Son, Rothley, Leics
- Allen's Bus Service, Mountsorrel, Leics
- Messrs Kemp & Shaw, Loughborough Road, Leicester

This formed the template for a charging mechanism that lasted until July 1950, when a flat rate 2d per departure from St Margaret's bus station was introduced.

The Town Clerk also submitted a statement of Income and Expenditure in relation to the Belgrave Gate bus station which makes interesting reading:

Estimated annual income	£465
Estimated annual expenditure:	
Rates	£100
Repairs to tarmac etc	£40
Lighting including renewal of lamps	£45

It was pointed out that this would leave a shortfall of £280 after rental charges and without making allowance for recovery by the Watch Committee of any part of the cost of construction of the Station, which amounted to £427, the major part of which was met in 1931/32.

Other schemes are planned

From 30 June 1929, all services running to and from the city via London Road were ordered to start and terminate at Regent Street. The availability of space in that area must have been at a particular premium, a situation exacerbated by a decision of the Watch Committee in April 1931 to move buses using stands in Fox Street[5] to Regent Street as well. The Watch Committee heard at their meeting on 19 April 1932

that there had been complaints from residents of Regent Street and Nelson Street, the essence of which were that these roads were totally unsuitable to be traversed by omnibuses, let alone used as an omnibus station. It was accepted that there were advantages in bringing passengers further into the city centre, and it was thought that this could be accomplished without congestion by asking bus proprietors to fix their terminus on vacant land on the east side of Charles Street, adjacent to the Horse Repository (which was very close to the site of the Hill Street Chapel, which the Committee had been considering only three years earlier). It was suggested that they might be charged a rental for the station, as was the case at the Belgrave Gate Omnibus Station.

The route into this proposed new bus station would be via London Road, Charles Street, Humberstone Gate, Clarence Street and Lower Hill Street, turning left in Charles Street and entering the omnibus station at a point near to the Horse Repository. On examination, however, it was found that Clarence Street 'is frequently encumbered with vehicles outside business premises, and the Clarence Street/Lower Hill Street turn is very acute, difficult for a large vehicle to negotiate'. The Committee suggested that the best route would be to cross Humberstone Gate and enter the omnibus station directly from Charles Street at a point ten yards south of the police box. Vehicles would emerge from it at the corner of Kildare Street. On 29 April 1932 the report of a specially convened Sub-Committee made no mention of a visit to see that part of Charles Street. Instead, they had inspected the portion of Charles Street in the vicinity of the new Police Headquarters and recommended that the Watch Committee 'institute, as an experiment, an omnibus stand for southbound motor omnibuses on the carriageway to the eastern side of Charles Street between Northampton Street and London Road outside the LM&S Railway stables, in substitution for the Regent Street omnibus station, all such southbound omnibuses to take up a position to the north of the existing electric light standard'. This was agreed and the new bus station – which comprised three shelters and off-road parking – became known as Northampton Square, and was operational for almost fifty years.

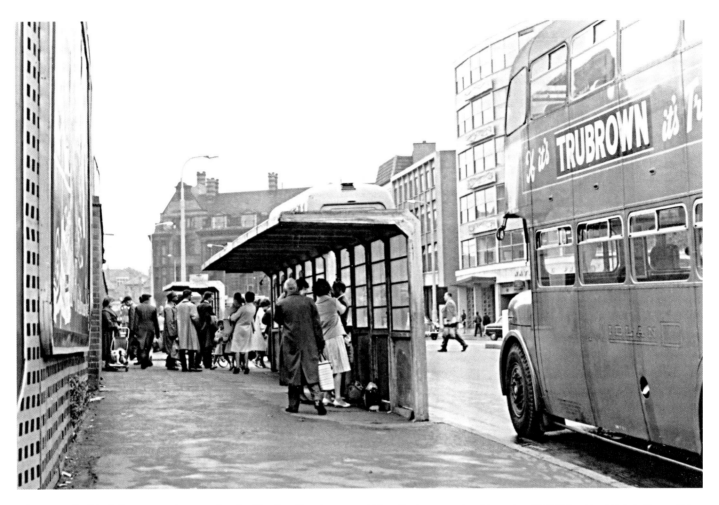

68. Instead of building a new bus station in Charles Street – something that was not achieved until 1994 – the Watch Committee decided that part of Northampton Street adjacent to the newly widened Charles Street would replace the stands for southbound routes in Regent Street. Northampton Square was opened in 1932; it consisted of nothing more than a bay for the buses and three shelters open at the rear for passengers, but it survived for nearly 50 years until services were moved to St Margaret's bus station in 1980. In this view, which appears to date from the late 1950s, passengers are boarding the leading vehicle, a D7, while a second bus – another D7 – waits out of service behind it.

Despite the fact that it had only been in use for a handful of years, and that it was one of the terminal points specifically designated by the Watch, the situation at All Saints Road was not without its problems. On 6 October 1930, the Committee heard a letter from Messrs S Pegg and Son of Alexander Street, complaining of congestion caused by omnibuses standing in All Saints Road and Ruding Street, alleging that these roads were blocked between 5.30 and 6.30 each evening. The Chief Constable reported:

'…licensed omnibuses do not use Ruding Street in any way but in fact between 5.30 and 6.30 each evening omnibuses do stand on each side of the whole of All Saints Road and Jarvis Street. In each street however the centre of the roadway is kept clear for through traffic (All Saints Road being a one way street).'

The committee decided that it was unable to take any action, which seems somewhat perverse since besides the lines of stationery vehicles, there would be a steady stream of new arrivals coming to take up their places which would also seriously congest these central roadways. However, it is probably no coincidence that this exchange should take place at more or less the same time that the City Surveyor was due to report on a

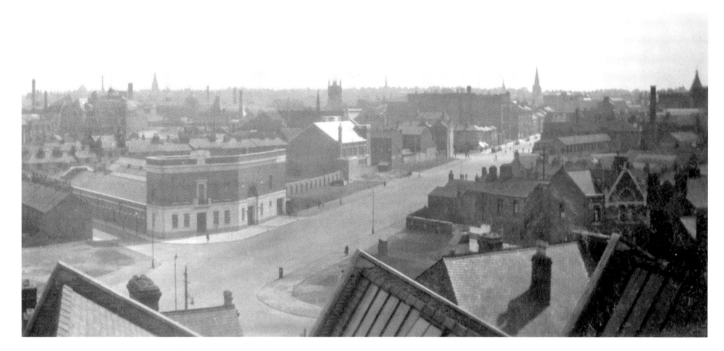

69. The central Leicester skyline circa 1932, showing the extension to Charles Street, which ran from Humberstone Gate to a new junction with Belgrave Gate. No provision for trams has been made; buses will always hold sway. The Old Cross has gone, but stood roughly where the pillar box is in the foreground. The Horse Repository – the imposing building on the opposite corner – was built in 1931; the vacant space to its left was filled by the Employment Exchange within a couple of years of that. The road to the left of the Horse Repository is Lower Hill Street, and continuing towards Belgrave Gate, just out of shot is Bedford Street, along which the bus station was situated. The Horse Repository was demolished in 1961 and replaced by the Epic House office block. The Employment Exchange, nowadays Job Centre Plus, remains, but the buildings on the right of the picture were cleared over the years before the arrival of the Haymarket shopping centre in the early 1970s. The bus station of the same name first appeared in 1994; it was upgraded and re-opened in 2016.

replacement for the Belgrave Gate bus station, and these shortcomings highlighted the need to move All Saints Road services also.

Abbey Street omnibus station

An Emergency Sub-Committee was created at the Watch Committee meeting on 6 December 1932, whose important task it was to prepare a scheme for the Abbey Street bus station for submission to the full Committee. Once again, this work seems to have gone on behind closed doors, as the minutes deal almost exclusively with the purchase of the land required. But on 4 September 1934, the City Surveyor submitted his plans for Abbey Street, with costings provided by the City Treasurer. These were in turn referred to the newly formed Permanent Omnibus Station Sub-Committee, which held its first meeting on 8 October to receive the detail. After reporting on the situation in neighbouring locations – Coventry, Nottingham, Derby and Birmingham – the

City Treasurer listed costs of acquisition, construction and laying out totalling £30,027. Annual running costs, on the assumption that only minimal essential services (fuel, light, water, rates, repairs and wages for one attendant) would be provided, were estimated at £2,560. By this time, the annual fees received from Belgrave Gate were £430 – £230 from Midland Red as rent for 70,000 departures, and £200 from other users for about 48,000 departures at 1d. There was no charge for the use of All Saints Road, where Midland Red departures were 55,000 and those of other users 36,000. The City Treasurer went on:

'I am informed that the proposed new omnibus station is intended to provide accommodation for all buses which leave from these two places. If the Traffic Commissioners make it a condition of ... licences that public service vehicles from Belgrave Gate and All Saints Open shall make use of the new omnibus

station ... BMMO will pay £410 rent for 125,000 departures and the others £350 rent for 84,000 departures'. (Alternatively)…if it is reasonable to double the present rate in consideration of the cost of providing and maintaining additional facilities, this would yield £1,520, leaving a shortfall the equivalent of an additional one farthing on the rates.'

The Town Clerk was left to communicate with the Traffic Commissioners and Midland Red regarding the proposed layout, while Committee members decided they should visit Derby at the earliest opportunity to inspect the new Corporation bus station there.

By 4 December, the Town Clerk and the City Surveyor had met with O.C. Power and representatives of the other operators. A long list of observations was read to the meeting, of which the key elements were:

- they all considered that the leading platforms should be covered along their whole length and not merely one-third of their length.
- there should only be six platforms instead of seven in order to allow easier movement of vehicles.
- each platform to have indication as to the destination of buses, and a large sign in Belgrave Gate informing the general public as to the position of the bus station
- maximum charge to be paid – 1d per departure
- parking spaces for waiting buses appear to be inadequate and further accommodation should be earmarked for this

The Committee noted that six platform islands with a 30ft (as opposed to 20ft) carriageway would not be sufficient to accommodate all the buses that it was currently suggested would be parked up, and with extra space being required for waiting vehicles, it would be necessary for yet more land to be acquired. The Town Planning Committee also felt that the bus park might need extension in the future, and suggested the site boundaries should be Abbey Street, Royal East Street and Orchard Street. Consequently, the City Surveyor was sent away to prepare and submit plans for the enlarged area, and the City Treasurer to recalculate the finances.

Another four months elapsed before this work was completed. On 25 March 1935, he put forward a revised scheme at something like four times the previously reported costs:

'Approximate cost of acquisition of land and buildings less cost of land for widening Abbey Street	£74,400
Estimated cost of construction of station including Orchard Street and Royal East Street widening	£12,000
Estimated cost of buildings to be erected on site, including platforms	£34,070
	£120,470

'The proposed new building, containing the Waiting Hall, has been placed at the junction of Belgrave Gate and Abbey Street. The accommodation of this building also comprises four lock-up shops, lavatories for men and women, parcels office and offices for the Bus Companies. Six telephone kiosks have been placed in one of the entrances.

'A small building has been planned at the north end of the Station. This comprises Office and Mess Room, with lavatories, for the use of Drivers and Conductors.

'The Station is divided into two separate sections, east and west of a central uncovered access platform. These east and west groups of platforms serve the Belgrave Gate and All Saints Road services respectively.

'The Station has been planned to permit of one-way traffic within the boundaries.

'In accordance with the wishes of the operating Bus Companies, it is suggested that all the Departure Platforms be completely covered with cantilever reinforced concrete roofs.

'The Station has been planned to accommodate 45 buses at platforms which have been placed 20ft apart so as to allow of waiting space for a further 45 buses. Representatives of the Midland Red and other operating Bus Companies have inspected the plans and approved of the layout generally, but a suggestion has been put forward by certain of these operators that there should be a smaller number of platforms with greater space between. An increase of distance between the platforms to 30ft would reduce the number of buses to be accommodated at the platforms to 39, and a reduction in the total cost of the Station would be approximately £2000.'

The design of the new bus station in Derby met with particular favour, but it was recognised that it was:

'…impossible to have a similar layout to Derby owing to the property fronting the main Belgrave Gate thoroughfare being unobtainable. Derby have [sic] two-way traffic, whereas this scheme is entirely one within its own boundaries. Both schemes have mess rooms and lavatory accommodation for the Bus Drivers and Conductors. Derby (bus) station accommodates the whole of the services for the City, whereas this scheme covers only a portion of the City's services. Derby has a cafe, whereas the addition of this is not considered warranted here. In both schemes the public waiting platforms are totally covered.'

By way of introduction, the City Treasurer's report began by referring back to the meeting in October 1934 and the proposals on the table at that time. He repeated the information gained from neighbouring cities and towns regarding their experience in working these stations, which in summarised form were:

- Coventry – was opened in 1931. Users paid 1d per departure but two extensive users paid annual costs of £450 and £55 respectively
- Nottingham charged 1d per departure with a minimum of 10/- per month
- Derby – was opened on 2 October 1933. The total building cost was £43,740. Charges – stage services 1d per departure, express services 3d per departure, both subject to a 10/- per month minimum
- Birmingham – no bus station. There was a loading station in the centre of the city where Midland Red was allowed to erect at its own expense shelters and signboards. There were no charges

His summary concluded with the statement 'In none of the towns mentioned is the bus station self-supporting'.

He then went on to point out that the revised scheme provided a bus station of considerably larger capacity than the one originally contemplated, of 2½ acres, bounded by Belgrave Gate, Abbey Street, Royal East Street and Orchard Street, plus a small area for waiting vehicles on the other side of Abbey Street. As 'the Traffic Commissioners feel 1d is the most that can be charged, this produces £1000 per annum leaving more

than a penny rate to be borne by the rate fund', and he concluded by saying that:

'…it would appear fairly certain, therefore, that some part of the cost of providing such a station as is now proposed would fall upon the rate fund, and in examining the financial aspect of the scheme, what has to be determined is the extent to which the ratepayers may reasonably be called upon to contribute towards the cost of a service rendered necessary by new traffic problems which must be dealt with in the interests of the community generally.'

He also took issue with bus proprietors' suggestions regarding covering all platforms to their full extent; 'this I consider to be an extravagance and one that could be reasonably curtailed'. Accordingly, provision was made only to cover only one-third.

Although the plans were approved on 13 May 1935, alarm bells appear to have been ringing in several quarters. On 10 July, a conference was held between the Watch (Permanent Omnibus Station) and the Town Planning (Schemes) Sub-Committees, which considered the revision along with a suggested alternative scheme for a permanent omnibus station on a slum clearance area between Burleys Lane and Gravel Street (approximately 100 yards from the proposed Abbey Street site). The City Surveyor thought that the vacant land already acquired for Abbey Street could be used as a temporary omnibus station which would accommodate the Belgrave Gate traffic pending the completion of the new scheme at Burleys Lane/Gravel Street. The Town Planning Sub-Committee felt that in view of the expense entailed in the acquisition of the Abbey Street site, consideration should be given towards obtaining a 'more economical' solution, and the Watch Committee pronounced themselves satisfied that the neighbourhood of Belgrave Gate and Abbey Street was a good position for the establishment of a bus station in the district and any suggestion for an alternative site must be situated in that locality. Estimated costs were given as £45,635. Not surprisingly, the alternative scheme was adopted at the Watch meeting on 16 July, where it was also noted that, contrary to previous thinking, 'provision be made for the erection of a cafe on the site'.

So, work was now proceeding on two fronts. For the Abbey Street bus station, November 1935 saw the

Watch approve an outlay of £330 to resurface a sufficient area of land on the site to accommodate the omnibuses now using the Belgrave Gate omnibus station. The following January, the construction of a temporary shelter to serve as a waiting room at a cost of £300 was authorised. Finally, having had the approval of the Traffic Commissioners for the East Midlands for the change of terminus from Belgrave Gate to Abbey Street, the various operators were asked to make arrangements for the changeover as from 3 February 1936. The regulations that accompanied them were effectively a restatement of the conditions attached to the 'Form of Undertaking' that had been introduced in 1928, but it appears that the intention was to apply them far more

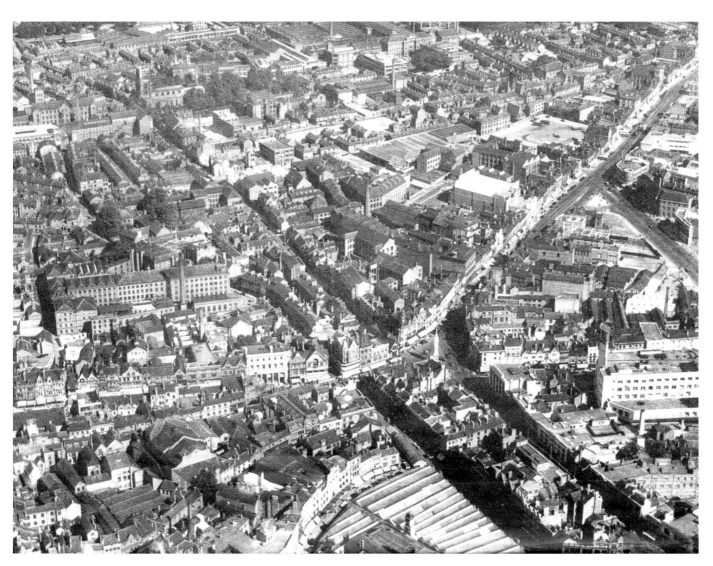

70. There is much to admire in this magnificent aerial view of Leicester city centre taken in 1937, but most importantly, it presents a rare opportunity to see the Abbey Street bus station. To help us get our bearings, the top of the Clock Tower can just be seen at the bottom of the photo, with Belgrave Gate going away diagonally to the right. Charles Street is on the far right, with the site of the Belgrave Gate bus station already having been partially redeveloped. The entrance to Abbey Street is almost opposite Charles Street, and the open space behind the buildings on the western side of Belgrave Gate is the bus station itself. At least three vehicles are parked up there, and it appears there are buses exiting onto Belgrave Gate from Garden Street and Orchard Street.

Meanwhile, on the left-hand side of the photo, roughly two-thirds of the way up, is another open patch of ground, shaped like a letter 'P'. This is the extent of the future St Margaret's bus station that has thus far been cleared of slum housing; clearly there was still some way to go before the entire site was secured. Midland Red's Sandacre Street garage, which opened on 1 February 1937, can be seen where the inverted 'V'-shaped roofs are, just to the south of the St Margaret's site.

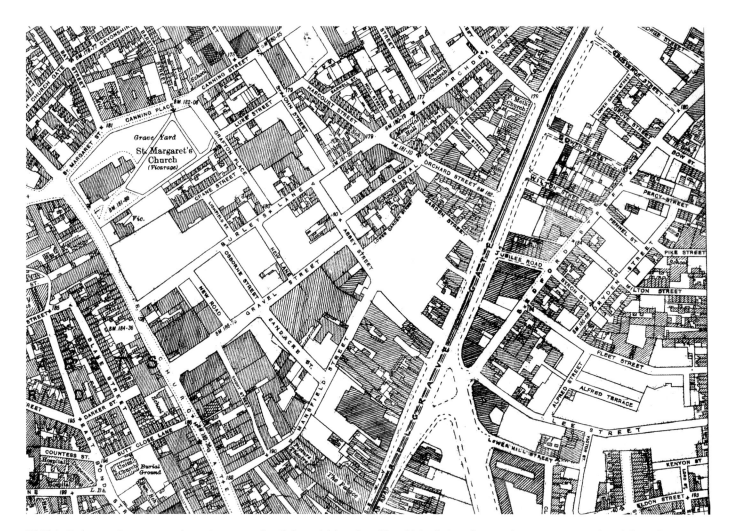

71. This Ordnance Survey map shows in greater detail the neighbourhood in which all three bus stations were situated, and dates from 1938.

The Abbey Street bus station can be clearly seen in the centre of the map. The original plan, which was to make Royal East Street and Orchard Street the outer boundaries, was not proceeded with when the cheaper option of St Margaret's was adopted, Lower Garden Street and Garden Street fulfilling that role instead. Although not named, Green Street was the first of two roads between Abbey Street and Garden Street and this was the means by which vehicles gained access to the station; departures were via Garden Street. The map also shows the two parcels of land put aside as additional waiting ground for buses – one on the Abbey Street/Mansfield Street corner, the other bounded by Abbey Street, Royal East Street and Burleys Lane.

It will be noticed that the land within the triangle formed by Belgrave Gate, Jubilee Road and Bedford Street has been almost entirely redeveloped in the three years since the closure of the Belgrave Gate bus station.

By 1938 work had started on the proposed Burleys Way bus station, and the three predominantly empty parcels of land bounded by Burleys Way, Abbey Street, Gravel Street and New Road indicate the extent of the slum clearance programme by that time. Osborne Street and New Lane will disappear when the building of the bus station finally gets underway. Midland Red's Sandacre Street garage which opened in 1937 is not specifically shown, but can be identified as the shaded section with entrances on each of Gravel Street, Sandacre Street and Mansfield Street.

Once again I am grateful to the staff at the Leicestershire, Leicester and Rutland Record Office for allowing me to use this document, which plays such an important role in giving a graphic perspective to this part of the narrative

stringently than had been the case at Belgrave Gate. The degree of control that the Watch wanted to exert over all operators is remarkable, though not especially surprising:

- *only public service vehicles operating on stage carriage services to and from the* city on routes via Belgrave Gate and Belgrave Road will be permitted to use the station.

- on all occasions while on service, vehicles on inward journeys are to enter the omnibus station via Green Street, and depart on outward journeys via Garden Street. No vehicle shall remain stationary on any part of either Green Street or Garden Street.
- all such vehicles shall use only the particular stand in the station to which they are allocated.
- all such vehicles shall be driven on to the stand in their order of departure only.
- the first vehicle to leave according to the timetable shall be driven to the head of the stand, and following vehicles shall be drawn up close behind.
- vehicles used for duplicating purposes shall take up positions alongside the service vehicles duplicated.
- vehicles intended for duplicating purposes shall not be so used unless immediately prior to the time of departure the service vehicle is unable to accommodate the passengers desirous of travelling by such vehicles. Duplicating vehicles shall not then be taken on to the stand until two minutes before the time the service vehicle is due to depart, and both vehicles shall leave together.
- no vehicle shall occupy a position in the station for a longer period than one hour at any one time, and unless the driver or conductor of the vehicle is in continual attendance.
- all vehicles waiting to take up service shall be so parked in the station that uninterrupted passage is allowed to each of the stands.
- vehicles shall on all occasions leave the station strictly to scheduled times.

An idea of the range of Midland Red services transferring to Abbey Street can be gained from this list, compiled from the September 1935 timetable:

SERVICES MOVING FROM:

- BELGRAVE GATE BUS STATION	- ALL SAINTS ROAD
L20 Humberstone Lane	631 Anstey
617 Syston Green	632 Newtown Linford
618 Queniborough	633 Woodhouse Eaves
619 Rearsby & Thrussington	634 Glenfield & Ratby
622/623 Twyford, Oakham & Melton Mowbray	657 Shepshed
625/626/628/629 Loughborough (*joint with Trent 121/22*)	665 Coalville
649 Ratcliffe & Hoby	667/669 Ashby-de-la-Zouch (*also departing from The Newarke*)
650/51 Barkby	670 Ibstock
652 Seagrave	
655 Sileby	
659 Loughborough	
661 Melton Mowbray (*one journey Mon-Sat*)	

There was still insufficient made-up ground upon which waiting buses could be accommodated, and on 17 March 1936 an additional area was sanctioned, to be resurfaced with tarmacadam at a cost of £95.

Leicester Mercury **readers remember**

In June 2013, a plea for readers to come forward with memories of either the Belgrave Gate or Abbey Street bus stations appeared on the Mr Leicester page of the *Leicester Mercury*. Not surprisingly, since Belgrave Gate had been closed for 78 years, responses tended to favour the Abbey Street site, which may have been helped by its continuing use as a parking ground until the early 1960s. But Ken West of Humberstone was old enough to remember both:

'I clearly remember using both of these sites, travelling on the L20 Midland Red buses from the City centre via Belgrave Road, Gipsy Lane, Barkby Road to its terminus at the railway bridge on Humberstone Lane.

'The 1920s one was situated behind where the present Kingstone store stands, on an area previously demolished and just levelled for the use of buses with no public service whatever. Presumably the site was sold to enable the Kingstone's to be built.

'The 1930s site was directly opposite across Belgrave Road, behind the frontage of shops and once again, a demolished site, cleared for the use of buses…to Syston, Thurmaston, Melton, Birstall, Loughborough, etc. I believe it was used until the first St Margaret's bus station was built.

'I recall as a callow youth of 14, having attended an Evening Institute's boxing competition in Orchard Street on a bitterly cold night, boarding the L20 bus at the Abbey Street site with a bag of hot chips. I was settled comfortably in my seat, only to be ordered politely by the conductor, that following a complaint by the only other person on the bus, that I must get off and eat my chips outside.'

Ted Brown of Markfield was an infrequent visitor to Abbey Street bus station but recalled the different companies that used it during this time:

'I remember, as a youngster of 10 or 11 (1936/37), using the Abbey Street station three or four times when travelling to Mountsorrel. It had a hard tarmacked surface …There was a good selection of buses on the Loughborough route. I recall the blues of Allen's (Mountsorrel), the yellow buses of Boyer's (Rothley) and the brown Kemp and Shaw ones (Leicester). Also 'Midland Red' and their allies 'Trent'. Buses left directly onto Belgrave Road. I don't recall entering the bus station on return journeys, assuming passengers were set down on the pavement of Belgrave Gate.'

Robert Brewin of Ravenstone was not only able to give some additional details about the Abbey Street facilities, but also added his recollections of the All Saints Road site, which he refers to as Soar Lane.

'During the period 1935-41, until St Margaret's bus station was opened, I can remember the area of waste land left from the demolition of old property that was bounded by Orchard Street, Abbey Street and Burley's Lane being used by buses arriving in Leicester from Loughborough and Birstall etc.

'It was just an area of brick rubble and ashes rolled reasonably flat and entry gained from Belgrave Road down Orchard or Garden Street. The only facility I recall was a café where a cup of tea and possibly sandwiches could be obtained, the access to which, if I remember correctly, was down a flight of stairs into a basement area, this could have belonged to the rear of one of the shops that fronted onto Belgrave Road being all that was left after the demolition work. The Haddenham family ran this establishment at one time.

'One can only suppose that there was a toilet facility somewhere nearby for use by the bus crews and passengers.

'Bus companies using this piece of land would have been Kemp & Shaw, Allen's Blue, Boyer and the Birmingham and Midland Motor Omnibus Company – the 'Midland Red'.

'In addition to this bus station there was another in use during this period situated under one of the arches bridged by the Great Central Railway. This was in Soar Lane opposite the entrance into Sanvey Gate; buses from here were destined for villages lying adjacent to the Groby Road and Anstey, Newtown Linford and Cropston etc.

'From memory these were Prestwell's, Hutton's and I think Brown's Blue and possibly Midland Red.'

Preparing the Burleys Lane site

At the new site, now known as Burleys Lane omnibus station, plans were still being worked upon. On 12 March 1936, the City Surveyor reported various changes to the surrounding road widths which would give increased accommodation to the bus station, providing for 47 buses at single platforms placed 20ft apart and allowing for a waiting space of a further 47 buses, with an additional area of 0.2 acre at the corner of Archdeacon Lane and Abbey Street for the accommodation of a further 20 waiting vehicles. This 'permitted two additional platforms to be constructed making a total of 12 and incurring a proportionate increase in the cost of canopies to partly cover same'. Costs for providing a large waiting room, cafe and kitchen, office and storeroom, kiosk and ladies and gents conveniences, when added, increased the overall estimate to £55,582. It was resolved that the scheme as now submitted be approved and reported to the Council at their next meeting.

The minutes indicate that, much as had happened with the 'temporary' Abbey Street station, considerable time would now elapse while the bureaucracy of acquiring and then demolishing the buildings that currently stood on the site of the new bus station took place. Tenders were being awarded for this purpose throughout the rest of 1936 and well into 1937, by which time Midland Red had opened its new, purpose-built garage for 70 vehicles on Sandacre Street (1 February 1937), which had the added benefit of an entrance on Gravel Street, opposite the proposed bus station, as well

as another on Mansfield Street. In fact, it was not until December 1937 that the City Surveyor appeared before the Watch with the plans for the bus station, claiming that 'the whole of this site has been acquired and demolition (is) nearing completion'. The basic platform layout and vehicle accommodation details were unchanged from his previous report. He went on:

'…the planning is so arranged as to permit of all buses standing at the platforms to face the Waiting Room building. It is suggested that the platforms, which are 7ft and 8ft wide shall be covered to the full width and for one-third of their length, and seats will be arranged for the full length of the platforms…should the need arise in the future, provision can be made to extend the canopies. The Waiting Room has been designed as a one storey brick structure upon an island in the centre of the site and will comprise public waiting space of 1300ft. In accordance with your Committee's suggestion a cafe has been included, leading off this space, containing an area of 840ft with necessary stores, services etc adjacent, and also a small kiosk at the Gravel Street end of the building which may be operated in conjunction with the kitchen or otherwise. Lavatory accommodation for both sexes has been included in the scheme. This is easily accessible from within and without the building.'

Instructions from the Committee were sought to enable tenders to be invited for construction, and Ministry of Health sanction to be obtained so that 'the work can be commenced, if possible, in April next year'. His report was carried in every respect. However, that proposed start date was missed, as the City Engineer admitted the following month that slow progress was being made on the demolition front, and in June,

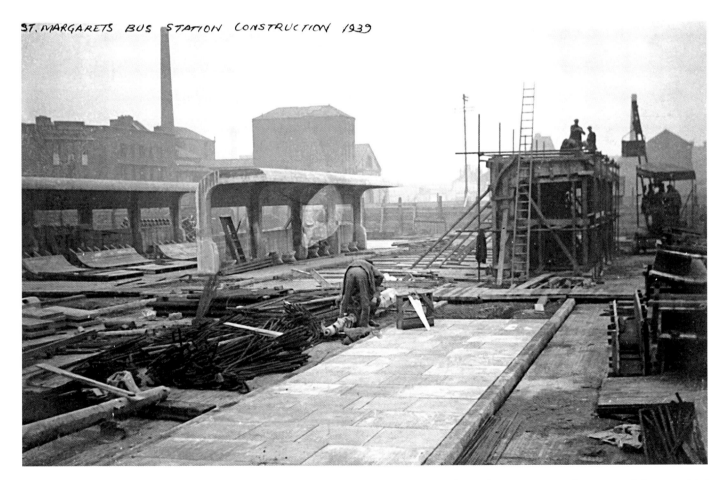

72. It is 1939, and although war is on the horizon, building work is in full swing at the Burleys Lane site at last. Two of the one-third length platform canopies have been completed, and a third, with its uncovered paved area, is under construction. It appears that this is the western side of the bus station, looking towards Abbey Street.

the Watch were told that, contrary to the earlier report, 'with the exception of a small portion, the whole of the property required for the omnibus station at Burleys Lane has now been acquired under the Housing Acts'. A start was however finally made; by December, tenders were being awarded for the construction of the Waiting Hall building (£8,840) and the general layout of the site including platforms (£14,322). Despite the storm clouds gathering over Europe, the Watch decided on 7 February 1939 that 'construction of an underground shelter at the omnibus station is considered not advisable', but otherwise, progress appears to have continued unimpeded until September. By 14 November, it was reported that 'work on the omnibus station at Burleys Lane had been completed up to ground level at the outbreak of war and has since been suspended. If the carcass only of the building were completed it could with certain alterations and additions be converted into a public shelter for 480 persons at an increased cost of £565'. It was resolved that the bus station be completed (subject to Home Office approval, which was forthcoming) with the alterations and additions incorporated and the increased cost met by the Committee.

Thus the cessation of building work proved to be only temporary, as by 17 September 1940 the Chief Constable told the Watch that the 'omnibus station in Burleys Lane is nearing completion and consequently it will be necessary for the Committee to consider (1) the amounts to be paid by the various operators of public service vehicles using the station, and (2) the appointment of an attendant'. The contract for the platforms and the canopies was completed in October. In addition, the Town Clerk highlighted the need for the City Council to make an order immediately under sub-section (2)(a) of Section 90 Road Traffic Act 1930 appointing Burleys Lane as a station for public service vehicles, a course of action which was unanimously recommended. But the prospect of enemy action was still impacting on the site, as the Watch were also asked to consider whether the land at the corner of Abbey Street and Archdeacon Lane, purchased to enable provision to be made for waiting vehicles, could be made available for the erection of surface-type air raid shelters, as it was thought doubtful that it would be required for buses until after the cessation of hostilities; a course they duly approved.

Preparations for opening

By the start of 1941 the main bus station was virtually ready for use. On 21 January, the Watch issued an edict detailing the operators that were 'required' to use the bus station, namely:

- BMMO Co Ltd
- Leicester City Transport
- Messrs Boyer & Son
- C.H. Allen
- Messrs Kemp & Shaw
- J.H. Hutton
- Prestwell's Garage
- Hylton & Dawson
- Astill & Jordan
- Windridge Son & Riley
- L.D. Brown
- Messrs Warner & Son
- H. Parsons
- T.H. Smith

A charge of 1d per bus departure would be paid by them in respect of all public service vehicles operating on their services to and from the city as follows:

- EASTBOUND, via Humberstone Road, Uppingham Road and Scraptoft Lane; city terminus previously Haymarket (Toll-ground)
- NORTHBOUND, via Belgrave Road and Melton Road or Loughborough Road and Thurcaston Road; city terminus previously Belgrave Gate station (note that this meant the temporary bus station on Abbey Street)
- NORTH WEST BOUND, via Woodgate and Groby Road or Woodgate, Blackbird Road and Anstey Lane; city terminus previously All Saints Road: via Woodgate and Groby Road (Midland Red services 667/668/669); city terminus previously The Newarke: via Woodgate and Groby Road (to Gilroes cemetery); city terminus previously Church Gate/Eastgates corner (Sundays) or Church Gate/Mansfield Street corner (other days)

All the city termini to be vacated would be abolished from the date the new station came into operation which, following confirmation of the Section 90 (2) order by the Ministry of War Transport on 24 June, was split into two parts. The 1 July 1941 edition of the *Leicester Evening Mail* takes up the story under the headline 'New City Bus Station'.

73. On 3 August 1941, a fortnight after the bus station was fully opened, the driver and conductor of Leicester 337 (DBC 228) pose with their vehicle. It was a Metro Cammell bodied AEC Renown, one of 16 received in 1940 and was due to work service 29 to Gilroes Cemetery from platform 12 – the only Leicester City Transport route to operate from St Margaret's in the early days. The unenclosed shelters, and the destination boards (which initially had white writing on a black background) can be clearly seen.

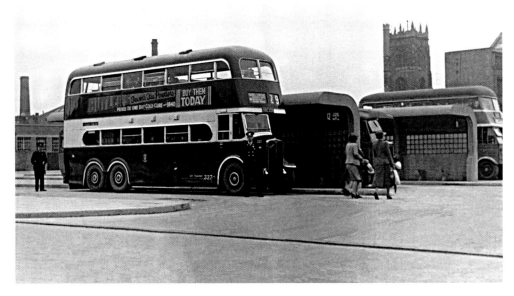

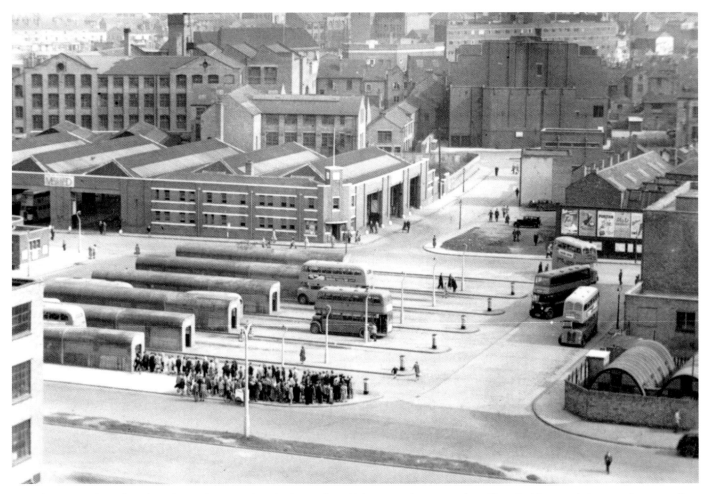

74. It is appropriate that this photo showing the platforms from 7 (nearest the camera) to 12 at St Margaret's bus station as well as Midland Red's Sandacre Street garage should have been taken from the tower of St Margaret's Church. It has the look of a Sunday or Bank Holiday in the mid 1950s, with the queue on platform 7 likely to be heading for local beauty spot Bradgate Park, maybe on the AD2 which seems to be heading in their direction. It seems that the ice cream salesman has had plenty of trade too. Both this and the next photograph show the enclosure of the shelters, which took place in 1945/46, in contrast with their 1941 appearance.

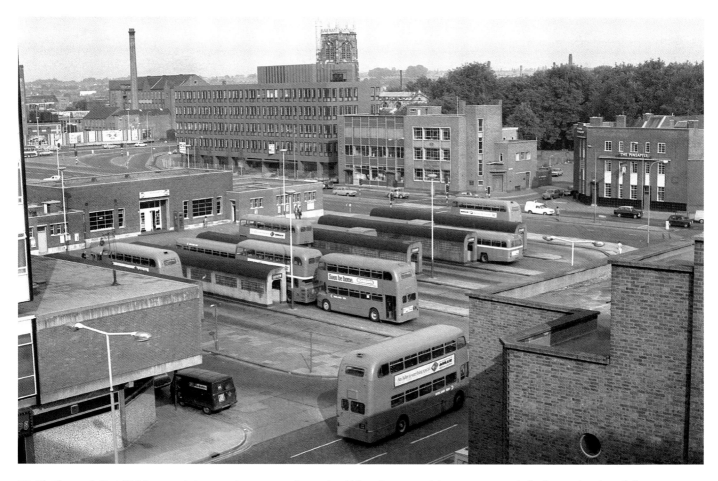

75. Platforms 1-6 at St Margaret's bus station as seen from the Abbey Street multi-storey car park (built on the site of the temporary bus station and subsequent parking ground) in June 1974. Wigston-based D9 5393 (AHA 393B) makes its way down Abbey Street, while the bus station itself houses three more D9s, and a couple each of Daimler Fleetlines, Leyland Nationals and Midland Red's own 36 foot saloons, probably S17s. The cafe, waiting room and the 1949/50 extension are clearly visible, while the old, narrow Burleys Lane has been transformed into the eight-lane inner-ring Burleys Way of today.

'Leicester central bus station in Burleys Lane, which has been ready for some months, is to be brought into use next Monday. On that date buses which have been using the temporary Green Street[6] stand will transfer to the new station, and on 21 July buses using All Saints Road (including those Ashby and Coalville buses which use The Newarkes), the Haymarket, and the Gilroes buses from Church Gate will also transfer. Other existing private bus stands will continue as at present.'

The minutes of the Watch Committee are silent as to the allocation of the bays between the various operators and services, but it has been possible to piece together from other documentary evidence the likely geographical division. Bays 1-6 handled all eastbound services along the A47 towards Uppingham, as well as the Twyford and Oakham routes, and most of the northbound services on the A6 and A607, including Loughborough, Derby, Syston and Melton Mowbray. Bay 7 also handled Loughborough services, although these were the country routes via Swithland and Woodhouse Eaves, while Bays 8-11 were for west and north-west bound services to Ratby and Glenfield, Groby, Coalville and Ashby-de-la-Zouch. Bay 12 was for services to Gilroes Cemetery.

Fruition at last

And so, finally, Leicester had its first purpose-built bus station, though this being wartime, there was still work to be done before it could be regarded as complete in every respect. On 7 October 1941, the City Surveyor was asked to report on the possibility of providing

accommodation in the central building at the omnibus station for the sale of refreshments, and also to give consideration to the provision of seats along the length of each platform. As regards the latter, he returned with an estimate of approximately £150, on the understanding that home-grown timber could be obtained for the work – obviously an important consideration in wartime. In February 1945, the provision and fixing of timber backs to existing seating to the platform shelters was put in hand at a cost of approximately £60. The question of the cafeteria however turned into a particularly long-running saga, as the successful tenderers, Midland Milk Bars Ltd, were denied the appropriate licence by the Ministry of Food in May 1942. There was a further, unsuccessful, application two years later, and it was not until October 1947 that the Watch agreed to the use of the premises by the Civic Restaurants (Special) Committee

for the purpose of a snack bar and sale of light refreshments (seven days a week service) at a rent of £375 per annum.

In November 1944, the Chief Constable recommended that 'some form of lighting at the Burleys Lane omnibus station' be installed. It was suggested (and subsequently approved) that this should take the form of one bulkhead light under the canopy of each of the 12 platforms and that on each platform there should be one standard lamp. The cost, approximately £69, was devolved onto the Watch Committee as it could not be considered to be street lighting. But a year later Midland Red wrote asking for the illumination of the platforms to be improved. The Watch instructed the Public Lighting Engineer to take whatever steps were necessary.

The Permanent Omnibus Station Sub-Committee visited Burleys Lane in December 1944 to consider

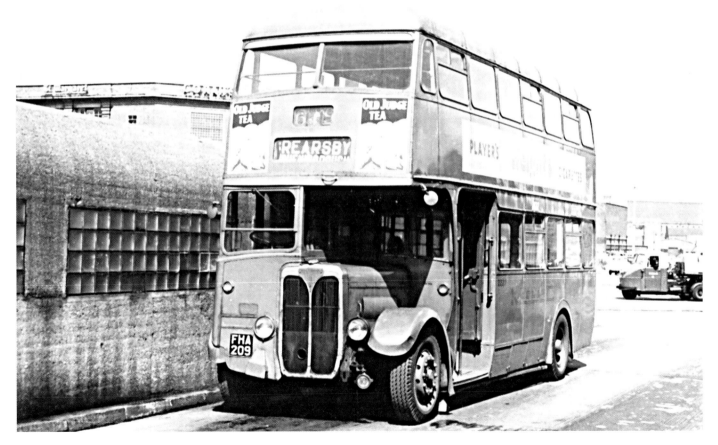

76. Three photos of buses at work in St Margaret's bus station in its early years start with the FEDD, or Front Entrance Double Decker. Over 300 were produced between 1933 and 1939; 2227 (FHA 209) came from the penultimate batch in 1938, and would shortly set off for Rearsby in this mid 1950s view, where it would occupy the terminus in Brookside last seen in Chapter 2 with A341 thirty years earlier. Note that the concrete shelter is already starting to look unkempt; more pleasing to the eye is the British Rail Scammell Scarab making its way along Abbey Street in the background.

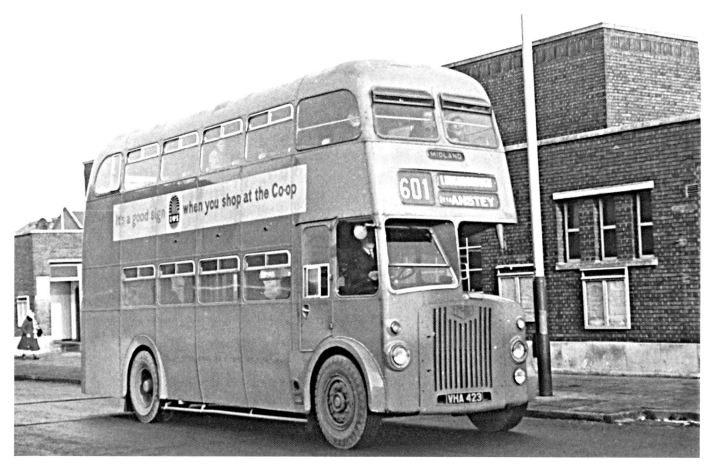

77. A close-up shot of D7 4423 (VHA 423) shows the western side of the cafeteria building; timetable display boards, four of which Midland Red had sought permission to fix upon the central building in July 1941 (with a further two dedicated to smaller operators' services), and to the rear, the toilet block, part of an extension completed in 1949 which had also seen the provision of a new parcels office, the old one becoming a cleaners' store.

what needed to be done to open the waiting rooms etc for the benefit of passengers using the station. They instructed the City Surveyor 'to approach the Ministry of Home Security regarding the release of a portion of the building being used as an air raid shelter, and subject to consent being received, to submit a report on the cost and possibility of obtaining requisite licences and sanction for the completion of the plans as originally submitted'. No objection was raised to the release of the premises and the removal of protective material so that it might revert to the use that had been envisaged for it, and the estimate for the cost for final completion of the whole scheme was £7,000.

It would appear that the passenger waiting facilities left quite a lot to be desired. At the meeting on 6 February 1945 Councillor J.J. Smith drew the Committee's attention to 'the unsatisfactory layout of the platforms and passenger shelters at Burleys Lane Omnibus Station' and suggested 'a scheme be submitted by the City Surveyor which would eliminate the draughty conditions now prevailing and provide greater shelter for waiting passengers'. This was carried, the City Surveyor being authorised to put in hand at the earliest opportunity plans to address the shortcomings. On 20 March 1945, he recommended enclosing the fronts of shelters with a concrete base wall made to tone with the existing structure and having metal framed glazed lights above. An entrance and exit would be formed at each end for passengers together with two entrances on the front to be utilised when vehicles are loading. The cost was estimated at £8,000. Tenders were eventually accepted for all the proposed improvements in September and November 1945 respectively; £6,526 for completion of

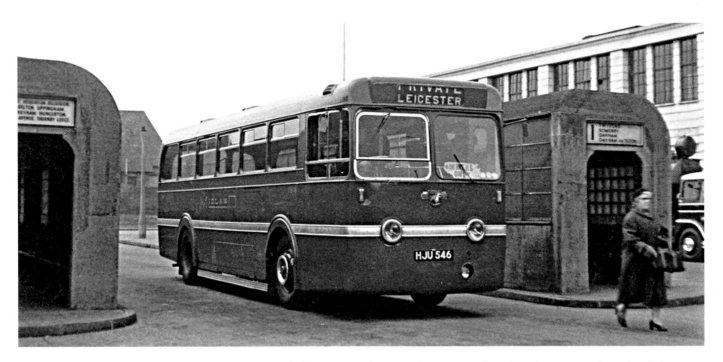

78. Although St Margaret's bus station had probably been in use for around 20 years when this photo was taken, the shelters are unchanged, though the destination panels now have the more familiar black lettering on a white background. 4848 (HJU 546) was a Leyland Royal Tiger with Leyland 44 seat bodywork that had been new to Allen's of Mountsorrel in 1952, passing to H Boyer & Son in 1955 and to Midland Red four years later. It worked out of Sandacre Street garage, just out of shot on the right, and was used both on stage carriage services and, as seen here, on "specials" for colliery workers – note the "Miners only" notice prominently displayed. The light-coloured building in the background was demolished in the late 1960s and was replaced by an office block housing three Inland Revenue tax districts, providing me with an excellent vantage point to watch the comings and goings at St Margaret's. 4848 saw seven years service with Midland Red, being sold in 1966 to Stevenson of Spath, and was not finally retired until 1973.

the omnibus station, and £7,387 for the work on the platform shelters.

On the subject of finance, the charges for the use of the bus station had been set at 1d per departure in 1941. At the Watch Committee meeting on 18 April 1950, the Town Clerk reported that the estimated cost of maintenance in 1949/50 was £1,750, and would be £1,675 for 1950/51. Income from bus operators in the 12 months to 31 March 1950 was £938 9s 4d. The total estimated deficit after allowing for loan charges was £3,045 in 1949/50 and £3,240 in 1950/51. The figure of £938 9s 4d was made up as follows:

•	BMMO Co Ltd	£719 17s 7d	• Allen's	£50 5s 11d
•	Kemp & Shaw Ltd	£42 12s 2d	• Barton's Transport Ltd	£34 18s 9d
•	L.D. Brown	£19 6s 4d	• Hylton & Dawson	£17 2s 11d
•	Boyer & Son	£12 19s 11d	• Prestwell's	£11 1s 6d
•	Astill & Jordan	£11 0s 11d	• Windridge & Riley	£8 18s 9d
•	T.H. Smith	£5 7s 11d	• W. Parsons	£4 16s 8d

After comparison with other local authorities in the area covered by Midland Red or its associated companies where there were municipal bus stations – Derby, Nottingham, Coventry, Peterborough and Oxford – the Town Clerk suggested an increase in charges effective from the start of the next quarter, 1 July 1950, from 1d to 2d. Midland Red subsequently complained and offered a flat rate £1,200 per annum for the next three years, but it was pointed out to the Committee that 2d per departure at current levels would yield approximately £1,440, and so the offer was not accepted.

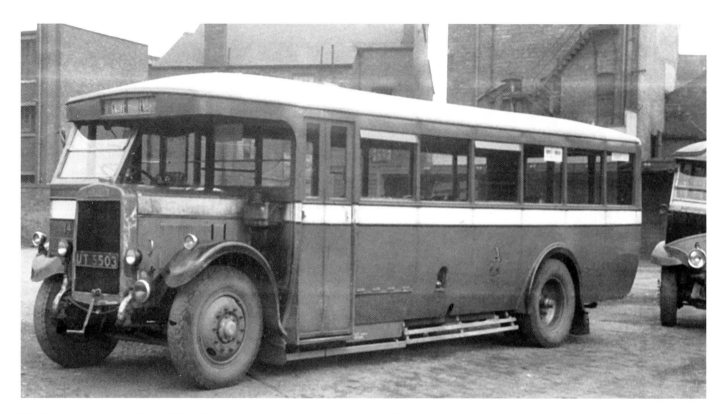

79. So what became of the Abbey Street bus station site? For almost 20 years after the war the entire area was used as a parking ground for out-of-service buses, and this view of Allen's 14 (UT 5503), a Leyland Lion LT1 new in 1929 and pictured in 1947, clearly shows kerbstones from the street layout that existed before 1935/36, and suggests that the Council's efforts to improve the surface of the bus station were fairly basic. Allen's operated stage services between Leicester, Mountsorrel (where the company was based) and Loughborough, and was a significant user of both the Belgrave Gate and Abbey Street bus stations. I'm rather pleased to be able to say I am distantly related to the Allen's – Charles Allen was the husband of my first cousin twice removed.

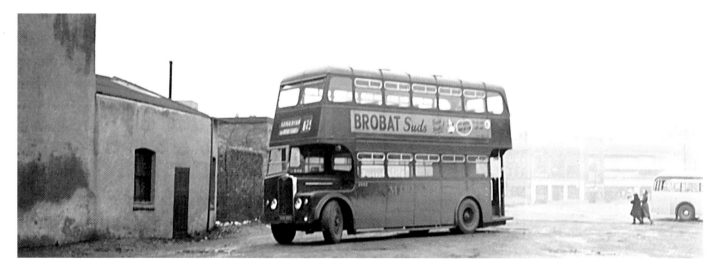

80. Not the finest quality photograph, but it does fully reveal the extent of the area covered by the Abbey Street bus station, and subsequently the parking ground. The photographer is standing in Royal East Street, and it is the businesses on Belgrave Gate that can be seen in the far distance. The coach standing on the right of the picture is facing onto Abbey Street, so the new St Margaret's bus station is to the photographer's right. Only one Midland Red vehicle is in evidence, 2452, a Guy Arab I new in 1942 with a wartime utility body by Weymann; the picture can be dated to 1950 onwards, when 2452 was rebuilt by Brush, though in this guise it had only a short working life, being withdrawn in 1956.

What's in a name

Variously referred to as the Burleys Lane or Abbey Street bus station, no-one seems to have given any thought to a proper name for the new facilities, that is until the Vicar of the nearby church wrote to the Watch Committee, who considered his letter at their meeting on 22 July 1947. It was unanimously agreed that henceforth Leicester's first and foremost bus terminal should be known as St Margaret's bus station.

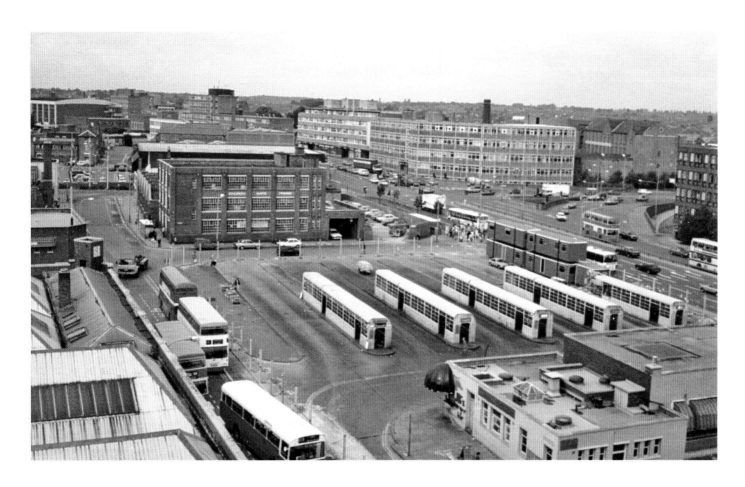

Above, right and overleaf: 81-84. Before we leave St Margaret's, one further, important aspect of its history should be considered. After some 43 years of operation in its original form, it badly needed updating. It closed in July 1984, with termini moved (in the main) to Gravel Street and Abbey Street, and was completely rebuilt. These four photos, in order and starting above, show platforms 7-12 before (3 August) and after (7 October) the site was cleared; the skeleton of the western half of the new bus station in position (9 November), and the completed facility, open for business on the first day (5 May 1985).

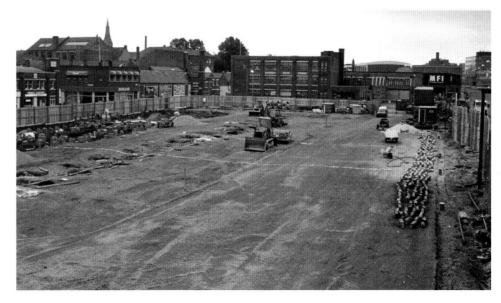

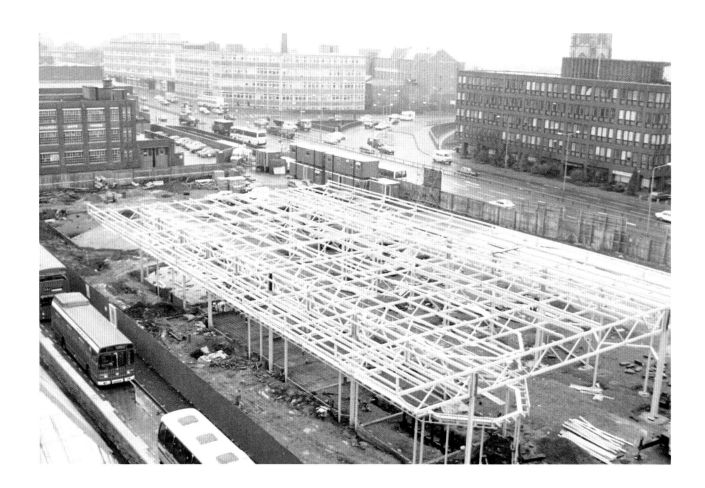

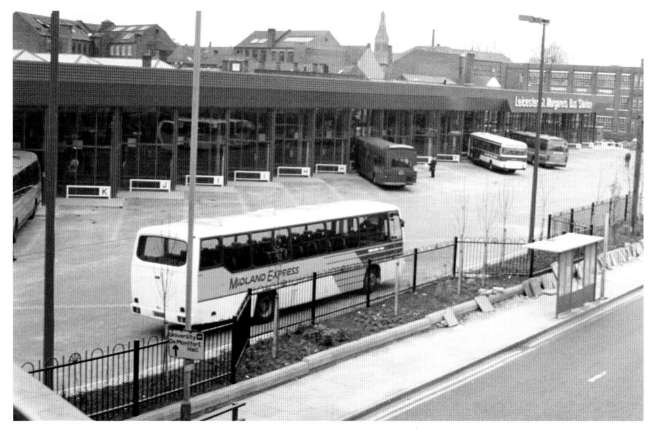

1924-1949: THE TWILIGHT OF THE ELECTRIC TRAMWAY

Introduction

After Melton Road in 1905 there would be only four further extensions to the tramway system; a short stretch along King Richard's Road on 23 September 1915, the Welford Road line on 26 September 1922, and a new section of reserved track along Blackbird Road and Abbey Park Road on 27 June 1924. The fourth, on 31 March 1927, was a branch line from Uppingham Road on the Humberstone route down Coleman Road to its junction with Green Lane Road.[1]

So by 1924 the system was more or less at its zenith, and it would be fair to say that city dwellers were so well accustomed to the trams that anyone born after 1899 would have been hard pressed to remember a time without them. But 1924 was also the year when the Corporation finally took the plunge and launched its ffirst motor bus route, from Charles Street to Norwood Road, a residential area off Evington Lane and roughly one mile from the nearest tram - the East Park Road circular. So perhaps this is the ideal time to look back on each of the lines in turn, before the story of their decline begins.

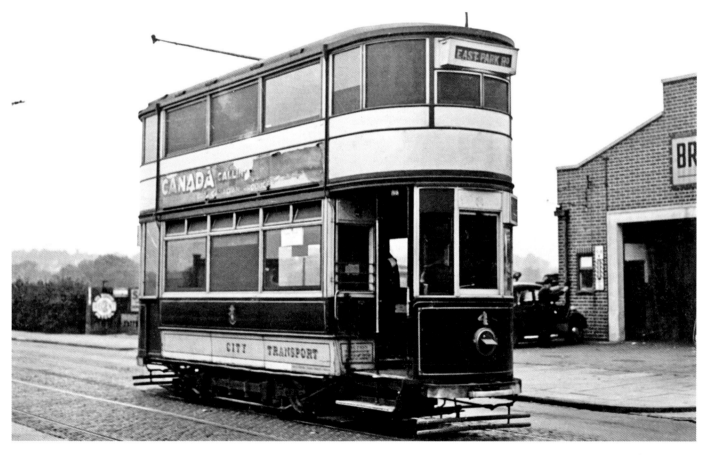

85. Three services were interworked as route 1 when service numbers were introduced in 1932; Belgrave, East Park Road (via London Road) and Western Park. Photographed by W J Haynes in 1940 and therefore typifying the appearance of Leicester trams during war-time, car 4 is standing at the Belgrave terminus of route 1 on Loughborough Road. Belgrave was one of the original services introduced on 18 May 1904, and its trams were replaced by motor buses after 9 October 1949.

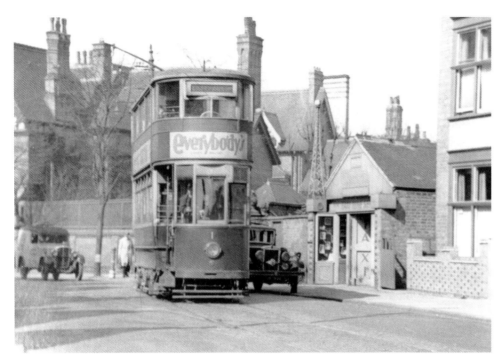

86. The East Park Road service carried two different numbers, dependent upon the direction of travel. Here car 1 is working the anticlockwise version, route 1, which climbed the London Road hill, bore left into Evington Road (where this photograph was taken in February 1949, not far from the junction), and then into East Park Road, returning to the centre via Humberstone Road. Route 2 was the clockwise version. The line was fully opened on 1 November 1904; it closed on 15 May 1949.

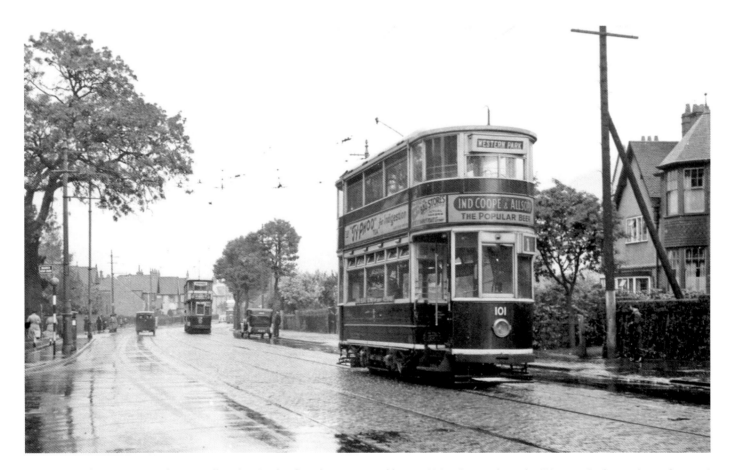

87. Leicester's trams were always well maintained, a fact demonstrated by car 101 as it stands at the Western Park terminus of route 1 on Hinckley Road during some particularly wet weather. Its bedraggled passengers for the journey to the centre wait at the roadside, and car 116 has also arrived and is waiting to take its place on the stand when 101 leaves. This line was opened on 12 July 1904; the photograph (by W A Camwell) was taken in 1938, and Hinckley Road finally lost its trams on 21 November 1948.

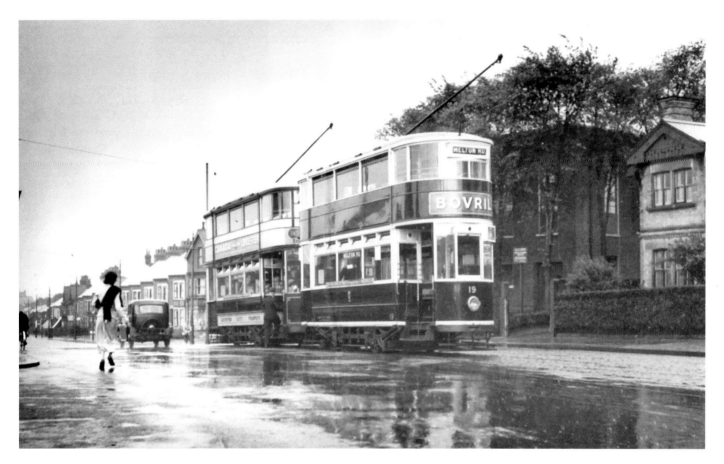

88. Route 2 married the East Park Road (via Humberstone Road), Narborough Road and Melton Road services for over 20 years, 1927-1948. W A Camwell took this photograph on 7 July 1938; judging by the weather it may have been the same day that he visited Western Park. Car 19 in the new livery is going to be the second vehicle to leave the Narborough Road terminus, which was situated a few yards north of the junction with Fullhurst Avenue and Evesham Road. Narborough Road was one of the West End services introduced on 12 July 1904, and the trams were withdrawn on 21 November 1948.

89. This is the Melton Road terminus of the 2, but in the days prior to route numbering. Car 129 is standing with the crew posing for the cameraman in 1917 or thereabouts. In view of the fact that the Corporation had seen around 50% of its staff volunteer or enlist to aid the war effort, a significant number of female conductresses came to replace them. 129 was one of the 1905 open-toppers new in 1905, and in 1911 fitted with this type of domed canopy which had been manufactured by the United Electric Car Company (successors to Dick, Kerr). The Melton Road extension was opened on 18 June 1905, and closed on 3 July 1949. The Premier Works building in the background was badly damaged by fire on 7 August 2014, and had to be demolished soon thereafter.

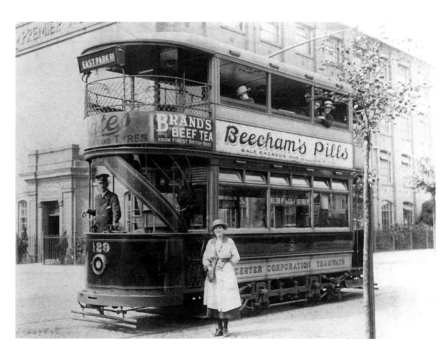

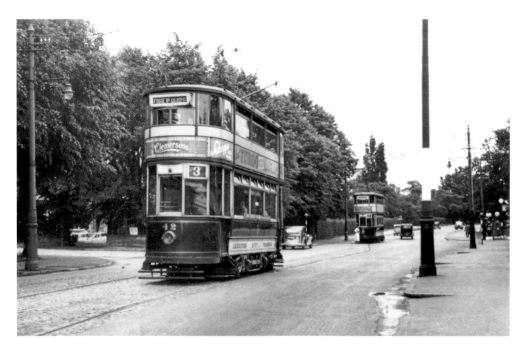

90. Route 3 brought together the Stoneygate and Fosse Road (via Great Central Street) services, and once again, W A Camwell was on hand during 1938 to record this scene, which appeared on a post-card of the time. Car 42 stands at the terminus on London Road, with car 2 in the background. At peak times, there was only a 4 – 4½ minute gap between services. Stoneygate was one of the first four routes, opened on 18 May 1904; along with Belgrave, it closed on 9 October 1949.

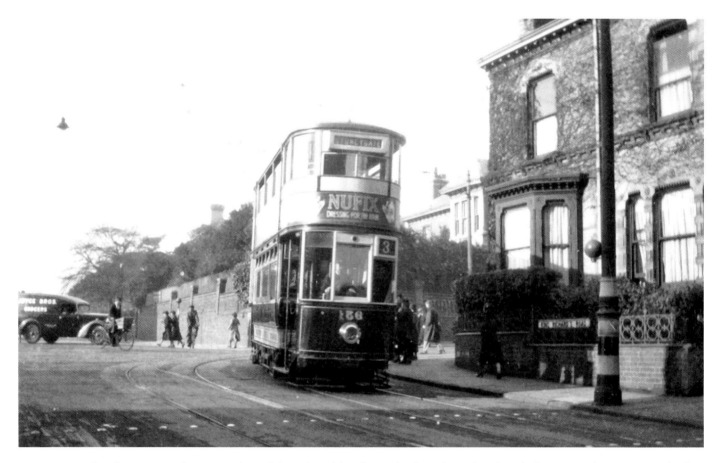

91. Car 156 makes the turn out of Fosse Road North into King Richard's Road – these days a bustling dual carriageway – on its way back to the Clock Tower and Gallowtree Gate, again in 1938. The destination screen is already set for "Stoneygate", and will have been changed around the midway point (between Beatrice Road and Pool Road). The King Richard's Road section was not opened until 23 September 1915, and closed on 2 April 1939, thus breaking the circle, with trams terminating in Fosse Road Central. 156 was one of ten cars received from Brush in 1914, built for the ill-fated "Pay As You Enter" (PAYE) experiment, for which it was fitted with larger platforms.

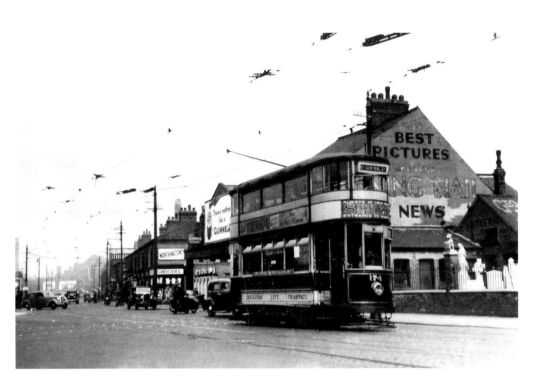

92. H B Priestley was in Leicester on 25 May 1938 and took this excellent photo of car 174, also on route 3 with a destination screen showing Great Central Street, which road it will already have traversed to get to this spot, at the junction of Woodgate with Blackbird Road, Fosse Road North and Groby Road. 174 was from the final batch of 12 cars received in 1920 from the United Electric Car Company. The Fosse Road services 3 and 4, introduced on 12 July 1904, ran for the last time on 6 July 1947.

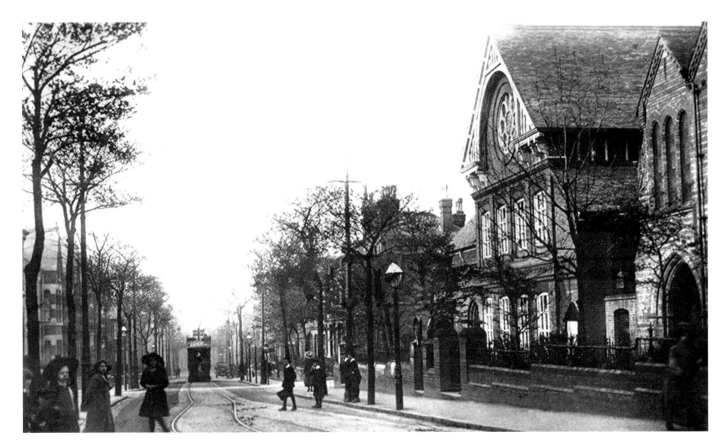

93. Despite the fact that it was one of the first four services launched on 18 May 1904, the Melbourne Road route 4 seems to have been photographed far less often than the others. This postcard view from the very early days of the system and pre route numbering does not allow the identification of the tram, but it does show the end of a passing loop followed by a straight section of single track, of which there were six along its complete length. The line was slow and by the early 1930s the track was worn out, so it came as no surprise that it was the first to close, on 13 December 1933.

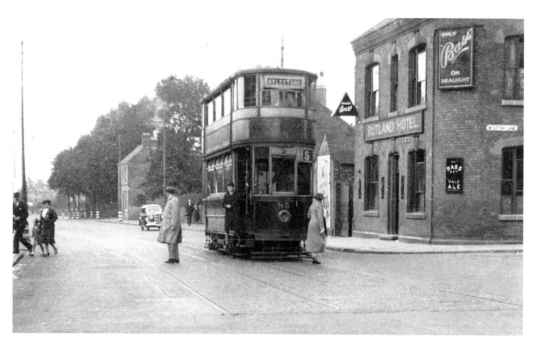

94. Route 5 to Aylestone was, at 2 miles, 5 furlongs and almost 3 chains, the longest on the system. This is car 85 newly arrived at the Aylestone terminus, which stood at the junction with Wigston Lane, opposite the Rutland Arms public house, in (it is believed) the summer of 1939. There is very little traffic to be seen, so most of those alighting from the tram are crossing in safety, though one might be concerned for the lady who is about to step out from the shadow of the tram. The Aylestone line was operative from 5 September 1904 to 5 January 1947.

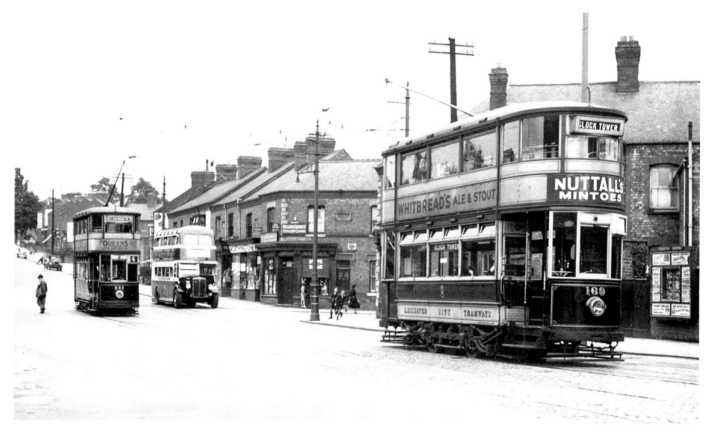

95. The Clarendon Park route 5, opened on 18 May 1904, operated via Victoria Park Road, Queens Road and Clarendon Park Road. By 1938, when W A Camwell took this photo (again, on his visit to the city on 7 July), the service had been renumbered 4 in consequence of the closure of the Melbourne Road line, and car 141 has arrived at the terminus on Welford Road, opposite Wordsworth Road; it was one of ten received in 1913 from the United Electric Car Company destined for the PAYE experiment. Car 169 is bound for the Clock Tower on the direct route via Welford Road, and a Northern Counties bodied AEC Regent from the 1937 batch (312-320) is also on its way to the centre with a 26 working from Knighton Lane. Clarendon Park trams on this line ceased on 13 March 1949.

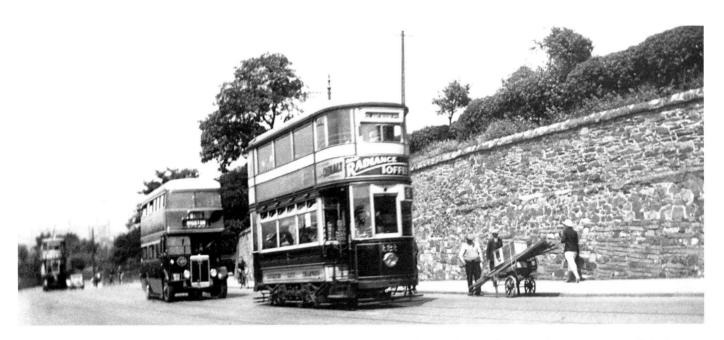

96. The alternative tram route to Welford Road was numbered 6 in 1933 and apart from a short time in 1939, was not linked to any other service. Because of the steep incline and sharp curve between Freemans Common and Victoria Park Road, cars on the route were fitted with magnetic track brakes as a safety precaution, one of these being car 121, seen making the climb past the cemetery in an S Newton photograph of 1937. The Midland Red behind it appears to be an SOS FEDD new the previous year, en route to Wigston. The Welford Road route had the shortest service life of any of those on the main roads out of Leicester, 26 September 1922 to 2 May 1945.

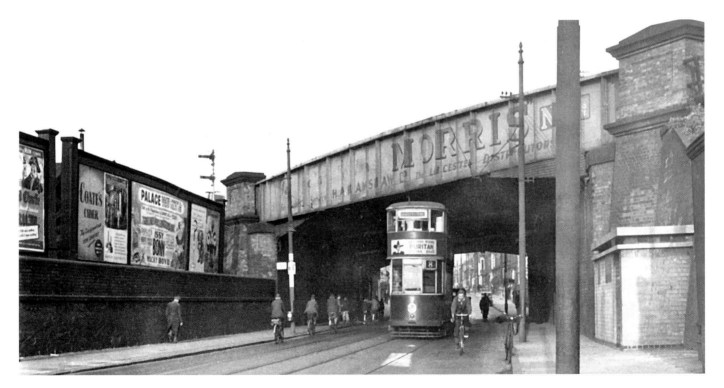

97. W A Camwell revisited Leicester on 21 October 1949 at which point only the former route 7, now renumbered 8, to Humberstone (Uppingham Road), was still operative. Car 7 is making its way back to the Clock Tower underneath the LMS railway bridge on Humberstone Road – the station of that name is on the left on the other side of the bridge. Note the advertisement for the Palace Theatre, whose variety show featured the actor, singer and comedian Issy Bonn at the top of the bill. The Humberstone line was fully opened on 1 November 1904; it was the last to close, on 9 November 1949.

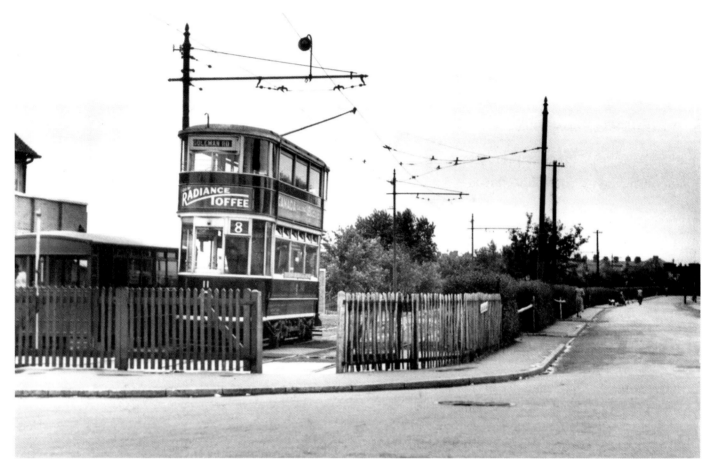

98. Camwell again – one must assume that on 7 July 1938 he rode on all nine Leicester tram lines as this is another of his views, this time of car 11 on the reserved track at the Coleman Road terminus of route 8. The introduction of bus services to serve the new estates in the Coleman Road area in 1932 and 1933 had a negative effect on tram patronage, which led to the demise of this short extension. It was the second to go, after Melbourne Road, and had a life span of just 11½ years, from 31 March 1927 to 23 October 1938.

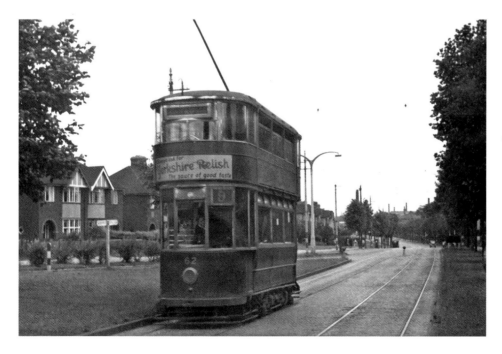

99. Route number 9 was given to the Groby Road service, though it too was subject to renumbering, appearing as service 8 by the time of the April 1938 timetable, reflecting a brief linkage with the Coleman Road route. In a J H Meredith photograph taken on 23 June 1948, car 62 sits at the terminus, just off the main Groby Road in Garland Crescent, awaiting the return trip to town. To get onto Groby Road might not have been too difficult in those post-war days of austerity when there was little other traffic around; however, for many years now, this busy junction has been controlled by traffic lights. The Groby Road line opened on 22 December 1904 and closed on 23 January 1949.

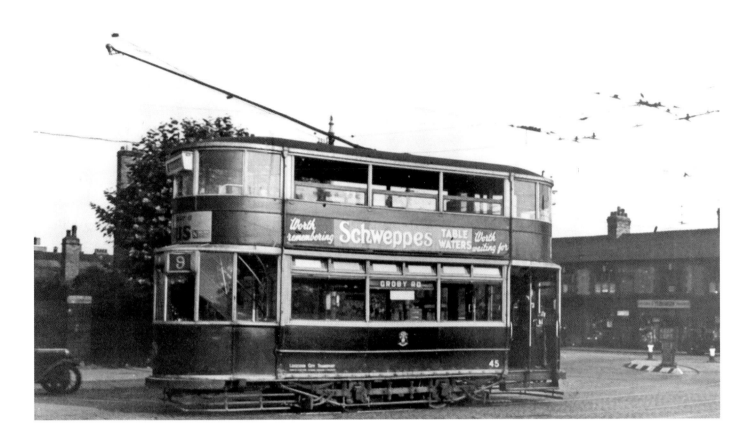

100. This I R Davidson photo dates from 1947, and the crew on car 45 have reverted to the use of route 9 to signify a Groby Road service. It is waiting on the Blackbird Road reserved track, at the junction with Woodgate, opposite where we saw car 174 earlier; when right of way is granted, it will take a right hand turn to bring it onto Groby Road. The Blackbird Road section, opened on 22 June 1924, closed on 13 March 1949.

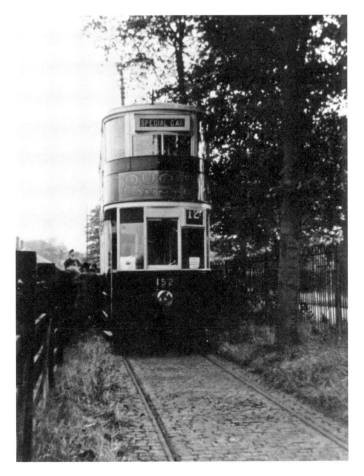

101. Visits from tram enthusiast societies, which grew in number as the system neared closure, ran as route 12, and "Special Car" would sometimes be displayed in the destination screen. Car 152 was thus employed when photographed by R B Parr on 18 August 1946 on the football siding at Aylestone. For other work, such as school outings, it is believed the route number blinds were left blank. My father, who attended Alderman Newton Grammar School (opposite the Midland Red Southgate Street garage) between 1934-39, provides an example of this. He remembers catching the tram at the bottom of Applegate Street for the journey to the school's playing fields on Narborough Road, adjacent to the terminus. He and his classmates would have their games lesson, and the tram would return them to St Nicholas Street afterwards.

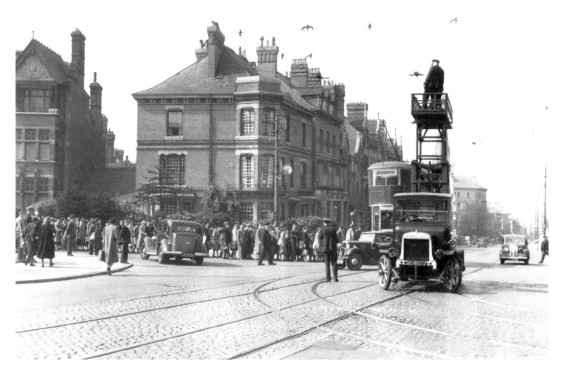

102. The Corporation maintained a fleet of three tower wagons, used when repairs to the overhead wires were needed. On 7 September 1941, the second of them, BC 8077, was on duty at the London Road/ Evington Road junction. It was acquired in February 1923 for £979, and sold on 2 December 1949 for the princely sum of £30 to R J Kerry & Co. The large numbers of people trying to board the inbound tram had been to a Jehovah's Witnesses meeting at the De Montfort Hall.

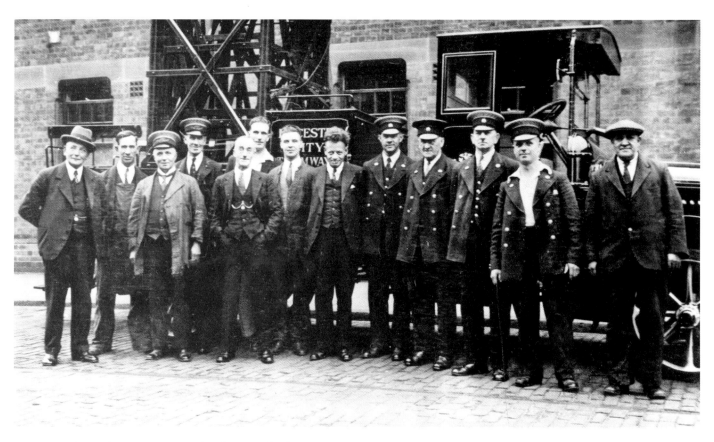

103. From about the same time as the photograph of the Midland Red crews at Welford Road garage in Chapter 2, we have a similar group of workers posed at the side of one of the Corporation's tower wagons, presumably at Abbey Park Road. From the fact that there are white and blue collar workers in evidence, it may be assumed that there was some special reason for the photo, though history does not recall what it was.

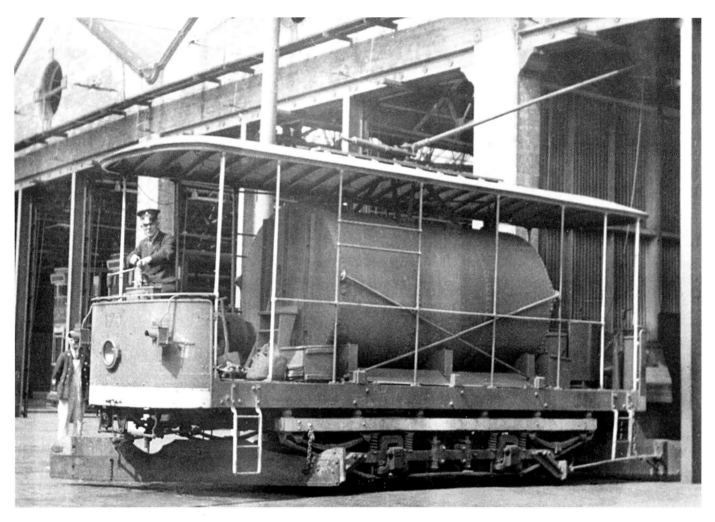

104. The Corporation also maintained three cars whose duties mainly involved the watering of the dusty tracks and streets. Known as "Cinderella" (181) or the "ugly sisters" (179/180), they were also pressed into service to repair depressions in the track caused by the cars, which could be anything up to 3" long and 1/50th of an inch deep. As M S W Pearson explained in his book *"Leicester's Trams In Retrospect"*, repairs were carried out using "a carborundum block fitted to mechanism between the wheels on each side, not unlike a track brake". This is 179, in a post-war view outside Abbey Park Road depot; it was new in 1904 as no. 100, but as new cars were received, it was renumbered to 141 in 1912, 151 in 1913, 161, and finally 179, in 1920. It was withdrawn in April 1949 and scrapped, presumably at Abbey Park Road.

At first, the new bus route was presented as a one-off. Council minutes from 27 November 1923 reported:

'...the Tramways Committee...have decided as an experiment to install a limited number of motor omnibuses for use within the City. Your Committee have gone very carefully into the subject and have inspected various types of chasses and omnibus bodies.

'Tenders have been received from several well-known firms and your Committee have decided to accept the tender of Messrs. Tilling Stevens Motors Ltd., of Maidstone, for 6 Tilling Stevens 40 horsepower type T.S.6 4 ton Petrol electric chasses (including electric light equipment) at the price of £1,072 10s 0d each, and the tender of the Brush Electrical Engineering Co. Ltd., of Loughborough for 6 single deck omnibus bodies of the "Northern" type at the price of £536 each.'

These 32-seaters were not dissimilar to the vehicles Midland Red was introducing to Leicester for their county services, and having come quite late to the motor bus scene, the Corporation was spared the teething troubles that characterised its early days. And it was at this point, a mere 20 years after the first trams had

entered service, that their future role started to be questioned. It was widely felt (then, as now) that city centre congestion was a particular problem, and one of the causes – for some, the main cause – was the tram. The fact that it should come to the fore just as motor buses were about to be introduced was a wonderful example – accidentally or deliberately – of synchronicity.

Royal Show Week had just ended, graced on the Tuesday (1 July) by the presence of Prince Henry, Duke of Gloucester, who had received a rapturous welcome from the city's population. On 5 July, and for what seems to have been the first time publicly, the trams came under fire in a leader article in the *Leicester Mercury*:

'TRAMS ARE OBSOLETE
'Royal Show Week has served to demonstrate the difficulties of Leicester's traffic problem. With the exception of the morning on which Prince Henry arrived, the traffic controls have been excellent, and the Royal visit arrangements failed not through inefficiency, but because the size of the crowd had been underestimated.

'The primary traffic lesson of the Royal Show Week is that the tramways are the chief cause of congestion. There can be no denying the fact. Streets carrying tramways are halved in effective width. As a result all traffic is slowed down and complete stoppages are inevitable. Tram tracks not only block up the street. They are a positive danger to the lighter kind of vehicle especially, and are responsible for many awkward skids. Another real objection to the electric tramcar under modern traffic conditions is its extraordinary accelerative and decelerative powers which demand violent braking from other vehicles at no small risk to drivers, passengers and pedestrians.

'No proposal to scrap the tramway system of the City could be entertained for one moment. The capital involved is enormous, and we shall be compelled to maintain the electric cars for some time yet.

'But their complete extinction is inevitable and the authorities should prepare the way for the obvious by setting their faces against any proposal to extend an out-of-date mode of transport. The Corporation's motor omnibus facilities should be developed. No more public money must be wasted on the obstructive tramcar.'

The final sentence was actually printed in italics. And moreover, of the four letters on the subject published in the following week, three supported such a view. These are two of them from 7 July:

'CUMBERSOME TRAMS
'The City will thank you for your courageous lead in the traffic problem discussion. One has only to stand at the corner of Belvoir and Rutland streets five minutes to see how the trams obstruct traffic.

'The Chief Constable said two years ago that the real solution of Leicester's traffic quandary lay in scrapping the obstructive tramway. –L.A.Y.'

'RUMOURS
'For some time I have heard it whispered that the Tramway Committee is contemplating an extension of the tramway undertaking. In years to come Leicester will be grateful to you for pointing out the absurdity of any proposal to spend public money on an obsolete kind of transport doomed to extinction.– PEDESTRIAN'

The one letter that stuck up for the tramway system had this somewhat trenchant note added at the end:

'... (the writer) forgets that the cumbersome tramcar is unsuited to present-day traffic conditions. It will have to go sooner or later.–Editor.'

The motor bus experiment was soon deemed to have been successful, and in 1925, eight more vehicles, double deckers that seated 50 people (24 up and 26 down), were acquired for a new service from Welford Place to Southfields Drive starting on 5 October. This route used Saffron Lane for much of its length, where a new Council housing estate had the potential to generate a considerable amount of traffic. No additional routes were added in 1926, but two appeared in 1927 – from Marfitt Street to Overton Road, and from Horsefair Street to Knighton Lane via Welford Road. In every case, there was some interworking with the trams along certain sections.

It is clear that the Corporation was seeking out new routes as assiduously as Midland Red were. Three more started in 1928 and 1929:

- Newarke Street to Coalpit Lane via Walnut Street and Narborough Road (12 January 1928)[2]

- Fosse Road/Hinckley Road corner to the Wyggeston Girls School and either Leicester University or the Collegiate School (12 September 1928)
- LMS Railway Station (London Road) to Knighton Church Road/Carisbrooke Road via Welford Road (7 October 1929)

By the end of 1929, in the space of 5½ years, the motor bus fleet had reached 52 vehicles,[3] or alternatively, over 30 per cent of the size of the tram fleet. Such a significant investment was inevitably going to lead to questions about how the future transport needs of Leicester's population would be met. Did the tram network, already 25 years old and with significant infrastructure costs that buses did not require, have a long-term future?

Trams or buses....?

The debate gathered momentum from the end of September 1929 onwards – at the same time as the Tramways and Watch Committees were looking at congestion and bus terminal issues – and Alderman Banton was once more to the fore. But first, it is instructive to look at a report of a public gathering held under the auspices of the *Leicester Mercury,* to test public opinion, as reported on 16 October 1929:

'SHOULD LEICESTER SCRAP THE TRAMS?
WHAT WOULD THE COST BE TO THE RATEPAYERS
BUS VIBRATION
'Leicester is apparently unconcerned over the question 'Should the trams be abolished for buses?'.

'When a debate was held last night on the subject, only 25 people were present.

'Councillor W.E. Hincks (the Lord Mayor-elect) was in the chair, and Mr J.H. Bott began the debate in favour of the "scrapping".

'The duty of a City Council, he said, was to make the city a magnet to outside people. The driver of a tram developed quite a different road sense from the drivers of other vehicles, with the result that the whole traffic in Leicester was dominated by the trams. They were responsible for slowing up the traffic, for making driving dangerous and they made Leicester a place to be avoided.

'There were of course a number of alternatives, though not the "juggernaut buses the Council had put on the streets".

'A defence of the tram was made by Councillor John Minto, who said, as a thrifty Scotsman, he considered the cost of such an abolishment. Every year the tramways department paid £16,676 towards a sinking fund, and interest on loans amounted to £24,017. They also paid £8,184 annually for the use of the roads, and they were responsible for maintenance of the roads covered by their tracks, which amounted to £12,250.

'Altogether the abolishment of the trams would mean a loss to the ratepayers of £104,645 – the equivalent of a tenpenny rate.

'Electricity would cost more if they took away the trams, they would remove the basis load of electricity, which would mean increased charges to the consumers. 'Buses would mean a damage to property through vibration, and also damage to gas and water mains.

'They would also have to have one-third more buses than trams, and while the life of a tram was 20 years, that of a 'bus was only five years.

'Last year 'buses in this country killed 613 people, and trams 113. The accident rate for trams was lower even than for horse-drawn vehicles.

'No one voted in favour of the abolition, but more people refrained from voting than those in favour of retaining the trams.'

Councillor Minto, of whom we shall hear more shortly, was the Chairman of the Corporation's Electricity Committee.

The statistics quoted by the councillors are somewhat dubious; the 'juggernauts' were Guy CX 6-wheelers which could carry 56 (as opposed to the usual – until then – 50) passengers; Leicester's trams would go on to clock up between 30-45 years in service, the first 14 buses were still in service after 4-5 years (and were not withdrawn until 1934), and the casualty figures are meaningless without some knowledge of the ratio of buses to trams on UK roads in 1929. Those considerations apart, it is easy to see a laissez-faire attitude on the part of the public, what few of them there were at the meeting, although it is more likely that they were perfectly satisfied with the transport provision at that moment in time and had little

or no comprehension of how much better other options might be – and in any event this was not going to be just a straight contest between trams and buses.

….or Trolley-buses?

Bearing in mind that this discussion was taking place at the same time as the attempts to open up the county, and also neighbouring counties, to Corporation bus services, as we saw in Chapter 2, it seems clear that in pursuing that debate with their opposite numbers in Nottingham, Leicester's politicians were to some extent being swayed by fleet developments there. That council was seeking to do away with its tram network and instead operate a fleet of trolleybuses. Nottingham was already using motor buses (the first examples of which were introduced in 1920) and put its first trolleybus into service in 1927.[4] This was the first of several conversations Alderman Banton was to have with reporters from the *Leicester Mercury* on the subject of fleet renewal, reported on 2 October 1929:

'LEICESTER TO HAVE TROLLEY 'BUSES?
TRAMWAYS CHAIRMAN FAVOURS THEM ON CERTAIN ROUTES
TRAFFIC PROBLEM
'"…Leicester will be compelled to move in a very short time," Alderman Banton, Chairman of the Tramways Committee, said to the "Mercury", "The powers we have already are so limited that we cannot do what is essential to be done by the Municipality.

'"We can run within the City and we have a fleet of 52 'buses already. When the question of the development of new routes comes, then we shall have to consider the new form of transport.

'"We have, to a certain extent, discussed it in regard to the new road that is being constructed from the Cross, Belgrave-gate, to the Station.[5] The question was whether we should extend the trams along that section, whether we should have trolley 'buses or whether we should use the 'buses we have. We decided, under the circumstances, to use the 'buses.

'"But we can look forward to the not far distant time when Melbourne-road will have to be considered. That is a narrow thoroughfare with long lengths of single track and loop lines. Under modern conditions, and with the demand for more speedy traffic, that is a hindrance.

'"The question as to whether we shall relay the permanent rails, use 'buses or go for trolley 'buses will have to be considered."'

Such considerations included the extent to which Parliamentary approval was required. The Tramways and Omnibus Committee met on 16 October 1929 and decided to recommend to the full Council that a Bill should be tabled to tackle the twin objectives of running buses outside the city boundary and promoting an alternative to the tram network. It might be thought that the Committee view was tending towards motor buses, since the unnamed Committee member quoted in the *Leicester Mercury* the next day indicated that once the powers were in place, they would be used to develop the Corporation estates outside the city boundaries, and later run to Oadby, Thurmaston and Syston:

'"I do not think any political question is involved at all…The decision was unanimous. We want to be in a position to protect our interests should there be any development of the possibility of railway companies competing locally in passenger transport by road."

'The "Mercury" understands that the Town Clerk reported how far he had been able to deal with the legal aspect of the question, and the committee decided that if a Bill was to be introduced into Parliament before the end of the year, sanction must be obtained from the City Council at the earliest possible moment.'

In fact, it took almost a year before the Leicester Corporation Act 1930 passed onto the statute books. On 30 September 1930, the full Council heard from the Parliamentary & General Purposes committee that 'the Bill promoted by the Leicester Corporation during the last session was, after consideration by the Select Committee of the House of Lords and a committee of the House of Commons, duly passed and received Royal Assent on the 1st of August last'. This is an extract from Part II (Tramways, Trolley Vehicles and Omnibuses), which contained the following powers:

'…enabling the Corporation to convert any part of the existing tramway to trolley vehicle services, with the necessary electrical equipment, and (with the consent of the Minister of Transport) to establish further trolley vehicle routes within the City…

'To discontinue tramways where trolley vehicles or omnibus services are substituted, and in that event, the charge on the tramway revenue in respect of the maintenance of part of the route is to cease, except to such extent as the Corporation may determine.'

Additional powers of running omnibuses along any routes within the City and of providing and maintaining (but not manufacturing) omnibuses were included, as well as the power to purchase lands, erect buildings and make bye-laws. There was also a provision restricting the running of omnibuses in competition with the tramway, trolley vehicle and omnibus services of the Corporation, all the effects of which, taken in tandem with the provisions of the Road Traffic Act 1930, were discussed in Chapter 2. The Town Clerk recommended that oversight and action arising from Part II be delegated to the Tramway Committee, and this was carried.

Further expansion of the motor bus network

The development of Corporation bus services from 1930 onwards did not follow the stated aim of moving into the estates outside the city boundary, and the effect of the Area Stop Agreement in 1932, as we have seen, was to effectively preclude it from doing so. Discounting the application for a service running between East Park Road/Gwendoline Road and the General Hospital, which began on 13 April 1930, the other routes introduced up to the end of 1933 can be seen as a consolidating the Corporation's position in areas which were not already adequately served by them:

- 2 October 1930, from Newarke Street via Walnut Street and Narborough Road, to Hallam Crescent (this service had been dependent upon improvements to the road surface in Hallam Crescent)
- 19 December 1931, from Welford Place via Saffron Lane, to Windley Road (this mirrored to some extent the Southfields Drive service of 1925)
- 28 February 1932, from Gimson Road via Winstanley Drive, to Imperial Avenue (the route was completed during the year by extensions on 14 July and 26 September)
- 19 May 1932, from Charles Street via Copdale Road, to Coleman Road/Green Lane Road (further extended on 6 March 1933)

- 1 July 1933, from Humberstone Gate to Catherine Street (extended to Gipsy Lane on 5 July 1934)

A further development - one that had been discussed for several years - was the introduction during 1932 of route numbers on the trams. Cross-city linkages were often changed, so this list only reflects the initial situation and does not necessarily correspond with the routes illustrated at the start of this chapter:

1. Belgrave – East Park Road via Humberstone Road – Western Park
2. East Park Road via London Road – Narborough Road – Melton Road
3. Stoneygate – Fosse Road via Great Central Street
4. Melbourne Road – Fosse Road via King Richard's Road
5. Clarendon Park – Aylestone
6. Clarendon Park via Welford Road
7. Humberstone
8. Coleman Road
9. Groby Road via Abbey Park Road

Melbourne Road trams are the first to go

But the Melbourne Road circular would carry the number 4 for only a matter of months. It is not unreasonable to say that the line had always been controversial. We saw in Chapter 1 that the slow speed of the trams even in the early days of operation had generated complaints from the public. The waiting time at the small number of passing places on the otherwise single-track line gave rise to the nickname the 'old gentleman's route', and it came as the final straw when it was found that the rails were in poor condition and most of the 18 sets of points needed replacing. On 20 July 1933 the *Leicester Mercury* told of its demise:

'MELBOURNE ROAD TRAMS TO BE SCRAPPED
CRUDE-OIL BUSES TO BE SUBSTITUTED
CHANGE-OVER EXPECTED WITHIN THREE MONTHS
METAL BODIES
'Leicester Melbourne-road tramcar route is to be scrapped in the course of the next few months, and heavy crude-oil driven 'buses, with all metal bodies, introduced.

'It was one of the first four electric car routes opened in Leicester in 1904, and the first to be abandoned.

'Members of the Tramways and Omnibus Committee were unanimously in favour of introducing oil-driven 'buses, a previous suggestion that trolley 'buses be installed having been turned down following an exhaustive inquiry into the merits of the system, relating particularly to the needs of Leicester.

'In order to relieve traffic congestion, 'buses serving the Melbourne-road district will not pass along Gallowtree-gate or Granby-street, but along the widened Charles-street from Humberstone-gate.

'…"We have decided the change only after very careful consideration," he added, "and after making all sorts of tests for ourselves."

'It is suggested that when the track is taken up, instead of re-making the road, a carpet of asphalt should be placed on the existing surface, but no decision will be reached until after consultations between the Tramways and the Highways Committees.

'No all-metal body 'buses are at present running in Leicester, and the decision to introduce them instead of the coach-built type, was reached chiefly because it was thought that the cost of repairs would be less.'

Surprisingly, the most controversial aspect of the announcement was not the conversion plan itself but re-routing the replacement buses via Charles Street. A correspondent calling himself EQUAL TREATMENT appeared in the *Leicester Mercury* just five days later:

'MELBOURNE-ROAD CARS
'Sir,–As a resident of the Melbourne-road, I strongly protest against the proposal to divert the Melbourne-road cars or 'buses into Charles-street.

'People going to the West End or centre of the city are those using the cars most, and Charles-street is no use to them. The argument for diversion on account of traffic congestion is very weak indeed, as the Melbourne-road cars can make very little difference either way, and people from this district demand equal treatment, and to be taken to the Clock Tower.

'That this point has escaped the notice of the Market Traders Association is surprising, as people simply won't carry their purchases into Charles-street, having to cross two main roads.

'As a rule we have been able to commend our tramway management, and are consequently more than surprised at this lapse from their usual display of common-sense under difficult circumstances.

'I am using the cars four times a day. Under the proposed arrangement I should not use them at all.'

This was not the only letter received on the subject. It is interesting to note that county dwellers whose buses departed from Belgrave Gate or Western Boulevard had always had much further to carry their purchases. But the protests fell on deaf ears, and it is clear that from this point on, Charles Street started to assume much greater importance in its role as a terminal point.

The final day of tram operation to Melbourne Road was set to be 13 December 1933, a Wednesday. In keeping with the role it had played when the tram lines were first opened, the *Leicester Mercury* carried a report looking ahead to the final night, and on 14 December, a report on the very last journey. The style makes it pretty clear that they were written by the same person:

'MELBOURNE ROAD'S LAST TRAMS TO-NIGHT
SUCH A QUIET FAREWELL
'The last tram will rattle over the Melbourne-road route this evening at 11p.m. To be correct, I should have said "trams", for at that time, one will travel via Humberstone-gate and the other via London-road.

'Many will be pleased to see the back of them, but if the Tramways Committee are glad, there will be no indication of it, for there will be no official farewell, no tears, no flowers (by request).

'"There will be none," I was told. "No, there will be no members of the committee travelling on the last tram."

'But on May 18th, 1904, there was a great fuss when the service on the Melbourne-road was opened. There were committee members, and ribbons and decorations then.

'But the going-away ceremony will be a quiet affair. Just a few more rattles and bumps. Residents of the district will sigh and say, "Thank goodness that's over," and then start grumbling about the 'buses.

'Radio listeners, too, will be grateful for the change-over.

'So, if you want to help make history you can ride on the last Melbourne-road tram at 11p.m. – but it will be a cold trip.'

'GHOST TRAM'S NOISY SWAN-SONG ON THE MELBOURNE-ROAD ROUTE

'It was a cold business making history by riding in the last tram to run on the Melbourne-road route… …Only three of us made the round trip – myself, Conductor Charles Johnson and Driver William Palmer.

'"You must be thrilled to drive the last car," I remarked.

'"Thrilled," said the driver. "Cold."

'An interested crowd of tramway men gathered round the tram at the stand. "This is the last tram on the route," the conductor informed intending passengers.

'Passengers were quite unmoved. One was ungracious enough to retort, "Jolly good job too."

'There were about thirty of us when the tram started on its historic (and cold) journey. There were no flowers, no decorations, not even any boos.

'The tram screeched and roared like an orchestral conclusion. It was a terribly noisy swan-song.

'The topic of conversation among the passengers was anything but tramcars.

'The vehicle bumped and swayed, developing awful lists, and soon I was the only traveller left. No one saw the tram go by; the streets were empty. It might have been a ghost tram.

'The conductor joined me on the top deck. "I shall miss this route," he said. "I've been on it for 15 years. That's a long time. I'd know every stop with my eyes closed."

'"And every bump," I said.

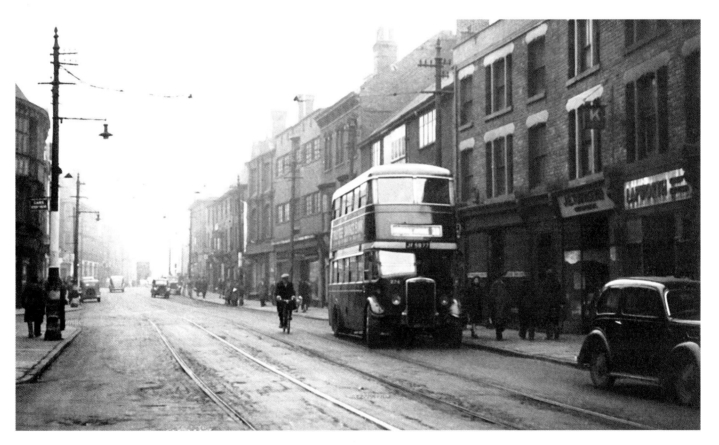

105. After buying only six new vehicles in each of the years 1932 and 1933, a marked increase in the fleet came the following year when 20 Leyland TD3s were purchased. Their Metro Cammell bodywork seated 50 passengers, as was the norm. They received fleet numbers 70-89, becoming 270-289 when renumbering took place in 1937. 274 (JF 5877) is pictured in St Nicholas Street, en route to Imperial Avenue on 25 November 1945. Virtually the entire class was withdrawn in 1949 at the same time as the last of the trams, while the scene has changed beyond all recognition; it is roughly where Jubilee Square can be found today.

'"And every bump," he added solemnly.

'I'm glad I helped to make a little history, and I am sure the conductor would have felt very aggrieved if no one had been interested enough to make the last round-up – sorry – I mean round trip.'[6]

.

The closure of the Melbourne Road line was not a signal that the whole system was about to go under – far from it – but it was a sign of the times. Even the *Leicester Mercury* leader writer on 14 December acknowledged that 'no special sanctity attaches to trams when circumstances render a change desirable'.

106. A rare glimpse inside the Abbey Park Road workshops, where another of the Metro Cammell bodied TD3s, 287 (originally 87, JF 5890) is having the necessary alterations made to its livery so as to comply with wartime restrictions – the white painted mudguard edges and the removal of references to Leicester. Thus we can be fairly certain that the photo dates from September 1939.

The first six trams ever to be withdrawn were taken out of service in 1934 – 12, 24, 29, 44, 122 and 128. It would appear that there was some knock-on effect on remaining services, and those already operated by motor buses, as December 1933 and January 1934 saw a spate of complaints about service levels. A correspondent from Jellicoe Road was highlighting problems with both late running and inadequate service as early as 18 December, when his letter appeared in the *Leicester Mercury:*

'TRAM IT OR TRAMP IT
IS IT QUICKER TO WALK?
'Sir,–I would like to protest against the inadequate service that the public of the city are now getting from our tramways. In my humble opinion drastic alterations should be made.

'On Friday night, December 15, I waited at the Green-lane East Park-road stop. After waiting a few minutes, and still no car in sight, I decided it would save time if I walked to the Uppingham-road stop via Green Lane-road, Bridge-road and Cottesmore-road. I found a number of people waiting there for a car, and seeing there was still no car in sight, although this stop is supplied by three services, I considered there would be more time wasted, so I decided to walk into the city.

'I got to Vulcan-road before the first car caught me up. Of course, when it did pass the passengers were packed like sardines. Another car followed in about two minutes. This was packed the same as the first.

'I might mention that as I walked up there was quite a number of people waiting at Spinney Hill-road. At St. Saviour's-road there was a crowd waiting, and at Nedham-street and Kent-street there were people who could not get on.

'I understand that quite a lot of the men have recently been placed on the spare list. It appears to me that it is a case of false economy at the ill-convenience of the public. Leicester has some fine cars and a fine body of men to operate them.

'There is one way in which the public could help, and that is by not getting on to a car if all the seats are occupied, but wait at the stop if possible for another car. This would soon demand more cars and more men on the routes, and not only that, it would give our conductors a fair chance to do their work with

room to move about. When there are three rows of passengers inside a car, whereas there should only be two, it is impossible for any man to watch the stops, remember the bell, and collect the fares.

'Bring more cars and men out on the routes so that people may travel in comfort.'

A similar complaint about the Stoneygate route appeared the same day:

'Sir,–The Stoneygate tram service must alter to be of any use to the worker. On Friday night I waited 30 minutes for a car. On Saturday night 20 minutes. This is since taking off the Melbourne-road trams. One dare not come home for dinner, as there would be no time in home, all available time taken up in getting to and fro. The public must have better facilities for travel to and from business or walking will be preferred. As one who believed trams were the safest and best means of conveyance, I must confess to great disappointment.

'DISILLUSIONED'

But it made page 1 headlines in the New Year when the men's trade union weighed in:

'LEICESTER'S "COMIC OPERA" TRAMS
MEN'S UNION ATTACK THE SYSTEM
DANGER TO PASSENGERS AND PEDESTRIANS
MENACE TO OTHER USERS OF ROAD
THE CRY FOR SPEED
OFFER TO TAKE CONTROL OF TRAFFIC DEPARTMENT
'Saying it is "nothing less than a comic opera," the Leicester branch of the Transport and General Workers Union (representing the men who work the system) makes a scathing attack on the Leicester tram and bus service. The branch alleges:

'That owing to the cry for speed and economy, the time allowance is not sufficient to conform with public safety.

'That the Department's vehicles are a danger to passengers and pedestrians and a grave menace to other users of the road, and

That drivers are being instructed not to stop and pick up passengers, but to leave them to wait for the next tram or bus.

'The Union state that they are prepared to submit proposals that will meet the needs of the travelling public, or take over the traffic section of the department and run it on sound practical lines.'

Reaction was mixed. The following day it was reported that the Tramways Committee were shocked by this 'thunder-bolt', and whilst admitting that not everything was right, members agreed to meet the union at an early date. The letters page of the *Leicester Mercury* on 8 January seemed however to tell a different story:

'..a user of the trams and (during the past twelve months) a patient waiter for their regularly belated arrival, I should like to thank (the union) for having at last moved an apparently inert mass of our City Council to action…'

'…I have reached the conclusion that the committee are unfitted to run an undertaking of this magnitude…sell the whole concern to a company. No doubt a substantial sum would be available yearly…'

'Speaking from a long experience as a driver, I can endorse every word of the Trade Union Committee's statement…these things have been going on for the past twelve months…the employees have given unstintingly of their best. If the Tramways Committee will treat them generously and drop this craze for breaking speed records, and false economies, "Comic Opera" will soon become useful social service.'

The members of the two committees met on 10 January, and the *Leicester Mercury* gave space on its front page to the inevitable outcome; that the trams were to be slowed down. At what was described as a 'very friendly' meeting, it was also pointed out that with more trams on all routes, costs would obviously be increased.

The future – oil or electricity?

Meanwhile, the debate about electricity versus oil was set to enter a new phase, as the Tramways Committee strove to decide on the best future course of action. Mr H. Pool, the general manager of the undertaking, was commissioned to produce a report on the best option(s) for the future. Between the beginning of 1930 and the end of 1934, 37 new motor buses entered the fleet; only 15 of

them were replacements for 1920s vehicles. It is fair to say that this may be taken as indicative of the way the Tramways Committee saw things going, but they had to convince the whole of the City Council, amongst whose numbers was Councillor J. Minto, the chairman of the Electricity Committee.

It should be pointed out that the supply of electricity was conducted on a different basis in those days. At the start of the 1920s, fewer than 10 per cent of households were connected to an electricity supply network, and those that were had it mainly for lighting only; gas was the principal domestic fuel. Before the National Grid was set up in 1926, electricity was generated and supplied by a variety of private companies and councils. In Leicester, plant was installed in municipal buildings at Aylestone Gas Works, which became operational from December 1893, and at Painter Street, from 1904. A third station, at Aylestone Meadows, was commissioned in December 1922, and the increased output from subsequent extensions and additions meant that the Council was able to close Painter Street in June 1930 and the Aylestone Gas Works site the following year. This situation remained until the industry was nationalised in 1948, when Leicester was one of 12 municipal undertakings vested in the East Midlands Electricity Board. Since 1904 the tramways had been the biggest single customer of the Electricity Committee and continued to be a substantial user, despite both the increase in industrial and household usage that started in the 1920s and the gradual introduction of the motor bus. Vested interest it may have been, but little wonder that the Councillor Minto was prepared to fight tooth and nail for his preferred option.

Having Mr Pool's report, the Tramways Committee decided at a special meeting on 3 October 1934 that trolley buses would not be introduced in Leicester, but also that the trams would be retained for some time yet. This prompted Councillor Minto to note that 'If oil 'buses replace trams they would use 750,000 gallons of crude oil per year, and all the money would go out of the country. In the case of trolley 'buses this would not apply, for the Electricity Department used 120,000 tons of coal, every ton mined in Leicestershire, per year.'

Battle lines were drawn, and the arguments for and against rumbled on in committee and in the press for another 12 months without there being any satisfactory

resolution. At a meeting of the Leicester Personal Health Association reported on 6 October 1935, Councillor Minto declared that trolley-buses would prove to be cheaper than oil vehicles 'even if the oil could be procured free'. In part, this was a response to a remark made by Councillor Charles Keene, who had said that the last defender of the tram would be dead in ten years. The *Leicester Mercury* leader writer on 7 October, under the heading 'City Transport Problem', whilst seeming to advocate a dual solution, was much more forthright about the trams.

'Of Mr. C.R. Keene's forecast, it can be said that ten years is a long time, and that many people in Leicester will hope that the tramways system will die a more rapid death, costly though the obsequies may be.

'The simple fact is, of course, that the trams have long since been doomed. In present conditions of congestion in our main streets they cannot reasonably be accommodated, and the only real considerations that delay their scrapping are the capital expenditure involved and the factor of time concerned with reorganising the transport system. There can, of course, be a speeding up in the tackling of the problem, and as a matter of urgency it is desirable that the city should have a settled policy as soon as possible. In the meantime we see the oil and petrol 'bus growing in favour, and establishing itself more firmly as a dominant feature in the Corporation's service.

'Whether this form of transport will establish itself in due course a civic monopoly is doubtful. On several grounds, the champions of the trolley 'bus have strong arguments, both in the matter of cost and the utilisation of power. Certainly in this respect the fuller use of electric traction has its advantages, for whatever the results may be, the pollution of the atmosphere by the 'buses is all too often forced upon the notice of the public.

'Members of the City Council have had the facts before them for some time. There are at present two schools of thought, but the time must come, without undue delay, when the Council will have to make far-reaching decisions in the matter.'

The Tramways Committee met that night, and the minutes record that the general manager was to be instructed to:

'... obtain from other towns where the trolley bus system is in operation all available information with regard to mobile omnibuses versus trolley buses, and that a synopsis of such information be forwarded to each member and a special meeting of the Committee called to further consider the matter, and, if thought necessary, to visit other towns where the trolley bus system is in operation.'

In December, such operations in Birmingham, Wolverhampton, Nottingham, Chesterfield, Manchester, London and Huddersfield were examined. But still no firm decision was reached, and in 1936, the year in which route numbers[7] were introduced for buses,

general manager Pool's ill-health finally led to his retirement, and it was to be his successor, Mr B. England, who was ultimately responsible for driving the long-awaited change. He produced two reports for the (now renamed) Passenger Transport Committee. The first, dated 11 October 1937, recommended that large motor buses should replace the trams rather than trolley buses.[8] This went to the Committee on 20 October, leading the *Leicester Evening Mail* to report the following day that there was 'Trolley bus deadlock after committee talk for three hours' at its meeting the previous night.

The second, dated 5 January 1938, reiterated his original recommendation, based on the fact that traffic movement around the Clock Tower by trolley buses would be

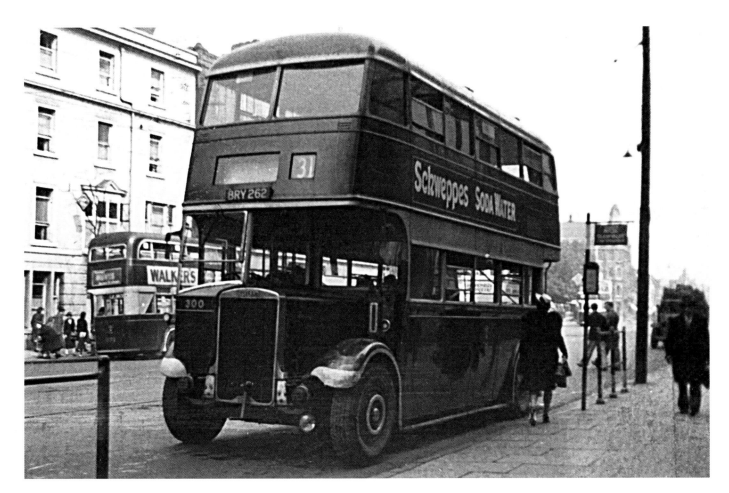

107. The double-deck fleet continued to expand, and after the arrival of ten Leyland TD4c/Metro-Cammell in 1936 (90-99, renumbered 290-299), the following year saw the appearance of 12 Leyland TD5c/Leyland, 300-311. Pictured here in wartime service, 300 (BRY 262) is waiting in Humberstone Gate before working a 31 service to the Braunstone estate on 12 March 1944. The Bell Hotel can be seen on the opposite side of the road; it was demolished in the late 1960s to make way for the Haymarket shopping centre. The area between the Clock Tower and Charles Street was pedestrianised some years ago, and the 31 stand would have been outside what is now a Superdrug store. 300 was withdrawn in 1950 as delivery of the PD2s gathered pace, and went via a dealer to an operator in County Durham.

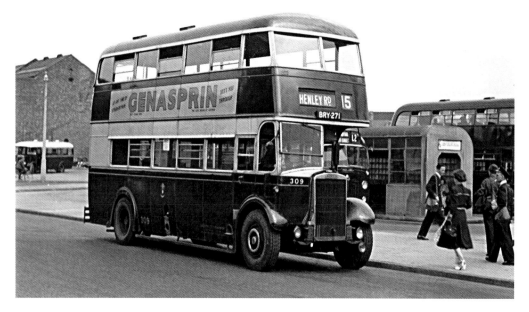

108. From the same batch, 309 (BRY 271) stands in Burleys Lane. A tramway replacement service introduced on 7 July 1947 as the 40, the Henley Road route was renumbered 15 in March 1949. Its normal route would have been from High Street via Great Central Street and Woodgate. Pre- and post-war Midland Red saloons are also in evidence.

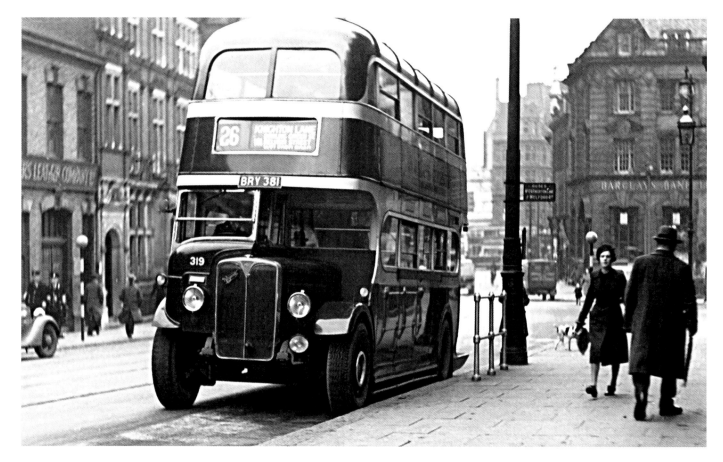

109. The nine AEC Regents that were delivered in 1937 were from an order originally bound for Cardiff but were surplus to requirements there and were snapped up by Leicester, bringing Northern Counties bodywork to the city for the first time. These handsome 56-seat vehicles gave sterling service throughout the war years, and were withdrawn in 1950, but this is 319 (BRY 381) when fairly new, awaiting its next turn on the 26 Knighton Lane service in Horsefair Street. It must be noted that this was at the time a two-way thoroughfare; a marked contrast to the one-way chicane that modern service vehicles are obliged to negotiate.

difficult, noting that 'it might become necessary to consider the removal of the Clock Tower'. The situation across Europe was giving rise to concern also, prompting him to surmise that 'Trolley buses could be put out of action by air attack on a generating station, while damage to cables in the streets would stop the services.' The Transport Committee held a special meeting on 3 February 1938, where it was unanimously resolved 'to discontinue in due course the Electric Tramway system, and to substitute this with motor omnibuses, having made the decision that a trolley vehicle service is not a suitable and workable proposition for the City of Leicester.' The news made the front page of the *Leicester Mercury* the following day:

'MOTOR-BUSES, NOT TROLLEY-BUSES, TO REPLACE TRAMS

TRANSPORT COMMITTEE'S UNANIMOUS DECISION – WILL CITY COUNCIL AGREE?

'Leicester Corporation Transport Committee last night unanimously and finally decided in favour of the replacement of trams by motor-buses, and not to entertain trolley-buses.

The last word now rests with the City Council, at the next meeting on February 22, and it is expected that the Electricity Committee will offer strong opposition, as the change means losing their best customer.

'Thus, this long controversy draws to its closing stages, after years of hesitancy, and at times, bickering, between the Transport Department and the Electricity Department…

'…The meeting lasted two hours, and every member of the committee was at the end finally convinced by Mr. England's arguments.

'The replacement, assuming the City Council accept the recommendation, will take place over a period of years, and it will probably be five before the last tram disappears from the streets of Leicester.

'The method will probably be route by route. No choice of the first route has yet been made, nor could until the Council have adopted the principle, but it is generally thought that the first tram route to be scrapped would be King Richard's-road.

'In any event, once the report is adopted, the committee will certainly make a start within a month or two.

'Despite the unanimity of the Transport Committee's recommendation, there is no question of the matter being a foregone conclusion, for

the Electricity Committee may be expected to fight staunchly for trolley-buses, and the Council debate is likely to be lengthy.

'The Electricity Committee stand to lose their biggest customer, and naturally are not going to lie down to this.

'However, Councillor J. Minto (chairman of the committee) would make no comment today. "That does not mean that I shall not have plenty to say at the Council meeting," he added.'

The full Council meeting was scheduled for the evening of 22 February 1938. That day, it was reported that it was still not clear whether an answer to the long-running saga would be forthcoming, as the Conservative group intended to seek an adjournment on the grounds that there should be a special meeting with that question only

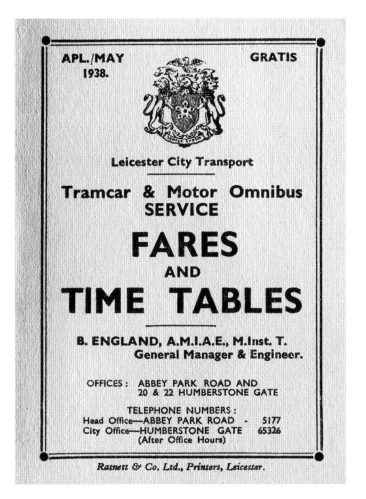

APL./MAY 1938. GRATIS

Leicester City Transport

Tramcar & Motor Omnibus SERVICE

FARES

AND

TIME TABLES

B. ENGLAND, A.M.I.A.E., M.Inst. T.
General Manager & Engineer.

OFFICES : ABBEY PARK ROAD AND
20 & 22 HUMBERSTONE GATE

TELEPHONE NUMBERS :
Head Office—ABBEY PARK ROAD · 5177
City Office—HUMBERSTONE GATE 65326
(After Office Hours)

Ratnett & Co. Ltd., Printers, Leicester.

110. All Leicester City Transport services are comprehensively documented in this free, 128 page timetable dated April/May 1938, which also lists fares and permissible transfers between buses and trams.

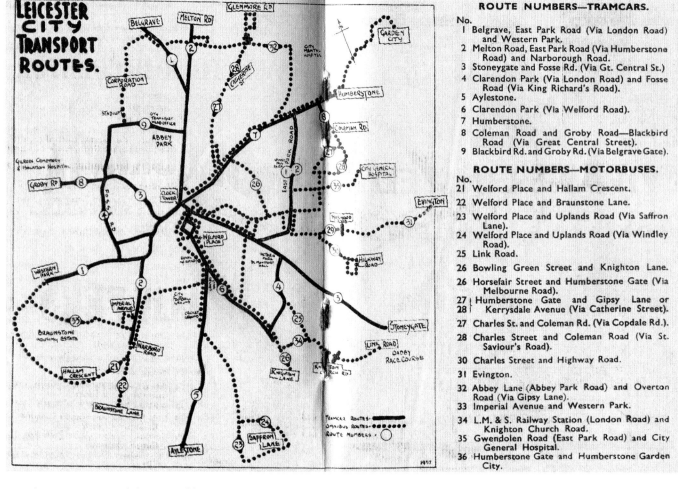

ROUTE NUMBERS—TRAMCARS.
No.
1 Belgrave, East Park Road (Via London Road) and Western Park.
2 Melton Road, East Park Road (Via Humberstone Road) and Narborough Road.
3 Stoneygate and Fosse Rd. (Via Gt. Central St.)
4 Clarendon Park (Via London Road) and Fosse Road (Via King Richard's Road).
5 Aylestone.
6 Clarendon Park (Via Welford Road).
7 Humberstone.
8 Coleman Road and Groby Road—Blackbird Road (Via Great Central Street).
9 Blackbird Rd. and Groby Rd. (Via Belgrave Gate).

ROUTE NUMBERS—MOTORBUSES.
No.
21 Welford Place and Hallam Crescent.
22 Welford Place and Braunstone Lane.
23 Welford Place and Uplands Road (Via Saffron Lane).
24 Welford Place and Uplands Road (Via Windley Road).
25 Link Road.
26 Bowling Green Street and Knighton Lane.
26 Horsefair Street and Humberstone Gate (Via Melbourne Road).
27 Humberstone Gate and Gipsy Lane or
28 Kerrysdale Avenue (Via Catherine Street).
27 Charles St. and Coleman Rd. (Via Copdale Rd.).
28 Charles Street and Coleman Road (Via St. Saviour's Road).
30 Charles Street and Highway Road.
31 Evington.
32 Abbey Lane (Abbey Park Road) and Overton Road (Via Gipsy Lane).
33 Imperial Avenue and Western Park.
34 L.M. & S. Railway Station (London Road) and Knighton Church Road.
35 Gwendolen Road (East Park Road) and City General Hospital.
36 Humberstone Gate and Humberstone Garden City.

111. The centre pages of the timetable were given over to this diagrammatic representation of bus and tram routes. It was printed on pale blue paper, the additional cost of which may have been borne by the advertising on the other two pages, for Belgravia wallpaper and iron and steel merchants Vipans Ltd.

on the agenda. As the Labour members had decided, albeit by a majority, to go ahead that evening, because the matter had been under review for such a long time it would be better to have it finished with, it was to be left to the Liberals, who were waiting on the decisions of the other two groups before deciding upon their attitude. They had, nonetheless, independently come up with an amendment, which would require the Transport Committee to go to the full Council every time it was proposed to close a tram route; in that way, other alternatives could be tried, based on experience gained up to that point. It was also reported that either Councillor J. Minto or his vice-chairman would move an amendment on behalf of the Electricity Committee that trolley-buses should be tried as an experiment on one route before any final decision is made.

As it turned out, the debate went ahead as planned. The following day, 23 February, the *Leicester Mercury* was able to report that a decision had at last been made, and, as the voting figures suggest, rather more easily than had been originally thought.

'OIL BUSES FOR LEICESTER
LEICESTER CITY COUNCIL HAS DECIDED IN FAVOUR OF OIL BUSES
'After a debate of 3¼ hours last night the voting was 36-14 in favour of the Transport Committee's recommendation.

An amendment by Alderman A.H. Swain, asking for a trial system of trolley buses on 'one route, among other things, was defeated by 36-20.

ROUTE No. 3.

STONEYGATE TRAMCAR SERVICE.
Between Clock Tower (Gallowtree Gate) and Stoneygate, via Granby Street and London Road.

CENTRE TO STONEYGATE.

WEEKDAYS.
6–12 a.m., 6–20 a.m., 6–27 a.m., 6–35 a.m., THEN :—

6–42 a.m. to 7–32 a.m., every 5 minutes. 12–4 p.m. to 2–25 p.m., every 4 minutes.
7–36 a.m. to 9–0 a.m., every 4 minutes. 2–29 p.m. to 11–2 p.m., every 4½ minutes.
9–6 a.m. to 12–0 noon, every 6 minutes.

SATURDAYS.
6–12 a.m., 6–20 a.m., 6–27 a.m., 6–35 a.m., THEN :—

6–42 a.m. to 7–32 a.m., every 5 minutes. 11–25 a.m. to 8–57 p.m., every 4 minutes.
7–36 a.m. to 9–24 a.m., every 4 minutes. 9–1 p.m. to 11–16 p.m., every 4½ minutes.
9–28 a.m. to 11–21 a.m., every 4½ minutes.

SUNDAYS.
9–38 a.m. to 4–56 p.m., every 6 minutes. 5–0 p.m. to 10–47 p.m., every 4½ minutes.

STONEYGATE TO CENTRE.

WEEKDAYS.
6–30 a.m., 6–38 a.m., 6–48 a.m., 6–54 a.m., THEN :—

7–1 a.m. to 7–51 a.m., every 5 minutes. 12–30 p.m. to 2–46 p.m., every 4 minutes.
7–55 a.m. to 9–19 a.m., every 4 minutes. 2–50 p.m., to 11–23 p.m., every 4½ minutes.
9–25 a.m. to 12–25 p.m., every 6 minutes.

SATURDAYS.
6–30 a.m., 6–38 a.m., 6–48 a.m., 6–54 a.m., THEN :—

7–1 a.m. to 7–51 a.m., every 5 minutes. 11–46 a.m. to 9–18 p.m., every 4 minutes.
7–55 a.m. to 9–27 a.m., every 4 minutes. 9–22 p.m. to 11–37 p.m., every 4½ minutes.
9–31 a.m. to 11–42 a.m., every 4½ minutes.

SUNDAYS.
9–57 a.m. to 5–15 p.m., every 6 minutes. 5–19 p.m. to 11–6 p.m., every 4½ minutes.

112. The Stoneygate tramcar service as it appears in the April/May 1938 timetable. The basic four minute frequency of 1904 has been adjusted to better reflect demand, with (for instance) weekday morning off peak times reduced to every six minutes. Whilst modern day providers might baulk at the use of the 12 hour clock, and complain (with some justification) that it is not the most user-friendly presentation of the information, it is refreshing to find that details of fares were given for all routes. High inflation and annual increases were still some way off, but the 2d it cost to ride from the Clock Tower to Stoneygate on the tram in 1938 had doubled to 4d on the 29 bus in 1959.

'The trams will be replaced route by route over a period of 5-7 years. The first tram route to go will very likely be the King Richard's-road route.'

Abandonment begins
But as it turned out, the first tram route to go was the short Coleman Road extension, on 23 October 1938, its working life turning out to be slightly more than 11½ years. Perhaps because of its relative unimportance in the scale of things, the local press did not mark the occasion, preferring instead to report on the new 'print-as-you-go' tram ticket machine being trialled by the Corporation, which at the turn of a handle printed the stage, the value of the ticket, and registered the amount of the total day's business. There was mention too of the Midland Red bus that killed a cow at Gracedieu,

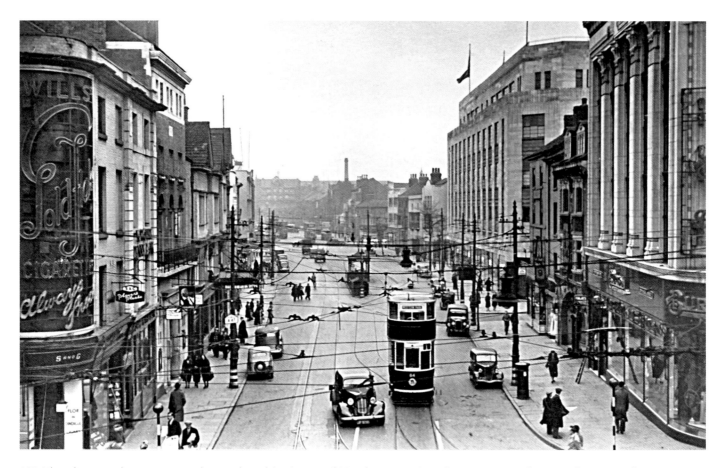

113. The photographer appears to have taken this picture of Humberstone Gate from an upper floor window on Gallowtree Gate. Although it covers virtually the same ground as photos 26 and 27, the changes wrought in the 30 years since are considerable, with Lewis's store, built in 1935/36, dominating the southern side of the roadway. Car 84 is on its way to Western Park, and is carrying the latest livery. There are few motor buses to be seen in this December 1938 view, though the scene will change within four months when Humberstone Gate is adopted as a terminal point for several Leicester City Transport services. It appears on a postally unused card published by A W Holmes & Sons.

near Coalville. Fortunately (it was reported) none of the passengers were injured although the vehicle was slightly damaged.

It *was* the turn of the King Richard's Road route next, and closure took place after the last services on Sunday 2 April 1939. The report in the following day's *Evening Mail* highlighted the new termini arrangements for buses, now using Humberstone Gate instead of Charles Street, and the issue of congestion around the Clock Tower – a subject that continued to vex the authorities:

'BUS TERMINI FEARS ARE UNFOUNDED
'Leicester tramway authorities and police controlling the traffic at the Clock Tower were satisfied with the experimental working today of the new Corporation bus termini in Humberstone-gate.

'The termini had previously been in Charles-street.

'Many people feared that the alteration would add to congestion at the Clock Tower but this proved unfounded.

'"There was no more congestion than usual," the *Leicester Evening Mail* was informed. "Everything worked smoothly."

'Impartial observers considered that the buses seemed to accentuate the slowness of the trams.'

The *Leicester Mercury* had a picture of a bus on one of the stands. It did at least make reference to the demise of the tram route:

'…(the) new bus stand in Humberstone Gate was in operation to-day for the first time. It is used by

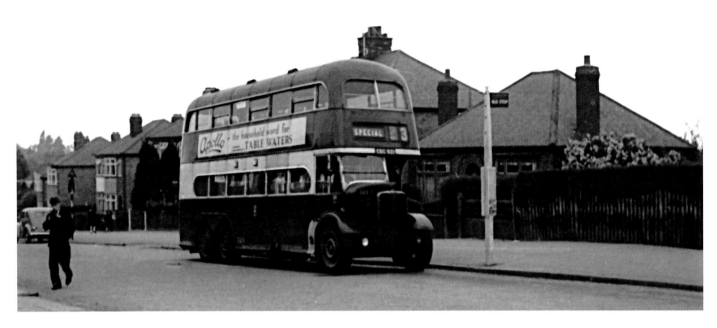

114. Leicester's final pre-war purchases were the 25 tri-axle AEC Renowns, delivered in 1939/40, one of which – 337 – was illustrated in Chapter 3. This is 329 (CBC 921), new in March 1939, photographed at the Wigston Lane terminus of the 23 Aylestone service on 19 May 1958. This was my home route, and I recall catching a Renown – displaying 23 "Special" – after having been taken to see the Queen open the Percy Gee building at Leicester University. That was ten days earlier on 9 May, and I like to think it was 329 as it was the last of the 1939 batch still in service, being withdrawn later that month. 329 has survived in preservation ever since, and now resides, in magnificent condition, at the Abbey Pumping Station in Leicester.

115. Leicester Corporation used its trams for advertising on special occasions long before the vogue for commercial "all-over" advertising caught on in the 1970s. This is car 168 in Abbey Park Road depot yard on 25 February 1942, decked out as HMS Renown as part of a drive to encourage Leicester people to save £200,000 for the war effort. Other cars carried similar "public service" guises at various times; 48 was a poster car for Safety First and a Keep Fit campaign between 1935 and 1938, while 143 was decorated for a "Save salvage" drive for the war effort in May 1943. Car 60, which was equipped with a loudhailer, carried counter staff from both the Post Office and the Trustee Savings Bank in 1948 for the Silver Lining Savings Week.

buses that serve King Richards-road route (the trams here were scrapped last night) and several other localities.'

Any further planned closures were scuppered by the start of the Second World War five months later, and that presents us with the opportunity to look at the

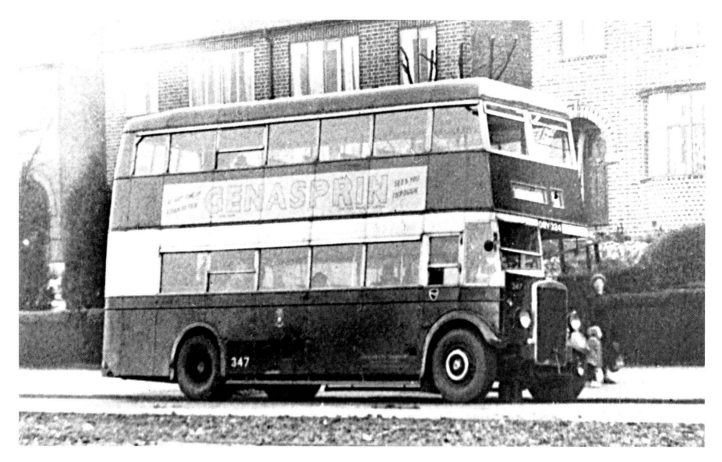

116. Leicester City Transport received just two new vehicles during World War 2, both Leyland Titan TD7s in 1942. 346 was bodied by Brush, and had a 13 year service life – not bad for a wartime utility vehicle – but 347 (DRY 324) received bodywork by Pickering, which by 1950 was showing distinct signs of wear, particularly to the upper deck. It was withdrawn and reduced to a single decker, in which state it saw a few months service, but was then stored before being sold to Jelsons, building contractors, in 1955.

system as it stood at that time. The bus service network at the start of September 1939 comprised 21 routes, most being linked for cross-city working – for example, the 31 to Glenfield Road, introduced on 3 April 1939, was linked to the Evington service with that number. A reduction to 15 routes came with the onset of war, but these were being operated by a fleet of buses that now totalled 100, with a further 15, ordered earlier in 1939, that would not be delivered until May and June 1940. There had been another slight reduction in the number of trams operated with ten further withdrawals in 1939, but that still left an active fleet of around 160 cars.

Wartime restrictions, particularly with regard to supplies of oil, meant that the trams were called upon to work harder than ever, and enormous demands were placed on the Abbey Park Road workshops to keep them in a fit state. As the final stages of the war were being played out, the Transport Department dusted off the tram replacement plans. It goes without saying that six years of make do and mend on the trams and, equally importantly, the tramway infrastructure, meant that the faster the closure of the system could be achieved, the less requirement there would be to expend money needlessly on it during its dying days. But every municipality and every independent bus company was in the same situation, requiring new vehicles at a time when raw materials and a skilled workforce were going to be in short supply. It would take some considerable time for everyone's orders to be fulfilled

The closures begin again

Despite this, the Transport Department decided it had enough motor buses to close at least one route in the short term, and Welford Road was chosen, being scheduled for 2 May 1945. At the time it took place, there was nothing in the press to mark its passing, but in fairness,

117. No new vehicles entered the fleet until 1946, when the decision to withdraw the remaining tram routes had been made and obtaining new stock was a priority. First to arrive were 18 AEC Regent 2's (211-228), followed by 20 all-Leyland Titan PD1s, 232-251. The photo shows three of them in Bread Street garage, opened in 1950 on land at the rear of the Humberstone Gate offices and former tram depot; from left to right Park Royal bodied Regent 218 (DJF 331) and PD1s 232 and 242 (DJF 333/343).

118. Weymann bodied AEC Regent 2 227 (DJF 322) makes its way past London Road railway station on an inbound 36 working in 1958. Destinations and service numbers were changed at the outer terminals on linked routes, but the 36 was the Melbourne Road bus, and as the trams had done, operated in both clockwise and anti-clockwise directions. 227 would have worked via London Road first, returning to the centre to take up the Humberstone Road variant. Upon reaching Thomas Street, the display would have been changed to "24 Saffron Lane". 227 was withdrawn in July 1959; the Ford Consul at its side with arguably one of the most desirable cherished number plates is also no longer with us, but BBC 1 lives on, attached to a Mercedes S350 luxury saloon at the time of writing.

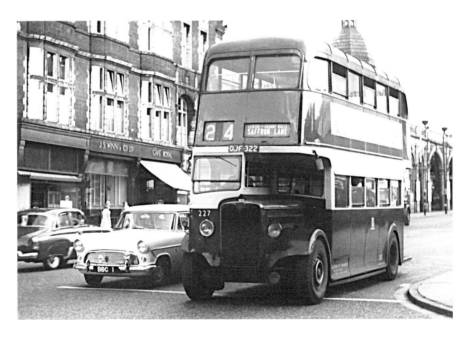

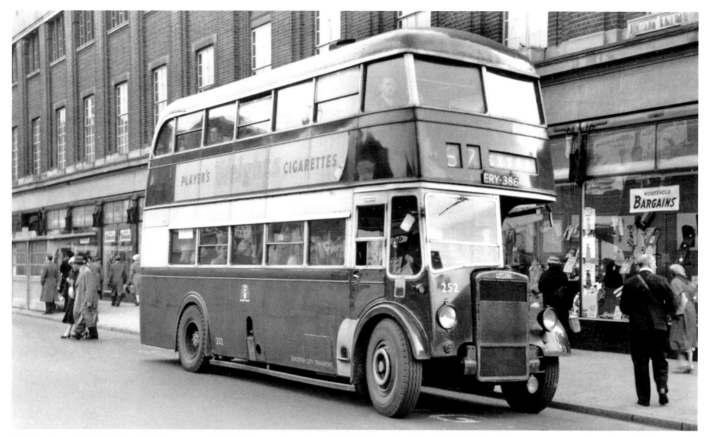

119. Leyland TD3 286 had to be scrapped after it overturned on Swain Street in March 1946. A replacement was ordered, and this turned out to be the only new vehicle received in 1947, 252 (ERY 386), an all-Leyland PD1A. It is seen here on 18 April 1959, ten months before withdrawal, outside Lea's store in Charles Street, an institution that was demolished to make way for the Haymarket centre. It is displaying the destination "Extra", which indicated that it was an addition to the timetabled service that would run all the way to the outer terminus. Had it shown "Special", passengers would have known that it would only go as far as an intermediate point along the route.

these were the last days of the Third Reich, and the papers were filled with the first reports that Hitler was dead, and speculation about his possible successor. A week later, everyone was celebrating VE Day.

Apart from two wartime utility buses received in 1942,[9] the next batch of vehicles for Leicester started to arrive in January 1946, the same month that the TD1 and TD2s from 1931/32 were withdrawn. By the end of the year, 38 new buses had arrived, a mixture of AEC Regent 2s with either Park Royal (211-19) or Weymann (220-28) bodywork, and Leyland bodied PD1s (232-51). That was sufficient for another phase of tram replacement to take place, and it was announced that Aylestone would be the next route to be converted, with buses taking over on 6 January 1947.

The *Leicester Mercury* that day carried another of its humorous pieces – a 'shaggy dog' story perhaps – to mark the closure:

'DOG GOT LAST TICKET ON THE AYLESTONE TRAMS

'The last ticket to be issued on the Aylestone tram route, the longest in the city, went to "Judy", a rough-haired terrier pup.

'It was an eventuality that was foreseen last night, neither by Mr. A A. Harris … the driver of the last tram out of Aylestone, nor the conductor, Mr. Frank Charles.

'During the few minutes wait at the terminus preceding the final "OK, let's go!", there had been some speculation as to whether the final ticket-holder would be a man or a woman.

'The odds had been so reduced after a quite logical argument that ruled out "boy or girl" on account of the lateness of the hour.

'But what happened at about the fourth or fifth stop came as a complete surprise. Five passengers

had received tickets when Miss F. Cox…climbed aboard with Mr. H. Griffiths.

'Then, on to the platform hopped the small figure of Judy, the property of Mrs. Kennedy, of … Hughenden-drive.

'Quite from habit, Mr. Charles's ticket-punch rang out – "one for the gent, one for the lady and one for the dog."

'Sentiments of a contrasting type were revealed by a male passenger who dismounted outside his home in Aylestone-road.

'"Let me see," he said, "this is the last tram, isn't it?" And, receiving an affirmative nod, he dismounted with the retort "Then at last I shall be able to get some sleep!"

'Eventually with 2¾ miles of rail behind, tram No. 101 rattled into the City centre and, finally and without ceremony, to the Abbey-road [sic] depot, where, with its nine Aylestone-route colleagues, it is due for breaking up for spares.

'From today, both Mr. Harris and Mr. Charles will be absorbed on other routes along with the other Aylestone-route conductors and drivers. It will be a simple process for, in anticipation of the change-over, many tram drivers have become qualified 'bus drivers.'

The Corporation could not have picked a worse date to make the change. At 8am on 6 January, snow began to fall. Tram services across the city were affected by the afternoon, with crow-bars having to be used to clear snow which had set solidly in the rails. The resulting delays made a nonsense of timetables and, it was reported, 'caused vehicles to move in groups of twos and threes. Queues of passengers soon formed at the stops and were often 40 or 50 deep.' The Stoneygate route was said to be particularly badly affected. This was in fact the start of a spell of prolonged bad weather which lasted until almost mid-March.

But in Aylestone, and on the Saffron Lane estate, passengers were finding it difficult on that first morning to come to terms with the new arrangements. The trams had travelled no further than the Aylestone Road/Wigston Lane junction, but the replacement bus service traversed the entire length of Wigston Lane, up to its junction with Saffron Lane, Southfields Drive and Stonesby Avenue, which opened it up to considerable extra patronage. However good the Transport Department's publicity might have been, there would surely be teething troubles

(in fact, there were on virtually all future conversions) and, perhaps unfairly, these were certain to be reported. This is the *Leicester Mercury* again, on 7 January 1947, when the general manager put up quite a spirited defence:

'TRANSPORT TROUBLE FOLLOWS SCRAPPING OF TRAMS

'Yesterday's first day's working of transport on the Aylestone-road and Saffron-lane route, following the closing down of the tram service has produced some complaints from travellers, particularly by people from the Saffron-lane quarter, as well as from residents along the mid-section of the Aylestone route.

'On the Saffron-lane side it was stated that people going to work had suffered long waits in the morning, and that there were lengthy queues for buses in the evening.

'Mr. C.H. Stafford, general manager of the City Transport Department, said to-day that road conditions were against services all over the city yesterday. He agreed that Saffron-lane service was for a time in a state of difficulty.

'But this, Mr. Stafford said, during the morning period, was contributed to by the public not paying attention to the change of terminus, although these had been widely published.

'Earlier travellers were congregating at old stopping places instead of using the newly arranged starting off points of Saffron-lane and Wigston-lane junction, and the Marriott-road terminus. In this particular respect there was, Mr. Stafford said, a great improvement this morning.

'Another complaint, this time from people on the Aylestone terminus, is that buses arrive there half full, and not able to take the full number of those waiting.

'Mr. Stafford points out that these buses are carrying people from Wigston-lane, who hitherto walked to Aylestone-lane terminus to catch the tram.

'The crowds in the queues for the evening buses arose through road conditions, so that at the peak times the buses could not keep dispersed on the route, and were more or less loading up in groups. This entailed waiting at the city end, and a consequent lengthening of queues.'

The Fosse Road trams succumbed on 6 July 1947, but there was then a gap of almost 18 months before the next

conversion took place. Only one new bus appeared in 1947; 252, a Leyland Titan PD1A, believed to have been a replacement for 286, a 1934 TD3 which was withdrawn after it overturned on Swain Street bridge in March 1946 and was subsequently withdrawn. But there were 29 new arrivals in November and December 1948; 20 AEC Regent IIIs with Brush bodywork (32-51) and the Corporation's first Daimlers, CVD6/Willowbrook models (76-84). 76 was already something of a star, having been exhibited at the Earls Court Commercial Motor Show. They came just in time for the replacement programme which saw trams taken out of the West End. Mr Leicester, in his *Leicester Mercury* column on 20 November 1948, paid tribute:

'As one who has so often spoken good and ill of the Leicester trams, it would be ungracious not to refer to the passing of the Western Park and Narborough Road routes.

'They were early on the list of those opened. Belgrave came first…together with Stoneygate and Clarendon Park.

'Two months later, Narborough Road and Fosse Road circle came into operation.

'Those who remember the occasion tell me that passengers were delighted with the speed, convenience and comfort of the latest form of travel.

'44 years later, another generation hankers after speedier and more mobile buses. By what means will Leicester citizens be getting to and fro in 1992?'

When buses came to Aylestone, it was snow. When their first day in Western Park and Narborough Road arrived (22 November), it was thick fog – of the type that truly was both impenetrable and injurious to health. The *Leicester Mercury* report makes grim reading:

'FOG 'SHAKES' NEW 'BUSES ONLY PLAN
'The "buses only" plan for West Leicester got away to a shaky start today, when the thick fog caused slow running on all the city's roads, and led to long queues at Western Park bus stops.

'The early morning business rush gave the transport authorities immense problems. Drivers and conductors were working on new routes for the first time, and many passengers were uncertain about the destination of buses on the Hinckley Road and Narborough Road journeys.

'Buses were held up by the fog, and this led to an irregular service. But when the fog lifted during the morning, the buses were able to get up to schedule.

'A transport Inspector told the "Leicester Mercury": "We could not have begun a new service in worse

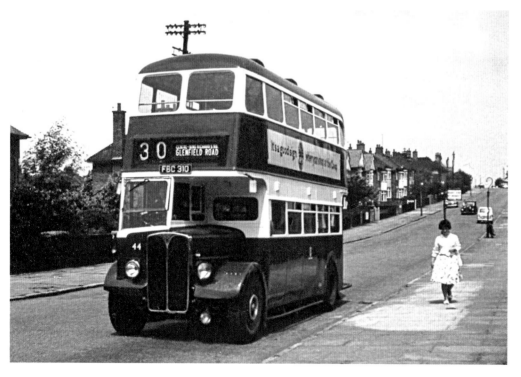

120. Starting in 1948, with the end of the tramway system in sight, and production getting back to normal after the war, the Corporation embarked on a large bus replacement programme which would eventually total 160 vehicles over a two year period. 44 (FBC 310) was one of 34 Brush bodied AEC Regent IIIs (taking fleet numbers 32-65), the first 20 of which arrived in November and December 1948. In 1961 it was photographed on Highway Road near to the junction with Gartree Road; the 30 was linked with the 16 Glenfield Road route, and the destination blind has already been changed, possibly while the young lady was alighting at the nearby request stop.

121. The replacement programme saw Leicester turning to Daimler for the first time. The company supplied thirty CVD6 chassis during 1948/49, 20 of which had Willowbrook bodies and, in yet another first for the Corporation, the remaining ten were bodied by Roberts. This is the first Roberts vehicle, 66 (FBC 541), sailing serenely down Abbey Street on 9 September 1959. At this time the 13 was a peaks only clockwise circular service to the Leicester Stadium, operating in tandem with the anti-clockwise 11. Note that the parking ground is still being actively used, with a couple of coaches – an AEC Regal and Bristol MW – and a handful of cars in residence.

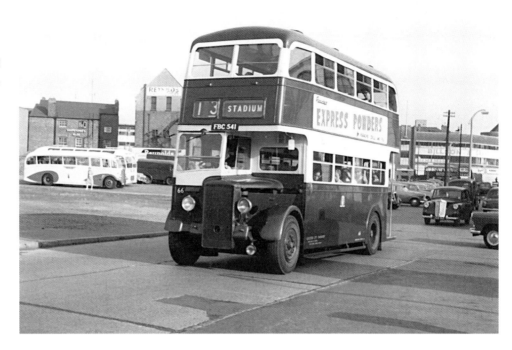

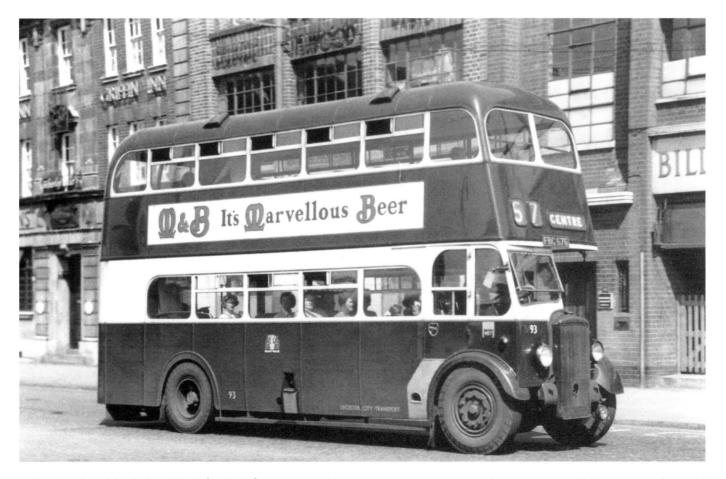

122. Willowbrook bodied CVD6 93 (FBC 676) is seen in Belgrave Gate, returning to town from Mowmacre Hill on a 57 working and displaying the destination "Centre" as at this time the 57 was not linked with another service. It served from March 1949 to January 1963, and then enjoyed a second career with Wessex Coaches.

conditions. If we can carry on somehow in this weather, then we can do anything. It should take about a week for the public to get used to the new system..."

'…There was a 20-minute delay on the 'bus service from Highway Road, and a long stream of traffic was held up near the Knighton tram terminus because of unusually heavy fog.

'Trams were in difficulty on the Clarendon Park service at Queen's Road, where there is a single line track, and the slow working here caused many long queues.

'At the main loading point in High Street, near the Clock Tower, traffic congestion was caused by buses waiting to pick up passengers.'

When there was no wind to disperse it, fog could linger for days. Indeed, only the previous day, the *Leicester* *Mercury* had led with the sort of headline the Corporation did not want – 'Leicester Buses in Fog Crash' – when two motor buses collided head-on in North Evington. There were at least 16 injuries, but thankfully no fatalities, and it was interesting to see that 'another Corporation bus was diverted from its normal run to take ten of the more badly cut passengers to the City General Hospital.'

1949 – the final year

The Groby Road route was the next to go, on 28 January, but it was mentioned only in connection with the annual general meeting of the Blackbird Road and Groby Road Owner Tenants' Association, when a local Councillor took suggestions, queries and complaints about the transport service in the area.

Orders had now been placed for motor bus requirements that would see the completion of the tram

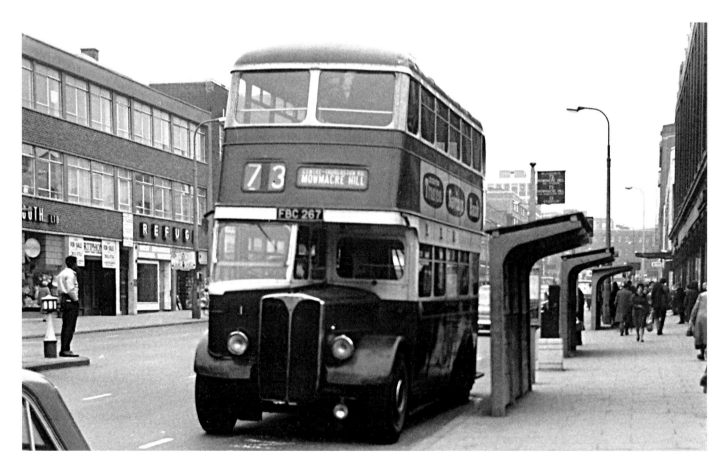

123. A further 76 vehicles joined the fleet in 1949; the balance of the order for the Willowbrook bodied Daimler CVD6s, plus the ten Roberts bodied examples; the complete order of AEC Regent IIIs with Metro Cammell bodywork, and the first ten Leyland PD2/1s. This is AEC Regent III 1 (FBC 267), standing in Charles Street at the 73 (Mowmacre Hill) terminus in 1965. It had a decent turn of speed, as I remember whilst making full use of my 1/- (5p) child's "Explorer" ticket on one journey along Spencefield Lane in 1965, the year before it was withdrawn.

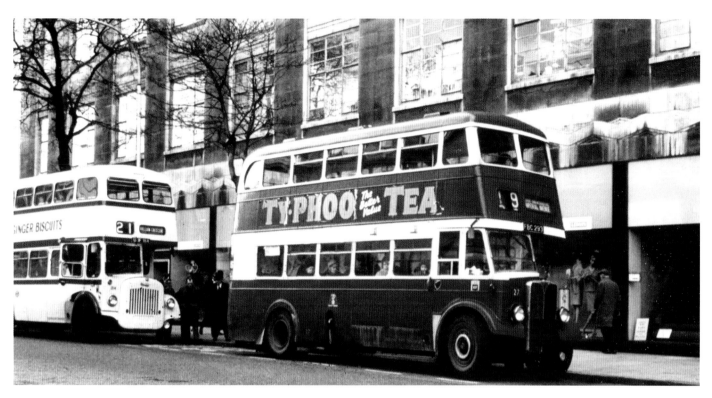

124. From the same batch, a colour view of 27 (FBC 293) in Humberstone Gate for a 19 service to Imperial Avenue. Behind it, 1959 Daimler CSG6-30/Metro Cammell 184 (UJF 184) which carries the new or "reversed" livery introduced in 1961.

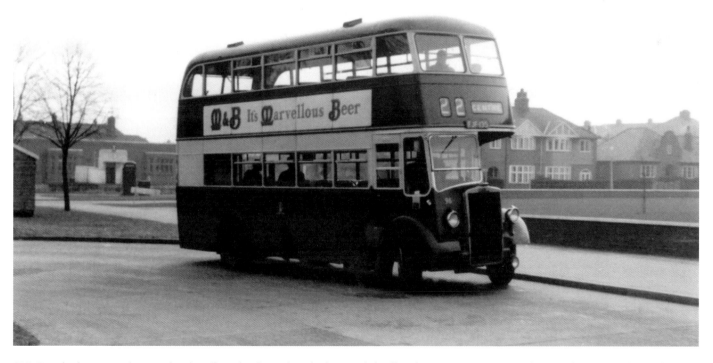

125. But the largest order was for the all-Leyland PD2/1s which joined the fleet between May 1949 and December 1950. This is the first, 96 (FJF 135), waiting time at the bus lay-by on Narborough Road with a return working of the 22. The city boundary runs along Braunstone Lane, seen in the background, and Braunstone Lane East – formerly Coalpit Lane and scene of the 1920s skirmishes between the Corporation and Midland Red – is away to the left. The PD2s gave many years of service; 96 was not unusual in clocking up over 18 years.

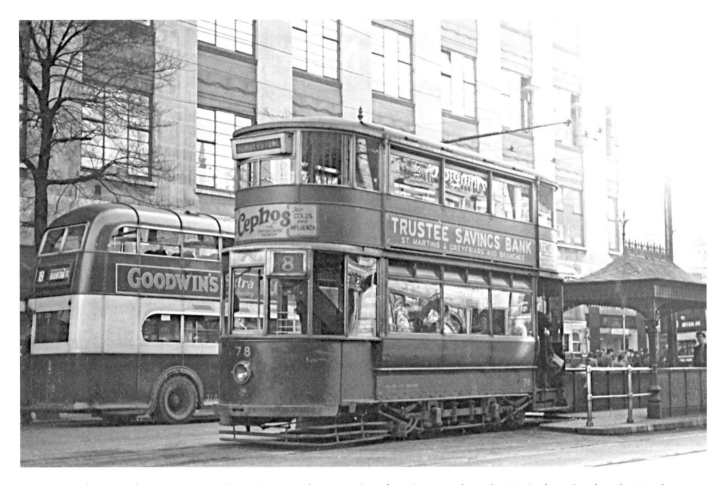

126. Pictured on 19 February 1949, car 78 waits in Humberstone Gate for a journey along the Uppingham Road to the Humberstone terminus, which later that year would mark the swansong for the trams. Standing behind it is one of the 1937 AEC Regents, 318 (BRY 380) on an 18 service to the Braunstone estate. It only had one more year left with Leicester City Transport, but after passing to Murphy (dealer), Rearsby, it found a new home, along with 312, 319 and 320 (and five of the Leyland TD5c's also from 1937), with the South Western Omnibus Company of Colombo, in what is now Sri Lanka.

replacement programme and the disposal of as much of the oldest stock as possible. Although deliveries would continue until December 1950, the only pre-war vehicles that would be left in the fleet by the start of 1951 would be ten Leyland TS7c/Metro Cammell saloons (201-210) – apart from the 'de-roofed' 347, the only single deck vehicles in the fleet – and the AEC Renowns (321-45). The new arrivals comprised 45 more AEC Regent IIIs, numbered 1-31 (bodied by Metro Cammell) and 52-65 (Brush). There were in addition 21 more Daimler CVD6s, those numbered 66-75 bodied by Roberts and 85-95 by Willowbrook. The final order was for 65 Leyland PD2/1s, also bodied by Leyland, of which the first ten, 96-105, had taken their places in Abbey Park Road by the end of 1949.[10]

With this steady stream of new vehicles coming into the fleet, an end to the tramway system was in sight. On 13 March 1949, trams ran for the last time on both the Clarendon Park and Blackbird Road routes. One effect of this was to take an estimated one-third of tram movements away from the Clock Tower, resulting in a smoother flow of traffic. An unnamed official from the Transport Department was quoted as saying, 'It is our first big step in unravelling the travel problem in the central area and we are well satisfied.' Buses for Blackbird Road now used Sanvey Gate instead of High Street and Great Central Street, which had the effect of reducing pressure on other congestion hotspots. But the *Leicester Mercury* noted that 'the change in route numbers caused some confusion, and many people found themselves on wrong buses.'

The next two routes scheduled to close were both short sections. Evington Road and East Park Road lost their trams on 15 May (workings continued to Stoneygate and Humberstone for the time being), and the Melton Road section went on 3 July, although trams still worked to Belgrave. Neither closure appears to have merited the attention of the press.

So, with five lines down thus far in 1949 and three remaining, it was announced that the next closure would again comprise two routes, those to Stoneygate and Belgrave, to take place on 9 October. This would mark the end of trams circumnavigating the Clock Tower, as the one remaining route, to Humberstone, used a central barrier in Humberstone Gate as its start/finish point. The *Evening Mail* of 8 October takes up the story:

'STONEYGATE AND BELGRAVE BUSES NEXT MONDAY

'Only one tram service will be running in Leicester next Monday – that to Humberstone. Stoneygate and Belgrave trams come off on Sunday night for replacement by buses, and for the first time in 45 years no tram routes will cross the Clock Tower.

'For the present, the Stoneygate buses will run on a self-contained route, but it is planned to link them with Humberstone when that route is served by buses.

'Although sufficient trams to operate the solitary Humberstone service could be housed at the Transport Department's Humberstone-gate premises, the Abbey Park Road depot cannot yet become redundant for trams, because all the maintenance facilities are there.'

The *Leicester Mercury* reported that the city fathers were already looking ahead to the days when the tram lines were no longer required. Once the Council had approved the expenditure, work would start on a two-year scheme to remove the track from nine miles of road, at a cost of £75,000, and resurface them with tarmacadam, a system that had already been used on Welford Road.[11] 'The remainder,' the report continued, 'will be tackled by Corporation workmen who have to give priority to work on housing.'

Come the Monday (10 October) and once again, teething troubles were manifesting themselves, as the *Leicester Mercury* reported on page 5:

'LEICESTER HAS ONLY ELEVEN TRAMS WORKING NOW

'Only eleven of Leicester Corporation's original fleet of 172 trams are now in active service. They travel the Humberstone route, and three or four of them are kept in reserve in case of breakdown.

'This morning the Belgrave and Stoneygate routes changed over from tram to bus services. Humberstone is now the only tram route in the city. No date has been fixed for the total discontinuance of tram services.

'Tram drivers and conductors have been absorbed as bus drivers, bus conductors and maintenance workers. Some had to be specially trained as drivers.

'Fares on the new bus routes are the same as those which operated when the routes were served by trams. As the new Belgrave bus terminus is further from the city centre than the tram terminus, the fare for the complete distance is 3d., compared with the 2½d. tram fare.

'The *Leicester Mercury* received several complaints this morning about the new Stoneygate bus service. Apparently residents of the area going to work found it difficult to get on buses. They had to queue. This did not happen when the route was served by trams.

'Leicester Transport Department are satisfied with the change-over, apart from normal teething troubles, and state it is only a question of people getting used to the new running times.'

The *Evening Mail* covered much the same ground but was also measuring the impact of the changes on traffic in the city centre:

'There were some difficulties in the rush period, principally between 8.20 and 8.40 a.m., but Mr. L.H. Smith, city transport traffic manager, who was watching the early vehicles, stated that adjustments would be made.

'"The first few days of bus substitution on any route are an observation period," he said.

First impressions today, from a motorist's point of view, of tram-free Clock Tower and city centre, was that there was much more room to manoeuvre, writes an *Evening Mail* reporter.

'A study of traffic conditions along the Stoneygate and Belgrave-gate routes, freed from trams for the first time today, showed that vehicles were moving quickly and without hold-ups.

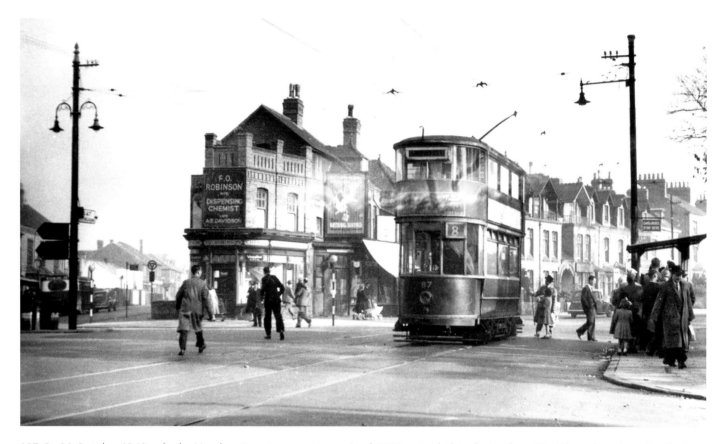

127. By 30 October 1949 only the Humberstone tram route remained. R B Parr took this photo of car 87 at the point where Uppingham Road and Humberstone Road meet. After the closure of the East Park line the previous May, circular services 32 and 33 (outbound via Humberstone Road and London Road respectively) were introduced, and since the queue at the bus stop do not seem to be in any hurry to board the tram, it may be that they are waiting for the bus.

'Traffic was admittedly thin, as it often is on Mondays, but one traffic expert who was keeping a watchful eye on the changing scene, thought the very thinness of the traffic was due to the absence of trams.

'"Cars and vans can now get straight away through the centre without any check or hindrance," he said.'

Two days later, Wednesday 13 October, the final decision was taken with the announcement that the Humberstone route would close on 9 November. Recognising that this was, finally, the end of an era, the line would not close in the late evening, but in the late afternoon, the last scheduled journey to Humberstone was at 3.30. On return to the centre, members of the Transport Committee and specially invited guests only would travel back to the Abbey Park Road depot. The tram would be decorated with flags and bunting and, as it turned out, a lot more besides.

On 9 November, the *Evening Mail* ran pictures of tram 58 in its special livery, Frank Timson the senior tram driver

and J.W. Bennett, the senior tram conductor, on the front page. The main report was found on an inside page:

'LEICESTER'S LAST TRAM TOOK CUE FOR ITS JOURNEY
'Like the star in a theatrical show waiting in the wings for her cue, Leicester's last tram waited today in the Humberstone-gate sheds for the 3.30 p.m. deadline to begin the last service run to Humberstone.

'Gaily painted and bedecked, the tram was inspected by many Transport Department employees reporting on and off duty at the central depot.

'On one side, they saw astronomical figures of tramway statistics since the beginning of the electric service on May 18, 1904.

'The trams have run 171,802,000 miles and carried 2,068,450,000 passengers.

'Between the upper and lower decks was the jingle:

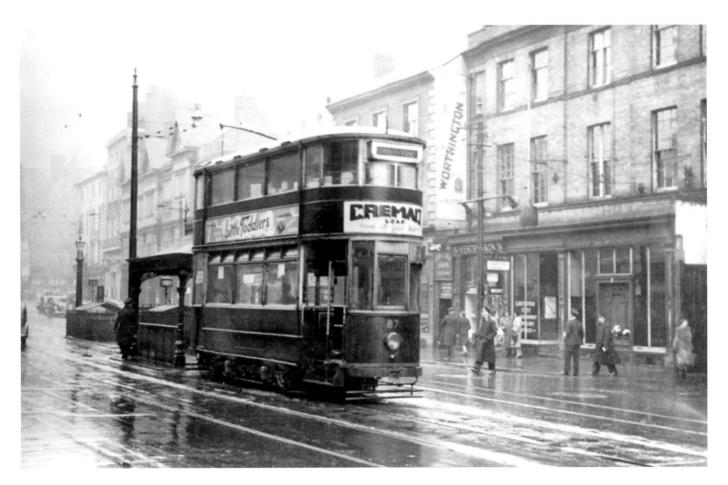

128. It is early on the final day of operation, 9 November 1949, and car 87 is seen again, this time at the Humberstone Gate terminus, prior to making one of the last tram journeys to the Uppingham Road terminus. As we will see, it was not to have the honour of making the final trip. R Tustin was the photographer on this occasion, and he has captured a scene as melancholy as the prevailing weather.

129. Car 58 was chosen to perform the final duty, which comprised a return trip to Humberstone before the very last journey to Abbey Park Road with an official party on board. 58 received a special livery for the occasion, with the inscription reading "We mourn the loss of faithful friends/From the streets of our grand old city/To move with the times, we cannot have lines/So – Go they must – it's a pity". On the other side, and with a nod to popular radio programmes of the time – "After much binding/These you have loved/Are now "Banned Wagons". Buses take it from here". As is also noted on the side of the car, trams ran 171,802,000 miles between 18 May 1904 and 9 November 1949, and carried 2,068,450,000 passengers.

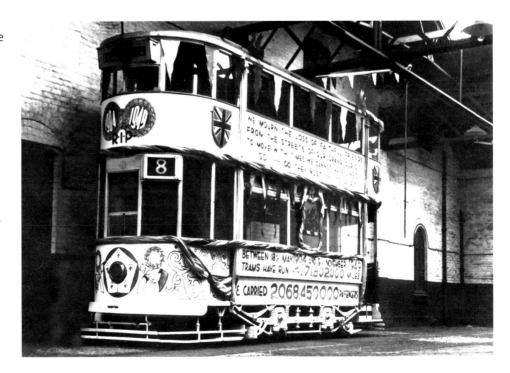

'"We mourn the loss of faithful friends from the streets of our grand old city,

'To move with the times we cannot have lines –

'So, go they must – it's a pity"

'The wits had also been busy elsewhere too, to think up appropriate literary decoration to mark the great occasion.

'In large letters readable from yards away, is the comment "After 'Much Binding', 'Those you have loved' are now 'Banned Wagons', Buses 'Take it from here'".

'The memorable run will be made with Mr. Frank Timson of Thames-street, Leicester, the department's senior driver, at the controls. He is retiring next month. He began his service in 1905 as a conductor.

'On the platform will be Mr. J.W. Bennett, of Marshall-street, Leicester, senior conductor, who has been on the job since 1914. "I'm sorry to see the old trams go," he said. Mr. Bennett has still nearly four years to do before superannuation.

'Both have been on the normal Humberstone service today.

'When the last tram leaves the centre on its last service run, passengers will be carried in the normal way, but on the LAST run to the depot, the passengers will be there by invitation only.

'Two former chief inspectors, Mr. Ted Stanyon and Mr. G. Potterton, and Mr. George Morris, former works superintendent, have been invited for the ride.

'What happens to the tram at the end of the run?

'No one knows yet. There have been suggestions that it should go to the museum, but it is a bit too big for that. Another is that it should be made the fuel for a ceremonial bonfire. Perhaps it will just fade into the oblivion of the scrap heap.'

One of those privileged to ride on that final journey was 'Old John', who had a daily column in the *Evening News* appropriately titled 'Round the Clock Tower'. Having already quoted one reporter's story of his trip on the first tram back in 1904, it is perhaps only right that Old John's recollections of the very last journey, which appeared in the 10 November edition, should be reproduced in full:

'TRAMWAY SHED

'It is a long time since I saw such crowds in Humberstone–gate and round the Clock Tower as there were yesterday to see Leicester's last tram. And what a cheer the thousands gave as the tram moved off to the depot !

'There must have been quite a few among those on the pavements and in windows along the route who had seen the first of the electric trams. Perhaps some had seen the first tram to make a test daylight run to Belgrave and which became immobilised for some hours because of a power station breakdown.

'It was a pity that the Lord Mayor could not be on the last trip. A picture of him on the platform of the last tram would have paired up with that published in the Evening Mail yesterday of the Mayor of the borough on the first of a line of trams at the inaugural ceremony on May 18, 1904.

'One could have wished also for a speech from the platform by the Committee chairman before the tram left the Clock Tower.

'I was among the privileged "invitation only" passengers on the ride to the depot. We took our seats in the Humberstone-gate sheds, where the tram had been switched after its last service run from Humberstone in case any over-enthusiastic members of the public did a little queue-jumping.

'The BBC recorded the event, Press photographers were there in force, but the greatest body of enthusiasts were the amateur camera operators.

'I don't recall seeing, for a long time, so many people squinting through viewfinders and, notably, a large proportion of them were Transport Department employees.

'All along Belgrave-gate we were photographed, cheered and waved at, and as we turned into Abbey Park-road children were hurriedly brought from the school on the corner to witness the event. Something to tell their grandchildren about!

'By the time the official party boarded the tram there was evidence that souvenir hunters had been busy, but we all got a souvenir in the form of a 1½d. ticket – the first I have ever had on a tram without payment.

'Furthermore, it was the first time I have seen men smoking inside a tram without having their attention drawn firmly to the "No Smoking" notices.

'Some names will go down in the records over this trip. The driver and conductor are by now well known, but recently-retired ex-Chief Inspector T.E. Stanion got the last ticket[12] and Mr. G.A. Smith, Chief Wages Clerk to the department, was the last passenger to alight.

'I won't mention the name of the man who got the reversing handle from the control box. Perhaps that was off the record!

'I am in no doubt about the respectful greeting given to the tram by the majority of the Abbey Park Road staff, who turned out to a man – and woman – when we arrived, but I am still wondering whether the chorus on the hooters of buses parked in the garage was in salutation – or whether this last representative of the old order was being positively and absolutely hooted off the road!'

Appendix 5 has a complete list of Leicester City Transport bus routes as they were on 10 November 1949, the first day after the trams had finally departed.

The last word

The turn-out in Humberstone Gate for the last run suggested that Leicester's citizens retained a good deal of fondness for the venerable cars, Mr Leicester, in his *Leicester Mercury* column on 9 November, it seems, included:

'HOPING THEY WILL FIND A NICE CLEAN HOME
'This afternoon we say farewell to our tramcars. It was in May, 1904, that horses ceased to be the motive power in our street transport, and in the succeeding 45 years the electric trams have travelled the astronomical distance of 170 million miles over Leicester's streets and carried over two thousand million passengers.

'Of their efficiency in latter years we may have had doubts, and I do not imagine there will be many tears

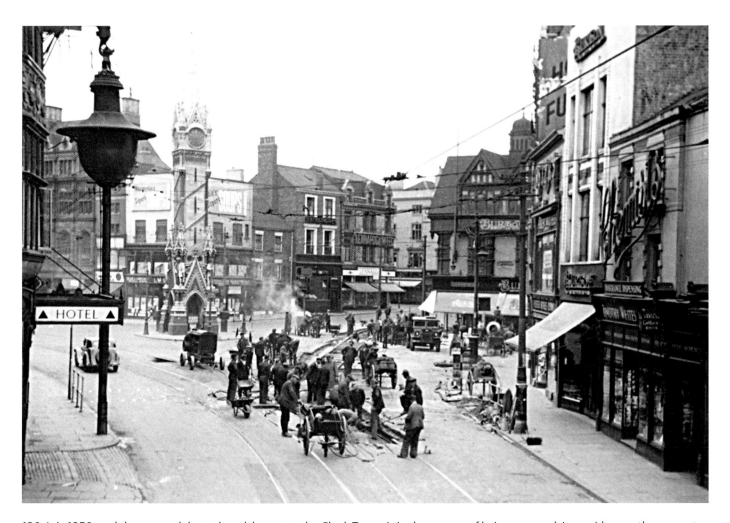

130. It is 1950, and the once celebrated track layout at the Clock Tower is in the process of being removed. It provides another opportunity to look at the changing face of Leicester, as we are in almost exactly the same spot as the 1905 view in Chapter 1, when the system was in its infancy. Most of the buildings that can be seen to the right of the Clock Tower are still in existence, though none are in the same ownership now, 67 years later.

shed, but one thing we can remember with satisfaction is that they were to the eye the cleanest and best maintained tramcars of any city in England. Their tidy appearance even drew favourable comment from the stranger.

'Seven trams sufficed to serve today's last remaining route, Humberstone Road. The year we opened with electric traction we had 99 in service.'

On that basis, it would not have been unreasonable to think that the public would inundate the pages of

Leicester's newspapers with their own paeans of praise. But no. Only these two gentlemen, whose letters in the *Leicester Mercury* on 11 November displayed especially uncompromising attitudes:

'CLEAN TRAMS
'I cannot let Mr. Leicester's words of Wednesday evening re Leicester's tram cars being the cleanest and best maintained of any city in England pass without comment. I suggest he takes a trip to mucky Sheffield

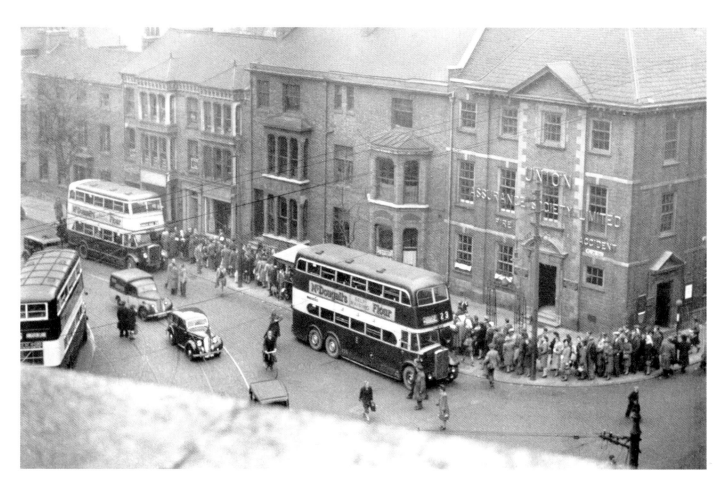

Above and Opposite: 131-132. It is interesting to compare and contrast these pictures of Welford Road at the three-way junction with Newarke Street and Pocklington's Walk. In the first, taken on 12 October 1946 from the roof of what was the Leicester Permanent Building Society offices, the tram lines are still in place and are still in use, as the line to Aylestone did not close until January 1947. Buses dominate the scene, along with crowds of intending passengers; AEC Renown 335 (DBC 226) is working a 23 service to Uplands Road and an unidentified Leyland TD4c appears to be loading for the 24 Windley Road service; both routes terminated in the Southfields Drive area. The vehicle partly in shot on the left is one of the year's intake of AEC Regent IIs and Leyland PD1s.

The later picture was taken on 22 January 1949 and shows the full extent of the junction, along with the statue of John Biggs (1801-71), a former Mayor and MP of Leicester. The tram lines have gone, and an AEC Renown, possibly 334, still graces the Welford Road stand nearest Newarke Street, though by now it will be working the 25 to Southfields Drive, which replaced the two previous routes in 1947. The vehicle approaching the junction in Newarke Street is Leyland TD4c 265 (JF 5007), which is engaged on driver-training duties, and the two Corporation vehicles on the opposite side are 211 (DJF 324, nearest the camera) and 216 (DJF 329), both on the 22 to Narborough Road. Midland Red vehicles are visible further along the street, underlining the importance of the road as one of the city centre terminals.

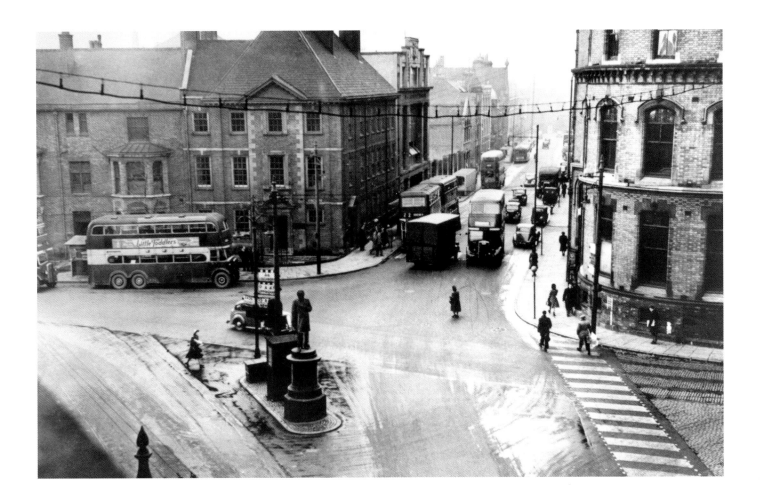

where he will find the trams not only cleaner but much more pleasing to the eye in not being disfigured by advertisements.

'A GREER, Braunstone'

'TUT-TUT

'Had I been blessed with the time or the tomatoes nothing would have pleased me more than to hurl the oldest and juiciest of the latter at the decorated ancient symbolising our "faithful friends" the tramcars. And if accidentally it came to rest on the ear of one of our Transport Committee, who should complain but he? Obsolete, rattling old junk! Discarded by more enlightened towns decades ago.

'R J PEMBERTON, Shanklin Drive, Leicester'

Leicester Mercury leader writers in 1924 and 1935 had pointed to the fact that the trams were 'obsolete' and 'doomed', the latter suggesting that many people would have been glad to see them off the road in less than the

ten years that Councillor Charles Keene was suggesting at the time. That their swan-song took 14 years from that point was due entirely to the war, and the difficulty in getting new buses quickly afterwards. Perhaps the letter writers of Braunstone and Stoneygate might have been more sanguine in their attitudes towards the trams had there been a steady, uninterrupted withdrawal from 1938 onwards, although that would be to decry the magnificent work they put in during the wartime years.

I was not born in the era of the trams, and so consequently feel it is appropriate that the last word should go to someone who knew them intimately, and wrote about them so eloquently – M.S.W. Pearson.[13]

'That they swayed, rumbled, clanked and jerked is perhaps true. But they had done a magnificent job over a period of nearly 75 years,[14] and had brought about a revolution in our daily lives. They had a character and had for so long been a part of the daily scene, that something quite indefinable seemed to be missing when they had gone.'

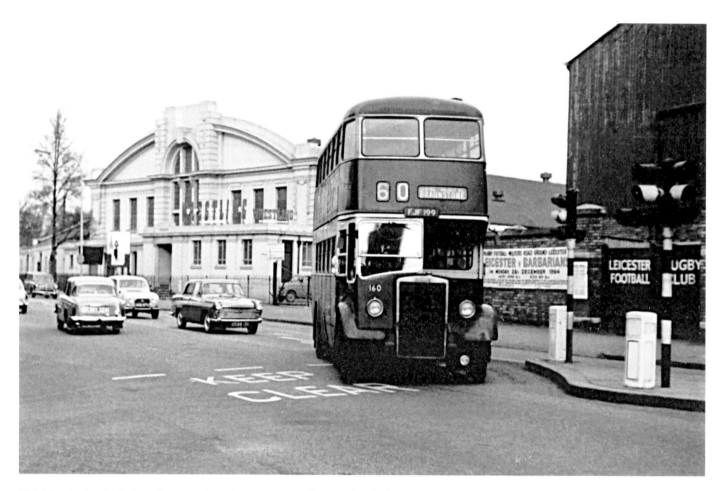

133. The final vehicle bought to replace the trams was the one that kick-started my interest in buses, circa 1955. While the Leyland PD2's from 96 to 159 were undeniably modern and comfortable, it was obvious to juvenile eyes that 160 (FJF 199) was different, not least because it was furnished internally in an attractive green and cream leather cloth as opposed to the usual red. 160, new in November 1950, had been exhibited at the Earls Court Commercial Motor Show the previous month; it was Leicester's first 8' wide bus, and was also a foot longer than its sisters, increasing its seating capacity by four to 60. It was Leicester's only PD2/12, and is seen here on a 60 working to Braunstone in 1964, turning from Aylestone Road into Walnut Street – a manoeuvre impossible today. The Leicester Tigers ground is on the right, and the Granby Halls, which were demolished in 2001, on the left. 160 became a training bus, renumbered 301, in late 1969, and was not finally withdrawn until 1975.

1981-1994: THE BUS WARS

Background

Once the issues about who could pick up and set down inside the city boundary were resolved by the introduction of the Area Stop signs in 1932, both Leicester City Transport and Midland Red could at last to settle down and build up their businesses within those parameters. Despite the fact that the original agreement was for a period of one year only, the relative calm that ensued in fact lasted for almost fifty years. Eventually, there was some degree of mutual co-operation – for example, in the agreement to and setting up of 'Joint Services' in the post-war period which in some cases saw Corporation buses venturing across the boundary and into the county.[1]

But once the Second World War was over, and the golden era of post-war bus travel – broadly the period between 1946/47 and 1955/56 – had passed, the rise in ownership of motor cars and TV sets began to change the way people went about their work commute and leisure time, heralding an increasingly negative effect on passenger numbers. To make matters worse, fare rises, not much seen in the pre-war years, were now sought on a more regular basis, as inflationary forces began to impact on the costs of vehicles, fuel and thus wages.

For some four years prior to 1970, the issue of possible rationalisation involving the two operators had been given some thought without any real idea as to how it might be achieved. But in July of that year a working party was set up, comprising the deputy General Managers of Midland Red and Leicester City Transport, together with the Traffic Manager of the former and the Planning Officer of the latter. Terms of Reference were agreed whereby the feasibility of greater co-ordination or integration was to be considered, taking into account factors such as structure, sphere(s) of influence, capital and viability. Meetings were held monthly from August onwards, and a report was produced in the summer of 1971. This identified the different options available to facilitate better co-ordination and co-operation:

MIDLAND RED
Associated with the National Bus Company

Service 74	Service 96
LEICESTER	LEICESTER
BEAUMONT LEYS	BEAUMONT LEYS
ANSTEY	ANSTEY
	CROPSTON

622
LEICESTER
ANSTEY
CROPSTON
ROTHLEY

624
LOUGHBOROUGH
WOODHOUSE
THURCASTON
LEICESTER

631
LEICESTER
GLENFIELD TURN
ANSTEY
NEWTOWN LINFORD

629
LOUGHBOROUGH
WOODHOUSE
ANSTEY
LEICESTER

S35
ANSTEY
THURCASTON
LEICESTER

County Travel
WOODHOUSE
LOUGHBOROUGH

Most journeys are operated by One-Man vehicles and passengers are requested to tender fares to the Driver when entering the vehicle. It would be appreciated if correct fares could be tendered whenever possible.

PLEASE STATE DESTINATION CLEARLY

In operation from 30th NOVEMBER 1975 until further notice

214 LD 0975 JU 11M **5**

134. A typical Leicestershire area Midland Red timetable leaflet from 1975 was very much of a "no frills" affair. Services to all points between Leicester and Loughborough using the country roads via Anstey, Cropston and Woodhouse Eaves are here; note also the inclusion of the County Travel route that seven years hence would play its part in an early "bus war" between Midland Red East and Leicester City Transport.

- a Midland Red takeover of Leicester City Transport
- a Leicester City Transport takeover of Midland Red interests in Leicestershire and Rutland

- a new operator combining Midland Red and Leicester City Transport operations
- a common policy covering joint operation and agreed rationalisation (including fare structures and facilities)
- joint independent operating boards and committees

It should be said that the pressures on Midland Red at this time were considerable. We saw in Chapter 2 that since it was founded, it had formed part of the British Electric Traction (BET) Group, one of two such organisations (the other being the Tilling Group) that owned bus operating companies with services across large parts of England. In 1968, both groups were acquired by the state, leading to the formation of the National Bus Company (NBC) on 1 January 1969. Ministerial diktat sought to have all NBC subsidiaries operating as commercial entities, but by the time of the Working Party review, the financial situation of some companies, including Midland Red, had deteriorated to the extent that they would find it difficult to meet their financial targets. The report makes it clear that, given what was happening nationally, their recommendations should not exist within a Leicestershire and Rutland 'vacuum' but should also take account of national trends, or as the report put it, 'national uncertainties'. There were also constraints to be considered:

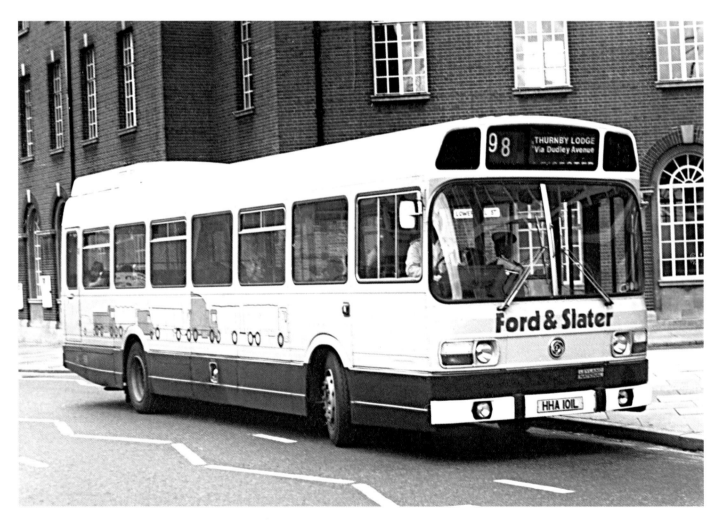

135. The National Bus Company (NBC) and British Leyland jointly developed a single decker bus, the vision being that it would become the standard saloon available to all NBC subsidiaries. Midland Red received its first example in October 1972, and went on to amass 420 of the type. 101 (HHA 101L) started a new numbering system (the previous one having ended at 6473), and was allocated to Southgate Street garage in March 1974, carrying this advertising livery for Ford & Slater. It remained in Leicester until the end of 1984, whereupon it moved to Midland Red West; it was acquired for preservation in 2008.

- neither operator wanted to lose its identity
- financial and operational conflicts of interest hindered the provision of a cohesive network
- some services outside the city boundary were unremunerative, and were likely to remain so
- radical change would be time-consuming when there were other pressing problems – most notably passenger losses – to be addressed

So the principal recommendation, insofar as it impinges upon this history, was that there should be established a defined area of agreement between the two operators in which an integrated, uniform pattern of service with a common fares policy could be introduced for the Greater Leicester area. This might be achieved through the setting up of a Joint Operating Committee. However, the Working Party muddied the waters by making alternative suggestions:

- that Leicester City Transport could take over complete control of bus services in the defined operating area with Midland Red providing vehicles and crews on a contractual basis; or
- a small holding company could be set up with a nominal share capital held in agreed proportions by the two operators that would carry out the functions of the Joint Operating Committee

There was some increase in the amount of joint working of services in areas where new estates straddled, or lay

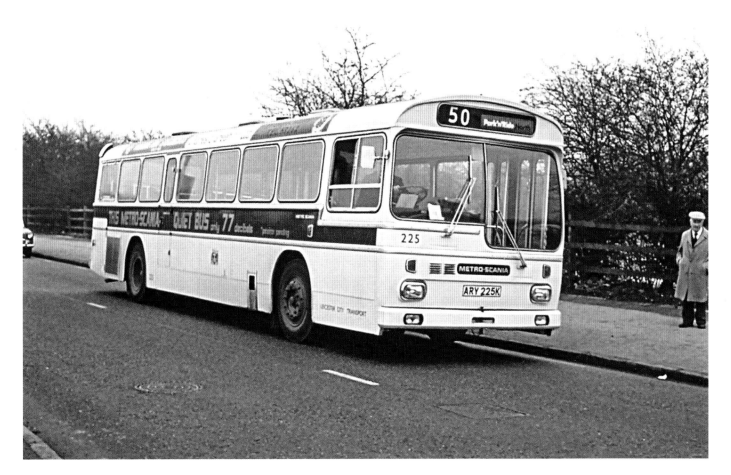

136. While the NBC was developing the Leyland National for its many and varied fleets, Leicester invested in an equally ground-breaking type of single deck vehicle in the shape of the Scania BR111MH, the result of an Anglo-Swedish collaboration between Scania and Metro Cammell. 35 were acquired, in two batches between March 1971 and July 1972, and this is the final one, 225 (ARY 225K), the much-vaunted "quiet bus", on Park & Ride North duties in Abbey Lane possibly as early as 1972, when the service was inaugurated. All the Metro-Scanias, as they were known, lasted into the bus wars era, withdrawals being made between August 1983 and October 1986.

It should also be recorded that the decision to change fleet livery to cream with a maroon band (or bands) had been taken towards the end of 1960, and these colours prevailed until the changes in 1984 discussed later in this chapter.

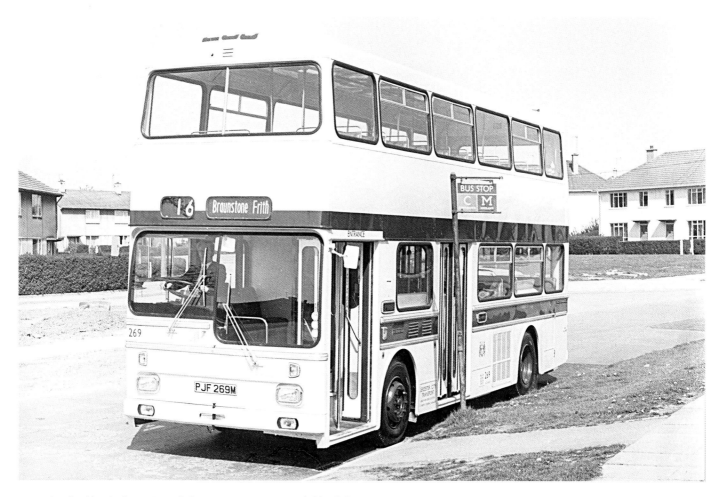

137. The double deck version of the Metro Scania was dubbed the Metropolitan, and Leicester put 43 of the type into service during 1974/75, replacing the earliest examples of the PD3s. This is 269 (PJF 269M), which came in May 1974 and was taken out onto the 16 Braunstone Frith route to pose for some publicity photographs. This shot was taken in Liberty Road, and of note is the bus stop flag, which shows that the route is jointly worked by Leicester City Transport and Midland Red.

just outside, the city boundary, but otherwise there was no further progress towards implementation of any of the Working Party recommendations. Midland Red was no doubt subject to wider political pressures through its subsidiary role in the NBC, but the extent to which this was an opportunity lost so far as Leicester City Transport was concerned can be judged as the events of the 1980s unfolded.

Introduction

Despite the mounting pressures it faced (declining passenger numbers, increased costs through higher inflation), Leicester's fleet continued to be updated on a regular basis throughout the 1970s. Geoffrey Hilditch, who became general manager in 1975, worked with Dennis on the development of the Dominator double

decker, the type that became the Leicester standard between 1978 and 1989, with over 140 examples entering service. In August 1979, in a move that took it outside its normal operating area, it acquired the business of Gibson Brothers (Barlestone) Ltd, with its fleet of ten Plaxton bodied Bedford YRT and YMT coaches and stage carriage services linking Market Bosworth with Leicester by two different routes.

Between 1969 and 1981, Midland Red felt these same pressures more keenly than most simply because of its size and diversity of operation. Nationalisation effectively spelled the end of Midland Red's bus building capability, ending a tradition that had spanned almost fifty years.[2] Then in December 1973, all Midland Red's services in Birmingham and the Black Country falling within the newly created West Midlands Passenger

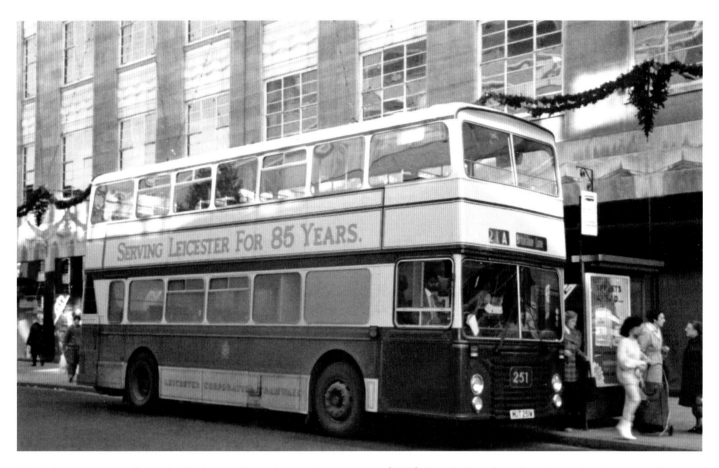

138. Leicester eventually took 68 Metropolitans, but in the same year (1977) that the last five, the only single door examples, were received, the first of a new generation of double decker appeared. Recently appointed general manager Geoffrey Hilditch had operated a Daimler CVG6LX, 9517 UA, in Leicester for three months in 1976 as a test-bed for the engine and gearbox that were ultimately used in the construction of the Dennis Dominator, and Leicester became an enthusiastic purchaser of the type for over a decade. Most examples were bodied by East Lancs, typical of which is 1980 arrival 251 (MUT 251W), which I photographed outside Lewis's store in Humberstone Gate on 29 October 1986, while it was carrying 1901 horse tram livery to celebrate 85 years of municipal transport in Leicester.

139. Gibson Brothers started trading as "Comfort Coaches" from premises in Barlestone in 1922. Leicester City Transport took over the company in August 1979, its fleet consisting of ten Plaxton bodied Bedford YRT or YMT coaches. Works, schools, shoppers services and private hire operations were accompanied by stage carriage services to Leicester which terminated at The Newarke. Following the closure of the bus station there, services were moved closer to the centre, and YRT 82 (PNR 320M) was photographed in Horsefair Street in or around 1981; it will shortly move onto the stand in Bowling Green Street before its next journey to Ibstock.

140. Following the takeover, six new Plaxton bodied Leyland Leopard coaches were acquired over the two years to November 1981 and put to work in Leicester City Transport livery but with Gibson fleetnames. This is 2 (TBC 2X), which although clearly a Gibson bus is making its way back to the city centre along Humberstone Road. with a 53 working from Goodwood. The railway bridge in the background provides a link with tram car 7, pictured in Chapter 4 in the same spot over 30 years previously.

141. Increasing congestion led to a series of changes to Midland Red's city centre termini in the late 1970s. Newarke Street had ceased to be used in the early 1960s when a new bus station was provided in 1963 on land situated between that thoroughfare and York Road, which also housed the new Phoenix Theatre. 5266 (5266 HA) was one of 50 rear-engined Daimler Fleetlines designated DD11 and received in 1963; both it and D7 4537 will be shortly be heading off along the Aylestone Road to Whetstone and Broughton Astley respectively. The bus station closed in April 1978 but the theatre continues in existence, and has recently been renamed in memory of Leicester author Sue Townsend, who died in 2014.

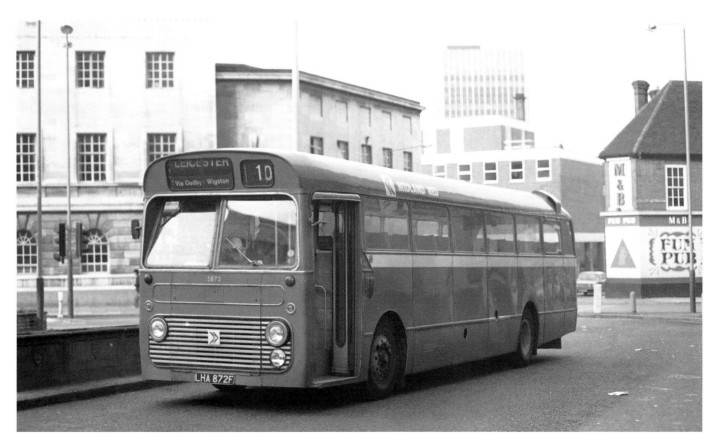

142. The island and pavements to the side and rear of Midland Red S21 class 5872 (LHA 872F), which is standing in Northampton Square, will soon be swept away with the widening of the inner ring road at this point. It is 1977, and 5872 will next be employed on the 10, which began life as the L10 to Wigston Magna (Bank) via Oadby. It was extended to The Newarke in the 1950s, at which point there were clockwise and anti-clockwise operations. 5872 was one of 30 dual-purpose saloons new in 1967 which were originally given red and maroon livery to denote their superior status. It operated out of Wigston garage for its last three years, by which time NBC colours ruled the roost, and was withdrawn in 1980, the same year that Northampton Square closed.

Transport Executive area were sold to that body for £3.6 million, a move which saw 413 vehicles, six garages and associated staff transferred under the deal.[3] Thus Midland Red's heart – a relatively profitable heart even then – was removed at a stroke. Excluding Leicester and the remaining Black Country operations, what was left was a largely unremunerative network.

In an attempt to stem the losses, in 1977 the company devised the 'Viable Network Project' – later re-christened the 'Market Analysis Project', or MAP – which sought to determine ways in which services could be maintained in the face of continually rising costs and falling ridership, at fare levels that were still acceptable to intending passengers.[4] It was while this survey-driven exercise was still in progress that the Conservatives won the general election in May 1979 with a majority of 44 and an agenda that promised to control inflation,

limit the powers of trade unions, and privatise as much state-controlled business as possible.

The 1980 Transport Act

Whereas in 1930 the then Labour Government had legislated to place the Traffic Commissioners in the role of arbiters in the matter of service provision, Conservative policy was effectively to turn that on its head, and a start was made almost immediately with the passing of the Transport Act 1980, which received Royal Assent on 30 June. Part I – which was concerned with bus passenger transport – began with an initial section in which public service vehicles were redefined and reclassified. After that, the legislation really got down to business. Road service licences for express services were abolished; it was made easier for applicants to obtain other road service licences and the ability to attach

conditions regarding fares to them was restricted. New provisions were introduced with the aim of securing the fitness of public service vehicles, and a new system of public service vehicle operators' licences came into force. Another clause provided for the designation of trial areas where road service licences would not be required for stage carriage services; this was in many respects a 'dummy run' for the deregulation legislation that was to follow

Clearly, restricting the ability to place conditions on fares that could be charged was hugely important, to both Midland Red and Leicester City Transport, but for different reasons. This was arguably the most important part of the legislation, and they would approach it from opposite sides of the spectrum. The protection that the Area Stop Sign restrictions had afforded the Corporation

during the past fifty years or more was now under threat, and it would not take long for Midland Red to seek to take advantage of this relaxation in the law. But before that could happen, another seismic shift in the constitution of the company was about to take place.

The formation of Midland Red East

In February 1981, it was announced that Midland Red would be split into five units; North, East, South, West, and a separate coaching unit (Express), leaving Midland Red Omnibus Co Ltd to continue as an engineering and property-holding company. Midland Red East came into being on 6 September 1981, with garages at Leicester, Wigston, Coalville and Swadlincote. Midland Red expert Malcolm Keeley has written of the four new operating companies, 'North has the architecture,

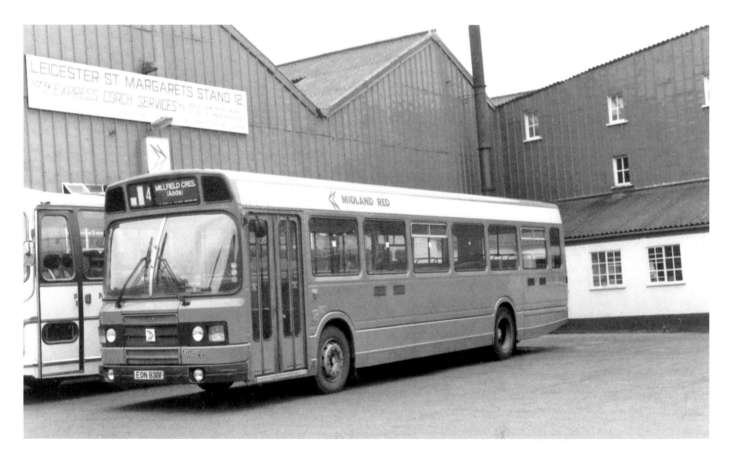

143. The Leyland National was not universally liked; one Midland Red Inspector described the type to me as "Cumberland dustbins", but the company, pursuing a single deck purchasing policy, was obliged to take them in large numbers. Eight years were to elapse before an improved version, the National 2, became available. Midland Red had 25, taking fleet numbers 807-831, and it is 831 (EON 831V) we see in the Southgate Street garage yard in Midland Red East ownership. The notice on the garage wall tells potential travellers that express services that had departed from the yard in coach station days were now all transferred to St Margaret's bus station. 831 became 3831 under Midland Fox; it spent three years in the mid 1990s in the London & Country fleet, but returned to Coalville garage, re-numbered 2154, for two years before final withdrawal in 1999.

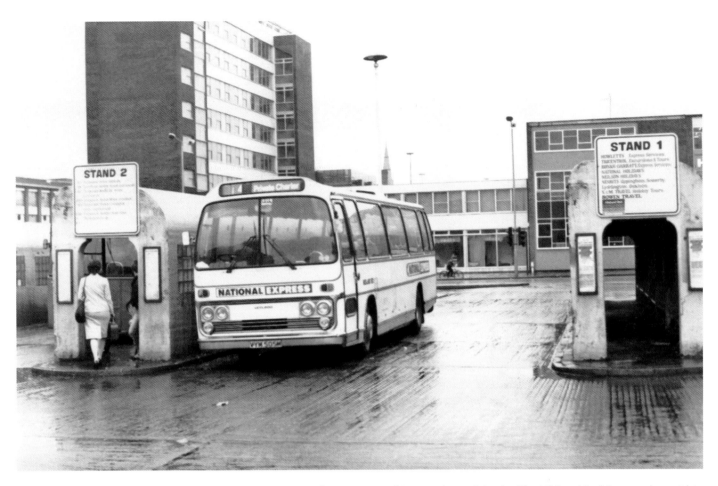

144. At the break-up of the Midland Red empire in September 1981, coaching stock was inherited by Midland Red Express, but within three months Midland Red East had reclaimed control of its fleet (as did Midland Red North at Cannock). With the development of the "Midland Express" network of routes and increasing commitment to holiday, excursion and private hire work, more coaches were needed, and Plaxton bodied Leyland Leopard 2610 (VYM 505M) was one such. New to Cumberland, it was allocated to Wigston in April 1982, moving to Southgates the following year. It had been undertaking private charter duties when seen in a soggy St Margaret's bus station, probably in 1983.

West the scenery, South the tourists, and East the passengers. A gross generalisation, of course, but one which may have more than a grain of truth in it'.[5] Midland Red East managers had already realised that they did not have a suitable vehicle mix to cope with these passengers. Purchasing policy between 1971 and 1981 had been geared exclusively towards the single decker,[6] and out of East's inheritance of a fleet of over 200 vehicles, only 50 were double deckers; Daimler Fleetlines of between 10 and 15 years old, most of which under normal circumstances would soon become due for withdrawal. So almost immediately, the company began to invest in younger, second-hand Daimler Fleetlines which were being withdrawn by London Transport; whilst it had been decided that they were unsuitable for further use

in the capital, they would go on to give several years good service in Leicestershire.

Take-over bid

One month before Midland Red East came into being, a meeting had been held between representatives of the Council and the Regional Director of the NBC. The purpose was to discuss the situation with regard to Leicester City Transport (LCT) taking over the Uppingham Road and Thurnby Lodge routes from Midland Red. With more than half an eye on the implications of losing some or all of the protection afforded by the Area Stop Sign restrictions, the Council subsequently extended the scope of this proposal by indicating that it would wish to enter negotiations to purchase all Midland Red

services operating within, or in close proximity to, the city boundary – estimated to be 50 vehicle workings across 26 different routes. To sweeten the pill, it was suggested that:

- LCT would assume responsibility for these services over a period of (say) three years, and cover any Midland Red losses incurred on those still operated during the take-over period
- offer a job with LCT to any Midland Red driver displaced as a result
- lend Midland Red vehicles to cover any shortfall that arise during the take-over period, and
- purchase any vehicles made redundant by the deal at market prices

The NBC spokesman was adamant that no sale could take place that would jeopardise the launch of Midland Red East operations, but neither could the current situation continue. He said that some of the difficulties faced by Midland Red in Leicester came from the picking up and setting down restrictions in the city, and the way the Council obtained as much concessionary fare revenue as possible for its own undertaking. Indeed, he believed that if a case under the Competition Act was put forward, it could well be successful. He wanted coordination, but the plain fact was that the Council didn't, claiming that there was no desire in the Council chamber to see any Midland Red bus on any road in the city where the company did not currently operate. Although the NBC spokesman said that it ought to be possible to open up the Leicester area as a result of the Transport Act, and that Midland Red managers had a whole raft of ideas as to how this could be achieved, he would not specify what these were, and Geoffrey Hilditch recalled that the meeting closed 'in what might be described as a somewhat unfortunate atmosphere'.

Two months later, on 12 October, the matter first hit the headlines. In a piece described as an exclusive, the potential financial cost to Leicester City Transport of losing its near monopoly on city services was exposed to view:

'BUS ROUTE WAR MAY BREAK OUT
'A cut-throat war could break out on city bus routes if a last-minute bid by Leicester delegates to

145. A Midland Red East timetable from May 1983, this one covering what was at that time my home route. Some attempt has been made to improve the covers with the addition of some interesting artwork, although the 599 was more used to seeing ex London Daimler Fleetlines than a Leyland National 2.

prevent it fails at an important transport conference at Llandudno this week.

'And if Leicester City Transport should lose out in such a war with Midland Red it could cost them about £370,000 a year in lost revenue.

'This in turn would inevitably mean an application for a 2p increase on City Transport bus fares for the whole of the city to make up the loss.

'In a war of this kind, which is now permitted by the Conservative Government's 1980 Transport Act, Midland Red could start picking up and setting down passengers within the city boundary.

'Until now, competition of this kind was not allowed under the regulations.'

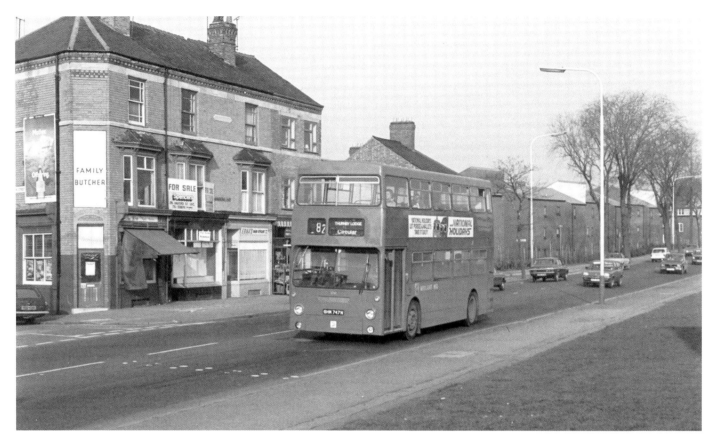

146. When Midland Red East came into being in September 1981 it received over half of the entire aged Midland Red double deck stock. The company needed newer vehicles as a matter of urgency, and fortuitously, London Transport was in the process of withdrawing large numbers of its Daimler Fleetlines that were some 3-4 years younger. Almost 80 came to Leicester between 1982 and 1984, a few of which were to see over ten years service with the company, so it was clearly a sound investment. 2747 (GHM 747M) was allocated to Southgates upon arrival in February 1982, and was seen on Humberstone Road, bringing an 82 Thurnby Lodge service – the subject of much subsequent argument between Midland Fox and Leicester City Transport – back to the centre in 1983. It is carrying a deeper red livery than the NBC version which, given Westminster's plans for the industry, was clearly a harbinger of change.

There is no doubt that the citizens of Leicester felt a strong attachment to the Corporation undertaking that had served them well for so long. So bearing in mind that it was Midland Red East who stood to benefit most from the change – or put another way, would be deemed to be responsible for disrupting the status quo – a firm but emollient tone was what their representative needed to adopt, and that is how Midland Red East manager Peter Lutman handled the interview reported in the *Leicester Mercury* on 14 October:

'LET'S NOT MAKE WAR ON THE BUSES, SAY MIDLAND RED
'Midland Red East management in Leicester have called for a "sensible agreement" over local bus services – and not for cut-throat competition.

'The company's manager, Mr Peter Lutman, said this was the key to success for the city's public transport.

'"War on the buses would benefit nobody," he said in response to the news that there might be out-and-out competition on Leicester bus routes.

'"What we would like is a sensible agreement between the county council, Leicester City Transport and Midland Red East – an agreement designed to give all passengers the freedom to use all the bus services."

'New regulations under the 1980 Transport Act mean that Midland Red can now pick up within the city boundaries, which was not previously allowed.

'"Offers to co-ordinate bus services were repeated by us at meetings in June and August, with members and officers of the city council," he added.

'"But regrettably, the city refused to make progress on co-ordination. Instead, they have proposed a take-over of some local services which could make it more costly for Midland Red East to provide services for other towns and villages."

'He said that co-ordination of the buses would bring an extra bonus for young and old. "Existing city arrangements for elderly and disabled passengers prevent them from having a full choice of all the available buses," he said.'

By the end of October, the Leicester Transport department annual report had been published, revealing that the undertaking had a £109,389 deficit in the last financial year, although this was after reserving £480,000 to buy new vehicles. Despite that, the chairman was bullish about the Council's intentions in his statement, which appeared in the *Leicester Mercury* on 29 October:

'BUS WAR WOULD BE HARMFUL TO SERVICES – WARNING
'Leicester transport committee chairman Mr Henry Dunphy stressed today that the City Council had no wish to wage a bus war with Midland Red.

'Under the 1980 Transport Act, which removed previous restrictions on competition between bus undertakings, such a conflict was possible.

'But, said Mr Dunphy in a statement, public passenger transport has declined to such an alarming extent since the war that any conflict of this nature will only cost public money and be harmful in the long run to the services.

'Mr Dunphy said it was estimated that Midland Red lost about £500,000 on the city services of their operation.

'"If that operation could be run by Leicester City Council that loss could be reduced to £170,000 through the reduction of overheads.

'"And if the City Council then reorganised the routes the loss could be further reduced to about £100,000.

'"The City Council have already got co-ordination agreements with Midland Red and for this we pay £70,000 a year to the company. The City Council does not wish to go any further down that road."'

It is fair to say that the Transport Department was flying in the face of the legislation, seemingly hell-bent on retaining the monopoly it had enjoyed since the

1930s, despite the fact that even a casual reading of the Transport Act indicated that this would be unsustainable. NBC and Midland Red East management talked of co-operation and co-ordination, but they were evidently not prepared to continue with the restrictive practices of the Area Stop Regulations if the law provided them with the opportunity to put an end to them.

It is instructive to note that the line of attack adopted by the Council was to attempt the buy-out of Midland Red services in and around the Leicester, but it begged several questions:

- it was not clear how the estimate of £500,000, representing Midland Red East's losses on the city routes, was calculated, or by whom; it is noticeable that Midland Red East management never commented on the figure, at least in print
- one also has to wonder why, having just made an annual loss of £109,000, the Transport Committee were prepared, on their own figures, to take on another, bigger six figure loss in the shape of the Midland Red East city services
- if the city services were losing money, wouldn't Midland Red East be glad to see them with another operator? Peter Lutman's stated view was that withdrawing from them would potentially make it more costly for Midland Red East to provide its county services, but it seems even more likely that Midland Red East wanted to retain the territorial advantage the city routes provided, whatever the cost, at least until the Government's longer term plans were clear. Peter Lutman's references to co-ordination imply that at this stage, an increase in joint working was the favoured option
- there was as yet no indication as to how the Transport Department intended to get round that critical part of the legislation – restricting the ability to attach conditions to fares – because even if Midland Red East did sign away all its city routes, there was still nothing to stop it applying to pick up and set down passengers within the city boundary on its county services when Area Stop restrictions were outlawed

There is no doubt that the various Transport Committees since the 1919-21 period had all been of the same mindset – that the Council should have jurisdiction over all

routes within its boundaries – and when this came to be tested by the 1980 Act, it seems that the Council had a significant measure of popular support in both the city and, surprisingly, in the county also. Perhaps this is because the Act was passed by a Conservative government whose policies were judged by a very vocal local opposition to be divisive. Despite Labour members' domination of the Council, and the expectation that a future Labour administration would reverse the 1980 legislation, it is impossible to suppose that the Transport Committee did not fully understand the implications of the Act. It is far more likely that, buoyed by an mixture of civic pride and political dogma, they simply decided to interpret them in such a way that would allow them to continue more or less as before, come what may, as one can read into their various pronouncements that they honestly believed that their plans were to the benefit of all customers, city and county alike. It is hardly surprising that such a view was not shared by Midland Red East.

A new route network?

November seemed to pass quietly, but on 4 December 1981, Midland Red East management submitted a report to the County Council which set out its plans for a new, streamlined network. 25 existing routes – nearly all those identified at the August meeting – would be replaced by eight cross-city services which would crucially *not* operate in or out of St Margaret's bus station, thus creating another potential financial loss for the Council. In addition, there would be no restrictions on the carriage of passengers over any section of the new services, unless imposed by Midland Red East to safeguard accommodation for longer distance passengers, and the company would also be seeking the lifting of all restrictions on 31 other services. All details of the proposed changes can be found at Appendix 6. The *Leicester Mercury* picked up the story on 8 December; at last, reference was made to the crucial role that the Traffic Commissioners would play in determining the outcome, but note also the reference to the County Hall subsidy, which came without acknowledging the fact that it was largely for unremunerative but socially necessary services:

'MIDLAND RED FIGHT FOR CITY ROUTES
'First shots have been fired in what could become a bus war between Midland Red and the City Council's Transport Department.

'Midland Red have sent plans to County Hall under which, it is understood, they propose to compete for passengers in the city.

'They called a Press conference to outline the plan, but declined to give details because they say their plans might be altered. They have not yet sent a copy to the City Transport Department.

'The City's Transport Committee chairman, Mr Henry Dunphy, who has warned of the consequences of a bus war, said today, "We are very intrigued to see the scheme."

'If the City Transport Department disagree with Midland Red's final proposals and resist them, a bus war could break out.

'But before then the East Midlands Traffic Commissioners have to endorse proposals. Recent legislation has increased the competitive possibilities.

'Both sides have denied recently that they want conflict at city staging points. Mr Dunphy has said it could only cost public money and be harmful to services elsewhere.

'The County Council's role is that they have a duty to try to co-ordinate public transport services in the county as a whole and try to ensure they are adequate.

'They also gave £1,109,000 towards Midland Red's Leicestershire operations this year, but they have no influence, other than giving subsidies of this kind.'

The leader column that day, under the headline 'Fare Deal', weighed in with more background detail and an appeal to common sense – on everyone's part:

'...while it is in the passengers' interests to have the best services, the prospect of a battle between Midland Red and the City Transport on the profitable routes is going to cost one of the organisations revenue. And somebody will have to make up the shortfall.

'The Traffic Commissioners, encouraged by recent Government legislation to break down monopoly situations to create a competitive environment, must take all these factors into account when they approve the blueprints.

'Wars can be expensive, whether they are fought with bullets or buses, and the final ratification of the proposals must take this very much into account. At the same time they must be fair to the consumers.

'It might be a good idea for them to lower fares on some routes – as some neighbouring cities have done – to increase the number of users. After all, it is the reduction in passengers using the buses that has caused the current problems.'

Geoffrey Hilditch had warned that the Transport Department would not sit back and watch Midland Red East take their revenues, and on 17 December, applications for five new services and variations to a further eleven were submitted to the Traffic Commissioners. These can be found at Appendix 7. Leicestershire County Council, with their responsibilities for co-ordinating services, not to mention those subsidies, responded to the report by calling a number of meetings between the parties in early January 1982. They appear not to have been particularly successful, as the *Leicester Mercury* reported that 'both sides were tight-lipped today over the possible outcome'. For his part, Peter Lutman for Midland Red East promised a statement in the future on the company's plans, while the local press once again reported that Leicester City Transport stood to lose at least £300,000 a year in any bus war, the equivalent of a 2p all-round fares rise on their buses. At the Council meeting on 28 January, Councillor Dunphy warned Midland Red East that the Transport Department could beat off any competition who tried to grab city routes. 'The undertaking was sound and would fight and win,' he said, adding that competitors should not think they could start a bus war just because Leicester City Transport needed a fares rise.[7]

By April 1982, both companies had produced sets of competing service applications, but the County Council asked that these should be withdrawn while the possibility of co-ordination was discussed once more. At the end of June, following a tripartite meeting, County Hall officials produced a paper on 'Bus services in Leicestershire'. These were the key paragraphs:

'(a) restrictions on loading, or protective fares, shall only be applied at times and locations necessary to preserve seats for longer distance passengers, to be fully operational by 1st July 1983. There should also be improved access by Midland Red services to the City central shopping area

'(b) any transfer of revenue from Leicester City Transport to Midland Red East because of the removal of current restrictions should be compensated for by adjustment of service sharing or other means to maintain each others respective revenue take and not unduly increase operating costs. (This implies there will be an agreed method of monitoring over an agreed trial period.), and

'(c) Midland Red (East), or any subsidiary company, shall undertake not to increase its current operations inside the City boundary, either singly or in association with another operator, except with the consent of Leicester City Transport and the County Council; and similarly, Leicester City Transport, or any subsidiary company shall undertake not to increase its current operations outside the City boundary either singly or in association with another operator, except with the consent of Midland Red East and the County Council.'

But one wonders how committed either side was to such noble aspirations, as within a year both operators were working against both the spirit and the letter of the document. Midland Red East managers were awaiting the results of a review designed to identify its strategic network; the Leicestershire Traffic Report, which looked in detail at bus usage across the county in order to arrive at a more focussed and efficient service network, one of the principal requirements of which was still the removal of the Area Stop restrictions. Detailed consultations took place throughout 1982 and well into 1983 with County Hall and all the local authorities. The full effects of this would not be seen until January 1984, when a revised network of services, including a system of cross-city links first envisaged in 1981 and new evening and Sunday timetables giving a half-hourly service were introduced. And by that time, the 'bus war' was in full swing.

Competition begins

Since taking over Gibson Brothers operations in 1979, Leicester City Transport managers had been looking to improve and increase the amount of work the unit undertook. In the period 1980-82, this mainly consisted of new routes and frequency improvements in the traditional Gibson's operating area. The first signs that they were starting to look further afield came on 9 May 1982,

when a joint service with independent operator County Travel was launched. The 121 was an amalgamation of two routes previously operated solely by County Travel, Loughborough to Anstey via Woodhouse Eaves and Newtown Linford (now extended so that the Anstey to Leicester section could be included), and Leicester to Fleckney via Wigston. Most of the route was already covered by other operators, so competition became a much bigger issue than previously. On 27 November, the Saturday-only 120 route was introduced. This ran from Leicester to Husbands Bosworth via Wigston, North and South Kilworth and Welford. It took Leicester City Transport into Northamptonshire for the first time, using their own, as opposed to Gibson's, vehicles.

Mention should also be made, despite it not being directly related to the ongoing issues with Midland Red East, of Leicester City Transport managers looking further even afield for new work. In May 1983, they became partners with the Burnley & Pendle and Maidstone Borough Council undertakings, supplying coaches and crew for the 100 'City Flyer' service which linked Blackpool and Dover by way of Burnley, Halifax, Sheffield, Leicester, London and Maidstone. Leicester's involvement was short-lived; it withdrew from the partnership at the end of the 1984 summer season.

Closer to home, an application was made to the Traffic Commissioners for a new Leicester to Loughborough service via Cropston and Rothley, jointly with local coach company Howlett's and in direct competition with Midland Red East service 620. A Sundays-only 120 began in July. Midland Red East was clearly not prepared to let this go unchallenged, and on 1 June applied for a new service inside the city boundary to Evington, a City Transport stronghold. This did not, in the end, materialise, and East's managers continued with their efforts to get agreement to the Leicestershire Traffic Report, which eventually came from County Hall in mid-September.

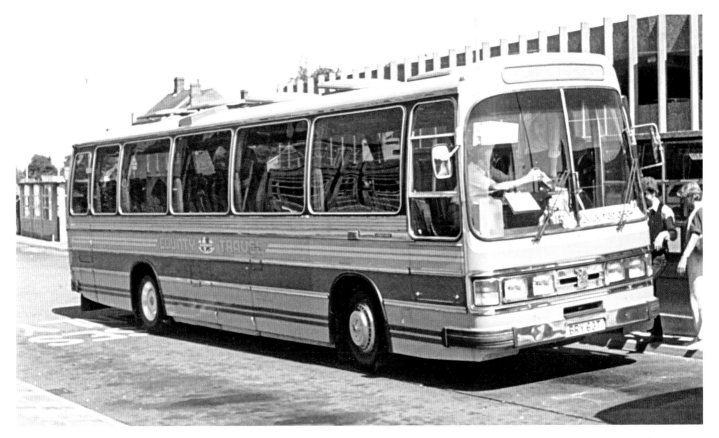

147. Picking up in Loughborough bus station is County Travel BRY 63T, a Bedford YMT/Duple Dominant new in 1979. It is on the 121, the jointly operated (with Leicester City Transport) service introduced in May 1982 which at its fullest extent ran between Loughborough and Fleckney, though this working will take it only as far as Leicester. In April 1988 the coach was sold to Carmel Zammit of Mosta on the island of Malta, where it was re-registered KCY 870.

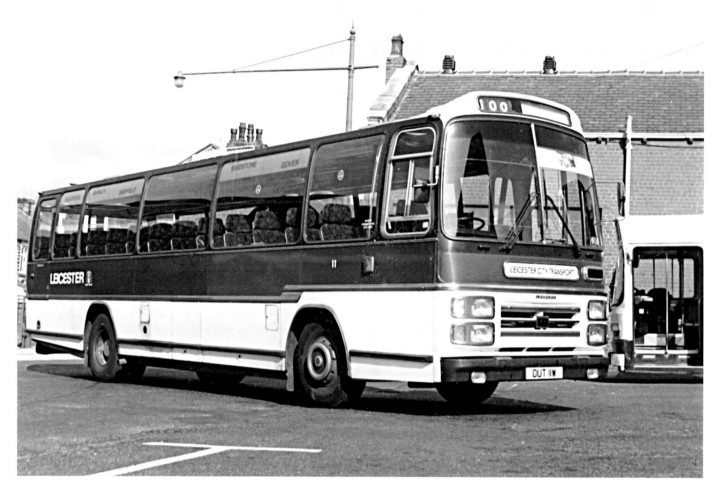

148. Leyland Leopard/Plaxton 11 (OUT 11W) on City Flyer 100 duty at the Burnley & Pendle depot in Queensgate, Burnley. New in 1981, it was sold after only four years service to B N & E R Cottrell of Mitcheldene.

But it was Leicester's next move that was to finally tip the scales – and this time it was not just Midland Red East who were upset. Free bus services, designed to bring passengers from surrounding towns into Leicester to shop, with particular emphasis on Leicester's market, were introduced from 4 October. They ran from Hinckley on Tuesdays, Coalville, Loughborough and Ashby-de-la-Zouch on Wednesdays, Melton Mowbray on Thursdays and Market Harborough on Fridays, and it seems they were a big hit with the public. Later editions of that day's *Leicester Mercury* reported on the new service, commenting that whilst the service was run by Leicester City Transport, the £45 a day costs[8] had been underwritten by the City Council's estates committee. Deputy surveyor Mr Danny Roberts was later to say that the free City Council buses reinforced the city centre's natural role as a shopping centre for people on outlying estates. Even those 15 miles away from Leicester, it seems.

Midland Red East manager Peter Lutman was not happy. The *Leicester Mercury* led page 1 the following day with a lengthy piece under the headline 'Shoppers' buses 'will hit fares'.

'Midland Red have warned that a new free "shoppers' special" started yesterday by Leicester City Council, could lead to higher fares for rural bus users.

'The warning came from Midland Red East manager Mr Peter Lutman who said the fares increase could be forced on the company by the new free market bus…

'…the aim of the new service is to encourage shoppers to travel into the city, but Midland Red say it is unfair competition for their services which run on the same route.

'They have now complained to the City Council... and have warned that the loss of revenue on their services leaves them with three options – higher fares, fewer buses or more ratepayers' money.

'Mr Lutman described the City Council's funding of the new service as "a waste of public money..."'

The response from the City and County Councils was one of mixed messages. The former put up their leader, Peter Soulsby,[9] who said that the Midland Red East response was an over-reaction:

'...(he) said he could not understand why the scheme had been criticised, bearing in mind that a similar scheme is run by another operator for Market Bosworth's market.

'Midland Red have been involved in similar schemes in the past, he said, and as a national company it had welcomed running a free service for a large retail store.

'Answering the point that the service was a waste of ratepayers' money, Mr Soulsby said the market traders are considering paying for the service at a cost of 10p a stall each day.

'He added that any increase in city trade was a benefit to ratepayers and this scheme should be seen as part of an overall council initiative at revitalising the city centre.

'He concluded by stressing that if Midland Red's finances were in such a bad state that one free bus a day causes them concern, they should accept a renewed offer by Leicester City Transport to buy out their operations.'

This was a theme he would return to again in the very near future. His counterpart at Glenfield was, however, somewhat bemused:

'The County Council were not consulted about the new service by the City Council, and were not even informed that it would be operating.

'"The first we knew about it was when we read about it in your paper," Mr David Smith, a member of the public transport team at County Hall, told the *Leicester Mercury*.

'"The matter will be discussed at a meeting of the highways and transportation sub-committee tomorrow. Until then we can make no comment."'

County councillors were reported as being concerned that if the free bus services threatened Midland Red East revenue, the company might seek further subsidy, and 'councillors of all sides criticised the city council for their role in the dispute'. But it seems there was acceptance of the fact that because it was a free service, it was a fait accompli; there was no way in which they could intervene, and they decided simply to monitor the situation.

The hidden side to the free bus service was how it would affect traders in the towns where the service operated. It was not long – 7 October in fact – before Hinckley and Bosworth Borough Council were 'angrily' attacking it for poaching shoppers from Hinckley. On 24 October, it was reported that Earl Shilton shopkeepers would be meeting that evening to protest against the services. Spotting an obvious case of double standards, when city centre traders complained about a proposed new shopping development in the north west of Leicester, one Coalville retailer wrote to the *Leicester Mercury* on 21 November to make his point very clearly.

'I don't know how city centre traders have got the cheek to complain about the proposed shopping development at Beaumont Leys.

'I have just had the pleasure, once again, of watching three "free" double-decker City Transport buses load up with my customers not 50 yards from my business, to go and spend their money with these poor hard-up traders.

'"Like all local traders in Coalville I deplore this subsidised customer-snatching."'

But one must assume that county shoppers were delighted with this development, and, by and large, city ratepayers were content with the situation, although one Beaumont Leys resident was not at all convinced; his letter to the *Leicester Mercury* was printed on 12 October:

'I've read the story about the free bus service being provided by Leicester City Transport into Leicester for shoppers and, as a ratepayer, I don't see why I should pay high rates so that people in the county can have this concession.

'I don't see any justification for this action at a time that bus fares are so high. I wonder what county ratepayers would say if they had to pay for a service from the city?'

Much else was going on behind the scenes at this point in early October. Howlett's, who were to have been a party to the joint service to Loughborough, wrote to the Traffic Commissioners withdrawing their application, though Leicester City Transport made it clear they would continue to pursue theirs. Midland Red East confirmed they would continue with their application for the Evington service after all and would also make a new application for a service to Mowmacre Hill, and re-route another proposed service through Rushey Mead, both of these being populous areas in the north west and north of Leicester not previously served by the company. And once again, the Traffic Commissioners were to be asked to rule on the removal of the Area Stop Sign restrictions. It was into the middle of this that City Council leader Peter Soulsby made his most trenchant attack yet on Midland Red East. The vehicle used was not, in this instance, the *Leicester Mercury*, but instead the *Leicester Trader*, a free weekly newspaper that enjoyed a circulation of approaching 150,000 copies. This article dominated the front page on Wednesday 12 October 1983; the banner headline alone occupied almost half the front page, and the piece was billed as an exclusive:

'BUS WAR: BUY OUT PLAN
COUNCIL CHIEF REVEALS PLOT TO TAKE OVER MIDLAND RED
LEICESTER CITY COUNCIL PLAN TO BUY OUT MIDLAND RED EAST.
'That's the sensational claim from leader of Labour controlled Leicester City Council Mr Peter Soulsby in the wake of the so called bus war between the two organisations.

'He told the *Leicester Trader*: "We have had a number of complaints over the years about the service Midland Red provide.

'"Now we are seriously considering taking over their county service.

'"I think our reliability is much higher than Midland Red's as well as our reputation and we are confident that we could guarantee the jobs of all the company's platform staff if the takeover went ahead.

'"Our fleet is very much newer, we have a very high standard of inspectors and Leicester City Transport uses closed circuit television to monitor traffic flow which helps us maintain a punctual service.

'"If Midland Red are prepared to talk business then we can talk about how their management can be absorbed into the scheme.

'"Looking at the figures, Midland Red total vehicle mileage for 1977 was 9 million and for 1982, 6.6 million, which is a 26.7 per cent reduction.

'"Leicester City Transport's figure for 1977 was 5.9 million, and in 1982, 5.7 million, a reduction of just 4.5 per cent."

'And Mr Soulsby eased ratepayers' fears that the takeover would be funded by Leicester householders when he said"'Midland Red East receive £1.4 million a year in subsidy from the county council.

'"The money for such a bid as this would probably come from the same source. The city council feel this is a good idea which will benefit everyone.

'"Besides, the Government are talking about breaking up the National Bus Company of which Midland Red are a subsidiary.

'"Obviously, Midland Red East is a large operation and there would be a lot of negotiating, but we are confident we could improve the service and make it more profitable."

'Midland Red, meanwhile, say a bid would be out of the question. "We believe we have a good network and if you work out the cost of fares per mile between the two companies, Midland Red is the cheaper and more efficient service," said a spokesman.

'"We are not even considering the idea," he added…'

The problem with a weekly paper is that readers might forget what the fuss was all about by the time a reply is published. Although consigned to an inside page of the 19 October edition of the *Trader*, the banner headlines were sensational enough to jog even the most forgetful memory:

'WAR ON THE BUSES AS FIRM SEES 'RED'
'BUY-OUT PLAN IS JUST A SMEAR'
'A leading Midland Red East official has hit out over allegations that his company's bus service is unreliable…

'…Midland Red East manager Mr Peter Lutman has hit back over the claims, saying they have all the 'hallmarks of an amateurish smear campaign.'

'"If anyone has a complaint about Midland Red services they would do well to contact us," he said.

"We receive very few criticisms of the services we provide for about 18 million customers we serve with our buses and coaches every year.

'"I would question too whether any operator maintains any higher standard of reliability than Midland Red which, despite traffic congestion, bad weather and the many other problems one can encounter on our busy roads, operates 99.86% of its scheduled mileage.

'"In the first nine months of 1983 the Company has run 176,000 more miles and has carried 4% more passengers than in the same period in 1982…

'"The support received by Midland Red to keep socially desirable but unprofitable buses running is substantially less than the support LCT receives by means of the concession fare scheme for elderly people and other payments from the city rates," he said.

'"With current running costs in the latest period of just £1.06¼p. per mile, Midland Red's running costs are far below those of any other major operator in the area and we believe that any other method of ownership would make our services far less viable than they currently are," said Mr Lutman…'

This was to be the thrust of Midland Red East's arguments over the coming months. Summarised, the intention was to:

- focus on County Council support for the removal of the Area Stop Sign restrictions which would increase the availability of buses on some routes out of Leicester by between 30-50 per cent
- demonstrate that significant savings in subsidy could be achieved through proper co-ordination between the two operators, even if that meant that Leicester City Transport should be compensated for any loss of revenue incurred as a result of removing the Area Stop restrictions
- show that Leicester City Transport proposals to buy out just the so-called loss making city routes would actually increase the cost of maintaining rural services, and might require some to be curtailed or even abandoned

Correspondence in the National Archives reveals that the representatives of first Midland Red, then Midland Red East, as well as the County Council, accepted that

efforts to secure co-ordination over an eight year period up to the autumn of 1983 had not succeeded. In addition, a County Council mandate to remove the Area Stop Sign restrictions by 1 July 1983 had not been met. Arguments between the two operators and County Hall continued and were now concerned with entitlements to subsidies in respect of operated mileages and the way that these should be divided between them. But the proverbial 'Sword of Damocles' hanging over the Transport Committee and the wider Council was still the potential abolition of the Area Stop Signs. On 25 November, the *Leicester Mercury* returned to the discussion of what Leicester City Transport might lose, prompted by the leaking of a confidential report:

'CUTS FEAR IN WAR OF THE BUSES
'The first casualties are feared in the war between Midland Red and Leicester City Council's bus undertaking, which could lose services and staff.

'The possibility of redundancy for more than 150 city transport staff and the loss of several bus services is revealed in a confidential report circulated to the city Labour group.

'The report, by council transport committee chairman Mr Henry Dunphy, discusses the implications of a likely application by Midland Red to pick up passengers at stops within the city boundary.

'These stops are a council monopoly and if Midland Red succeed in "poaching" their passengers, the city department could be hit hard, possibly losing £500,000 a year.

'The city could either accept the position, fight back by applying to compete on profitable Midland Red routes, or continue to talk to Midland Red in the hope of reaching an agreement.

'Mr Dunphy said today he felt the first priority would be to try negotiations. He regretted the report had been leaked at this stage.

'But Leicester Civic Society spokesman Mr John Burrows commented: "It seems the last people to be consulted are the passengers of both Midland Red and Leicester Transport.

'"This is unfair, and the war of words does no good at all.

'"The two bus undertakings should invite the public, their passengers, to a brains trust to lay out their operation policies."'

That day's editorial, which was fortuitously placed alongside the article, wanted common sense to prevail, although the reference to Midland Red as 'not-so-friendly' flew in the face of the fact that the company was seeking to implement something that the legislation allowed:

'OFF THE BUSES
'The war of words about who provides what services for the bus passengers of Leicester and county is hotting up again. Both sides are clearly not afraid of making exaggerated claims about what effect one is having on the other.

'Now the City Transport – once the most profitable, most admired, service in Europe – are claiming that they MAY have to get rid of lots of buses and more than 150 staff if the not-so-friendly Midland Red are allowed to pick up passengers coming into the city.

'These exercises in semantics are not the slightest use to a passenger waiting in the rain for a non-existent bus.

'They are no use to the elderly or the young wanting to get into the city regularly from a rural area and wondering whether the already sparse services will continue.

'Somebody, somewhere, should enforce a truce on the two parties and, if not, bang a few heads together until they can work out the best co-operative package.

'A programme that will give equal slices of the passenger cake, equal benefits from subsidies that are paid out quite generously, and equal job security for the men and women who work long, hard and sometimes dangerous hours providing a service that is, to some, as vital as water and electricity.

'Forget the politics, forget the sectional interest and get talking, for the sake of the passengers – that is the *Leicester Mercury*'s message.'

But the message was going to go unheeded, at least until such time as the Traffic Commissioners ruling was finally made.

Midland Fox

Another major change was occupying the minds of Midland Red East managers at this time. From the outset, they had felt that the name bestowed upon them at the September 1981 break-up of the empire was contrived. As well as implementation of the Leicestershire Traffic Report, serious consideration was now being given to creating a new identity; one that better reflected its operating area. In a first step, and signalling a further, tacit relaxation of NBC livery rules,[10] the company received its first new double deckers for 12 years. Fittingly, they were 12 Leyland Olympians with ECW bodywork, carrying fleet numbers 4501-12 and painted yellow at the front and red at the rear, the colours being split diagonally. Sighting one in service towards the end of October 1983 caused one *Leicester Mercury* correspondent, claiming to be a member of RSPO (the Royal Society for the Protection of Omnibuses), to see if there might be a funny side to it:

'A HYBRID
'I must draw attention to a matter of grave concern. While cycling in Birstall I saw a sinister sight – a double decker bus.

'Why sinister? Because this bus was half yellow and half red.

'I came to the awful conclusion that Midland Red buses had been crossed with Leicester City Transport buses without our knowledge.

'Who is responsible for this outrage? David Bellamy[11] should be told about this new hybrid.'

Leicester City Transport for one did not find it amusing, and public opinion was split. Some felt it far too bright a shade of yellow to be confused with the cream of Leicester City Transport buses, while the Leicester Mercury published a letter from BEATTY on 19 January with an alternative, and dare one say somewhat sexist, point of view:

'I'll bet the committee that decided on the new colour for the Midland Yellow buses was all male. I'm sure that if a woman had been (involved) she would have been quick to point out the similarity in colour to Corporation buses. Any other colour would have been better. Can we have a few black, green or pink spots or stripes? Anything will do if it helps in identification of the bus.'

One wonders whether 'Beatty' ever paid any attention to the routes numbers and destinations displayed on

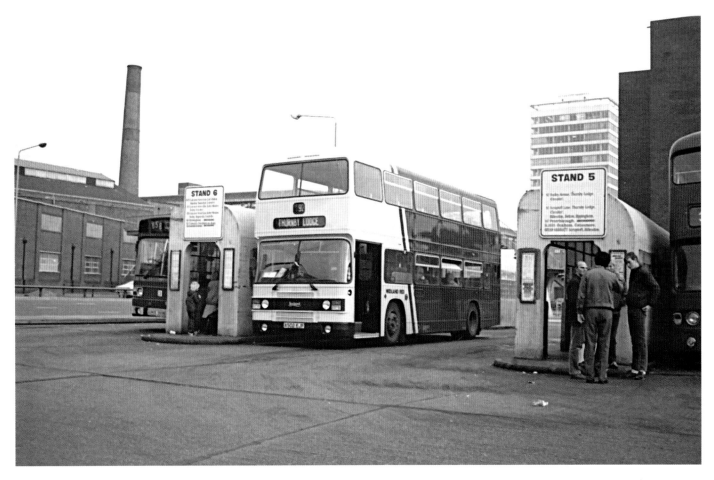

149. Midland Red East still needed newer vehicles to augment the influx of second-hand Fleetlines, the youngest of which had already seen seven years service in the capital. September 1983 heralded the arrival of 12 Leyland Olympians with 77-seat ECW bodywork which carried, for the first time, the distinctive yellow and red livery that would characterise the Midland Fox fleet. With Midland Red fleetnames – the "East" was never used during the company's existence – 4502 (A502 EJF) is about to work a local 92 service to Thurnby Lodge from Stand 5 at St Margaret's on 22 October 1983. It passed to Confidence (63) in 2004, and following its retirement in 2015, was donated by owner Ken Williams to the Leicester Transport Heritage Trust for preservation.

the buses, which has always been the traditional method of determining which bus to catch? Nonetheless, it was felt that the need to differentiate the buses from those of Midland Fox was paramount, and the answer was to display the city's coat of arms above the front destination display. In January 1984, Dennis Dominator 189 became the first vehicle to be so adorned.

That month also saw Midland Red East's new identity finally revealed. After weeks of mysterious notices in the local press, exhorting people to 'Follow the Fox', on 15 January all was revealed and Midland Fox was born. By the time of the official launch (which was actually carried out on the 16th, a Monday, with Leicester Tigers star Peter Wheeler officiating at a champagne ceremony at St Margaret's bus station), the coverage had been

stepped up; a full double page advertisement appeared in the *Leicester Mercury* on Saturday 14th, followed by a full single page on Tuesday 17th, and a quarter-page on Thursday 19th. As far as news reports go, there was only a small item about the launch in Monday's paper.

New 'top-level' talks were taking place around the same time, with City councillors asking their counterparts at County Hall to withhold the £1.4 million subsidy to Midland Fox unless a truce was brokered between the two undertakings. Given that six months had now elapsed since the County Council deadline for removal of the Area Stop Sign restrictions, it is difficult to shake off the thought that this was just another attempt at procrastination by the City Council, and that County Hall officials might not be well disposed towards it.

Leicester
City Transport

Services
27, 28, 29, 46, 47

South Knighton
Stoneygate
University Lunchtime Circular

(Services 27, 28, 29, 47 operate
via London Road Station ₹)

Timetable Enquiries

☎ 24326

Effective from 15th January, 1984

G. G. Hilditch, O.B.E., F.I.Mech.E., F.C.I.T.
General Manager,
Leicester City Transport,
Abbey Park Road,
Leicester LE4 5AH

Leaflet No. 5.

150. A Leicester City Transport timetable for January 1984. It was not the first time that the city's coat of arms (a cinquefoil ermine on a red field) had been used on leaflets and booklets, but was it the inspiration for the subsequent use of the city's crest on the buses?

The decision to continue with the free shoppers' bus services, albeit on a monthly rather than weekly, basis, could be seen as another potential sticking point. City Council leader Peter Soulsby was quoted on 12 January as saying 'We are holding fire at the moment in the hope that the County Council can bring some sanity into this and help bring an end to the bus war' in an article that yet again reiterated the threat to jobs and revenue for City Transport.

Midland Fox implemented the Leicestershire Traffic Plan recommendations at the same time as the launch, and while the changes bedded in, there were inevitably complaints from certain areas – most notably Thurmaston – about the alterations to services. The Traffic Commissioners had adjourned the various applications before them, including those in respect of the Area Stop Sign restrictions, in the hope that both sides might now come to some sort of accommodation, despite continuing disagreements over services and mileage operated under the existing co-ordination arrangements.

The hearing before the Traffic Commissioners finally began on 13 March 1984, and the chairman indicated at the end of proceedings that the decision would not be announced for at least four weeks. Other correspondence held at the National Archives shows that the two sides were actually starting to move towards some form of understanding, albeit slowly, although one surprising area of disagreement was that Leicester City Transport did not – at least initially – co-operate in the updating of bus stops flags with the Midland Fox name and logo, and with the display of Midland Fox timetables and other information material. With City Council elections looming in early May, the *Leicester Mercury* was at last able, on 28 April 1984, to report that an agreement had been reached:

'COUNTY BUS WAR: AT LAST IT'S PEACE
'Peace has broken out in the long-running bus war between Midland Fox and Leicester City Transport. Leaders of both sides have reached agreement that "enough is enough".

'Their decision will have little visible impact for passengers in the short term, but co-operation should mean good news for travellers and ratepayers, as more costly battles over routes should be avoided for both operators.

151. To this observer at least, it almost beggars belief that some people thought the bright yellow fronts of Midland Fox buses were not sufficiently distinguishable from Leicester City Transport's cream. However, their managers felt compelled to do something about it, and for several months some, though by no means all, of their deckers carried the city crest on a maroon background within a diamond strategically placed above the route and destination display. Dominator 195 (YRY 195T) demonstrates how this looked in practice, as it makes its way along Charnor Road on the 81, a free service to Asda at Fosse Park, on 15 May 1984. Metropolitan 177 (UFP 177S), one of the last five single door examples, follows on a New Parks stage carriage service.

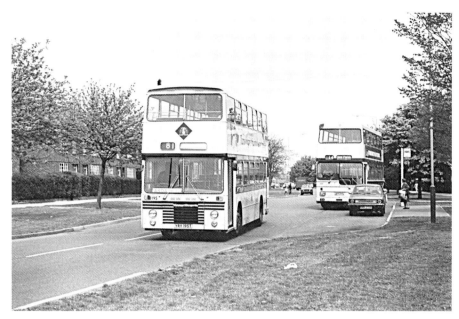

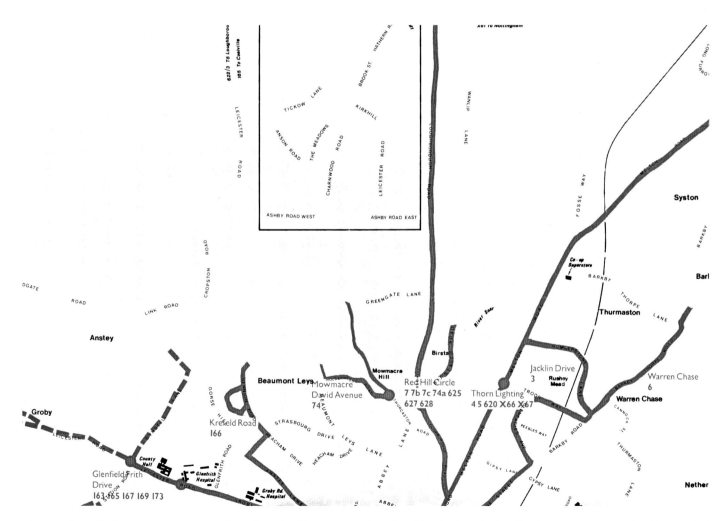

Above and Overleaf: 152-154. In amongst the welter of publicity material produced for the launch of Midland Fox was a 36 page booklet entitled "Serving the City of Leicester" which contained maps showing the new routes, split here into north and south sections. There was also a full series of timetable summaries, all of which, such as the one here for services using Welford Road, dealt only in times of departure for the city centre.

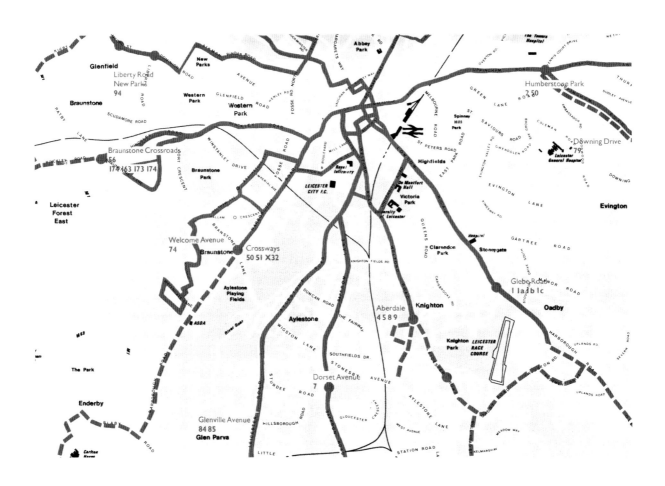

WELFORD ROAD　　　　4, 5, 5a, 5c, 8, 8a, 9, 9a

City Centre — Aberdale Road
Services 4, 5, 5a, 5c, 8, 8a, 9, 9a

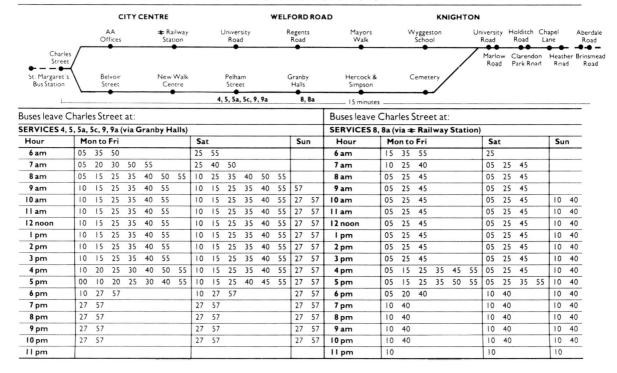

Buses leave Charles Street at:

SERVICES 4, 5, 5a, 5c, 9, 9a (via Granby Halls)

Hour	Mon to Fri	Sat	Sun
6 am	05 35 50	25 55	
7 am	05 20 30 50 55	25 40 50	
8 am	05 15 25 35 40 50 55	10 25 35 40 50 55	
9 am	10 15 25 35 40 55	10 15 25 35 40 55	57
10 am	10 15 25 35 40 55	10 15 25 35 40 55	27 57
11 am	10 15 25 35 40 55	10 15 25 35 40 55	27 57
12 noon	10 15 25 35 40 55	10 15 25 35 40 55	27 57
1 pm	10 15 25 35 40 55	10 15 25 35 40 55	27 57
2 pm	10 15 25 35 40 55	10 15 25 35 40 55	27 57
3 pm	10 15 25 35 40 55	10 15 25 35 40 55	27 57
4 pm	10 20 25 30 40 50 55	10 15 25 35 40 55	27 57
5 pm	00 10 20 25 30 40 55	10 15 25 40 45 55	27 57
6 pm	10 27 57	10 27 57	27 57
7 pm	27 57	27 57	27 57
8 pm	27 57	27 57	27 57
9 pm	27 57	27 57	27 57
10 pm	27 57	27 57	27 57
11 pm			

Buses leave Charles Street at:

SERVICES 8, 8a (via ⇌ Railway Station)

Hour	Mon to Fri	Sat	Sun
6 am	15 35 55	25	
7 am	10 25 40	05 25 45	
8 am	05 25 45	05 25 45	
9 am	05 25 45	05 25 45	
10 am	05 25 45	05 25 45	10 40
11 am	05 25 45	05 25 45	10 40
12 noon	05 25 45	05 25 45	10 40
1 pm	05 25 45	05 25 45	10 40
2 pm	05 25 45	05 25 45	10 40
3 pm	05 25 45	05 25 45	10 40
4 pm	05 15 25 35 45 55	05 25 45	10 40
5 pm	05 15 25 35 50 55	05 25 35 55	10 40
6 pm	05 20 40	10 40	10 40
7 pm	10 40	10 40	10 40
8 pm	10 40	10 40	10 40
9 am	10 40	10 40	10 40
10 pm	10 40	10 40	10 40
11 pm	10	10	10

'City transport committee chairman Mr Henry Dunphy said he had met Mr Peter Lutman of Midland Fox to thrash out a peace settlement.

'He said "Management will continue to meet with a view to doing all we can to assist the travelling public.

'"I was never a willing participant in any dispute over public transport," he said. "Over many years public transport has been slowly losing ground, and enough is enough.

'"I hope this will be an end to the so-called bus war, which has done neither side any good."

'But the impact of the bus war could still be felt, particularly by city ratepayers.

'The Traffic Commissioners have still to decide whether to let Midland Fox pick up passengers within Leicester.

'Along with the city's controversial free market bus service to county towns, this was one of the main causes of antagonism between the two sides.

'If the Traffic Commissioners give Midland Fox the go-ahead, Leicester City Transport stand to lose up to £500,000 in revenue, threatening up to 150 jobs and the loss of several services.

'Mr Dunphy said this could still go ahead, but the impact would be much less if the two sides co-operated, and there could well be no job losses entailed.'

In essence, the old co-ordination agreement was scrapped, and Midland Fox agreed what was considered to be a fairer share of revenue, although there were still issues over the mileage entitlement. Three weeks later, the Traffic Commissioners decision was announced and for Midland Fox, it was, as Peter Lutman said, a 'vindication of the stance we have taken over the last 2½ years'. Despite the front page prominence given to so many aspects of the bus war over the previous three years, this report on 19 May 1984 was published on page 9:

'MIDLAND FOX WIN BATTLE FOR TERRITORY
'Midland Fox have won their bid to scrap restrictions stopping buses picking up in the city centre.

'But the decision may lead to higher fares, job shedding and other measures to make up the estimated loss of £710,000 to Leicester City Transport.

'LCT general manager Mr Geoffrey Hilditch warned this could happen at the public hearing… unless extra grants were forthcoming.

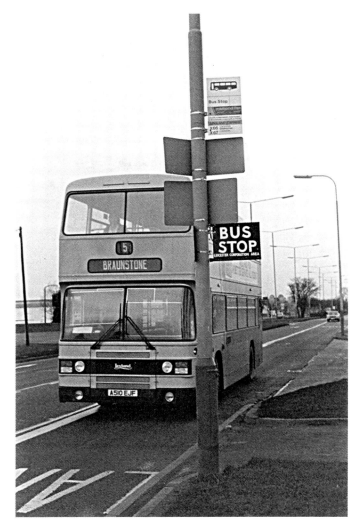

155. Midland Fox Olympian 4510, heading down Melton Road towards the city centre, has reached the Leicester Corporation Area Stop sign; the next inbound stop will be the terminus of Leicester City Transport's 42 Melton Road route, opposite the Lanesborough Road junction. Until the restriction was removed in July 1984, once past this point Midland Fox vehicles could stop to allow passengers to alight, but any that might want to board would have to pay a surcharge, and in practice there were not many that did. The 5 was one of the new cross-city routes introduced by Midland Fox in January 1984, and having started from Melton Mowbray, 4510 would continue to Braunstone Crossroads. In theory a good idea, in practice these routes tended to be affected by congestion; by October 1984, the 5 group was linked with Wigston instead of Braunstone, and the whole system of route linkages was discontinued in 1986.

'He said today the contents of the Traffic Commissioners' decision would be reported fully at the next meeting of the city transport committee on June 12.

MIDLAND WANDERBUS
Your chance of a day's unlimited travel around the Midlands for under £3*. Just buy the Wanderbus ticket from the driver on the first bus you board and enjoy the freedom to choose from nearly all the routes offered by five local NATIONAL companies.
Adult ticket £2.97*. Child (5-15 years inclusive) £1.80*.

Ask for a leaflet. *Fares correct at time of printing

FARESAVER
The Season ticket that means big savings for regular travellers on Midland Fox buses.
● No more searching for change every morning.
● One ticket only, even though you may need to change bus on your journey.
● As many journeys as you like between your chosen points!

Excursions
A wide range of day trips and excursions are operated to a number of destinations throughout the year — look out for our leaflets and press advertisements for full details.

Private Coach and Bus Hire
Even though we operate a large fleet of Modern Coaches and Buses, many people don't realize they can be hired for private functions such as Club outings, Sports fixtures — anything, anywhere you like! We can arrange bookings for theatre, concerts and hotels to save you time to enjoy yourself. Telephone Frank Laidler on Leicester 58412 or 532048 for professional advice.

For details of all these and any service information
☎ Leicester 29161.

midland fox ltd

The Company will make every effort to maintain these Services, but will accept no liability for loss, damage, injury or delay sustained by any passenger by reason of unpunctuality or failure to mantain Services.
For full details of Rules and Regulations please apply to Company Offices.

Head Office:	Keswick House, 30 Peacock Lane, Leicester LE1 5NY.	☎ Leicester 28156
Local Offices:	**LEICESTER** St Margaret's Bus Station LE1 3DS (Enquiries, Travel Sales & Lost Property). (Private Coach Hire)	☎ Leicester 29161 ☎ Leicester 58412
	LEICESTER Southgates Garage, 12 Peacock Lane LE1 5PX	☎ Leicester 25466
	COALVILLE Garage, Ashby Road, LE6 2LF.	☎ Coalville 36517
	SWADLINCOTE Garage. Midland Road DE11 0AN. (Lost Property and Travel Sales)	☎ Burton 217071
	SOUTH WIGSTON Garage, Station Street LE8 2TH. (Travel Sales)	☎ Leicester 782361

LINCOLNSHIRE »

Head Office:	P.O. Box 15, St Mark Street, Lincoln	☎ Lincoln 22255
Local Office:	Bus Station, Grantham	☎ Grantham 2397

5	**LEICESTER**
5A	**REARSBY**
5B	**MELTON MOWBRAY**
5C	**GRANTHAM**
X66	

156. Midland Fox timetables were certainly as colourful as their buses. This is the front cover for the January 1984 edition of the 5 – the route on which Olympian 4510 was employed.

'"I shall then seek instruction of members as to any future action they feel should be taken in the matter. I have no idea what that might be."

'Midland Fox director/manager Mr Peter Lutman, said no new routes into traditional LCT territory would be implemented before July 1, allowing discussions to continue.

'"The traffic commissioners granted all our applications with no restrictions, except over two licences where the county council expressed a hope of better co-ordination of services, one involving Braunstone and the other Thurmaston.

'"On these, the commissioners granted substantive licences for six months from June 8, after which the position would be reviewed." All other applications received permanent (i.e. five year) licences.

'Mr Lutman added that…"the restrictions never made any sense and were certainly not in the interests of the travelling public."'

Later that month it was quietly announced that the free shoppers' bus services would be ending in June – earlier than originally planned. Although they had been well used, representations from county shopkeepers and the new closer relationship with Midland Fox were the deciding factors. And effectively, it can be said that this marked the end of the first phase of the bus war. It would not be long before the two sides were once again at loggerheads, but Midland Fox had first to make the most of its new-found territory.

'A better service all round'

The Midland Fox publicity machine was working overtime in the run-up to implementation on 1 July. Booklets and advertisements stressed how 'at last, after 60 years of local restrictions, the Traffic Commissioners have made Midland Fox buses available to local passengers in Leicester'. What this would mean in terms of weekday daytime off-peak service levels was made very clear:

● Stoneygate and London Road – was 5 buses NOW 11 BUSES PER HOUR
● Uppingham Road – was 6 buses NOW 14-15 BUSES PER HOUR
● Melton Road – was 6 buses NOW 11-12 BUSES PER HOUR
● Loughborough Road – was 4 buses NOW 11 BUSES PER HOUR
● Belgrave Road – was 10 buses NOW 22 BUSES PER HOUR
● Hinckley Road – was 6-10 buses NOW 12-16 BUSES PER HOUR

All this was contained in a 20-page booklet which proclaimed "a better service all round" and also showed the benefit to other parts of the city (such as the rail station, Royal Infirmary and Polytechnic, and new crosstown links); at which stops inside the city boundary services would be calling (this worked out at roughly one in every two Leicester City Transport bus stops), and the fares that would be charged. Already, the use

of the 'Fox' in the company name was leading to valuable promotional spin-offs – the new ticket designed for cross city journeys was the City 'Foxtrotter'.

But this was also the time when the government's proposals, which would complete the changes in the industry been envisaged back in 1979, were making the news. Put simply, their aim was to increase competition to provide a better service for passengers. The key elements of the 1985 Transport Act were to be:

- deregulation. This would abolish road service licensing in Great Britain (except in London), from October 1986, replacing it with a system of registration. By removing the duties of

local authorities to co-ordinate public passenger transport in their area, it meant that a bus company – any bus company, hence the scope for competition – could register any service that it chose to operate on a commercial, i.e. unsupported, basis. The local authority would step in to invite tenders for additional routes or journeys if it considered social needs were not being met. The Traffic Commissioners would lose many of their powers, as any licensed bus operator would only have to register the intention to run a service with them, giving a minimum of 42 days' notice. The criteria for registration did not include any reference to public demand or to

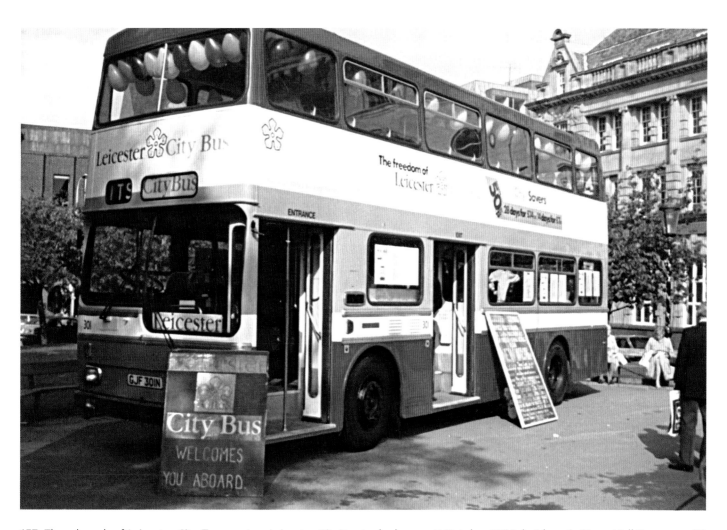

157. The relaunch of Leicester City Transport as Leicester CityBus took place on 7 October 1984, but here in Town Hall Square on 28 September was the first public exhibition of the new order. Gone was the cream and maroon scheme and the diamond logos meant to differentiate its vehicles from those of Midland Fox. What came now was the Council's own livery, already carried by its varied collection of utility vehicles, of red, grey and white, and Scania Metropolitan/Metro Cammell 301 (GJF 301N) was the vehicle chosen to show how this looked on the buses. It turned out to be not particularly successful, as the lighter areas attracted the unwanted attention of graffitists.

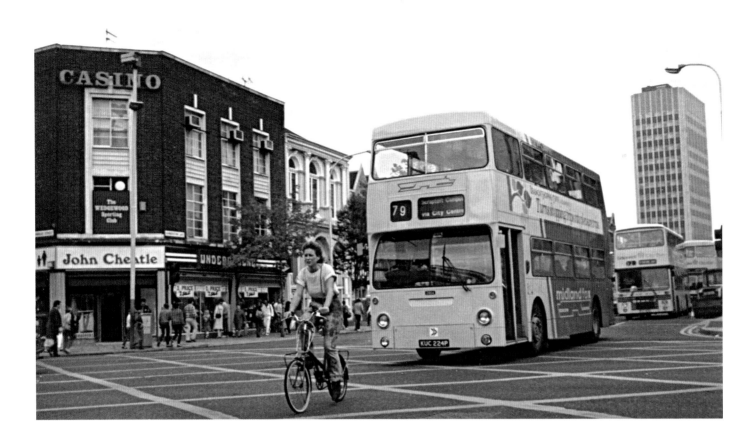

Timetable Enquiries

☎

Leicester 24326

Leicester City Council
Transport Department
Abbey Park Road
Leicester LE4 5AH

Effective from 7th October 1984

10p

159. On 29 September 1984, the day after the Leicester CityBus launch party, I happened upon Midland Fox Fleetline 2904 (KUC 224P), chasing after the lady cyclist at the Humberstone Gate/ Charles Street junction and carrying the outline of the stylised Fox logo below the upper deck windows. It is the only example of additional branding applied to a Midland Fox vehicle of which I am aware, and I'm sure it was a very short-lived phenomenon.

158. The front cover of the timetable book launching the new Leicester CityBus identity on 7 October 1984. The colour scheme replicates that of the new bus livery – red, white and grey.

existing services and objections could no longer be made by other operators or local authorities
- privatisation. The Act would require National Bus Company subsidiaries to be sold to the private sector. Council-controlled operators such as Leicester would have the power to dispose of their bus undertakings, but until such time as they did, they would have to be reconstituted as separate companies, and Councils would be precluded from subsidising their former companies' operations

The ramifications were infinitely more serious for Leicester City Transport than for Midland Fox. With the Traffic Commissioners decision having gone against them, the undertaking was already faced with the prospect of losing a proportion of its passengers to its larger rival without much in the way of realistic opportunities to branch out into new areas without it being in competition with that same rival.

So, having digested the impacts of the legislation on its business, the City Council announced that, first of all, it too was going to change its image. The fleet-name would become Leicester CityBus and the new livery, red, white and grey, would be that already carried by the myriad vehicles in City Council ownership. The newly streamlined services would be renumbered and in future, each route would have the same number in both directions. All the changes would take effect on 7 October 1984, and by the end of September, Metropolitan 301, the first to receive the new livery, was being shown off to the public, complete with a full array of promotional hand-outs about the changes. The new timetable book, which contained as sweeping a number of changes to existing routes and linkages as Midland Fox literature had done ten months earlier, was priced at 10p. However, for a complete picture of the CityBus network, it was necessary to purchase a map costing 30p. As this measured a hefty 600mm by 630mm, it was not the most practical of aids. In Appendix 8, a full list of the services operated from October 1984 is given, together with some illustrations of the route diagrams and descriptions from the timetable book.

The second war
The respite following the Traffic Commissioners decision on the Area Stop was short-lived. Henry Dunphy had

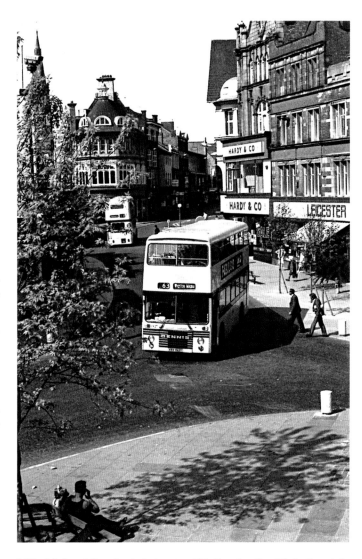

160. Midland Fox took Leicester CityBus to the High Court in October 1984 in order to establish its rights to the Welford Road 62 and 63 services. Before the troubles, this is Dennis Dominator 192 (YRY 192T) passing the Clock Tower on its way to the 63 barrier in Charles Street.

by now retired, and his place as Chair of the Transport Committee had gone to Councillor Philip Harley. Although agreement had been reached that Leicester CityBus would operate the whole of the Braunstone Frith via Glenfield Road route and Midland Fox would operate the whole of the West Knighton and Wigston route, service changes made by Leicester City Transport over the summer, principally on the Uppingham Road and at Beaumont Leys, were, in Midland Fox managers' view, neither in keeping with the spirit of the April agreement nor matched by concessions towards Midland Fox on the routes to Fleckney and Blaby. Worst

of all, Leicester CityBus continued to operate their West Knighton service in contravention of the April agreement. In October 1984, Midland Fox took Leicester City Council to the High Court and obtained the appropriate injunction.

That it should have come to this so quickly seems to have been no surprise to the people at Midland Fox. A briefing note on the events leading up to the date at the High Court which went to Robert Brook CBE, Deputy Chairman and Chief Executive of the National Bus Company, concludes that it was City Council policy since at least 1981 to delay and defer, and that 'the time for talking is past and we must seek remedies in other ways.' But feathers were evidently ruffled in the City Transport Department by having the court action taken against them. Notices were handed out to passengers on the affected CityBus services 62/63 which read:

'LEICESTER CITY COUNCIL
NOTICE TO PASSENGERS
SERVICE 62 LEICESTER – WEST KNIGHTON – SOUTH WIGSTON
SERVICE 63 LEICESTER – WEST KNIGHTON – WIGSTON MAGNA

LEICESTER CITY COUNCIL REGRET THAT BECAUSE OF HIGH COURT ACTION TAKEN BY MIDLAND FOX, LEICESTER CITYBUS IS UNABLE TO CONTINUE OPERATION OF THE ABOVE SERVICES AFTER MIDNIGHT THURSDAY 25 OCTOBER 1984

ANY INCONVENIENCE CAUSED BY THIS ACTION IS DEEPLY REGRETTED.'

Councillor Harley was interviewed on BBC Radio Leicester on 26 October. A shortened transcript is held in the National Archive papers, the following key points of which were:

- we (Leicester CityBus) backed down because it was acknowledged that we had broken the agreement, though not the spirit of the agreement
- because of the Government White Paper Midland Fox is going to have to move quickly into the city where the money is

- Midland Fox broke their agreement on Aylestone Road – we did not take them to the High Court
- Leicester CityBus will discuss anything without going to Court but Midland Fox will not
- there will be a war when the White Paper comes into effect – we will be ready

There is neither mention of nor justification for the service changes on Uppingham Road that led Midland Fox to increase frequencies on the Blaby/Aylestone service.

Philip Harley was implacably opposed to the government's plans; his notes for the Open Day held at Abbey Park Road garage in June 1985 claimed a loss in fares to the Department of £250,000 since the abolition of the Area Stop Signs nearly a year earlier and foretold of worse to come when deregulation was introduced:

'Some of our better routes help to support the poorer ones so that the City Council can maintain a full network of services throughout the day. We know that competition when it comes is bound to be on the better routes. This means we shall be unable to support the less-used but socially needed services and they will have to be cut.

'The City Council is determined to oppose this legislation but it needs the help of all who use and rely on CityBus services.'

The only realistic way this might be achieved would be through a change of government, and soon, but that was never going to happen since the Conservatives could have carried on until June 1988 before calling the next election. On the ground, the spirit of co-operation Henry Dunphy had tried to foster had evaporated, and the situation was once again one of stalemate – the City Council and CityBus portrayed Midland Fox as an aggressor and Leicester CityBus a victim; Midland Fox was simply following the path laid down (or to be laid down) by statute. It is arguable whether many intending passengers were particularly interested in the minutiae of the conflict anyway – it may be imagined that all they wanted was a punctual and affordable bus service – but this new resumption of hostilities with its increasingly tetchy claims and counter-claims was in truth doing neither side's public image much good.

As 1985 dawned, there was at least some stabilisation on the service front, with no new battle lines having

161. We saw in Chapter 3 that St Margaret's bus station was closed during 1984/85 for rebuilding, and terminal points were moved for the duration to surrounding streets. From that period, this is Midland Fox Fleetline 2790 (GHM 790N), parked up at Stand 11 in Abbey Street, from which it will soon depart for the Meadows estate in Wigston Magna. Fifty years since the original bus station, Abbey Street was once again enjoying this "temporary" status in the absence of the facilities at St Margaret's. Four other Midland Fox vehicles are in view at their respective termini, including Leyland National 2 3828 (EON 828V) on service 7 to Wigston.

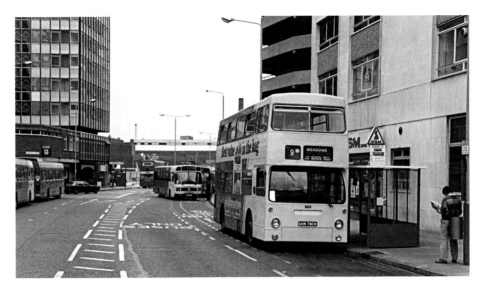

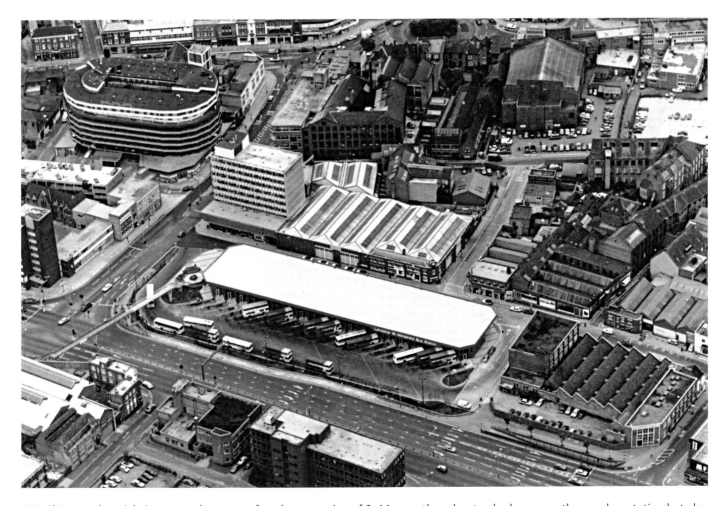

162. This superb aerial view was taken soon after the reopening of St Margaret's and not only showcases the new bus station but also gives a modern geographical context to places described in this and earlier chapters; Jubilee Road (top left), the Old Cross (now the area of the roundabout, top centre) and the Abbey Street site (the entire block now dominated by the multi-storey car park on the left). The Belgrave Gate bus station was situated behind where the row of buildings ending with Billson & Grant's now stands (top centre). To the rear of St Margaret's is Sandacre Street garage, closed in 1980 and used as an NCP car park, but taken back by Midland Fox in September 1985, first as a vehicle store, and then, from the spring of 1986, as the base for the Fox Cub fleet.

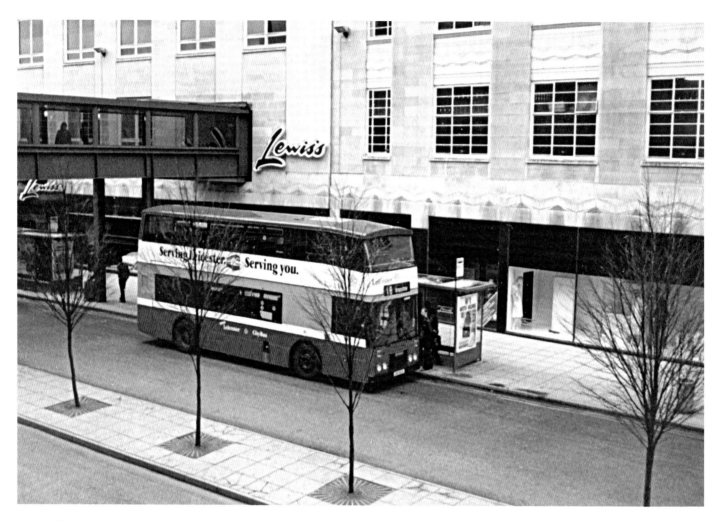

163. As the war of words continued after Midland Fox succeeded in having the Area Stop restrictions scrapped, Leicester CityBus began to apply slogans in its attempts to appeal to the people. Dennis Dominator/East Lancs 81 (B81 MJF) is serving Leicester, so therefore "serving you"; sister vehicle 82 was bedecked with even larger fleetnames below the front upper deck windows and "No fuss…go CityBus" vinyls liberally applied below upper and lower deck windows. 81 was photographed in Humberstone Gate from the first floor balcony of the Haymarket Centre on 16 March 1985, which was a marvellous vantage point for observing the comings and goings of the two operators.

been drawn since the October High Court appearance. St Margaret's bus station had been closed since the summer for redevelopment, as we saw in Chapter 3, and the street termini in and around Abbey Street recaptured to some small extent the situation in the area in the 1930s, when the temporary bus station was open. But there were still unresolved issues, this time around mileages and subsidies, that were about to be raised again, and this now brought Midland Fox into open conflict with the County Council.

The company believed that in exercising its role in co-ordinating services across the whole of Leicestershire, the County Council had failed to divide the three revenue streams – passengers, concessionary schemes and direct subsidy – fairly. The control over Midland Fox operations in the county was said to have led to county residents suffering fare increases above the rate of inflation, and in some cases, service reductions, to allow the County Council to maintain the largest network of services it could at the least cost in terms of revenue support. And if that wasn't enough, it transpired that following a meeting between City and County councillors, County Council policy would be to favour Leicester CityBus applications for services within the city boundary, leaving Midland Fox – and others – to run outside it, the presumption being that CityBus would retain its monopoly and Midland Fox would lose the city services it already operated – even though it was, at least for the time

being, the responsibility of the Traffic Commissioners to consider new service applications.

There was also another issue regarding concessionary fares for pensioners, the blind and the disabled. It was said that Leicester CityBus received £1.7 million for this, while Midland Fox received only £100,000, although it was responsible for one-third of the mileage in the city. The City Council refused to make its pensioner passes valid on Midland Fox buses. It was claimed (contentiously) that if the City Council was to act fairly to all its pensioners, it would allow them to catch any bus, and if this was the case, Midland Fox would get an extra £500,000 from the City Council, which would allow a cut in its County Council subsidy. Once again, West Knighton was the battleground. The City Council indicated that it would make joint passes available to people in the Welford Road and West Knighton areas, which would enable them to get concession fares on Midland Fox buses throughout the city. Despite the High Court action that saw them withdraw their West Knighton service, the joint passes were not issued, and this state of affairs carried on into 1985. To prevent the elderly suffering hardship as a result, Midland Fox accepted CityBus-only passes on their services 8, 9, 62 and 63, with no guarantee that they would be reimbursed. When a further application for a West Knighton service was refused by the Traffic Commissioners, the City Council did renew the joint passes, and this allowed some elderly and handicapped people in West Knighton who lived beyond reasonable walking distance of the CityBus services 27 and 28 to benefit. As a result, Midland Fox, with some reluctance, limited the concessions to joint pass holders. In a letter to the *Leicester Mercury* on 15 July 1985 Philip Lutman apologised to those affected for a problem he said 'was not of Midland Fox's making, nor its drivers.' And with an eye to the forthcoming legislation, he pointed out that the City Council could not continue like this indefinitely:

'One piece of good news is that even if the City Council stubbornly resists such approaches, once the Transport Bill becomes law in 1986, local authorities will be prevented from restricting concession passes in this way. They will be forced by law to make them available, as they should be, on all bus services, and to reimburse the various companies accordingly.'

The birth of the Fox Cub

The genesis of the next, far-reaching change – one that would restart the war and place further strain on Leicester CityBus – lay 200 miles away in Devon. For the previous 12 months, Midland Fox – along with the rest of the bus industry – had been watching an experiment begun by the Devon General bus company on 27 February 1984, when a high-density minibus service had been introduced between Exeter city centre and the suburb of Pinhoe. A second route began in April. Although earlier attempts to introduce minibuses in other parts of the country[12] had been relatively successful, the idea had still not really caught on. But this was the first step in what was to become a concerted effort to convert 'big bus' routes to minibus operation by cashing in on two unique selling points – increased frequency and the ability to penetrate areas where the larger vehicles were not able to go. The march of the minibus had begun, and soon there would be few companies, NBC or Council, that could not claim a Ford Transit conversion, or its rather more upmarket cousin the Mercedes L608D, amongst its fleet.

However unkind the dubbing of these vehicles as 'bread vans' may have been, it is undeniable that in the areas where they were introduced, they were the catalyst for an immediate and much needed upturn in passenger numbers. Midland Fox management made plans for a phased minibus introduction in the city and county, and orders were placed. Such was the urgency that thirty vehicles (M25-54) were diverted to Leicester from Bristol.[13] The same red and yellow livery was used, and one factor that may have helped to endear them to the travelling public was the inspired choice of Fox Cub as the fleetname in preference to the more prevalent (at the time) and contrived 'Hoppa'.

Coalville was chosen as the first location where Fox Cubs would be rolled out, and Saturday 27 July 1985 was the opening day. Good publicity, and as much of it as possible, was key to the enterprise, and therefore for each of the three launches in the county scheduled for 1985 – Coalville, Hinckley and Market Harborough – an article, photograph and advertisement would appear in the issue of the local weekly newspaper immediately prior to the launch. Thus on Friday 26 July, the *Coalville Times* ran a full page article on the 'radical' new service that was about to take to the streets. The fun actually started that day with a

pre-launch jamboree at the New Broadway Shopping Centre, where besides Coco the Clown and the tallest man in the world, Mr Stilts, Mrs Alice Hall, chair of the District Council, would perform the necessary ribbon-cutting ceremony. Coalville's manager, Russell Macdonald, was also on hand to stress the key selling points of the minibus revolution:

- 'brand new vehicles'
- 'highest safety and comfort standards'
- 'tremendously high frequency with very low fares'
- 'all of the drivers …trained to the highest PSV standards'
- 'the passenger always comes first'

Details of the routes appeared in the advertisement below the article, along with an opportunity to win a 13-week travel pass on the network. Initially, there were two routes: 'Blue', which ran between Agar Nook and Ashburton Road, and 'Green', which joined the two smaller towns of Whitwick and Ibstock,[14] travelling, in both cases, via Coalville's Memorial Square. Passenger timetables were deemed to be no longer required; with a bus every five minutes in some places, clearly it was felt that they were unnecessary.

The following week (2 August), the *Coalville Times* reported on the launch under the headline 'Off to a flier…'. The upbeat message was that targets had certainly been met, and that 'the service has generally been tremendously successful and we want to encourage

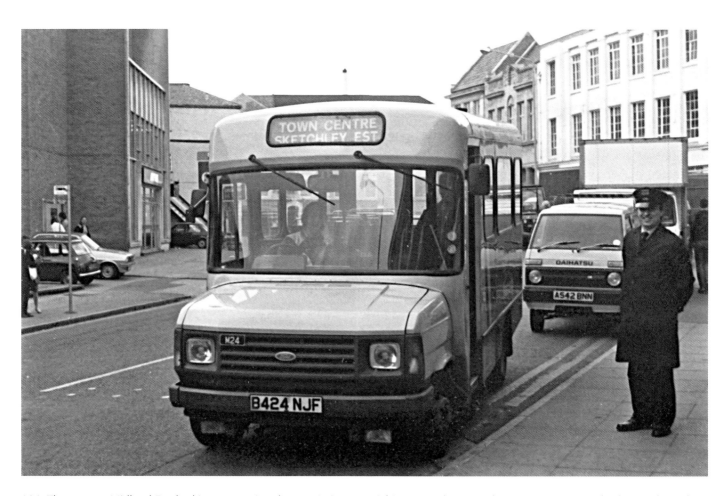

164. The success Midland Fox had in overturning the restrictions on picking up and setting down passengers inside the city boundary, coupled with the advent of the minibus era, ensured that it would now become the dominant operator in both the city and county. Wisely, so as to test out the minibus concept in less demanding territory, the first 14 cleverly named "Fox Cubs" were introduced on local services at Coalville on Saturday 27 July 1985, while M15-M24 were put to work in Hinckley two months later on 28 September. Here is Rootes bodied M24 (B424 NJF) in Regent Street in the town, about to work to the Sketchley estate in 1986. At this time, Hinckley was an outstation of Wigston garage.

165. Such was the demand for vehicles to introduce the new city and county minibus networks that 30 Ford Transits, bodied by Robin Hood and numbered M25-54, were diverted to Leicester from Bristol Omnibus Co. Fox Cub M28 (B428 PJF) was pictured in the yard at Southgate Street garage on 7 August 1985 prior to entering service as part of Leicester's first phase. Eventually Midland Fox would operate 177 of the type from new, though in common with virtually every other user of Transits, their next "small" vehicles would be over 50% bigger; the Fiat 49-10 that, at 25, seated nine more passengers.

people to go on using the new Fox Cubs.' One Greenhill Estate resident was certainly a convert and her letter, in the same issue, began 'praise all the way for the new Fox Cub service'. Having used it four times during the week and 'enjoyed the friendliness of the drivers', she concluded 'let us hope the idea catches on and people realise the benefits of this new splendid service. Well done Fox Cubs'.

It made sense to test the Fox Cubs and iron out any problems that might arise in a less demanding environment than Leicester city. Inevitably there were some teething troubles; the biggest section of complainants, the elderly, the disabled and young mothers with pushchairs, were finding it more difficult to cope with these 16-seater, step-entrance vehicles. But these were quickly addressed, if not always overcome. Russell Macdonald

conceded that vehicles did bunch at times due to heavy traffic and peaks in demand, but radio control was being used to solve this problem. He was adamant that the minibuses had been designed with the elderly and infirm in mind, having fewer, lower entrance steps than on ordinary buses, and that the luggage pens *would* accommodate pushchairs.

Generally though, the people of Coalville were satisfied with their new services, as the *Hinckley Times* pointed out on 20 September 1985, heralding the introduction of Fox Cubs there in eight days time. 'The minibus scheme has already proved to be a big success in Coalville, where new passengers have increased by up to 40 per cent. And Midland Fox officials are confident of similar results in Hinckley.' But that lay in the future. A week before the Hinckley launch, Midland Fox were

due to introduce Phase 1 of the Fox Cub revolution to Leicester.

Yet another war

As 1985 wore on, Midland Fox management continued to be mired in discussions with Leicester City and County Councils. The latter had not shifted from its position earlier in the year of opposing Midland Fox applications to operate services within the city boundary, while the City Council, which had at least now looked at the future and the type of threat that Midland Fox would pose in the post-deregulation era, was nonetheless adamant that as soon as Labour was returned to power nationally the legislation would be repealed. Thus, ideology continued to stand in the way of progress towards a settlement.

We have seen that the City Council had wanted to introduce a new service to the Thurnby Lodge estate for quite some time, claiming that there was considerable public dissatisfaction with the existing provision by Midland Fox. Naturally enough, it was opposed by Midland Fox. So inevitably, when the details of the first wave of applications for Fox Cub services became available, they would be held up as further evidence of the city's core network being attacked. The *Leicester Mercury* on 12 June 1985 carried two stories – this was the one on the front page:

'FURY OVER 'POACHING' MINIBUSES
'Midland Fox's new £2.5 million minibus scheme for Leicester was condemned as a "shanty town bus service" by Mr Phil Harley, chairman of the City Transport committee.

'At last night's City Council transport committee it was decided to object to the scheme which proposes to operate up to 125 mini buses criss-crossing Leicester.

'Mr Harley said: "The scheme is a deliberate provocative move designed to antagonise us. The proposals are geared to flood areas with 16-seater minibuses every few minutes to deliberately compete with the Leicester CityBus routes.

'"The minibus routes do not offer anything new, they are just meant to poach."

'Transport department director Mr Bob Hind claimed the minibuses were not suitable for Leicester. "They are just like converted vans, and we are concerned about the comfort of passengers, especially the elderly.

'"The majority of bus users are shoppers, elderly, and people with children. The minibuses have little room for luggage, and are quite uncomfortable."

'Mr Harley said: "Although Midland Fox claims this proposal will create 150 new jobs, they don't say at the similar Exeter scheme double-deck drivers have been made redundant.

'"The City Council believes the proposals could affect at least 50 jobs in its own department, and suggests Midland Fox will dispense with 50 or 60 conventional bus driving jobs."

'But Mr Reg Williamson, a Leicester County Councillor for the Thurnby Lodge district, welcomed the proposed new service.

'"There has been an inadequate service in the past so I am very pleased that there is to be some improvement," said Mr Williamson.'

The response from Midland Fox was tucked away on page 11 and concentrated on the fact that while full-size buses would always be wanted at certain times and on specific routes, the minibuses would be able to penetrate estates that were difficult, if not impossible, for larger vehicles to manoeuvre their way through. Nonetheless, there would be some duplication on the main roads Fox Cubs were scheduled to use, and the fact remained that CityBus managers were determined to fight to the death for the right to get into the Thurnby Lodge estate. With no softening of the stance within the Councils towards Midland Fox service applications inside the city boundary, it was inevitable that the parties would end up before the Traffic Commissioners once more.

The hearing in Leicester Town Hall took five days to complete – 19-23 August 1985 – and looked at all outstanding applications of both operators. The proceedings were widely reported in the local press and began on the first day with a rebuke for CityBus, which had accused the Commissioners' office of bias towards Midland Fox,[15] which the deputy chairman, Charles Arnold-Baker, rejected out of hand. The parties then got down to discussion of the major bones of contention, starting with CityBus and their proposed Thurnby Lodge service. Their argument was that residents had been campaigning for a City Council service for 20 years and that the Midland Fox provision was not satisfactory. Another

city councillor, Mike Lee, told the Commissioners that Thurnby Lodge residents had become 'frustrated and demoralised' at not being able to secure a City Council-run bus service, and it had become a key campaigning issue. This was strongly countered by Peter Lutman, who appeared for Midland Fox. The company currently made a profit of £22,600 on Thurnby Lodge routes, and if City Bus services operated alongside those of Midland Fox, then the cost to ratepayers could be anything between £350,000 and £445,000. Indeed, Midland Fox would consider running bus services to Thurnby Lodge at a loss to prevent CityBus winning a monopoly in the area, and he claimed that the motivation for the proceedings was political, rather than a desire to improve services. And the Transport Department was obliged to admit that of ten letters of complaint written about Thurnby Lodge services in the past year, only three were from people who could not be connected to the hearing.

Having spent nearly half the week in discussions about Thurnby Lodge, attention finally turned to the Fox Cubs, although, as can be seen from the report in the *Leicester Mercury* on 22 August, City Bus traffic manager Mr William Arthur Bishop believed the two were inextricably linked:

'CITY FOX CUB PLAN IS 'PURE RETALIATION'
'An extensive new minibus network proposed for Leicester by Midland Fox is "retaliation" against Leicester CityBus…

'…Applications for the Fox Cub minibus services were attacked by both city and county council officers at a traffic court in Leicester yesterday, part of a week-long hearing dealing with different applications by the two local bus operators.

'"This revolutionary new network that supposedly offers so many new links is in fact retaliation against an application my department has made to serve the Thurnby Lodge area," said Mr Bishop.

'The planned service would follow similar routes to those already covered by Leicester CityBus, he said. It could also take away from CityBus revenue and might even lead to cuts and job losses.

'…Mr Bishop told the commissioners he had been informed at a meeting with Midland Fox that if Leicester CityBus had not gone into Thurnby Lodge, the minibus network would not have been introduced to Leicester.'

This is most unlikely to have been the case. NBC companies across the country were hurrying to implement minibus schemes, and a management team such as that at Midland Fox would not have formulated plans to operate a 125-vehicle network on a city-wide basis simply because the opposition wanted access to one estate. Mr Bishop also failed to mention was that CityBus might have had 50 per cent of this 'revolutionary new network'. It was left to Peter Lutman to explain, as reported in the *Leicester Mercury* on 23 August. To some, this was nothing short of sensational.

'MINIBUS OFFER "WAS NOT TAKEN UP"
'A partnership offer which might have created an effective new bus service in Leicester has not been followed up by the city council, claims Midland Fox manager Mr Peter Lutman.

'A joint company to administer a minibus service in the city had been suggested by Midland Fox, Mr Lutman told Traffic Commissioners at a hearing in Leicester.

'Both sides would have contributed 125 minibuses and Leicester CityBus would have had the chair and the casting vote on the board.

'Midland Fox is applying for four minibus routes through Leicester and several changes to existing regulations. Leicester CityBus and Leicestershire County Council object to the plan.

'The suggestion had gone no further at Leicester CityBus because it had been considered "not politically realistic", he claimed.

'Mr Lutman agreed under cross-examination that the idea had not been followed up, neither had it been rejected by the City Council. He also agreed that councillors had been prepared to discuss the matter again in the future.'

After the many arguments and counter-arguments, the Commissioners' verdict was announced on Friday 23 August, and it led both sides to claim that they had won, although there can be no doubt that Midland Fox was the outright victor. While Leicester City Bus managers achieved their aim of running a service to Thurnby Lodge, Midland Fox got approval to run the Fox Cub network. CityBus director of transport, Bob Hind, told reporters, 'We came here to get the Thurnby Lodge services and that is what we have achieved. People have

been waiting for CityBus services for a long time and now it is up to the public to decide whether they want the conventional double-decker service or not. We don't think minibuses are the answer for Leicester.' However, he did not intend to close the door on future minibus talks with Midland Fox. 'Now these decisions have been made we have got to wait and see what the effects are.' Peter Lutman said he too was pleased with the verdict. 'Now we are able to offer the public a really up-to-date service. We will be implementing it as quickly as possible.'

To all intents and purposes, that marked the end of the major conflicts between the two operators. Midland Fox publicity material reproduced opposite reveals the extent and frequencies of the first two phases of Fox Cub introduction, and also shows how the routes were designed to cover as great a catchment area as possible whilst still making them attractive to use. Missing from the list is the Phase 3 introduction on 7 December – a five minutes daytime, 15 minutes early mornings, evenings and Sundays service numbered M10 and running between the city centre and Eyres Monsell. The Hinckley Fox Cubs appeared for the first time as scheduled on 28 September, initially working a single, un-numbered service between Earl Shilton, Hinckley town centre and the Sketchley Estate. New services to the Hollycroft Estate, to Barwell via Middlefield, and the extension of the Sketchley estate route to Burbage followed in 1986.

166. Another avenue that Midland Fox was keen to exploit was advertising, and the Fox Cubs' smaller size and flexibility when it came to penetrating deeper into Leicester's estates was attractive to would-be clientele. Robin Hood bodied Transit M44 (C444 SJU) received this navy blue livery to the order of Brooks plumbing and heating engineers in November 1991, and the photo dates from the following summer, when it was clearly warm enough for the driver to keep his door open. Note that in common with most post-deregulation advertising, the front of the vehicle retained fleet colours. M44 is passing the Job Centre on Charles Street; Bedford Street can be seen in the background.

FOX CUB. THE FAST FRIENDLY AND MORE FREQUENT SERVICE.

September 21st sees the 1st phase of Leicester's new exciting and more frequent way to get around – FOX CUB. The second phase starts in October .

There will be 7 main routes all starting from the city centre in Humberstone Gate or Charles Street. 3 routes will serve the Thurnby Lodge Estate with 30 buses an hour during the day, that's a bus every couple of minutes! Many buses go on to Scraptoft, Nether Hall, Evington and Thurnby Turn.

The 2 other routes serve the Polytechnic, Braunstone (Rowley Fields) every 6 minutes and Wigston (Little Hill), via the University, Knighton, Stoneygate Halls of residence and Oadby every 20 minutes.

FIRST PHASE. THE ROUTES STARTING SEPTEMBER 21st

Scraptoft · City Centre · Braunstone (Rowley Fields) numbered M2 from the city runs via Humberstone Road and Uppingham Road then Colchester Road then Elmcroft Avenue, Ocean Road, Dudley Avenue, Dakyn Road, Thurncourt Road, Bowhill Grove, New Romney Crescent, Hamilton Lane to Scraptoft Campus, returning via Scraptoft Lane and Bowhill Grove into town following the same route. This service crosses town via the Polytechnic to Braunstone (Rowley Fields). **Braunstone (Rowley Fields)** route, numbered M12 leaves the city centre via High Street, St.Nicholas Circle, Duns Lane, Western Boulevard, Mill Lane (Polytechnic), Gateway Street, Jarrom Street, Havelock Street, Walnut Street, Upperton Road, Narborough Road, Dumbleton Avenue, Rowley Fields Avenue returning via Narborough Road (numbered M2). This service crosses town to the Scraptoft Campus.

— **How Often?** —

	Early Mornings	
Daytime	**& Evenings**	**Sundays**
Every 6 Minutes	Every 12 Minutes	Every 15 Minutes

Wigston (Little Hill) via University, Halls of Residence and Oadby Route (numbered M9) leaves Humberstone Gate then via London Road, University Road, Victoria Park Road, Queens Road, Knighton Road, Stoughton Road, Guildford Road, Knighton Rise, Manor Road, Launde Road, Uplands Road, Oadby Shops, Chestnut Avenue, Brabazon Road, Oadby Road, Wakes Road, Wigston Magna, Launceston Road, and returning along Horsewell Lane, Homestead Drive, Newton Lane, Keimarsh Avenue and Paddock Street.

— **How Often?** —

Week day daytime – every 20 minutes.

Service M8 operates evenings and Sundays between the City Centre and Knighton Rise via the same route as service M9 then the Broadway and Manor Road before returning to the City Centre.

— **How Often?** —

Evenings and Sundays – every 20 minutes.

SECOND PHASE. THE ROUTES STARTING OCTOBER

The Nether Hall Route is numbered M1 from the city centre and runs via Humberstone Road, Uppingham Road, Scraptoft Lane, Brook Road, Thurncourt Road, Bowhill Grove and New Romney Crescent. Return journeys are numbered M6 and continue from the city to Regent Road and the General Hospital.

— **How Often?** —

	Early Mornings	
Daytime	**& Evenings**	**Sundays**
Every 6 Minutes	Every 12 Minutes	Every 15 Minutes

The Thurnby Route Runs via Humberstone Road and Uppingham Road then Colchester Road, Elmcroft Avenue, Ocean Road, Dudley Av. to Dakyn Road. On this route alternate journeys circle either clockwise (numbered M4) via Thurncourt Road, Station Road, Thurnby Hill, Downing Drive, Welland Vale Road, Spencefield Lane, Uppingham Road, Lodge Farm Road and Wintersdale Road to Dakyn Road or anti-clockwise (numbered M3) via Wintersdale Road continuing until Thurncourt Road where it runs onto Kinsdale Drive, Wreford Crescent, Bowhill Grove, Thurncourt Road to Dakyn Road, then all journeys return to the city numbered M7, continuing to Highfields and Goodwood.

— **How Often?** —

	Early Mornings	
Daytime	**& Evenings**	**Sundays**
Every 6 Minutes	Every 12 Minutes	Every 15 Minutes

The Highfields and Goodwood Route (numbered M7) leaves the city centre from Charles Street calling at London Road Station then Sparkenhoe Street, St. Peters Road, East Park Road, Evington Road, Evington Drive, Ethel Road, Wakerley Road, Falmouth Road, Ethel Road again to Goodwood Road. The bus continues to the City Centre and Thurnby Lodge via the General Hospital and Spinney Hill (numbered M3 or M4).

The General Hospital Route (numbered M6) leaves the city centre via Belvoir Street, King Street, Regent Road, Granville Road, Evington Road, East Park Road, St. Saviours Road, Broad Avenue, to Leicester General Hospital and returns to the city centre and Nether Hall via Evington Drive and Highfields (numbered M1).

— **How Often?** —

Services M6 and M7 run as follows

	Early Mornings	
Daytime	**& Evenings**	**Sundays**
Every 6 Minutes	Every 12 Minutes	Every 15 Minutes

Most routes give **Cross City Links**. The Scraptoft route is linked with the Braunstone route, giving a high frequency service between the Scraptoft Campus and the Polytechnic. The Nether Hall and Thurnby/Thurnby Lodge routes link with the East Park Road routes.

AND THERE'S MORE ...

This is the shape of things to come and as the months go by more areas will have their own FOX CUB service.

For further information about **fox cubs** Leicester
☎ **29161**

AFTER 6.30 p.m. & ALL DAY SUNDAY YOU CAN HIRE YOUR OWN FOX CUB FOR SPECIAL EVENTS ETC.
DON'T DRINK & DRIVE – DRINK & RIDE! ☎
Leicester 58412 for the best prices by miles.

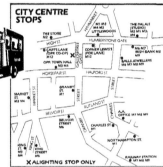

CITY CENTRE STOPS

X ALIGHTING STOP ONLY

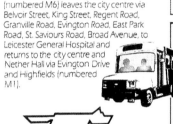

fox cub *Along in two ticks...*

167. Midland Fox publicity material for Phases 1 and 2 of the introduction of Fox Cubs to Leicester in September and October 1985.

Market Harborough Fox Cubs made their debut on 7 December, with a town route from the Southern Estate (Cromwell Crescent) to Great Bowden via the town centre, and a village route to Fleckney via Lubenham, Foxton, The Langtons and Kibworth. As with Hinckley, service revisions and new routes were introduced later in 1986, in which year new networks were also started in Ashby-de-la-Zouch (March), Burton-on-Trent and Swadlincote (both April).

With its large majority in the House of Commons, the Conservative government had no difficulty in getting all its bus industry legislation onto the statute books. As far as Leicester was concerned, it did not really make that much of an impact in the end, as all the issues, as we have seen, were thrashed out in the period leading up to it. The biggest change was for Leicester CityBus, which now had to be self-financing, the City Council henceforth being limited to a shareholder role.

In February 1986, the *Leicester Mercury* carried a report under the title 'City takes Fox Cubs to its heart'. Midland Fox manager Peter Lutman reported that even after a few months, passenger numbers were expected to reach six million in a full year in Leicester. Satisfied customers were quoted on issues such as convenience and ease of boarding. And despite everything that had gone before, there was a concession from Phil Harley, Transport Committee chairman, that Fox Cubs *did* fulfil a public demand, and an admission that he was 'surprised' at how popular they were. Nonetheless, he still maintained that the council would not be using them.

Leicester CityBus continued to trade as a municipal company, and actually increased its operating area for

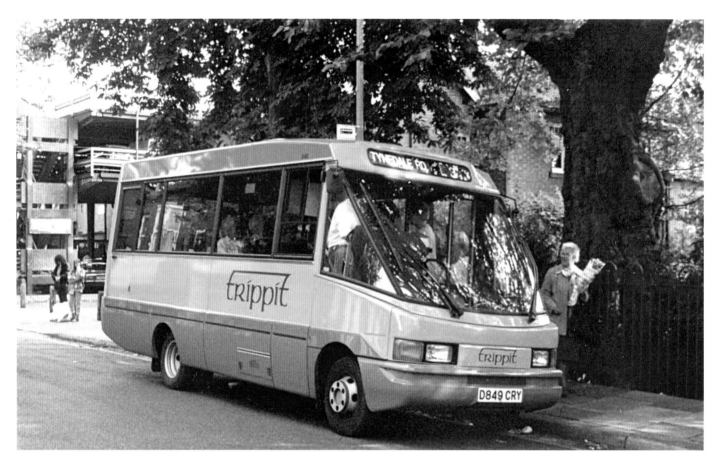

168. With the take-over of Gibson's of Barlestone in 1979, and a joint working agreement with County Travel in 1982, Leicester CityBus vehicles were now working well outside the city boundary, and in the immediate post-deregulation period, this was likely to be their best hope for expansion. The Loughborough Coach & Bus subsidiary, trading as "Trippit", began in July 1987 with a fleet of 11 Optare City Pacer midibuses, increasing to 15 by January 1988, the month that Trent withdrew from the town, its garage passing to Leicester CityBus in return for a minority shareholding in the company. Trippit 849 (D849 CRY) was seen loading on route 3 in Granby Street, Loughborough, on 29 September 1987.

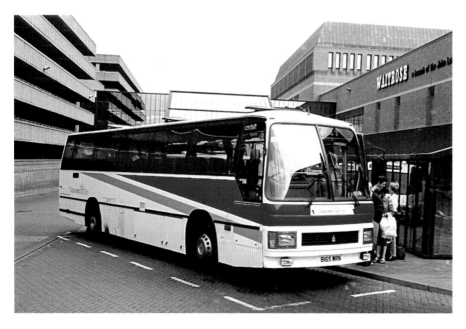

169. During the 1980s, the X47 service between Peterborough, Leicester and Birmingham had been a shared operation between Eastern Counties (later Cambus) and Midland Red/Midland Red East/Midland Fox. Service revisions in 1986 saw the end of through working to Birmingham, and at the end of July 1987, the route was won by Leicester CityBus. Pictured at the Queensgate bus station in Peterborough on 28 June 1990 while loading for the return trip to Leicester, 24 (B165 WRN) was a Duple bodied Leyland Tiger; new to Ribble, it came to Leicester in March 1988.

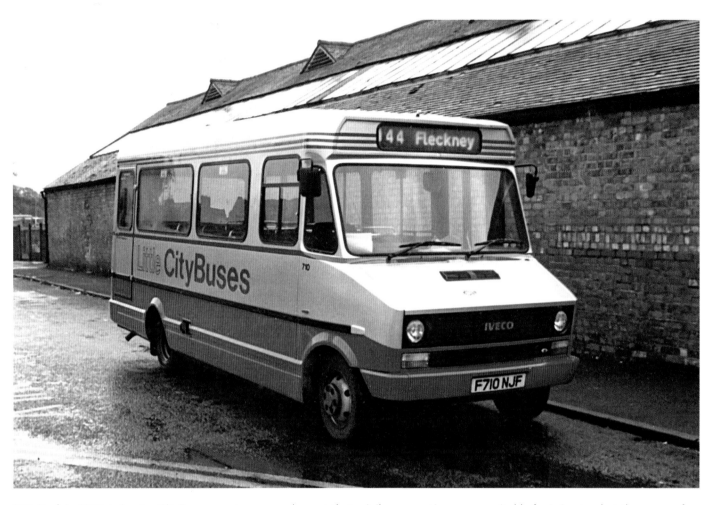

170. Back in 1985, Leicester CityBus managers were adamant that minibus operation was unsuitable for Leicester, but three years further on and the first ten had arrived. Admittedly, their use at first was confined to the Outer Circle, and county routes 143/144 and 254, but by 1992 there were over 40 in the fleet, and they were commonly found in the city centre. The original ten were Carlyle bodied Fiat 49-10s, and the last of these, 710 (F710 NJF), in the chosen livery of red and silver and "Little City Buses" fleetnames (thus ensuring the "LCB" association) was working the 144 to Kibworth and Fleckney – a service operated by Centrebus that survives at the time of writing despite being threatened by cuts in council subsidies. It was seen in the old Market Harborough bus station on a rainy 27 October 1988.

a time with the setting-up of a minibus operation in Loughborough in 1987 using the trading name 'Trippit'. And despite all those protestations that minibuses were not suitable for Leicester, CityBus began operations with them in the city and county in 1988, the first ten being Iveco Daily vehicles with Carlyle bodywork that carried an attractive silver and red livery and 'Little City Buses' logos. With 25 seats, they were over 50 per cent bigger than the 'bread vans'. Midland Fox introduced 20 of the same type that year too.

Relative calm
After 1986, competition between Leicester CityBus and Midland Fox, and to a lesser extent, Trent, Barton and

local operator G.K. Kinch[16], continued sporadically, but on nothing like the scale seen previously. The Trippit operations in Loughborough were not profitable and were sold to Midland Fox in May 1989. Competition on the Loughborough corridor between Kinch and Midland Fox ended in October 1989 with the sale of Kinch's commercial bus operations to Midland Fox, and one of the conditions attached to the sale was that Kinch would not compete against them in Leicestershire for three years (in the interim, Kinch operated a number of services in Nottingham and the surrounding area). By this time, Midland Fox was part of the Drawlane (later British Bus) Group, and had embarked on a buying spree of smaller companies, primarily in Leicester

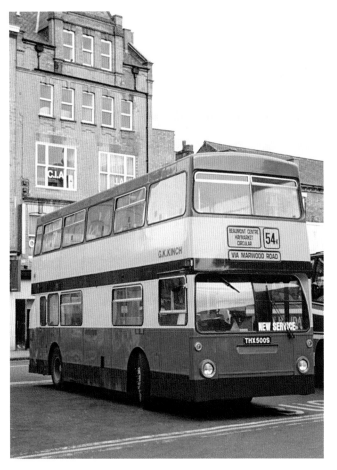

171-172. The Kinch name has for many years been associated with transport in Leicestershire. Gilbert Kinch, also a one-time director of Leicester City football club, ran a successful coach business from premises in Mountsorrel before taking advantage of the opportunities presented by deregulation and moving into bus work. Competition on the Loughborough corridor ended in October 1989 with the sale of Kinch's commercial bus operations to Midland Fox, and one of the conditions attached to the sale was that Kinch would not compete against them in Leicestershire for three years. In the interim, Kinch operated a number of services in Nottingham and the surrounding area, but returned to Leicester in 1992 to take on Leicester CityBus on the 54 to the Beaumont Centre, and to Loughborough, competing with Midland Fox on town work. The situation was resolved early in 1994, after GRT had acquired CityBus; under the terms of the agreement Kinch withdrew once again from Leicester but the Loughborough Bus operations, started by CityBus in 1987 and taken over by Midland Fox in 1989, passed entirely to Kinch. He sold the company to the Wellglade Group in 1998, but the Kinchbus name and blue and yellow livery live on in 2018 with routes linking Leicester, Loughborough, and Nottingham, and the prestigious Skylink service which connects Derby, Loughborough and Leicester with East Midlands Airport.

The left-hand photo shows former London Transport Fleetline THX 500S on 8 December 1992, resting in Humberstone Gate between duties on the Kinch 54A to the Beaumont Centre; the notice in the front windscreen proclaims it to be a " new service". Below, Dennis Dart 402 (L402 CJF) loads for the Loughborough town service to Thorpe Acre in Swan Street on 15 February 1995.

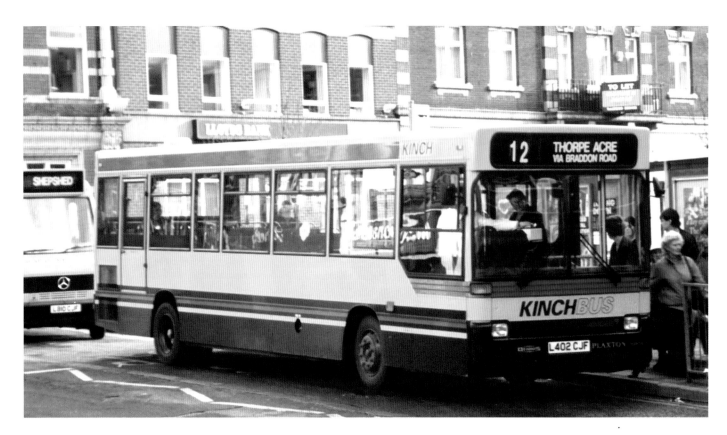

but also in London. Kinch returned to Leicester in 1992 to take on Leicester CityBus on the 54 to the Beaumont Centre, and to Loughborough, competing with Midland Fox on town work.

In the country as a whole, several former municipal bus companies had already been sold to private sector groups. In 1993, after suffering a number of loss-making years, it was decided that Leicester CityBus should also join them.

One last war

On one hand, the lofty ideal behind deregulation was to promote competition. However, one effect of privatisation would be that successful bidders would start to build empires; unlikely as they were to compete group against group (except in some isolated cases), they almost always stifled any entrepreneur who tried to set

up on their patch with a few second- or third-hand vehicles. And as their operating areas usually surrounded those of the former municipals (as was the case with Midland Fox and Leicester CityBus), any announcement of a sale was bad news. Why? Because the Monopolies and Mergers Commission, a body created in 1988, was there to scrutinise take-overs and ensure that the consumer was not disadvantaged as a result. The prospect of all city services falling into the hands of one operator was more than enough to spark its interest, and it could legally instruct a company to divest itself of an acquisition, such as it did with Stagecoach when it bought Portsmouth Citybus in 1989.

In late 1992, Lancaster put its municipal operation on the market. The government wanted local authority companies to be sold by open tender, and that had a two-fold effect on neighbouring operators: one, that their

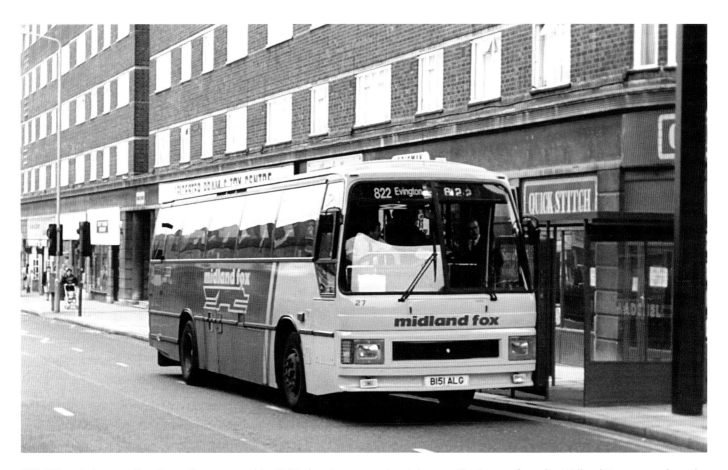

173. When Leicester City Council announced in 1993 that it was putting Leicester CityBus up for sale, Midland Fox stepped up the competition by registering six services that mirrored existing CityBus routes. The same route numbers were used, but prefixed with an '8'. Vehicle provision varied from minibuses all the way up to coaches, such as 27 (B151 ALG), a Leyland Tiger/Duple that came from Crosville in September 1993 and was immediately put in service to impress the citizens of Evington, who could now choose a CityBus 22 or a Fox 822. 27 was waiting at the stand in Charles Street on 22 September 1993.

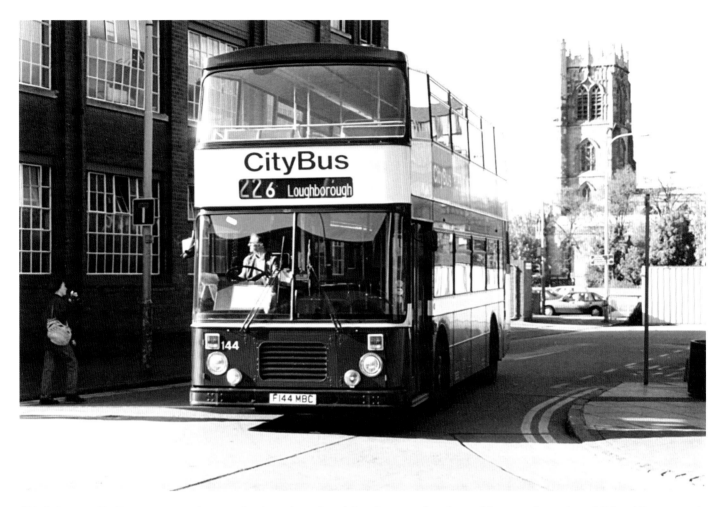

174. Leicester CityBus was not going to take these intrusions lying down, and registered four services where Midland Fox was vulnerable. One such was Loughborough, where the existing 126 was supplemented by Citybus 226, and on which Dennis Dominator/East Lancs 144 (F144 MBC) was employed as it left St Margaret's bus station on 16 October 1993. Geoffrey Hilditch had returned to Leicester as CityBus chairman, and it was during this time that the decision was taken to replace the unpopular red, white and grey livery and return to a maroon and cream scheme similar to that used before 1961, as worn by 144. Hilditch, a man whose influence on the bus industry in general and in Leicester specifically cannot be underestimated, retired in 1993 when GRT took over; he passed away aged 88 in June 2014.

rivals could get a foothold in their area, but two, that the Monopolies and Mergers Commission would not look kindly on them buying the companies themselves! So as some of Lancaster's network was shared with local ex-NBC company, Ribble, now part of Stagecoach, Ribble management decided to protect their position by registering services that mirrored Lancaster's own routes, the aim being to destabilise the local operator and scare off potential bidders. Losses mounted, Lancaster Council were forced to liquidate the business, and Ribble was left to buy up just the depot and a handful of buses.

For Lancaster read Leicester CityBus. For Ribble read Midland Fox. The CityBus fleet was almost three times

the size of Lancaster, and so would have made a most appealing addition to the portfolios of the other two major groups, Stagecoach and Badgerline. What were the chances of Midland Fox being able to bring both companies together without upsetting the competition authorities?

On 19 August 1993, buses were back as a page 1 headline in the *Leicester Mercury*. 'Bus wars set to break out', it announced, with Midland Fox registering six routes in head-to-head competition with CityBus – to Goodwood, Rushey Mead, Evington, the Beaumont Centre, Mowmacre Hill linked with Eyres Monsell and in the county, Newbold Verdon. Management said

that a bid had been made by Midland Fox, but it was unlikely that it would be permitted. Whilst their spokesman believed that a merger would have been the most benefit to the public, he admitted that 'in the deregulated competitive environment in which we are required to operate we felt we had to take steps to protect our market share and safeguard the future of the company and its employees.' The new services were planned to start on 20 September, and were likely to put an extra 36 buses an hour onto Leicester's streets.

CityBus management's response was inevitable. Peter Connolly, the chairman, said that they would react, 'not just on these routes but in other parts of the city. I didn't want this but I have to respond'. It did not take long for Midland Fox management to be accused of adopting tactics designed to scare off potential bidders, but if anyone outside of CityBus thought there would be a long wait before the new owners were revealed, they were wrong. On 25 August, news of the sale was made public. To the surprise of many, the successful bidder was the Grampian Regional Transport (GRT) group, based in Aberdeen. A former municipal company itself, Grampian was privatised in 1989; Northampton Transport (purchased in October 1993) and CityBus were its first acquisitions south of the border. When viewed simply in terms of size, British Bus, the parent company of Midland Fox, was by far the bigger, but now having another group behind it meant that CityBus would be no pushover.

The routes upon which CityBus planned to retaliate were announced at the same time; Syston and Queniborough, Groby and Ratby, Loughborough, Wigston and Hinckley were the chosen battlegrounds, and services would begin on 27 September, a week after Midland Fox. The *Leicester Mercury* led with 'City bus chaos is expected' on 20 September, followed a day later by reports that the extra buses were slowing traffic on three main routes in the city centre – Humberstone Gate, Haymarket and Charles Street. When CityBus started its own competing services a week later, its offer of two days free travel on the Wigston and Queniborough routes made the headlines. Whilst its services would run during the day at 20 minute intervals, frequencies on five of the six Midland Fox routes would, it was said, now operate every ten minutes. The competition would only work to the advantage of Midland Fox if it managed to abstract enough CityBus passengers to seriously undermine the latter's finances.

The problem inherent in 99 per cent of these cases is that insufficient new passengers are attracted and both sides lose money.

Leicester divided

And so it proved after only a couple of months. The GRT bid could not be finally confirmed until November, as Trent, with its minority shareholding (acquired in 1988 when it pulled out of Loughborough), had the opportunity to throw its hat into the ring. It decided not to, so the stage was set for conciliation, when all three parties – Midland Fox, Leicester CityBus and Kinch Bus – could gather round the table to thrash out the future of Leicester services.

In the week before Christmas 1993, it was front page news again. Midland Fox announced it would be withdrawing four services from the end of the week (actually Friday 24 December) – those to Goodwood, Rushey Mead, Evington and the linked Mowmacre Hill & Eyres Monsell route. Leicester CityBus revealed that not only was it withdrawing the competing services, but also it would also be giving up work in certain areas of the city, with effect from 9 January. Operations Director Julian Heubeck explained:

'The services were not economically viable to run as there were too many buses.

'So where are we withdrawing services from these areas, Midland Fox will continue to operate.

'And where they withdraw their services, ours will remain unaltered. [Both companies had realised there was] no point in running services that were not profitable.

'It seemed the sensible thing to do in commercial interests to withdraw these competitive services.'

The most complete description of the changes came in yet another front page article on Wednesday 5 January 1994, where the changes insofar as they related to Midland Fox were outlined:

'BUS FIRM ANNOUNCES NEW CUTS IN SERVICES
'Bus firm Midland Fox today released details of cuts to its services throughout Leicester.

'Leicester CityBus last week announced the withdrawal of several services, some of which will still be covered by Midland Fox

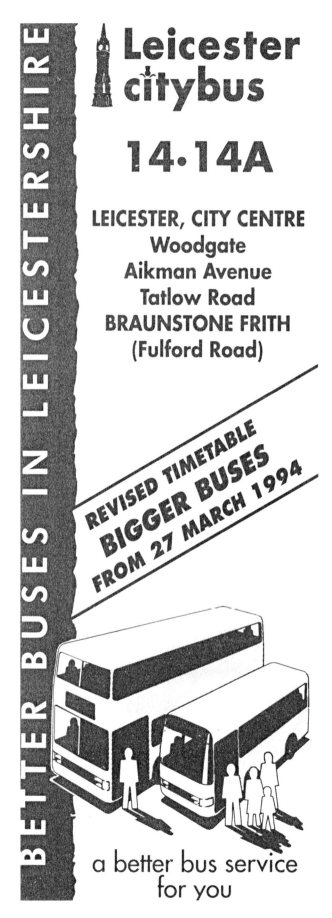

'The two operators have divided the city between them in a bid to reduce congestion and make both companies more viable.

'The Midland Fox services being withdrawn from January 9 are: 61 Birstall; 66/67 Birstall (Harrowgate Drive); 72 Scraptoft, City General, city centre; 74A Anstey; 81 Highway Road and 94/94A Glenfield.

'All these services will be retained by Leicester CityBus.

'Midland Fox is putting on a new service, numbered 53A, covering Scraptoft and Thurnby Lodge to city centre.

'The company will be providing revised replacement services – some where Leicester CityBus have withdrawn them – number 8 Braunstone; 27/27A Pendlebury Drive/Shanklin Drive and 29/30/31 Coombe Rise/Oadby Grange.

'Midland Fox and Leicester CityBus will be operating a joint service on the 37/37A service covering Mowmacre Hill and Eyres Monsell.

'Revised services are the 53 Thurnby Lodge; 105 Loughborough and Sileby; 113/114 Groby and Ratby.

'The 121/122/123/124 services covering Derby, and Loughborough will be operated by Midland Fox, Kinch and Barton Buses.

'Coalville and Loughborough will be served by the 125/126/127 services by Midland Fox and Kinch Bus.

'Services 2/2A in Sileby and Loughborough will be a revised service by Kinch Bus. The 106 Thurmaston and Loughborough service will be operated by Kinch Bus and A & S Travel until January 14, and A & S Travel from that date.'

Kinch Bus also got the Loughborough town network, and those round table talks at the end of 1993 may be credited with devising a network with relatively little duplication of services by the various companies that still remains largely in place today.

So what should we make of it all?

Hark back to 1929, when Alderman Banton was addressing concerns that there might be coming a 'big 'bus

175. A Leicester CityBus timetable leaflet from the early days of GRT control, March 1994.

monopoly, privately controlled, operating throughout the country'. And to *Leicester Mercury* correspondent W. Green, who the same year cautioned that 'when the little man is eliminated…the residents of Greater Leicester will be entirely at the mercy of huge private companies and combines over whose affairs they will have no control'. How prophetic they were.

But like most cities in Great Britain, Leicester's bus companies have been subject over the years to council control, state control and private sector control in various forms and in various combinations, and determining which delivered the best outcomes for the general public is not easy. There can be no doubt that the Corporation ran a highly regarded and efficient network *within the city* for almost fifty years, but did it do

so by taking unfair advantage over its rivals by virtue of the Area Stop regulations? Certainly, by placing so much reliance on protecting the existing boundary, and by failing to properly engage with the opposition at a time when the outer suburbs were rapidly expanding, it made it difficult to expand and tap into these new markets. That there was harmony between Leicester City Transport and Midland Red from the 1930s until the end of the 1970s is undeniable, but as we have seen, the squabbling and in-fighting that took place before and after, driven by the policies propounded by both Labour and Conservatives, played a major part in shaping the transport provision of today.

What if it had been possible to put political considerations aside? Would time have been better spent

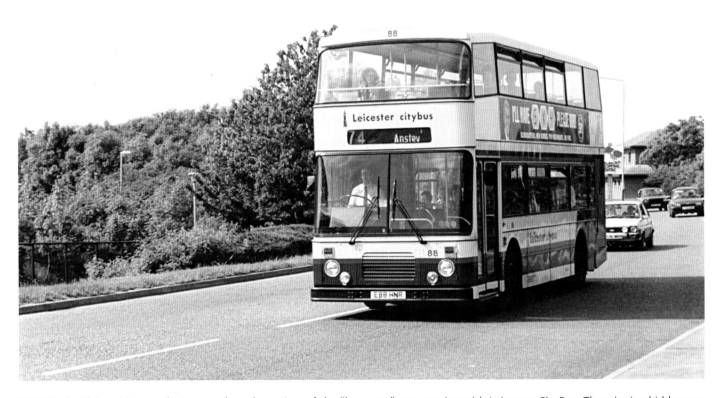

176. Finally, three photographs to complete the review of the "bus wars" era, starting with Leicester CityBus. The winning bidder was Grampian Regional Transport, or GRT, and by January 1994, agreement had been reached between GRT, Midland Fox and Kinch as to which areas each would serve. A new livery was devised, which could be said to hark back (to some extent) to the cream and maroon scheme jettisoned in 1984, and a new stylised fleetname incorporated a representation of the Clock Tower, but also, as a reminder of its Scottish parentage, a thistle over the 'i' in "citybus". Dennis Dominator 88 (E88 HNR) models the end result as it travels along Beaumont Way en route to Anstey on 11 June 1994.

considering what benefits could flow from a fully (and properly) integrated city and county-wide service network? Undoubtedly yes, and crucially, there were two opportunities in the 15 years before deregulation when it would have been possible to do so. The first, the most comprehensive and more important of the two came as we have seen in 1970 and 1971, when managers from both companies were discussing an amalgamation of Leicester City Transport with Midland Red. It is unfortunate that it came to naught as at that time, the acquisition would not have troubled the competition authorities.

The second opportunity was in 1985 when the Council had the chance to take Leicester CityBus into the minibus partnership proposed by Midland Fox on what in the circumstances appear to have been very generous terms. It may be assumed that the offer was made so as not to put either side in contravention of the forthcoming legislation, and there is no way of knowing how creating the joint venture would have impacted on both companies 'big bus' operations. But had there been an affirmative response, it seems reasonable to say that CityBus would have been in a far stronger position than the one it actually found itself in at the end of 1986.

Overall, I think that a merger would have been the better option. The brand of protectionism favoured by the Council since 1930 was starting to look dated by the 1960s, when passenger numbers were falling and the number of estates outside the city boundary was

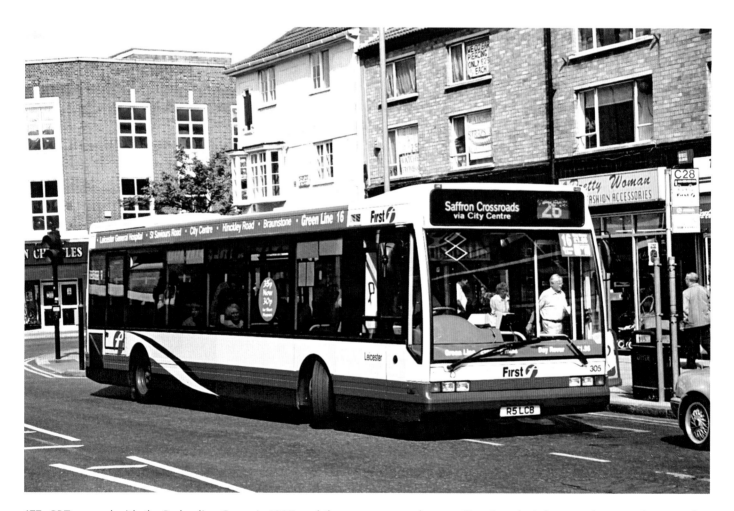

177. GRT merged with the Badgerline Group in 1995, and the new company became First Bus plc. It became the second group, after Stagecoach, to introduce a corporate livery. 305 (R5 LCB) was one of ten Optare Excels received in 1997; all were originally given local colours (of which there were several variations by that time) before being quickly repainted into the new colours, which soon acquired the nickname "Barbie". 305 shows off its "Green Line" branding for the 16, which linked the General Hospital with Braunstone via the city centre, although inevitably it is working a different route – the 26 to Saffron Cross Roads – on 19 August 2000.

rising exponentially. Conservative party policy on public transport in the 1980s was the final nail in the coffin. The Council's impact on the events that flowed from the forthcoming deregulation legislation was unnecessarily combative and did Leicester City Transport/CityBus no favours at all. Particularly in 1970/71, and to a lesser extent in 1985, Leicester city and county could have derived immense benefit from having a strong, outward-looking and *passenger-focused* organisation, whether it comprised one united company or two co-operating companies, that would have been better placed to withstand the fluctuating demands of successive political masters, locally and nationally, and deliver a service on behalf of those that really matter – the service users themselves.

But ironically, it is the fact that no-one had the foresight or the resolve to pursue such ends to a logical conclusion that has enabled this story to be told.

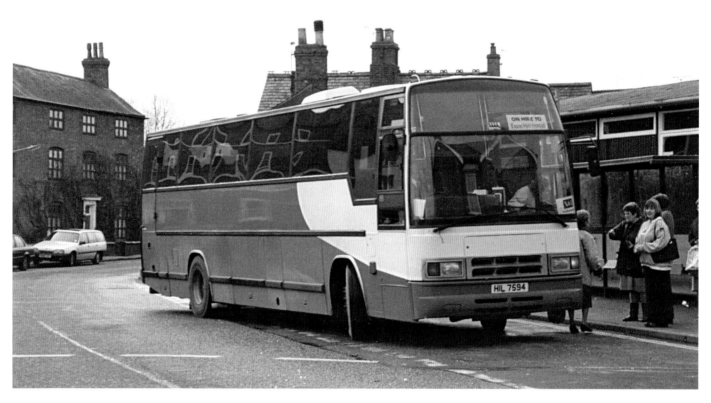

178. The Cowie Group acquired British Bus plc in August 1996. Outwardly there was no change so far as Midland Fox was concerned until the end of 1997, when the group was renamed Arriva, a new local descriptor (as opposed to fleetname) – Arriva serving the Fox County – was born, and a corporate livery of turquoise and stone was introduced. Picking up at Kibworth Square on an X61 working on 29 December 1997, 234 (HIL 7594) was my introduction to the new order; a Plaxton bodied Volvo B10M, it had been received from Luton & District the previous month.

APPENDIX I

Compulsory and permissible stopping places as originally defined by the Leicester Tramways Committee for the electric tram routes opened in 1904

CLOCK TOWER – BELGRAVE (surveyed 22 March 1904; line opened 18 May 1904)

COMPULSORY	PERMISSIBLE
Tower	
	Old Cross
Pavilion Music Hall	
	Foundry Square
Junction Road	
Great Northern Station	
	Gresham Street
Rothley Street	
Melton Turn	
	Portsmouth Road
	Shaftesbury Avenue
Windsor Avenue	
	Roughton Street
Checketts Road	
Stanton Place	
Terminus	

NOTES

1 The Old Cross was removed in 1930 as part of a scheme to extend Charles Street between Humberstone Gate and Belgrave Gate and widen Belgrave Gate

2 The New Pavilion Theatre of Varieties stood at the corner of Belgrave Gate and Wilton Street. It closed on 29 November 1930, and it was at this time that Belgrave Gate was widened from its new junction with Charles Street northwards

3 Only a small section of Junction Road now remains, the part from Belgrave Street to Melton Street having been redeveloped

4 The Great Northern Station closed in the 1960s; the site became a Sainsbury's supermarket which in turn was demolished in 2014

5 The area around Gresham Street has been redeveloped

6 Stanton Place no longer exists, but in a contemporary edition of Kelly's Directory for Leicestershire and Rutland it is shown as the first road on the right-hand side of Thurcaston Road after leaving Loughborough Road

CLOCK TOWER – STONEYGATE (surveyed 24 March 1904; line opened 18 May 1904)

COMPULSORY	PERMISSIBLE
Tower	
Horsefair Street	
Belvoir Street	
	Northampton Street
Station	
	De Montfort Street
Victoria Road Church	
Evington Road	
	St James Road
Mayfield Road	
	Knighton Park Road
	Holmfield Road
	Albert Road
	Sandown Road
	Knighton Road
	Ratcliffe Road
	Holbrook Road
Portland Towers	

NOTES

1 Portland Towers is a group of properties on a road set some distance back from London Road, accessed via Grenfell Road, being roughly 40 yards north of the Stoneygate Tram Depot. It appears from maps of the time that they would have been visible from London Road, as one of the few developments built in the area by 1904. It is not to be confused with Portland House – now the Leicester High School for Girls – which is 200 yards further to the north

CLOCK TOWER – CLARENDON PARK (WIGSTON ROAD TERMINUS)

(surveyed 24 March 1904; line opened 18 May 1904)

As Stoneygate route to Mayfield Road, then…

COMPULSORY	PERMISSIBLE
	St Marys Road
	Howard Road
Clarendon Park Road/Queens Road	
	St Leonards Road
	Lorne Road
	Wigston Road

NOTES

1 'Wigston Road' is in fact a reference to Welford Road

CLOCK TOWER – MELBOURNE ROAD (surveyed 22 March 1904; line opened 18 May 1904)

As Stoneygate route to De Montfort Street, then…

COMPULSORY	PERMISSIBLE
	Saxe-Coburg Street
Highfield Street (corner of London Road) – inbound journeys only	
	Tichborne Street
Saxe-Coburg Chapel	
	St Peters Church
St Peters Road (corner Melbourne Road)	
Clipstone Street	
Melbourne Road Board School	
	Buxton Street
Cecil Road	
	Charnwood Street

NOTES

1 Saxe-Coburg Street was renamed Saxby Street in 1917
2 The Saxe-Coburg chapel is now known as the Wesleyan Chapel. It stands on the corner with Sparkenhoe Street
3 The Clipstone Street area was completely redeveloped in the 1970s
4 The Melbourne Road Board (or Council) School was situated between Dale Street and Berners Street. It is now a Community Health Centre and Islamic Academy

CLOCK TOWER – WESTERN PARK (surveyed 22 June 1904; line opened 12 July 1904)

COMPULSORY	PERMISSIBLE
Eastgates	
	Carts Lane
Highcross Street	
Corner of Applegate Street	
	West Bridge
New Park Street	
Hinckley Road junction	
	Latimer Street
Fosse Road	
	Hill Top
	Kirby Road
	Allotment gates

CLOCK TOWER – NARBOROUGH ROAD (surveyed 22 June 1904; line opened 12 July 1904)

As Western Park route to New Park Street, then…

COMPULSORY	PERMISSIBLE
Narborough Road junction	
	Roman Street
Equity Road	
	Harrow Road
	Walton Street
	Danvers Road

CLOCK TOWER – FOSSE ROAD (surveyed 22 June 1904; line opened 12 July 1904)

As Western Park route to Hinckley Road junction, then…

COMPULSORY	PERMISSIBLE
	Latimer Street
	Arundel Street
King Richards Road	
	Bosworth Street
	Park Gates
Pool Road	
	Beatrice Road
Groby Road end	

CLOCK TOWER – AYLESTONE (surveyed 16 August 1904; line opened 5 September 1904)

COMPULSORY	PERMISSIBLE
Bowling Green Street (Belvoir Street corner)	
Welford Place	
	Pelham Street
Regent Road	
Recreation ground	
Walnut Street	
	Freemans Common
	Saffron Lane
Gas Office (return)	
	Boundary Road
	Cavendish Road
	Lansdowne Road
	Duncan Road
	Cats Lane
	Leicestershire Club (return)

NOTES
1 The recreation ground is now Nelson Mandela Park
2 Cats Lane was renamed Hall Lane in 1931
3 The Leicestershire Club is now called the Firs Club

CLOCK TOWER – HUMBERSTONE (surveyed 19 October 1904; line opened 1 November 1904)

COMPULSORY	PERMISSIBLE
Tower	
	Charles Street
Wharf Street	
	Between Ann Street and Arthur Street
	Erskine Street
Curzon Street	
Cobden Street	
	Vulcan Road
	Flint Street
	St Saviours Road
Forest Road	
Harewood Street	
	Victoria Road East
St Barnabas junction	
	Haynes Road
	Between Coleman Road and Trafford Road

EAST PARK ROAD (surveyed 20 October 1904; line opened 1 November 1904)

Clockwise as Humberstone route to St Barnabas junction, then…

	Green Lane Road
St Saviours Road	
	Moat Road
	Park Vale Road
St Peters Road	
	Dore Street
Evington Road (corner of East Park Road)	
St Stephens Road	
	Skipworth Street
London Road (corner of Evington Road)	

Anti-clockwise as Stoneygate route to Victoria Road church, then the reverse of the above

FOOTNOTE
The Tramways Committee did not minute their decisions in relation to the Woodgate section that opened on 22 December 1904, or to the Melton Road extension, which opened on 18 June 1905.

APPENDIX 2

Services in the Leicester area introduced by Midland Red 1920-29

What immediately becomes apparent is the sheer volume of new services introduced during the period. Their popularity may be judged by the number of short workings that were introduced, particularly from 1928 onwards, to combat overcrowding on many of the longer routes. What had started out as a single route in 1921 had mushroomed by the end of the decade to a complex network of around 75 services covering every part of the county of Leicestershire, and extending into Rutland, Warwickshire, Staffordshire, Nottinghamshire and Lincolnshire. On top of which, it should be noted that although outside the scope of this work, Midland Red were also developing route networks in Hinckley and Coalville.

Details of each route are given on the basis of when each was introduced, and with all subsequent changes during the decade listed. There was no apparent logic to the allocation of route numbers (unlike Leicester City Transport, albeit with a smaller network – see Appendix 4).

Initially, there was no specific system by which routes were numbered. Those numbers applicable to Leicestershire services are shown in **Column 1**.

In April 1925, Midland Red decided to renumber all services on a geographical basis. Services originating in Leicestershire were given numbers beginning at 449, as shown in **Column 2**.

Such was the growth of services throughout the Midland Red empire, with some areas having used all their allotted numbers, that a further renumbering was soon called for. A new system was introduced in February 1928, and services originating in Leicestershire were given numbers beginning at 600, as shown in **Column 3**.[1] With some exceptions, such as the introduction of letter prefixes for local services (i.e. L for Leicester), many of the elements of this final system lasted well into the 1980s.

Column 4 shows the details of the main population centres visited by each route.

The dates upon which each route was introduced, and any significant changes made subsequently, are shown in **Column 5**.

COL 1	COL 2	COL 3	COL 4	COL 5
68	525	725	Nuneaton – Hinckley – Barwell – Earl Shilton Extended to Leicester	Introduced 10 August 1920 11 May 1921
103	500		Burton-upon-Trent – Ashby-de-la-Zouch Extended to Coalville, Leicester Diverted via Woodville The route was then split into three:	Introduced 27 January 1921 15 July 1921 30 January 1926
		665	Coalville – Markfield – Groby – Leicester	By February 1928
		667	Ashby-de-la-Zouch – Ravenstone – Coalville – Leicester	By February 1928
		668	Burton-upon-Trent – Midway – Woodville – Ashby-de-la-Zouch – Leicester	By February 1928
131	---	---	Coventry – Hinckley – Earl Shilton Extended to Leicester, plus Hinckley – Leicester shorts	24 February 1921 By November 1921 **DISCONTINUED BY APRIL 1922**
45A	---	---	Coventry – Lutterworth – Leicester	Date unknown **DISCONTINUED BY APRIL 1922**
69	449	600	Coventry – Sharnford – Stoney Stanton – Huncote – Narborough – Leicester	Introduced 4 June 1921

COL 1	COL 2	COL 3	COL 4	COL 5
69A	450		Leicester – Broughton Astley	Introduced 3 September 1921
			Curtailed at Cosby; diverted via Enderby	26 July 1924
			The route was then split into two:	
		601	Leicester – Enderby	By February 1928
		602	Leicester – Enderby – Cosby	By February 1928
69B			Leicester – Blaby	Date of introduction n/k
	451		Extended to Cosby, Broughton Astley	By April 1922
			Extended via Dunton Bassett	15 December 1926
		603	Leicester – Blaby – Broughton Astley	By February 1928
		604	Leicester – Blaby (shorts)	By October 1928
104	502		Ashby-de-la-Zouch – Heather – Ibstock – Barlestone – Desford – Leicester	Introduced 3 May 1922
			Extended Barlestone to Bagworth	17 July 1926
			The route was then split into three:	
		671	Leicester – Barlestone	By October 1928
		672	Leicester – Barlestone – Nailstone – Ibstock	By October 1928
		673	Leicester – Ibstock – Heather – Normanton – Ashby-de-la-Zouch	By October 1928
132			Leicester – Oadby – Wigston Magna – South Wigston – Leicester circular	Introduced 23 September 1922
			Extended to Great Glen	8 December 1922
	452	605	Leicester – Wigston Magna via Welford Road	By April 1925
	453		Leicester – Wigston Magna – South Wigston – Leicester; circular route in both directions	By April 1925
		606	Leicester – Wigston Magna – South Wigston – Leicester circular	By February 1928
		607	Reverse of 606	
	454		Leicester – Oadby – Wigston Magna **OR** Leicester – Oadby – Great Glen	By February 1928
			The 454 was then split into two:	
		610	Leicester – Oadby – Wigston Magna	By February 1928
		611	Leicester – Oadby – Great Glen	By February 1928
		655	Leicester – Oadby (shorts on service 610)	By February 1929
134	461		Leicester – Syston	Introduced 11 October 1922
		617	Extended from Syston to Queniborough	19 September 1925
		617	Extended from Syston to Rearsby	9 December 1925
			The route was then split into three:	
		617	Leicester – Syston	By October 1928
		618	Leicester – Queniborough	By October 1928
		619	Leicester – Rearsby	By October 1928
105	501	670	Leicester – Markfield – Ellistown – Ibstock	Introduced 18 October 1922
133			Leicester – Mountsorrel	Introduced 18 October 1922
	470	626	Extended to Loughborough	28 February 1923
			Leicester – Loughborough services were significantly re-organised, viz:	By October 1928
		625	Via Red Hill	
		626	Via Birstall	
		627	Via Mountsorrel	
		628	Via main road	

COL 1	COL 2	COL 3	COL 4	COL 5
135	460	616	Leicester – Billesdon - Uppingham	Introduced 28 October 1922
136	456	612	Leicester – Tur Langton – Mkt Harborough	Introduced 28 October 1922
			Some journeys via Great Bowden	6 November 1926
		613	Great Bowden journeys renumbered	By February 1929
134A			Leicester – Syston – Rearsby – Rotherby – Kirby Bellars – Melton Mowbray	Introduced 31 October 1922
	462	620	Rerouted via Hoby and Asfordby	By January 1923
134B			Melton Mowbray – Langham – Oakham	Introduced 31 October 1922
	463	621	Rerouted via Whissendine and Langham	By January 1923
136A	457	614	Mkt Harborough – Welford	Introduced 31 October 1922
				Discontinued by 1929 when the number 614 was reallocated (see below)
104A	520	696	Measham – Snarestone – Swepstone – Heather – Ravenstone – Coalville	Introduced 17 November 1922
133A			Leicester – Anstey	Introduced 9 December 1922
	473		Extended to Newtown Linford	Date unknown
133A			Leicester – Cropston – Woodhouse Eaves	30 March 1923
	473		Diverted via Cropston and Swithland	7 January 1924
			Diverted via Rothley station	5 December 1925
			The route was then split into two:	
		632	Leicester – Anstey – Newtown Linford	By February 1928
		633	Leicester – Anstey – Cropston – Rothley station – Woodhouse Eaves	By February 1928
		631	Leicester – Anstey (shorts on service 632 and 633)	By October 1928
68B	503	646	Leicester – Desford – Market Bosworth	3 October 1923
		648	Extended from Market Bosworth to Atherstone	6 October 1928
137	475	636	Leicester – New Found Pool	8 December 1923
138	474		Leicester – Anstey Turn – Glenfield – Kirby Muxloe	26 July 1924
			Extended to Ratby (via Red Cow daily; via Glenfield Sat/Sun)	22 August 1925
		634	Operated to Ratby via Glenfield ONLY	15 August 1927
138	474		Leicester – Red Cow – Kirby Muxloe	Date unknown
	476	635	Leicester – Red Cow – Kirby Muxloe	15 August 1927
---	504	---	Loughborough – Hathern – Coalville	Date unknown
			Extended to Leicester	17 July 1926
				NO RECORD OF THIS SERVICE IN THE 1928 RENUMBERING
---	471	629	Leicester – Sileby – Barrow – Loughborough	Introduced 11 April 1925
		630	Loughborough – Sileby (shorts on service 629)	By October 1928
---	499	669	Leicester – Coalville – Peggs Green – Coleorton – Ashby-de-la-Zouch	Introduced 22 July 1925
---	478		Leicester – Arnesby – Welford	Introduced 5 December 1925
		638	Extended to Husbands Bosworth	By February 1928
---	464	622	Leicester – Queniborough – Twyford – Melton Mowbray	Introduced 9 February 1926

COL 1	COL 2	COL 3	COL 4	COL 5
---	480		Enderby – Blaby – Wigston – Oadby	Introduced 15 August 1926
		640	Extended to form Leicester Outer Circle	15 May 1927
			640 amended to run Wigston – Narborough (Mon-Sat); Oadby – Enderby (Sun)	14 July 1928
		641	Leicester Outer Circle (ex 640)	Introduced 14 July 1928
---	481		Leicester – Leire – Wolvey – Bedworth	Introduced 25 September 1926
		642	Curtailed at Claybrooke Magna	By October 1927
---	427	575	Leamington – Rugby – Lutterworth – Countesthorpe – Leicester	Introduced 10 November 1926
---	477	637	Leicester – Stoney Stanton – Sapcote (Sundays to Hinckley)	Introduced 20 February 1927
---	497	664	Leicester – Kirby Muxloe – Thornton – Ellistown	Introduced 23 February 1927 Discontinued by October 1928
---	562	792	Tamworth – Twycross – Newbold Verdon – Leicester	Introduced 9 March 1927
---	134	162	Birmingham – Coleshill – Nuneaton – Hinckley – Leicester	Introduced 18 June 1927
---	479	639	Leicester – Great Glen – Fleckney	Introduced 15 August 1927
---	482		Leicester – Blaby or South Wigston – Countesthorpe The route was then split into two:	Introduced 15 August 1927
		643	Leicester – Blaby – Countesthorpe	By February 1928
		644	Leicester – South Wigston – Countesthorpe	By February 1928
---	465		Leicester – Queniborough – Twyford – Somerby – Oakham	Introduced 17 August 1927
		623	Diverted via Knossington	13 September 1927
---	466	624	Melton Mowbray – Knossington Extended to Oakham via Cold Overton	Introduced 13 September 1927 By October 1928
---	483	645	Leicester – Enderby – Thurlaston – Earl Shilton – Burbage	Introduced 14 September 1927
---	138	168	Birmingham – Coventry – Leicester (limited stop)	Introduced 16 October 1927
---	---	663	Leicester – Ibstock – Heather – Newton Burgoland	11 July 1928
---	---	654	Leicester – Market Harborough via main road	1 September 1928
---	---	608	Leicester – South Wigston – Wigston Magna – Leicester	By October 1928 NB – The 606 and 607 circulars operated from The Newarke to The Newarke; the 608 operated from Newarke Street to the Hind Hotel
		647	Leicester – South Wigston (shorts on service 608)	By October 1928; discontinued by February 1929
---	---	609	Leicester – Wigston Magna	By October 1928
---	---	650	Leicester – Barkby Lane – Barkby	November 1928
---	---	651	Leicester – Syston – Barkby	November 1928
---	---	656	Leicester – Uppingham – Morcott – Ketton – Stamford	23 November 1928
---	---	660	Leicester – Syston Willoughby – Keyworth – Nottingham	1 December 1928

COL 1	COL 2	COL 3	COL 4	COL 5
---	---	661	Leicester – Syston – Rearsby – Kirby Bellars – Melton Mowbray	1 December 1928
---	---	652	Leicester – Humberstone Lane (railway bridge)	January 1929
---	---	615	Leicester – Oadby – Great Glen – Burton Overy	By February 1929
---	---	659	Leicester – Syston – Sileby – Barrow – Loughborough	22 June 1929
---	---	657	Leicester – Anstey – Ulverscroft Priory – Shepshed	25 June 1929
---	---	658	Leicester – Hinckley – Nuneaton – Coventry	27 July 1929
---	---	614	Leicester – Kibworth – Hallaton – Medbourne – Weston-by-Welland – Market Harborough	13 August 1929
---	---	662	Leicester – Melton Mowbray – Grantham	7 December 1929

APPENDIX 3

Operators in the Leicestershire area known to have been acquired by Midland Red up to 31 December 1929

Godwin (later J.Weston) Syston	1 December 1928
J. Lewitt, Countesthorpe	25 February 1929
J. A. Smith, Enderby	4 March 1929
T. Haines, Huncote	18 March 1929
C. W. Moore, Anstey	29 March 1929
J. W. Jarratt, Blaby	1 October 1929
St. Saviours, Coalville	26 October 1929
J. Forman, Leicester Forest East	26 October 1929
V. J. Wheeler, Kirby Muxloe	31 December 1929

Operators in the Leicestershire area known to have been acquired by Midland Red between 1930 - 1939

R. Mould, Enderby	1 January 1930
J. Luddington, Bagworth	4 February 1930
H. Hunt, Countesthorpe	25 March 1930
G. W. Woodward, Barwell	25 March 1930
Mrs F. A. Hall, Dunton Bassett	12 April 1930
H. Peters, Bagworth/Thornton	30 September 1930
A. C. Allen, Walton	24 December 1930
W. Wallis, Shearsby	1 January 1931
T. J. Miller, Welford	1 March 1931
J. H. Squire, Rothley	25 March 1931
J. E. & A. M. Jarratt, Blaby	30 May 1931
F. Preston, Kirkby Mallory	24 June 1931
F. Hall & Co., Broughton Astley/Dunton Bassett	28 September 1931
A. Clarke, Oadby	28 December 1931
Highfields Motor Services, Leicester	1 January 1932
J. Moore, Whitwick	25 March 1932
A. Underwood jnr, South Wigston	28 March 1932
W. Bond, South Kilworth	16 April 1932
H. Bircher, Ibstock	6 June 1932
C. S. Peach, Glenfield	11 June 1932
J. C. Peberdy, Fleckney	12 June 1932
A. W. Whetton, Coalville	27 June 1932
J. W. Jordan, Ratby	1 July 1932
J. W. Neale, Cosby	20 February 1933
L. Wood, Ratby	20 February 1933
A. Underwood, South Wigston	20 August 1933
L. H. Pole & Sons, Syston	1 March 1934
W. & C. Smith, Syston	1 March 1934

C. W. Bishop, Asfordby	25 March 1934
Mrs A. M. Wright, Thurlaston	1 October 1934
C. T. Mann ('Pride of the Forest'), Whitwick	1 December 1934
J. Chapman, Fleckney	5 January 1935
E. A. Hames, Oadby	1 February 1935
A. Lord, Burbage	25 March 1935
T. H. Smith, Groby *	23 November 1935
J. Squires, Barrow-on-Soar	25 November 1935
R. Phillips, Enderby	30 December 1935
R. H. Reeve, Fleckney	1 March 1936
A. V. Simkin, Hallaton	1 March 1936
J. E. Ball, Hugglescote	21 May 1936
H. Fowkes, Ibstock	28 September 1936
Leicester & District Bus Co., Leicester	1 November 1936
F. R. Wadd, Syston	1 November 1936
C. W. Shaw ('Forest Greyhound'), Coalville	1 March 1937
H. T. Errington, Evington	24 March 1937
C. W. Moore ('Royal Blue'), Measham	25 March 1937
H. & A. Saunt, Ellistown	31 December 1938
A. Toone, Billesdon	1 March 1939
J. Clark, Narborough	25 March 1939
T. H. Vernon, Stoney Stanton	29 April 1939
J. Richardson, Lutterworth	1 September 1939

In addition, on various dates during 1936, the Gilroes cemetery services of ten different operators were acquired.

* Partial take-over – remainder 16 August 1954

APPENDIX 4

Leicester City Transport vehicle acquisitions 1924-1950 in numerical order

FLEET NO	REG. NO	CHASSIS	BODYWORK	SEATS	NEW
1-6	BC9162-67	Tilling-Stevens TS6	Brush	32 *	July 1924
7-14	RY 1572-79	Tilling-Stevens TS6	Brush	24/26	Sept/Oct 1925
15-18	RY4373-76	Guy B	Brush	25	July 1927
19-29	RY 4377, RY5541-50	Guy CX	Brush	30/26	Sept 1927 – Jan 1928
30-33	RY 5551-54	Guy B	Brush	25	Dec 1927
34-39	RY 6469-74	Guy CX	Brush	30/26	July – Sept 1928
40	WT 6436	Guy B	Brush	24	June 1928
41-46	RY 7696-98, RY 7851-53	Guy B	Brush	25	Feb – July 1929
47-52	RY 7854-59	Guy CX	Brush	30/26	July – Aug 1929
53	JF 1529	AEC Regent	Brush	24/24	June 1931
54-57	JF 1530-33	Leyland Titan TD1	Brush	26/24	June 1931
58-63	JF 2705-10	Leyland Titan TD2	Brush	26/24	May 1932
64-68	JF 5006-10	Leyland Titan TD3	Metro Cammell	26/24	Dec 1933
69	JF 5005	Crossley Condor	Crossley	26/24	Nov 1933
70-89	JF 5873-92	Leyland Titan TD3	Metro Cammell	26/24	May – July 1934
90-99	ABC 175-84	Leyland Titan TD4c	Metro Cammell	26/26	May 1936
1-10	ABC 31-38, ABC 173/74	Leyland Tiger TS7c	Metro Cammell	34	Aug 1936
NB In 1937 1-10, 19-22, 25-29, 34-39, 47-49, 51-99 were renumbered to 201-10, 219 etc					
300-311	BRY 262-73	Leyland Titan TD5c	Leyland	27/26	Nov 1937– Jan 1938
312-320	BRY 374-82	AEC Regent	Northern Counties	30/26	Sept – Oct 1937
321-329	CBC 913-19	AEC Renown	Northern Counties	32/32	Feb – Mar 1939
330-345	DBC 221-36	AEC Renown	Metro Cammell	32/32	May June 1940
346	DRY 323	Leyland Titan TD7	Brush	30/26	Jan 1942
347	DRY 324	Leyland Titan TD7	Pickering	30/26 **	May 1942
211-219	DJF 324-32	AEC Regent II	Park Royal	30/26	Feb – Mar 1946
220-228	DJF 316, 315, 317-23	AEC Regent II	Weymann	30/26	Jan – Oct 1946
232-251	DJF 333-52	Leyland Titan PD1	Leyland	30/26	Jun – Dec 1946
252	ERY 386	Leyland Titan PD1A	Leyland	30/26	May 1947
1-31	FBC 267-97	AEC Regent III	Metro Cammell	30/26	July – Oct 1949
32-65	FBC 298-331	AEC Regent III	Brush	30/26	Nov 1948 – Mar 1949
66-75	FBC 541-50	Daimler CVD6	Roberts	30/26	July – Nov 1949
76-95	FBC 659-78	Daimler CVD6	Willowbrook	30/26	Nov 1948 - Mar 1949
96-159	FJF 135-198	Leyland Titan PD2/1	Leyland	30/26	May 1949 – Dec 1950
160	FJF 199	Leyland Titan PD2/12	Leyland	30/26	Nov 1950

* Rebodied by Brush as 50 seat double deckers in 1927

** Rebuilt as a 26 seat single decker in October 1950

APPENDIX 5

Leicester City Transport route network November 1949

Starting in the north west of the city, services between 10 (the first available number after the tram routes) and 43 follow an almost perfect anti-clockwise circle of the suburbs.

10	Abbey Lane
11	Blackbird Road (via Belgrave Gate)
12	Groby Road
13	Blackbird Road (via Sanvey Gate)
14	New Parks Estate
15	Henley Road
16	Glenfield Road
17	Hinckley Road
18)	Braunstone Estate (via Hinckley Road)
18)	Braunstone Estate (via Narborough Road)
19	Imperial Avenue (via Hinckley Road)
20	Imperial Avenue (via Narborough Road)
21	Narborough Road
22	Braunstone Lane
23	Wigston Lane (via Aylestone Road)
24	Wigston Lane (via Saffron Lane)
25	Southfields Drive
26	Knighton Lane
27	Link Road
28	Clarendon Park
29	Stoneygate
30	Highway Road
31	Evington
32	East Park Road (via Humberstone Road)
33	East Park Road (via London Road)
34	Coleman Road
35	Coleman Road (Ambassador Road)
36	Melbourne Road
37	Humberstone Garden City
38	Humberstone
39	Gipsy Lane
40	Glenmore Road
41	Catherine Street
42	Melton Road
43	Belgrave
44	Towers Hospital
45	Football Ground (starting from Humberstone Gate)
46	Football Ground (starting from LMS station)
47	Willowbrook Road
48	General Hospital
50	Gilroes

An un-numbered route also ran on race days to Leicester Racecourse

APPENDIX 6

Proposed service alterations by Midland Red East, December 1981

EXISTING NETWORK		
ROUTE	FROM	TO
1	St Margaret's	Saffron Cross Roads
2	Southgates	Braunstone Cross Roads
3	St Margaret's	Gilmorton Estate
4	Southgates	Braunstone Asda
9	St Margaret's	Wigston Magna, Meadows Estate
74	Charles Street	Beaumont Leys
79	St Margaret's	Scraptoft
82	St Margaret's	Thurnby Lodge
89	St Margaret's	Scraptoft
92	St Margaret's	Thurnby Lodge
94	Charles Street	New Parks
603	St Margaret's	Sutton-in-the-Elms
605	St Margaret's	South Wigston
606	St Margaret's	South Wigston
608	St Margaret's	Oadby Severn Road
609	St Margaret's	Oadby Severn Road
622	St Margaret's	Birstall Harrowgate Drive
624	St Margaret's	Birstall Windmill Avenue
625-628	St Margaret's	Loughborough – Shepshed – Coalville
630	St Margaret's	Thurmaston
631	St Margaret's	Thurmaston
632	St Margaret's	Dominion Estate

PROPOSED NETWORK	
a	Coalville–Shepshed–Loughborough (Shelthorpe Road)
b	Shepshed–Loughborough–Birstall–City–Braunstone Cross Roads
c	Birstall–City–Gilmorton Estate–South Wigston
d	Scraptoft–City–Gilmorton Estate–South Wigston
e	Thurmaston–City–Wigston Magna–Meadows Estate
f	Thurnby Lodge–City–New Parks
g	Beaumont Leys–City–Oadby Severn Road
h	Birstall–City–Braunstone

OTHER SERVICES FOR WHICH ALL RESTRICTIONS WOULD BE LIFTED	
Via	
Melton Road	615, 616, 617, 618, 619, 620
Uppingham Road	X47, 650
London Road	264, 610, 611, 612, 613, 614
Aylestone Road	640, 642, 643
Narborough Road	599, 600, 601, 602
Hinckley Road	657, 658, 662, 663, 664
Groby Road	629, 662, 663, 665, 666, 667, 669

APPENDIX 7

New licences and route variations sought by Leicester City Transport, December 1981

NEW LICENCES
Leicester (Charles Street or St Margaret's)–Braunstone Asda
Leicester (Charles Street)–Bowhill Grove (circular)
Leicester (Haymarket)–Birstall (Windmill Avenue)
Leicester (Haymarket)–Birstall (Woodgate Drive)
Leicester (St Margaret's)–Bushby village
VARIATIONS TO EXISTING LICENCES
Leicester (Charles Street or St Margaret's)–Braunstone Cross Roads
Leicester (Charles Street)–New Parks Boulevard/Dominion Road
Leicester (Humberstone Gate)–Hamilton Lane/New Romney Crescent
Leicester (Humberstone Gate)–Nicklaus Road/Jacklin Drive
Leicester (Haymarket)–Bewcastle Grove
Leicester (Charles Street)–Bewcastle Grove
Leicester (Charles Street)–Leicester (Humberstone Gate)[1]
Leicester (Haymarket or St Margaret's)–Shanklin Drive
Leicester (Melton Road/Loughborough Road or Nicklaus Road/Jacklin Drive)–Braunstone Lane
Market Bosworth (Square or Station)–Leicester (Horsefair Street)
Ibstock–Leicester (Horsefair Street) via Kirby Muxloe

APPENDIX 8

Leicester CityBus service revisions from 7 October 1984

10	Outer Link (anticlockwise circular)
11	Outer Link (clockwise circular)
12	Braunstone Frith (Park Rise)–City Centre–Thurmaston (Blount Road)
13	Braunstone Cross Roads–City Centre–Cannock Street
14	New Parks–City Centre–East Park Road (anticlockwise circular)
15	Braunstone Frith (Tatlow Road)–City Centre–East Park Road (clockwise circular)
16	Braunstone (Cort Crescent)–Hinckley Road–City Centre–Goodwood
17	Braunstone (Cort Crescent)–Narborough Road–City Centre
18	Braunstone (Cort Crescent)–Hinckley Road–City Centre–Evington
19, 19A	Winstanley Drive–Hinckley Road–City Centre–Highfields (anticlockwise circular)
20	Winstanley Drive–Narborough Road–City Centre–Highfields (clockwise circular)
21	Braunstone Cross Roads–Narborough Road–City Centre–Catherine Street–Rushey Mead
22	Rushey Mead–City Centre–Evington
23	Rushey Mead–City Centre–Goodwood
24	City Centre–Green Lane Road–Goodwood
25	City Centre–Uppingham Road–Evington
26	City Centre–General Hospital–Goodwood
27	Beaumont Leys–City Centre–South Knighton
28	Beaumont Leys–City Centre–South Knighton
29	Beaumont Leys–City Centre–Stoneygate
30, 31	Anstey Lane (Avebury Avenue)–City Centre–Oadby
32	City Centre–Mowmacre Hill
33, 33A	Mowmacre Hill–City Centre–Gilmorton Estate
34	Braunstone (Millfield Crescent)–City Centre–Beaumont Leys (Beaumont Lodge)
35	City Centre–Southfields Drive
36, 36A	Mowmacre Hill–City Centre–Aylestone (Saffron Cross Roads)
37	Fairfield–Eyres Monsell (Exchange)–City Centre–Beaumont Leys (Beaumont Lodge)
38	Nether Hall–City Centre–Eyres Monsell
45	Halls of Residence–University and Polytechnic
46	Lunchtime Link University Circular (anticlockwise)
47	Lunchtime Link University Circular (clockwise)
50	Inner Link (anticlockwise circular)
51	Inner Link (circular clockwise)
120	Leicester–Wigston Magna–North Kilworth–Husbands Bosworth
121	Loughborough–Anstey–Leicester–Wigston Magna–Fleckney (jointly operated with County Travel)
122	Leicester–Newbold Verdon–Ibstock
123	Leicester–Market Bosworth–Twycross Zoo
124	Leicester–Kirkby Mallory–Ibstock
125	Desford–Hinckley
126	Leicester–Barton-in-the-Beans Early morning buses to the city centre from:
511	Braunstone Cross Roads
512	Aylestone
513	Beaumont Leys
514	Nether Hall
515	Braunstone Frith
516	Rushey Mead

Access special bus services for the elderly, disabled or handicapped to the city centre from:

901	Rushey Mead & Catherine Street (Monday only)
902	Nether Hall & Spinney Hill (Tuesday only)
903	Thurnby Lodge & Highfields (Thursday only)
904	Evington & General Hospital (Wednesday only)
905	Highway Road & Stoneygate (Tuesday only)
906	Aylestone & Eyres Monsell (Monday only)
907	Narborough Road & Braunstone (Tuesday only)
908	Braunstone Frith & New Parks (Wednesday only)
909	Beaumont Leys (Thursday only)
910	Stocking Farm & Mowmacre Hill (Friday only)
911	Glenfrith Hospital (Wednesday only)

12 Braunstone Frith (Park Rise) — City Centre — Thurmaston (Blount Road)
13 Braunstone Cross Roads — City Centre — Cannock Street

12,13

ROUTE:

Service 12 — Braunstone Frith (Park Rise), Park Rise, Scudamore Road, Liberty Road, Dominion Road, Glenfield Road, Glenfield Road East, King Richards Road, West Bridge, St Nicholas Circle, High Street, **City Centre (Humberstone Gate)**, Humberstone Road, Overton Road, Hastings Road, Victoria Road East, Gipsy Lane, Edgehill Road, St Ives Road, Barkby Road, Humberstone Lane, The Roundway, Hill Rise, Colby Drive, **Blount Road**, returning via Blount Road, Ridgeway Drive, Colby Drive then as reverse of above route using Marston Road instead of Edgehill Road.

Service 13 — Braunstone Cross Roads, Ratby Lane, Kirby Lane, Wembley Road, Scudamore Road, then as route for Service 12 to Humberstone Road, then Forest Road, Hastings Road, then as route for Service 12 to Humberstone Lane, Barkby Thorpe Road, Cannock Street, **Wenlock Way** returning via Wenlock Way, Cannock Street then as reverse of route using Marston Road instead of Edgehill Road.

Route diagram:
(not to scale)

14 New Parks — City Centre — East Park Road
15 Braunstone Frith (Tatlow Road) — City Centre — East Park Road

14,15

ROUTE:

Service 14 — New Parks (Dominion Road/Glenfield Road), Dominion Road, Charnor Road, Battersbee Road, Aikman Avenue, Petworth Drive, Henley Road, Fosse Road, Woodgate, Frog Island, Northgate Street, Sanvey Gate, St Margarets Way, Churchgate, Gravel Street, Abbey Street, Belgrave Gate, **City Centre (Haymarket)**, Gallowtree Gate, Granby Street, London Road, Evington Road, **East Park Road (Park Vale Road)** returning from East Park Road (St Saviours Road) via East Park Road, Evington Road, London Road, Granby Street, Gallowtree Gate, Humberstone Gate, **City Centre (Charles Street)**, Belgrave Gate, Abbey Street, Burleys Way, St Margarets Way then as reverse of above route.

Service 15 — Braunstone Frith (Tatlow Road), Ibbetson Avenue, Cranstone Crescent, Tournament Road, Tatlow Road, Liberty Road, Dominion Road, Charnor Road, Battersbee Road, Aikman Avenue, Petworth Drive, Henley Road, Glenfield Road, Glenfield Road East, King Richards Road, West Bridge, St Nicholas Circle, High Street, **City Centre (Humberstone Gate)**, Humberstone Road, Uppingham Road, St Barnabas Road **East Park Road, (St Saviours Road)** returning from East Park Road (Park Vale Road) via East Park Road, St Barnabas Road, Uppingham Road, Humberstone Road, Humberstone Gate, **City Centre (Charles Street)**, Belgrave Gate, Haymarket, High Street then as reverse of above route.

Route diagram:
(not to scale)

16 Braunstone (Cort Crescent) — City Centre — Goodwood
17 Braunstone (Cort Crescent) — City Centre
18 Braunstone (Cort Crescent) — City Centre — Evington

16,17,18

ROUTE:

Service 16 — Braunstone (Cort Crescent), Cort Crescent, Hinckley Road, Braunstone Gate, Duns Lane, West Bridge, St Nicholas Circle, High Street, **City Centre (Humberstone Gate)**, Charles Street, Northampton Street, Swain Street, Sparkenhoe Street, St Peters Road, Chesterfield Road, Evington Valley Road, Gedding Road, St Saviours Road, Broad Avenue, Coleman Road, Green Lane Road, Wicklow Drive, Ambassador Road, Goodwood Road, Davenport Road, Gamel Road, **Goodwood (Goodwood Road)**, returning via Goodwood Road, Ambassador Road, then as reverse of above route.

Service 17 — Braunstone (Cort Crescent), Cort Crescent, Hallam Crescent East, Fullhurst Avenue, Narborough Road, Walnut Street, Aylestone Road, Infirmary Road, Oxford Street, Newarke Street, Pocklingtons Walk, Horsefair Street, Gallowtree Gate, **City Centre (Humberstone Gate)** returning from City Centre (Charles Street) via Charles Street, Rutland Street, Belvoir Street, Welford Road, Infirmary Road, Jarrom Street, Havelock Street, Walnut Street then as reverse of above route.

Service 18 — Braunstone (Cort Crescent) then as route 16 to St Saviours Road, Broad Avenue, General Hospital, Coleman Road, Goodwood Road, Whitehall Road, **Evington (Downing Drive)** returning via Downing Drive, Welland Vale Road, Spencefield Lane, Whitehall Road and reverse of above route.

Route diagram:
(not to scale)

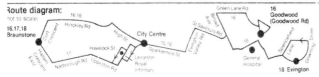

Winstanley Drive — City Centre — Highfields

19,20

ROUTE:

Service 19 — Winstanley Drive (Rancliffe Crescent), Winstanley Drive, Hinckley Road, Woodville Road, Glenfield Road, Glenfield Road East, King Richards Road, West Bridge, St Nicholas Circle, High Street, **City Centre (Humberstone Gate)**, Humberstone Gate, Charles Street, Northampton Street, Swain Street, Sparkenhoe Street, St Peters Road, Melbourne Road, **Highfields (Berners Street)** returning via reverse of above route. (Certain journeys to Winstanley Drive operate via Hinckley Road, Winstanley Drive, Hamelin Road, Blackmore Drive, Hamelin Road, Winstanley Drive — Service 19A).

Service 20 — Winstanley Drive (Rancliffe Crescent), Winstanley Drive, Guthridge Crescent, Imperial Avenue, Narborough Road, Braunstone Gate, Duns Lane, West Bridge, St Nicholas Circle, High Street, **City Centre (Humberstone Gate)**, Humberstone Gate, Humberstone Road, Nedham Street, Melbourne Road, **Highfields (Berners Street)** returning via reverse of above route.

Route diagram:
(not to scale)

24 City Centre — Spinney Hill — Goodwood
25 City Centre — Uppingham Road — Evington
26 City Centre — General Hospital — Evington

24,25,26

ROUTE:

Service 24 — City Centre (Humberstone Gate), Humberstone Gate, Humberstone Road, Spinney Hill Road, Mere Road, St Saviours Road, East Park Road, Green Lane Road, Wicklow Drive, Goodwood Road, **Goodwood (Goodwood Road)**, returning via reverse of above route.

Service 25 — City Centre (Humberstone Gate), Humberstone Gate, Humberstone Road, Spinney Hill Road, Green Lane Road, Coleman Road, Uppingham Road, Ambassador Road, Goodwood Road, Davenport Road, Spencefield Lane, Downing Drive, **Evington (Downing Drive/Chatteris Avenue)** returning via Downing Drive, Welland Vale Road, Spencefield Lane then as reverse of above route.

Service 26 — City Centre (Humberstone Gate), Humberstone Gate, Humberstone Road, Spinney Hill Road, Mere Road, St Saviours Road, Broad Avenue, General Hospital Drive, Coleman Road, Goodwood Road, Whitehall Road, Downing Drive, **Evington (Downing Drive/Chatteris Avenue)** returning via Downing Drive, Welland Vale Road, Spencefield Lane, Whitehall Road then as reverse of above route.

Route diagram:
(not to scale)

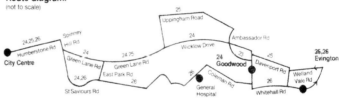

Anstey Lane (Avebury Avenue) — City Centre — Oadby

30,31

ROUTE:

Service 30 — Anstey Lane (Avebury Avenue), Avebury Avenue, Anstey Lane, Buckminster Road, Medina Road and Groby Road (IN), Blackbird Road (OUT), Fosse Road North, Glenfield Road East, King Richards Road, West Bridge, St Nicholas Circle, High Street, Humberstone Gate, **City Centre (Charles Street)**, Charles Street, London Road, Evington Road, Stoughton Drive North, Kingsway Road, Highway Road, Stoughton Road, Gartree Road, Stoughton Drive South, Manor Road, Stoughton Road, New Lane, New Street, London Road, Wigston Road, Brabazon Road, **Oadby (Chestnut Avenue)** returning via Chestnut Avenue, The Parade, Harborough Road, Stoughton Road, Manor Road, Stoughton Drive South, Gartree Road, Stoughton Road, Broadway Road, Trueway Road, Kingsway Road, Stoughton Drive North, Evington Road, London Road, Charles Street, **City Centre (Humberstone Gate)** then as reverse of above route.

Service 31 — Anstey Lane (Avebury Avenue), As service 30 route to Evington Road, Evington Lane, Stoughton Road, Gartree Road, The Fairway, The Broadway, Manor Road, then as service 30 route to Oadby. Return route is reverse of outward route.

Route diagram:
(not to scale)

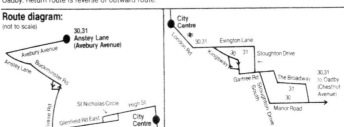

27,28 Beaumont Leys — City Centre — South Knighton
29 Beaumont Leys — City Centre — Stoneygate

27,28,29

ROUTE:

Service 27 — Beaumont Leys (Beaumont Centre Bus Station), Bennion Road, Orwell Drive, Strasbourg Drive, Heacham Drive, Burnham Drive, Babingley Drive (IN), Somerset Avenue (OUT), Parker Drive, Blackbird Road, Woodgate, Frog Island, Northgate Street, Highcross Street, Vaughan Way, St Nicholas Circle, High Street, Humberstone Gate, **City Centre (Charles Street)**, Charles Street, London Road, Victoria Park Road, Queens Road, Knighton Road, Carisbrooke Road, Meadvale Road, Overdale Road, Aberdale Road, Cairnsford Road, Woodcroft Avenue, **South Knighton (Pendlebury Drive)** returning via Pendlebury Drive, Woodcroft Avenue then as reverse of above route to Charles Street, Blegrave Gate, Abbey Street, Burleys Way, St Margarets Way, Sanvey Gate, Northgate Street then as reverse of above route to Orwell Drive, Beaumont Way, Rutherford Road to Beaumont Centre Bus Station.

Service 28 — Beaumont Leys (Beaumont Centre Bus Station), Bennion Road, Orwell Drive, Strasbourg Drive, Beaumont Leys Lane, Abbey Lane, St Margarets Way, Churchgate, Gravel Street, Abbey Street, Belgrave Gate, **City Centre (Charles Street)**, Charles Street, London Road, Victoria Park Road, Queens Road, Clarendon Park Road, Welford Road, Overdale Road, Meadvale Road, **South Knighton (Shanklin Drive)** returning via reverse of above route to Abbey Street, Burleys Way, St Margarets Way, Abbey Lane, Beaumont Leys Lane, Strasbourg Drive, Orwell Drive, Beaumont Way, Rutherford Road to Beaumont Centre Bus Station.

Service 29 — Beaumont Leys (Beaumont Centre Bus Station), Bennion Road, Orwell Drive, Strasbourg Drive, Tolling Road, Collett Road, Marwood Road, Halifax Drive, Beaumont Leys Lane, Abbey Lane, Abbey Park Road, Belgrave Gate, **City Centre (Haymarket)**, Haymarket, Gallowtree Gate, Granby Street, London Road, **Stoneygate (Shanklin Drive)** returning via Shanklin Drive, London Road, Granby Street, Gallowtree Gate, Humberstone Gate, **City Centre (Charles Street)**, Charles Street, Belgrave Gate, Abbey Park Road, Abbey Lane, Beaumont Leys Lane, Halifax Drive, Marwood Road, Collett Road, Tilling Road, Strasbourg Drive, Orwell Drive, Beaumont Way, Rutherford Road to Beaumont Centre Bus Station.

33, 33A Mowmacre Hill — City Centre — Gilmorton Estate
36, 36A Mowmacre Hill — City Centre — Aylestone

33,33A 36,36A

ROUTE:

Service 33 — Mowmacre Hill (Bewcastle Grove), Bewcastle Grove, Holderness Road, Beaumont Leys Lane, Heacham Drive, Burnham Drive, Babingley Drive (IN), Somerset Avenue (OUT), Parker Drive, Blackbird Road, Woodgate, Frog Island, Northgate Street, Sanvey Gate, St Margarets Way, Churchgate, Gravel Street, Abbey Street, Belgrave Gate, **City Centre (Charles Street)**, Charles Street, Rutland Street, Belvoir Street, Welford Road, Almond Road, Aylestone Road, Lutterworth Road, Gilmorton Avenue, **Gilmorton Estate (Holts Close)** returning via Gilmorton Avenue, Lutterworth Road, Aylestone Road, Infirmary Road, Oxford Street, Newark Street, Pocklingtons Walk, Horsefair Street, Gallowtree Gate, Humberstone Gate, **City Centre (Charles Street)** then as reverse of above route.

Service 33A — Mowmacre Hill (Bewcastle Grove) Then as service 33 route to Blackbird Road, Abbey Park Road, Belgrave Gate then as service 33 route to **Gilmorton Estate (Holt Close)** returning via reverse of service 33 route to Charles Street, then reverse of service 33A route to Mowmacre Hill.

Service 36 — Mowmacre Hill (Bewcastle Grove) Then as service 33A route to Aylestone Road, Wigston Lane, Aylestone Drive, **Aylestone (Saffron Cross Roads)** returning via reverse of 36 route to Aylestone Road and reverse of 33 route to Mowmacre Hill.

Service 36A — Mowmacre Hill (Bewcastle Grove) Then as service 33A route to Aylestone Road, Wigston Lane, Aylestone Drive, Glenhills Boulevard, **Aylestone (Saffron Cross Roads)** returning via reverse of 36A route to 36A route to Aylestone Road and reverse of 33A route to Mowmacre Hill.

Route diagram:
(not to scale)

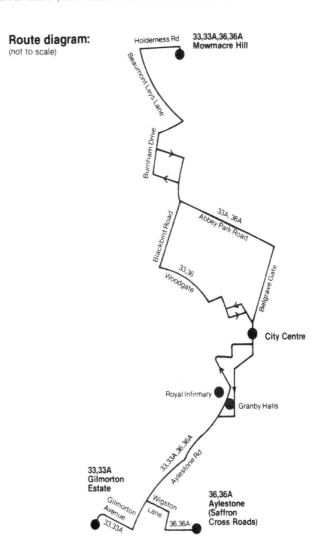

Route diagram:
(not to scale)

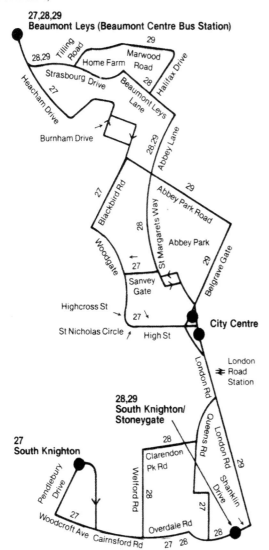

34 Braunstone (Millfield Crescent) — City Centre — Beaumont Leys (Beaumont Lodge)
37 Fairfield — Eyres Monsell (Exchange) — City Centre — Beaumont Leys (Beaumont Lodge)

34,37

ROUTE:

Service 34 — **Braunstone (Millfield Crescent)**, Millfield Crescent, Lubbesthorpe Road, Watergate Lane, The Osiers, The Glade, The Chase, Kingsway, Ravenhurst Road, Hathaway Avenue, Shakespeare Drive, Braunstone Lane, Waltham Avenue, Folville Rise, Gooding Avenue, Fullhurst Avenue, Narborough Road, Braunstone Gate, Duns Lane, West Bridge, St Nicholas Circle, High Street, Humberstone Gate, **City Centre (Charles Street)**, Charles Street, Belgrave Gate, Abbey Street, Burleys Way, St Margarets Way, Sanvey Gate, Northgate Street, Frog Island, Woodgate, Blackbird Road, Anstey Lane, Calver Hey Road, Heacham Drive, Strasbourg Drive, Orwell Drive, Beaumont Way, Rutherford Road, **Beaumont Centre Bus Station**, Rutherford Road, Beaumont Way, Bennion Road, Astill Lodge Road, **Beaumont Leys (Beaumont Lodge Road)** returning via Astill Lodge Road, Bennion Road, **Beaumont Centre Bus Station**, Bennion Road, Orwell Drive then as reverse of above route to St Margarets Way, Churchgate, Gravel Street, Abbey Street, Belgrave Gate, **City Centre (Haymarket)**, Haymarket, High Street, then as reverse of above to Watergate Lane, Millfield Crescent.

Service 37 — **Fairfield (Cornwall Road)**, Cornwall Road, Kenilworth Road, Gloucester Crescent, Saffron Road, Sturdee Road, **Eyres Monsell (Exchange)**, Sturdee Road, Glenhills Boulevard, Lutterworth Road, Aylestone Road, Infirmary Road, Oxford Street, Newarke Street, Pocklingtons Walk, Horsefair Street, Gallowtree Gate, **City Centre (Haymarket)**, Haymarket, Belgrave Gate, Belgrave Road, Loughborough Road, Red Hill Circle, Abbey Lane, Thurcaston Road, Belgrave Boulevard, Border Drive, **Mowmacre Hill (Belgrave Boulevard)**, Holderness Road, Beaumont Leys Lane, Barshaw Road, Tolwell Road, Bursom Road, Leycroft Road, Bennion Road, Astill Lodge Road, **Beaumont Leys (Beaumont Lodge)** returning via reverse of above route to Belgrave Gate, **City Centre (Charles Street)**, Charles Street, Rutland Street, Belvoir Street, Welford Road, Almond Road, Aylestone Road, Lutterworth Road, Glenhills Boulevard, Sturdee Road, **Eyres Monsell (Exchange)**, Sturdee Road, Saffron Road, Gloucester Crescent, **Fairfield (Cornwall Road)**.

Nether Hall — City Centre — Eyres Monsell

38

ROUTE:

Service 38 — Nether Hall (Nether Hall Road/New Romney Crescent), Nether Hall Road, Steins Lane, Main Street, Tennis Court Drive, Scraptoft Lane, Uppingham Road, Humberstone Road, Humberstone Gate, **City Centre (Humberstone Gate)**, Charles Street, Rutland Street, Belvoir Street, Welford Road, Almond Road, Aylestone Road, Saffron Lane, Glenhills Boulevard, Pasley Road, Sturdee Road, Hillsborough Road, Featherstone Drive, Monmouth Drive, **Eyres Monsell (Monmouth Drive)** returning via Monmouth Drive, Hillsborough Road, Sturdee Road, Pasley Road, Glenhills Boulevard, Saffron Lane, Aylestone Road, Infirmary Road, Oxford Street, Newarke Street, Pocklingtons Walk, Horsefair Street, Gallowtree Gate, **City Centre (Humberstone Gate)**, Humberstone Gate, Humberstone Road, Uppingham Road, Scraptoft Lane, Tennis Court Drive, Main Street, Steins Lane, Nether Hall Road, Ivychurch Crescent, Keyham Lane West, Hamilton Lane, New Romney Crescent, **Nether Hall (Nether Hall Road)**.

Route diagram:
(not to scale)

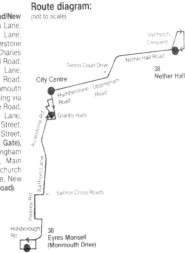

Route diagram:
(not to scale)

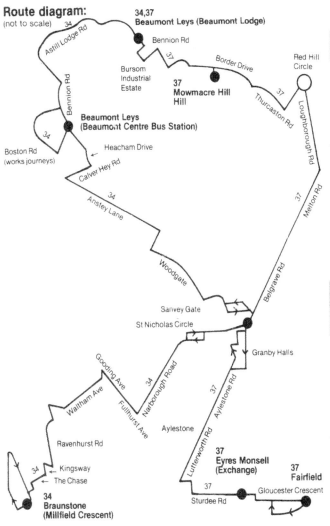

Inner Link

50,51

ROUTE:

Service 50 — Abbey Lane, Red Hill Circle, Loughborough Road, Checketts Road, Marfitt Street, Gipsy Lane, Victoria Road East, Hastings Road, Overton Road, Humberstone Road, Spinney Hill Road, Green Lane Road, Coleman Road, General Hospital Drive, Gwendolen Road, Evington Valley Road, Evington Drive, Evington Road, Beckingham Road, Mayfield Road, Victoria Park Road, Queens Road, Clarendon Park Road, Welford Road, Knighton Fields Road, Saffron Lane, Duncan Road, Aylestone Road, Middleton Street, Braunstone Lane East, Narborough Road, Fullhurst Avenue, Fosse Road South, Fosse Road Central, Fosse Road North, Blackbird Road, Abbey Lane.

Service 51 — Abbey Lane, Blackbird Road, then as reverse of service 50 route.

Route diagram:

120 Leicester — Wigston Magna — North Kilworth — Husbands Bosworth
121 Loughborough — Anstey — Leicester — Wigston Magna — Fleckney

120,121

ROUTE:

Service 120 — Leicester (St Margarets Bus Station), Charles Street, Rutland Street, Welford Road, Wigston Magna, A50, Arnesby, Shearsby, North Kilworth, South Kilworth, Welford, **Husbands Bosworth**.

Service 121 — Loughborough (Bus Station), A6, Quorn, Old Woodhouse, Woodhouse Eaves, Swithland Triangle, Newtown Linford (for Bradgate Park), **Anstey**, (Hollow Road, Stadon Road, The Nook), Leicester Road, Gorse Hill, Anstey Lane, Bennion Road, **Beaumont Leys (Beaumont Centre Bus Station)**, Bennion Road, Orwell Drive, Krefeld Way, Anstey Lane, Ravensbridge Drive, St Margarets Way, Churchgate, Gravel Street, **Leicester (St Margarets Bus Station)**, Abbey Street, Belgrave Gate, Charles Street, Rutland Street, Welford Road, Wigston Magna, A50, Kilby Bridge, Kilby, **Fleckney (Edward Road)**.

Note: Services 120 and 121 pick up and set down passengers at all recognised bus stops along the line of route.

Route diagram:

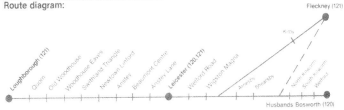

Above and on pages 234-235: 179-181. Sample route descriptions and diagrams for selected services listed in Appendix 8.

FURTHER READING

Many of the books about Leicester's buses have long been out of print. They may occasionally appear on eBay or at bus rallies, but the following will be easier to track down for the modern reader.

CREESE Geoff *Leicester's Trams* Irwell Press 2000

CREESE Geoff *Leicester and its Trams – Tramscape and Townscape 1903-1949* Irwell Press 2006

GREENWOOD Mike *Maroon to Cream* Leicester Transport Heritage Trust 2011

GREENWOOD Mike, ROBERTS Paul *Midland Red in NBC Days* Ian Allan 2014

HARVEY David *Leicester Buses* Amberley 2016

LAMB Philip (Series Editor) *Leicester in Colour* Presbus Publishing 2013

The **LEICESTER TRANSPORT HERITAGE TRUST** has produced reprints of some relevant documents from the tramway era:

Leicester Corporation Tramways – Souvenir of the Opening Ceremony

City of Leicester Tramways – Souvenir of the Coming of Age

Celebration of the Electric Tramways System

Operation Scrap-Iron – The Story of the Abandonment of Leicester's Trams

It has also reproduced the memoirs of Raymond Tuft from Midland Red Staff Magazines under the title *Raymond Remembers* Details of how to contact the Trust can be found at its website, www.ltht.org.uk

NOTES

Chapter 1

1. Earlier works credit this to Solomon Andrews, but exhaustive research by members of the Leicester Transport Heritage Trust has revealed that the operators of that first horse bus service in 1863, from Leicester to Oadby, were Messrs Brown and Bent. Unfortunately, little else is known of these pioneering gentlemen.
2. The standard fare on the horse trams was 2d on all routes for any distance.
3. In his book *Leicester's Trams In Retrospect* (1970) M.S.W. Pearson notes that when the Corporation took over in 1901 'they found that the standard of discipline had fallen to an unsatisfactory level, and that the inspectors were just not doing their job.'
4. It seems there is no contemporary explanation as to what the term 'LERO' actually stands for.
5. Saxe-Coburg Street was renamed Saxby Street in 1917.
6. An earlier report in the Leicester Daily Post (16 May) said 'it will probably be of interest to state that the drivers and conductors of the cars will wear a uniform of blue serge, piped with red, and a cap to match.'
7. Newarke Street was never laid out for the tramway system, and was therefore to play an important role in the development of bus services, as will be seen in Chapter 2.
8. One of the earliest and most successful was the GWR 'railway – motor bus' service from Helston to The Lizard in Cornwall that began in August 1903.

Chapter 2

1. Both East Street and Regent Street were thoroughfares close to London Road railway station. East Street was just a short-term terminus, but Regent Street continued in use until 1932, when Northampton Square bus station was opened.
2. The Midland Motor Bus Co also had, but appear not to have used, licences for services to Anstey, Enderby and Wigston granted in 1919. Competition with Trent in the north of the county, and Midland Red to the south and west, led to their complete withdrawal from Leicester by September 1921.
3. The British Electric Traction Co (BET) was formed in 1896 to promote electric tramways around the country. In 1899 it set up a new company, the Birmingham General Omnibus Co Ltd., to operate horse buses in the area. In 1902 those operations were put under the control of the Birmingham & Midland Tramways Ltd.; these included a new fleet of 'red' buses, and thus the name Midland 'Red' came into being.
4. As this legislation was effective from 1 January 1921, and the Committee were in no position to agree matters until after that date, Midland Red opposition to the clause was recorded but the matter was to all intents and purposes dropped.
5. This meant that outward minimum fares would be set at twice the maximum tramway fare, and 50% of inward fares from the outer termini of each tram route were to be handed back to the corporation; virtually the same thing Power said at the meeting on 29 March 1920. He also suggested that in order to comply with the committee's clause 4, the Corporation should supply Midland Red with the necessary tickets and waybills, 'in exactly the same manner as Birmingham Corporation Tramways Department'.
6. Southgate Street garage was actually built upon part of Leicester's ancient city walls; a Roman tessellated pavement was discovered while excavating for an inspection pit. The Welford Road premises still stand, and in January 2017, were in use as an antiques centre. The building that formed Frog Island garage was demolished after a fire in 2015.
7. Bearwood was Head Office, and Midland Red's Leicester local booking and enquiry office was then situated at 69 Granby Street.
8. The operating area envisaged a boundary drawn around Stafford, Uttoxeter, Burton-on-Trent, Melton Mowbray, Oakham, Market Harborough, Daventry, Towcester, Buckingham, Chipping Norton, Shipston-on-Stour, Evesham, Tewkesbury, Ross-on-Wye, Hereford, Hay, Kingston, Prestigne, Knighton, Montgomery, Oswestry, Ellesmere, Whitchurch and Market Drayton before arriving back at Stafford. Check that on a map and it will become obvious why Midland Red was the largest operator in England outside of London Transport.
9. One case did relate to Midland Red's great rivals, Leicester & District. It was reported on 31 October 1929 that 'Wm. A. Bailey and Fredk. Smith, of Leicester, the driver and conductor respectively of a Green 'bus, were summoned at Hinckley today for having their bus overcrowded in Earl

Shilton on October 5. It was stated that there were 49 persons in the 32-seater vehicle. Bailey was fined 5s and Smith £1'.

10. Note that data compiled by the Royal Society for the Prevention of Accidents (RoSPA) for road accidents which were reported to the police shows that 1,732 people were killed on Great Britain's roads in 2015.

11. By virtue of this one, small sub-paragraph, competition would cease to be an issue.

12. This was an important clause, as, for example, it would affect Midland Red services from Leicester to Nuneaton, Coventry and Birmingham, all of which were within the West Midland Traffic Area.

13. Leicester's last boundary changes had been in 1892, when Belgrave, Aylestone, North Evington, Knighton and Stoneygate were taken into the town (as it then was). It obtained its current boundaries in 1935 when the remainder of Evington, Humberstone, Beaumont Leys and part of Braunstone were added. Interestingly, in 1949, the Council's Parliamentary & General Purposes Committee wanted a Parliamentary Bill to allow an extension of the boundaries to swallow up Oadby, Wigston, Barkby Thorpe, Birstall, Wanlip, Syston, Thurmaston, Scraptoft, Stoughton, Stretton Magna, Thurnby, Braunstone, Glenfield, Glen Parva, Kirby Muxloe and Lubbesthorpe. Subsequent reports suggested that such a challenge had little or no chance of success – in fact it never got off the ground. If it had, it would have had a major impact on Midland Red.

14. In broad terms, the Worcester Corporation took the net profits from all routes passing through the city for the portion of the route that the Corporation was authorised to operate, while Midland Red retained 3d per mile for interest and depreciation.

15. Leicester (Northampton Square) and Leicester (Newarke Street) via Humberstone Road, Catherine Street, Forest Road, Humberstone Road, St Saviours Road, Gedding Road, Stoughton Drive North, London Road, Avenue Road, Queens Road, Knighton Road, Chapel Lane, Welford Road, Knighton Fields Road East & West, Cavendish Road, Aylestone Road and Welford Road.

16. New Year's Day was not a Bank Holiday in the UK until 1972.

17. Now known as Stonesby Avenue

Chapter 3

1. The well-respected H. Boyer and Son of Rothley, who began services into Leicester in 1911 with buses converted from lorries and in one instance, a Lancia car, is a good example.

2. An establishment that is still trading under that name at the time of writing.

3. Hill Street Chapel was approximately 300 yards from the Belgrave Gate site. However, the Council did not lose interest, as it re-emerged in 1932 as part of the plan for a Charles Street bus station.

4. The General Furnishers Ltd premises stood between Bedford Street and Jubilee Road, beyond the Griffin Inn public house, and can clearly be seen – as can the effects of the widening of Belgrave Gate – in the photograph of tramcar 118.

5. Fox Street was a small thoroughfare leading from Campbell Street – site of the original Leicester railway station – to Northampton Street.

6. In other words, the Abbey Street bus station

Chapter 4

1. Alderman Banton favoured a further extension as far as the General Hospital, but this idea never left the drawing board.

2. It is this route that led to Midland Red taking court action against the Corporation for operating outside the city boundary, as described in Chapter 2.

3. A full list of all acquisitions from 1924-1950 can be found in Appendix 4.

4. For nine years from 1927 Nottingham operated all three types of vehicle. The trams were not finally withdrawn until September 1936, when a number of tram routes were converted to motor bus, as opposed to trolleybus, operation.

5. This was Charles Street. The section from Humberstone Gate to Belgrave Gate was an entirely new build, while the remainder comprised two sections, from Humberstone Gate to Rutland Street, and from Rutland Street to Northampton Street, which until the early 1930s was named Upper Charles Street. Both were widened as part of the whole process, and carried round into what had been the southern end of Northampton Street, to create a new junction with Granby Street, which layout survives more or less unchanged today.

6. Reproduced with the article was a picture of the last ticket to be issued on a Melbourne Road tram. For the record, it was for 1d, number 41S 2548.

7. As the tram blinds covered numbers 1 to 12, it was decided to start bus route numbers at 21. In the first instance, numbers up to 35 were utilised.

8. Interestingly, it was about this time that Leicester acquired a batch of nine AEC Regents with Northern Counties bodywork, fleet numbers 312-20. They had been ordered by Cardiff Corporation and built to their specifications but were

surplus to requirements there and AEC took the opportunity to offer them to a number of other municipalities.

9. These were Leyland TD7s with Brush (346) and Pickering (347) 56 seat bodywork. 347 suffered the indignity in 1950 of being rebuilt as a single decker, though it was rarely used in service thereafter.

10. The final vehicle in this batch, 160, was a PD2/12 built to the new permitted width of 8ft, enabling four more seats to be provided. It is illustrated later in this chapter.

11. It was further reported on 5 November that the Highways Committee were to recommend that the remaining 18 miles of main roads in the city with abandoned tram lines should be resurfaced at a cost of £261,779, with the Transport Department contributing £85,427. It seems that this did not go ahead, as in the years since 1949 there have been various instances when roadworks on city streets have uncovered sections of tram lines; on Belgrave Gate, adjacent to the old ABC cinema; on the slip road alongside the Belgrave Gate flyover (demolished in 2014), and on Aylestone Road near to the Leicester Tigers ground to name but three.

12. This was a 1½d.ticket, KA 29537.

13. *Leicester's Trams In Retrospect* (1970), page 59.

14. Including the horse tram era, from Christmas Eve 1874 to 9 November 1949 is indeed nearly 75 years

Chapter 5

1. At the start of 1980, these jointly licensed services comprised the 3 to the Gilmorton Estate, the 5-10 to Wigston Magna via different routes, the 74 to Beaumont Leys and the 79 to Braunstone Frith, which were wholly operated by Midland Red. The 87 and 88 to Eyres Monsell and 97 to Fairfield were wholly Leicester City Transport operated, and the 12, 16 and 44 to Braunstone Frith, the 62 to South Wigston and 63 to Wigston Magna were jointly operated.

2. The last vehicle to be completely built at Carlyle Works, S23 class saloon 5941, joined the fleet early in 1970.

3. The PTE was required by law to have control of all the services within its area, and as the PTE and Midland Red were unable to agree to the latter operating on an agency basis, a sale was the only other option.

4. Only one area of Leicestershire – Coalville – saw changes to its services and to its buses, which appeared with "Lancer" branding, reflecting the area's connection with the legend of Ivanhoe.

5. *Bus Operators : 1 Midland Red* (Ian Allan, 1983).

6. Midland Red did in fact order Leyland Atlanteans double deck buses in 1970, but none ever made it to the Midlands; 60 went to Merseyside PTE (1236-95), 30 to London Country (AN91-120) and 20 to Maidstone & District (5701-20). A batch of 20 ordered later in the decade were also diverted, this time to Ribble (1405-24).

7. This amounted to a 13 per cent increase, helping to offset an impending large wages settlement and other additional costs. The fare rise, which also included Gibson's services, came into effect on 7 March. Concessionary fares were increased from 2p to 5p at the same time, raising an extra £300,000. Midland Red East also increased its fares on the same day.

8. Although it did not make it clear, this was the cost per route, not per day.

9. Peter Soulsby was a Labour councillor from 1974-2003. He was knighted in 1999 for services to local government. In 2005 he became the MP for Leicester South, a position he held until 2011 when he became the Labour candidate for the directly-elected position of Leicester Mayor, which he won by a large majority. He was re-elected in 2015.

10. Back in 1981, the incoming Daimler Fleetlines had been given a deeper red than the 'poppy' specified by the NBC.

11. David Bellamy is an author, botanist, environmental campaigner and broadcaster who regularly appeared on our TV screens in the 1980s.

12. Most notably London in the 1970s, and in Devon General's own operating area – Torquay and Paignton – in winter months, as a means of making certain services more viable.

13. By the completion of deliveries in mid-1986, the fleet comprised M1-M24 (B401-24 NJF), M25 (B400 WTC), M26-M29 (B426-29 PJF), M30-M64 (C430-64 SJU), M65-M88 (C465-88 TAY), M89-M97 (C489-97 TBC), M98-M153 (C498-553 TJF) and M154-M177 (C554-77 TUT). Body conversions were by Rootes (M1-24/65-69/115-162), Robin Hood (M25-64/70-76), Dormobile (M77-97/163-177) and Alexander (M98-114).

14. At a later date a third route – 'Yellow' – between the town centre and Thringstone was added. Later still, route numbers were substituted for the colour system.

15. It was claimed that while the Commissioners had been slow to deal with CityBus service applications and route changes, on three occasions they had allowed Midland Fox to run new services without the necessary licences. As a result, CityBus said it might have to consider running new services without Commissioners' permission.

16. At that time three separate companies, Trent, Barton and Kinch are now united within the Wellglade group. The Kinch name and livery are still used in the Loughborough area.

Appendix 2

1. Later there were also services numbered 598 and 599.

Appendix 7

1. This is presumably a circular route to a destination away from the city centre but I have not seen the licence application and cannot therefore identify it.

INDEX